Nettitudes

STUDIES IN NETWORK CULTURES
Geert Lovink, Series Editor

This series of books investigates concepts and practices special to network cultures. Exploring the spectrum of new media and society, we see network cultures as a strategic term to enlist in diagnosing political and aesthetic developments in user-driven communications. Network cultures can be understood as social-technical formations under construction. They rapidly assemble, and can just as quickly disappear, creating a sense of spontaneity, transience and even uncertainty. Yet they are here to stay. However self-evident it is, collaboration is a foundation of network cultures. Working with others frequently brings about tensions that have no recourse to modern protocols of conflict resolution. Networks are not parliaments. How to conduct research within such a shifting environment is a key interest to this series.

Studies in Network Cultures is an initiative of the Institute of Network Cultures (INC). The INC was founded in 2004 by its director Geert Lovink and is situated at the Amsterdam University of Applied Sciences (Hogeschool van Amsterdam), as a research programme inside the School for Interactive Media. Since its inception, the INC has organized international conferences about the history of webdesign, netporn, the critique of ICT for development, new network theory, creative industries rhetoric, online video, search and Wikipedia research. For more information please visit: http://networkcultures.org/publications/studies-in-network-cultures/

The series Studies in Network Cultures *is published by the Institute of Network Cultures in collaboration with NAi Publishers, Rotterdam.*

Series Coordinator: Sabine Niederer, Institute of Network Cultures
For more information please visit www.networkcultures.org/naiseries

Previously published in this series:

Ned Rossiter, Organized Networks: Media Theory, Creative Labour, New Institutions *(Rotterdam: NAi Publishers and Amsterdam: Institute of Network Cultures, 2006)*

Eric Kluitenberg, Delusive Spaces: Essays on Culture, Media and Technology *(Rotterdam: NAi Publishers and Amsterdam: Institute of Network Cultures, 2008)*

Matteo Pasquinelli, Animal Spirits: A Bestiary of the Commons *(Rotterdam: NAi Publishers and Amsterdam: Institute of Network Cultures, 2008)*

Vito Campanelli, Web Aesthetics: How Digital Media Affect Culture and Society *(Rotterdam: NAi Publishers and Amsterdam: Institute of Network Cultures, 2010)*

Nettitudes

Let's Talk Net Art

Josephine Bosma

NAi Publishers
Institute of Network Cultures

This publication was made possible thanks to the financial support of the Mondriaan Foundation, Amsterdam

Mondriaan Stichting
(Mondriaan Foundation)

Series editor: Geert Lovink, Institute of Network Cultures, Hogeschool van Amsterdam (HvA)
Series coordinator: Sabine Niederer, Institute of Network Cultures, Hogeschool van Amsterdam
Editor: Bart Plantenga
Copy editor: D'Laine Camp
Design: Studio Tint, Huug Schipper, The Hague
Cover design: Studio Léon&Loes, Rotterdam
Type setting and printing: Die Keure, Bruges, Belgium
Binding: Catherine Binding
Paper: Munken Lynx 100 gr
Project coordination: Barbera van Kooij, NAi Publishers, Rotterdam
Publisher: NAi Publishers, Rotterdam

© 2011 the author, NAi Publishers, Rotterdam.
All rights reserved. No part of this publication may be reproduced, stored in a retrieval system, or transmitted in any form or by any means, electronic, mechanical, photocopying, recording or otherwise, without the prior written permission of the publisher.

NAi Publishers is an internationally orientated publisher specialized in developing, producing and distributing books on architecture, visual arts and related disciplines.
www.naipublishers.nl info@naipublishers.nl

Available in North, South and Central America through D.A.P./Distributed Art Publishers Inc, 155 Sixth Avenue 2nd Floor, New York, NY 10013-1507, Tel 212 6271999, Fax 212 6279484.

Available in the United Kingdom and Ireland through Art Data, 12 Bell Industrial Estate, 50 Cunnington Street, London W4 5HB, Tel 208 7471061, Fax 208 7422319.

Printed and bound in Belgium

ISBN 978-90-5662-800-0

Contents

Acknowledgments

This book is the result of 15 years of listening to Geert Lovink talk about the importance of print media in the age of new media networks. I didn't believe him for the first five years. Numerous publications about net art and new media art began appearing in the next five years, and, although by then I knew Geert had been right, print media still seemed like a hostile environment to a network addict. After ten years, I began to recognize a slow network that led to inside the book and the libraries of the world. Soon afterwards, Geert Lovink offered me the opportunity to play with this network, and that's how it all got started.

Without the passion and conviction of Geert Lovink and Sabine Niederer of the Institute of Network Cultures this book would never have seen the light of day. Hurdles along the way made it difficult to maintain my focus and faith in the project. I am incredibly thankful for the positive energy and support, especially that which Matthew Fuller, Florian Cramer, Olga Goriunova and Sandra Fauconnier gave me at various stages of the book, as friends and advisors. A great deal of support also came from the Fonds voor Beeldende Kunsten in Amsterdam, which subsidized this project, and the people there have been very patient with schedules and deadlines. The extensive comments and advice I received from Arie Altena, Armin Medosch, Josephine Grieve, Pit Schultz, Cornelia Sollfrank, Kim Cascone, Jon Ippolito and Jaromil were invaluable. Others I would like to thank for their help and support are Olia Lialina, Vuk Cosic, Rob van Kranenburg, Ine Poppe, Frederic Madre, Helen Thorington, Brian Mackern, Steve Dietz, Peter Luining, Christiane Paul, Annet Dekker, Sarah Cook, Friedrich Tietjen, Jan Robert Leegte, Honor Harger, Stefan Haeflinger, Michel Zai, Menno Grootveld, Karen Lancel, Remko Scha, Debra Solomon, Martine Neddam, Richard Rinehart, Edward Shanken, Alex Galloway and Micz Flor. Special thanks go to Rachel Somers Miles, who had the difficult task of working with me during Sabine Niederer's leave of absence, while my mind was too focused to suddenly start working

with someone else. Special thanks also go to the café crew at De Balie, who supplied me with free cups of coffee every now and then when I was working there after my office at home became impossible to work in. More special thanks go to the Netherlands Institute for Media Art (NIMk) for offering me sanctuary in the form of a steady workplace after that. I am most grateful for the patience and support of bart plantenga, editor and friend. Last but not least, I would like to thank my father Piet Bosma for the endless conversations regarding the mysteries of the world, and I thank my daughter Jasmijn for her patience and support while I was writing this book. Her smarts, warmth and love brighten my days.

A book about net art has no function without a network context. I am very grateful to Juan Martín Prada and Marcus Bastos of Medialab Prado for inviting me to the energetic 3rd Inclusiva-net meeting in Buenos Aires. Moreover, working with Kees de Groot and Viola van Alphen at Gogbot in Enschede has also been a very inspiring experience, as was being invited to Stockholm by Dan Karlhom for the symposium 'Whatever happened to net art?' I hope this book will provide a unique answer to that question.

Josephine Bosma

Net Art Back to Square One

Florian Cramer

Net art never really fit into the innovation-focused discourse on media art, in which specific forms of technological development and skill seem to have priority over cultural relevance. For me, this is a key sentence in this book. The fact that it states needs to be stressed all the more in a time where most early net art is no longer accessible on the Internet and is, instead, preserved on paper, in publications like this one. The 'high velocity decay' of digitally stored information did not only affect this art as such, but also public awareness of the difference it has made since the mid- and late 1990s: a subversively imaginative, non-institutional, activist countermovement to institutional high-tech media arts on the one hand, and a radically 'relational' art outside of the white cubes and without works of art as commodities on the other. The previous major books on net art, from Tilman Baumgärtel's *Net.art* (1999) and *Net.art 2.0* (2001) via Rachel Greene's *Internet Art* (2004), Mark Tribe's and Reena Jana's *New Media Art* (2006) to Edward Shanken's *Art and Electronic Media* (2009) tell, as we can see simply by reading the titles and their publication dates, a history of a gradual loss of differentiation, with net art being ultimately lumped together with institutional 'media art' of the dreadful, techno-affirmative, artistically uninteresting kind that continues to dominate the respective festivals and institutions worldwide.

I hope that I won't do this book injustice by calling it a timely revisionism of revisionism, and clarification of differences that still make a difference. At the time of this writing, the early net art that spelled itself with a dot in between is unknown to most people except those who witnessed it in the 1990s. There's some poetic justice in the fact that Josephine Bosma was among the very first writers and critics covering net.art – as a very close participant observer – and now the latest to publish a book on the subject. The chapter 'Net.art – From Non-Movement to Anti-History' provides a first, useful historical account that should be mandatory reading for anyone studying this particular 'international group of artists', as Josephine calls it.

For me personally, precursors to net art (with or without the dot) were not always identifiable by their similar use of media, such as

computers and telecommunication systems, but by a particular social dynamic of practicing art as, and within, certain historical moments of transformations of media, communication, culture and society; moments that could be called, using Heidegger's term, *Ereignis* in the double sense of incidence and appropriation, or, to twist Carl Schmitt, a perceived revolutionary state of exception – with all of the interesting perversity involved. Similar momentums existed in the experimental film co-ops of the 1960s, early activist radio art, early activist-artistic video and television, and the beginnings of mail art. If one watches, for example, Claudia von Alemann's 1967 TV documentary on the Danish film festival *EXPMNTL Knokke*, one gets a good idea of how avant-garde filmmakers of that time did not simply consider themselves fine artists working with moving images, but were focused on redefining what was the most powerful mass medium of that time, of course with the ultimate aim of rethinking culture and society.

Likewise, the early 1970s' issues of the magazine *Radical Software* give first-hand insight into how early video and television art was linked to media activism and the hopes of achieving a lasting change in the broadcast media and, consequently, mass culture. The same is true for artistic radio activism, and – if one reads, for example, early issues of General Idea's magazine *FILE* – the beginnings of mail art with its pre-World Wide Web drive to forge an 'eternal network' that was not so much about art in the narrow sense, but the networking of diverse subcultural fringes. What links, in other words, all these movements is an *Ereignis* of a mass communication medium, for purposes not only of aesthetic experimentation and breaking out of established art systems, but also shaping the medium itself and indirectly the culture and society influenced by it.

This is what Josephine describes as the implicit politics of net.art. At the same time, she insists that net.art was not a political movement – like many of the currents previously described (and never mind the fact that it involved political activist work like that of Heath Bunting, Rachel Baker and Cornelia Sollfrank) – early net art was rooted in a notion of being directly involved in a new 'net culture' and the global issues attached to it. In the mid-1990s, these artists still had the opportunity to shape the Web as their own medium. A recognition gap between jodi.org, for example, and Yahoo.com existed but was not dramatic, and

allowed Jodi to win the industry's 'Webby Awards'. The fact that artists now had mass communication tools equal to those of the big players, and could also create websites that were as believable as corporate or governmental media, was a crucial prerequisite for the spectacular social interventionism of groups like the Yes Men, 0100101110101101.org and ubermorgen.com. In this sense, I read Josephine's statement that net artists 'internalized the net' as being neither about technological craftsmanship nor some cyberpunk fusion of bodies and machines, but an artistic understanding of the Internet as a cultural apparatus rather than merely a new channel for existing work.

The ultimate loss of initial media-utopian momentum transformed all of the artistic currents described above, even net.art, despite its less-naive politics. Once the New York Film Coop – to pick a prominent example – had to give up the idea that it represented the 'New American Cinema', experimental film mutated from an attack and reconceptualization of cinematic image and culture to, these days, either fine art practices or intimate love affairs with the old materiality of chemical film. Video mutated from artist's anti-TV into the successor of painting as the major medium of contemporary exhibition art, while the broadcast stations themselves became even less permeable for contemporary artistic work. For similar reasons, experimental radio turned into audio art, and mail art ended up as a postal exchange of collage and stamp art work of hobbyists.

Josephine's definition of net art as 'art based in Internet cultures', while concise and historically correct, also describes the major challenge to this kind of art today. The notion of an Internet-specific social communication culture has migrated from artist- and activist-run online systems (fully in parallel and agreement with the movement of artist-run spaces) to corporate services like Blogspot.com and Facebook, which have turned social networking into a commodity. The 'Web 2.0' domination of the Internet through a handful of slick, shrink-wrapped platforms had a much more detrimental effect on the net art ethos of self-designed and self-organized media than the dotcom crash at the turn of the millennium. I remember how in 2002, Jodi's Dirk Paesmans was mildly culture-shocked when he discovered that all Internet art projects shown in an exhibition at ICC Tokyo were based on existing major websites such as Google and Yahoo. A few years later, this had become the norm for Internet-based art, globally.

Nowadays, younger-generation fine artists who create strictly non-electronic white-cube installation works are the most avid networkers via blogs and social networks, more so than many net and media artists with their frequent reservations towards these systems. In sheer reader and posting quantity, e-flux for example has by far surpassed Nettime and all other net artistic mailing lists, and has created a powerful network of artists, critics and curators. A blog like VVORK is likely to be read by far more people from the 'classical' fine art system than *We Make Money Not Art* or *neural.it* in the net and media art world. If net.art was 'most of all the beginning of a serious debate about online art', does this mean – to play the devil's advocate here – that it was nothing more than a historical milestone in between earlier art that experimented with telecommunication systems and the countless contemporary art blogs and networks of today?

Let me continue to flip perspectives for a while in order to flesh out a conflict addressed in this book. From a typical curatorial and critical perspective, speaking of net art is as problematic as speaking of video art – as a genre or field of its own, apart from the countless hybridizations of media and materials in all contemporary art, and given everyone's use of googled information, YouTube videos and downloaded music in today's art. On top of that, the idea of medium-specific art yields strong anti-reactions in the contemporary art world. If the branding 'relational aesthetics' helped a larger audience to frame what could be called the curatorial art of the last two decades, the term 'post-media' has been much more important for artists themselves.

The chapter 'Let's Talk Net Art' discusses the oedipal schism of Rosalind Krauss – the coiner of post-media – with Clement Greenberg. In his famous 1960 essay 'Modernist Painting', Greenberg had decreed that 'the unique and proper area of competence of each art coincided with all that was unique in the nature of its medium'. With this, he meant (last but not least as a core member of the CIA's Congress of Cultural Freedom) the very opposite of artistic media cultural interventions from the New York Film Coop to net.art. The passage intrinsically refers to abstract painting, seen by Greenberg as a desirably pure form of art. But, at the very heart of the controversies and rifts about 'media' in contemporary art is simply a linguistic misunderstanding. Greenberg, Krauss and academically trained contemporary artists like Fowler

understand 'medium' in the sense of 'material or technical means of
artistic expression' (*Merriam-Webster*), a notion that has existed in
Anglophone art criticism since the eighteenth century. This notion was
canonical for defining the single departments of art academies until the
1970s, and, for a good part still is today: painting, sculpture, drawing,
nowadays also photography, performance, video, etcetera. The socially,
politically and economically much farther-reaching communication
studies notion of medium as 'a channel or system of communication,
information, or entertainment' (*Merriam-Webster*, same article, differ-
ent definition) did not converge with the traditional fine art notion of
medium until – with Fluxus and Nam June Paik – TV and other elec-
tronic mass media 'system[s] of communication' were effectively turned
into 'technical means of artistic expression'. This illuminates, by the
way, a crucial difference between net art and classical media art: most
media art, even Paik's, focused on turning mass communication devices
into individual artistic tools and objects while the art described in this
book on the contrary embraced mass communication media in order to
radically move art away from objects and individual practices, described
in this book as the 'potential and actual expansion (or even redefinition)
of various art practices' in net art.

 The notion of 'expansion' reminds one of George Maciunas's
'Expanded Arts Diagram' and of a 1960s' discourse of extending art's
expressive means, including ones which Dadaists employed in the
1920s for ostensibly anti-artistic ends. But even the concepts of 'mixed
media' and later Dick Higgins's 'intermedia' (see page 84) conformed
to the traditional notion of artistic media as materials akin to paint or
clay, from the eighteenth century to Greenberg. Their only twist was to
demand their hybridization instead of purity. To leave the fixation of
artistic work on 'media', in this sense of craftsmanship, entirely behind,
embracing a post-media art that focuses on larger aesthetic, conceptual
and social issues rather than material mastery, makes perfect sense if
one understands 'media' in this particular (limited) sense. This might
explain, to quote page 43 of this book, some of the 'undefined reasons
art historians apparently no longer felt a need to deal with specific
issues of technology in their field' after the 'modern periods'. The
difficulty of seeing media and technology as broadly cultural, not sim-
ply formal-aesthetic concerns – in both systems, it should be said, fine

art as well as 'media art', each in their own way – is the persistent collateral damage by Greenberg's modernism.

Of course, post-media is an abstruse term from a media theoretical understanding of the word 'medium'. There can, after all, be no communication and thus no art without some medium – including of course exhibition spaces. The real downside of a notion like post-media is that it gives artists and curators an easy excuse to no longer critically reflect the media (and politics) of art display and distribution but to fall back – as is now massively the case – to the white cube installation paradigm with no further questions asked. In the same vein – and to conclude my switching of perspectives – e-flux and VVORK function as conventional news resources on art happening anywhere else but on the mailing list itself. Despite the Internet marking the arguably most massive transformation of media since the Gutenberg press, the contemporary art world is still stuck in a mentality of regarding (and using) it merely as a medium *on* art instead one where art can happen (and whose cultural impact presents urgent aesthetic-political issues such as the notion of intellectual property). The situation is comparable to earlier times when photography, books and magazines were considered media only for the reproduction, not the production, of contemporary art.

A book on net art therefore is as legitimate as one, for example, on artist books or artist-run spaces. The early net.art of the 1990s had grasped the potential of the Internet just like Fluxus artists had grasped the potential of artist books and punk culture had grasped the potential of zines a few decades before they became major contemporary artistic media. From a strict media theoretical point of view, media do not merely define the aesthetic parameters but also the social constraints of art. Oddly enough, however, net.art was perfectly post-media in the arts sense of being post-Greenbergian. Alexei Shulgin's 1996 manifesto 'ART, POWER AND COMMUNICATION' ends with the following call to his fellow artists: 'Don't be dependent on [sic] medium you are working with – this will help you to easily give it up. Don't become a Master.' Which brings us back to square one and the quote at the very beginning of this foreword, that net art addressed issues of 'cultural relevance' rather than 'specific forms of technological development and skill'. How exactly, can be read in this book.

Introduction

This book is a mixture of highly accessible and more theoretical reflection on art in the context of new technologies, specifically the Internet. In some ways it is the result of my efforts over the past 15 years. Most of the texts, however, are new and were written especially for this project. It is not my habit to walk down trodden paths. In fact, I dislike it immensely. I like to keep moving as I explore new territories (or hidden layers in familiar territories). But the field of net art – although it has been much discussed and several books on the subject have appeared – still feels like virgin land. I do not see that my views are sufficiently represented in the available books on net art I have read, even if some of them have been very sympathetic. I think it is necessary for me to describe the framework from which I work to avoid misreadings and misunderstandings regarding my position.

Therefore, I think it is essential for me to explain what I think net art is. I do this in the first text in this book, 'Let's Talk Net Art'. Here I try to explain my view on what I think net art is to 'insiders' as well as to people less familiar with it. Art in digital media (or practically all electronic media, for that matter) faces significant amounts of prejudice that have been expressed quite passionately. I try to address what I consider the misconceptions about net art from two sides: from people involved in the Internet or media art, and from the angle of the critics and viewers from a more traditional contemporary art background. I have discovered there are people in both worlds who find it difficult to fully value art in all of its complexity. The main problem seems to be the location of the medium. I believe it is impossible to judge a work of art based solely on its conceptual or material elements. Although many critics would agree, they find it difficult to comprehend or imagine the roles that the computer or the Internet may play in an art work. I have tried to establish my argument in favour of a new, very distinct form of medium specificity by referencing the works of various critics and theorists.

'Let's Talk Net Art' sometimes becomes quite theoretical, but it is accompanied by the more accessible and practical text 'Levels, Spheres and Patterns: Form and Location in Net Art'. These two texts were originally parts of the same text. They now serve as parts one and two of a 'definition of net art'. As I sent my manuscript off to the editor, I noticed that the second text could have easily been expanded. What I tried to do, and where I think I succeeded, was to offer a useful multiple 'view' of net art. It is necessary for audiences and critics to realize that net art appears in a variety of guises. On the other hand, I would have liked to have created a stronger link to 'Let's Talk Net Art'. I would have preferred being much more explicit about form and 'what matters' in these different works of art. However, this would have made 'Levels, Spheres and Patterns' less accessible to many readers. Still, I believe that the main goal of this text – to show a radical diversity in net art – has been achieved.

Some readers will find familiar names and histories in this book. There are simple reasons for this. My main interest in writing about net art as a whole is to try to explain the field to those who are unfamiliar with it. I use examples that I think are helpful. This is, therefore, not a book for those of you who simply want to read about, say, the slickest and latest art gadgets and devices, or for those who are looking for a top ten list of the best net artists over the past five years. The art works I mention in this book range from 1968 to 2010 and I have already mentioned some of them in earlier texts.[1] Secondly, I was asked to include a history of 'net.art' (with period), a specific era of net art that I have witnessed from up close. This was not an easy task for me, however. The net.art text is actually the only text in the book that is not new. It first appeared in a catalogue for an exhibition curated by the Norwegian artist Per Platou in 2003.[2] I had to rewrite and expand the text extensively before it could be published. What was more difficult, however, was having to again deal with this topic at all, because this era was such an emotionally charged period in net art as a whole.

'Net.art: From Non-Movement to Anti-History' has departed dramatically from the original text entitled 'The dot on a velvet pillow'. First of all, it is three times as long, and it contains far more historical information and 'links'. I have tried to maintain its connection to the Internet by adding extra quotes in the footnotes for nearly each reference to a website. I recommend that you use these footnotes, because

together they serve as a kind of text that can be read on its own. I did this consciously because I am aware that many online sources will disappear over time, as much of it from this era already has. I was very happy to find the remains of websites of important events like the Next5Minutes2 festivals, and I felt almost like an archeologist at times. I found traces of it via the Italian hacker site strano.net, far from their original location.[3]

'Net.art: From Non-Movement to Anti-History' is fairly rich in details, although some would no doubt prefer even more. The original text 'The dot on a velvet pillow' ended without ever going into the details of net.art's tumultuous 1997. Here I elaborate on what happened at documenta X, Ars Electronica '97, the Extension exhibition in Hamburg, and on the net.art mailing list called 7-11. What many involved in or around this specific 'scene' or period in net art will notice in particular is that I refrain from judging net.art *as a whole*. My approach to this period in net art is to remain quite neutral, maybe even positive. I have done this deliberately: there has been too much judgment already. There has been so much, in fact, that many do not even want to be reminded of this era. If media art has its 'wound', as American art historian Edward Shanken calls it, net.art has its trauma. Writing about net.art felt cathartic, but there is no relief.

Net.art has been an emotional rollercoaster for many of those involved, even for some not generally affiliated with it, but who may have collaborated with net.artists or did similar work. It was the first time that artists explored a potentially powerful new technology where their work could be immediately discussed, weighed and judged by people from very different, often academic backgrounds, from around the world. It was as if all of the earlier art theories about the inclusion of audiences and the democratization of art were being tested simultaneously. It was an exciting period for everyone, the artists included. While it worked miraculously well for a while, and numerous art practices evolved that still serve as examples today, practice and theory came to a head-on collision in the end. The revolutionary lyricism of some artists was interpreted as a functional, purely political agenda, and, instead of artists being confronted on this aspect on an individual level, net.art was judged as a whole. In their prime, the involved artists were suddenly accused of having 'failed'. They had allegedly failed to

subvert the art world, had failed to escape commodification, failed to keep their noses clean, or failed to include other artists in net.art's very relative success. In my opinion, the artists were laid out to slaughter.

It was unpleasant dealing with this negative social dynamic at the time (around 1999), and it still is. At the same time, the net.art period was also characterized by a tremendous surge of energy, the likes of which art had not seen in a long time. Ten years have passed and it is now possible to reflect without the pressure of an online 'community' demanding functional or politically correct behaviour. By describing the social circle and the intense history it underwent over only a short period of time, I hope to at least recall some of the 'good times'[4] of net. art while also exposing the still partly hidden history to a larger audience. It is important to realize that this history is only the tip of the iceberg. There is a huge amount of online art practice that has never made it to the public eye at all, and of which much has disappeared without a trace. My review of Brian Mackern's 'netart_latino database'[5] in 'Levels, Spheres and Patterns: Form and Location in Net Art' should give you some idea of how much art has unjustly never found its way into the channels, pages and floors of the institutional art world, precisely where we miss the presence of net.art and its tremendous power to move and adopt new artists in its slipstream. The void in self-representation that has been left since net.art was prematurely declared dead has never been adequately replenished, although many good initiatives have come along since then. There is, however, the renewed interest in net art as a whole, and many new artists, curators and educators, which means we may even see some unexpected flowers blossom from the dust left behind by net.art.

We also explore how new media cultures influence art from two other angles in the final two essays in this book. 'The Gap between Now and Then' deals with memory and the conservation of art works. This is a critical issue for both transferred and 'born digital' objects in the digital domain. What fascinates me the most about this issue is how easily it is assumed that interactive 'born digital' art (that is: art works created in digital media) cannot be preserved in any state other than a 'dead' state. Conservation strategies for these works currently only involve their documentation. While I welcome any attempt to preserve important works of art for posterity it seems illogical to me to not focus

first and foremost on keeping them 'running'. Net art works could simply remain online, instead of being filed away in some archive with limited access. Documentation should serve solely in a secondary capacity as a backup. When a piece is online its chances of survival increase: works can be copied, 'quoted' and even maintained or adapted by users, and actively maintaining art works rather than simply documenting them also encourages the conservator or institution to invest money, as well as time and energy, into the development of new technical approaches to the work. In the digital domain, the curator, conservator and archivist all become co-producers of an art work. Further changes to the shape of the art work, and especially to its direct context, require a conservational approach alien to the traditional archive. Conservation strategies need to incorporate the potential of the hive, they need to be open to an active audience. There are very strong arguments in favour of such a development. I hope to revive the notion of living archives by interweaving the struggle of the conservator into the life and death tales of the digital domain.

Last but not least, 'The Source and The Well' explores the extraordinary field of sound art and music in the context of new technologies. More than the visual art domain, the sonic domain has collapsed inward, and surprisingly revealed its tremendous flexibility in the process. Sound and music seem to simultaneously vaporize into ever-smaller 'samples' and disappear into overcommodified musical experiences. These two extremes made me think about the meaning of sound, which seems most strongly explored in John Cage's 4'33" and other works dealing with silence. Here the work of American writer and musician Seth Kim-Cohen[6] inspired me to listen for the 'cut' in silence today. I took Cage's work to explore how silence and its counterpart, noise, are part of the same universe of listening. 'The Source and The Well' is about new roads to silence as well as new roads to meaningful sound and music experiences. The listener will lead the way.

Part I

Let's Talk Net Art

> But suppose now that technics were no mere means, how would it stand with the will to master it?
> Heidegger, *The Question Concerning Technology*[1]

Sometimes what seems obvious and probable needs to be totally abandoned to see the real. This is certainly the case when it comes to art. Things are hardly ever what they seem to be at first glance in contemporary art: a painted surface, a collection of metal scraps, a lump of fat. The forte of art, its reason for being perhaps, is its ability to escape or transcend the projections of its apparent form in order to disclose the art work's relations, its meaning and its power. The digital realm, especially that of the Internet with its dazzling proportions and numerous applications, also allows such multifaceted, intricate cultural forms to appear or expand. However, works of art in the realm of digital media somehow have a hard time liberating themselves from their restrictive prejudices. Their poetry, their aesthetics and their message tend to be obfuscated by the computer as an object and the expectations or prejudice cast upon it. Net art, in particular, is seldom described – and thus perceived – in its full dimensions, leaving the art world and its audience the poorer for it. The view of net art is not just obscured by the smoke and mirrors of the IT industry (as part of that infamous Adornian industrial complex), but also by the hypnotizing drone of humanist art criticism that is predominantly traditional. The stage is set. The curtain rises. Let's look up the magician's sleeves.

Preface

This is an invitation to enter an art world that has been enriched and expanded by artists who use the Internet. Net art, to put it more precisely, is the potential and actual expansion (or even redefinition) of various art practices. Since the computer and Internet are used to suit all kinds of art practices, a definition of net art needs to embrace a much larger variety of forms than common interpretations of the term currently present, which are largely based on apparent 'carriers' such as the computer screen or the browser (or even the industry that produces

these). A definition of net art needs to be able to help reach beyond a misdirected obvious observation (the presence of a screen on a computer) or probable observation (that the industry producing the screens and computers defines the shape of what is represented through them).

I have had to answer the question of definition over and over again in my own work in this area over the past 15 years. My engagement in the online communities of Nettime, Rhizome, 7-11 and other mailing lists, plus my experiences at various offline events, made me a witness as well as an adamant researcher in this field. My preference for a specific type of art (existing in different realms simultaneously, often changing over time or per location), and my desire to discuss and explore it, however, meant having to confront some rather puzzling resistance from more traditional art critics and curators in particular. I quickly learnt that this was a general experience found across the entire field of new (and old) media art. Certain art world forces continue to block the development of insightful criticism and the presentation of art practices that involve science or technology. I am convinced that this tendency is not only bad for these specific art practices but for *all* art. Moreover, this situation is not solely due to recent conservative trends in the contemporary art world either.

For some involved in the net art world it was necessary to resist obvious and likely interpretations of art works as well as the field as a whole. This was not always easy. I developed a definition of net art that is as flexible as the Internet itself, but also specific in its foundation, a definition that includes both highly formal and conceptual art practices. This definition developed gradually from 1996 to 2001, and is especially influenced by a few particular experiences between 1993 and 1998 that needed to sink in. The work of various critics and theorists has further reinforced my views, even if some of them take quite different positions on certain issues. In this respect, I am particularly touched by Tilman Baumgärtel's essays on net art, although our ideas and approaches have developed in their own directions.[2]

From a more traditional art criticism context, I found some of American art critic Rosalind Krauss's ideas concerning medium specificity very insightful, although her general views on technology are odd, illogical and highly problematic. On the one hand, I would gladly take up her challenge to 'wrestle new mediums to the mat of specificity',[3]

no matter what she means by it. On the other, I have difficulty with some – what I see as – rigid academic studies on this topic, since much of it reveals little understanding of net cultures. They seem unable to relate to their vitality, with little awareness of any necessity for a deeper engagement with online communities.[4] However, in other academic research one *does* find genuine interest in eliminating misconceptions about art and technology. The work of American art historian Edward Shanken in particular challenged and sharpened my thoughts regarding the strange position of medium and technology in art theory.[5] Yet Shanken prefers to follow the ghost of conceptualism, while I believe it should be kept in check.

In my view, the art and technology problematic arose because of a misunderstanding of the various complex technologies as individual mediums. Another reason is the development of the dogma of 'art as philosophy', or art as a predominantly conceptual space. Both of these maintain the illusion of a linear art history, in which art practices can be categorized in neatly defined disciplines and movements. Net art is not a movement. It is more of a transition, an ongoing evolution of the practice and reception of art, culture as well as science and academia, which was stimulated by the advent of new network technologies. Traditional, detached approaches hardly fit here.

Defining Net Art

So what is net art? The most compressed definition is that net art is art based in or on Internet cultures. These are in constant flux. Net art's basis in Internet *cultures* means that a physical (hard-wired or wireless) connection to the Internet is not necessary in individual net art works. A net art work can exist completely outside of the Net, and it may be superfluous to say, but it does not always include a web page. The 'net' in net art is both a social and a technological reference (the network), which is why the term net art is highly flexible, more so than for example 'system' or 'relation' (as in Systems Esthetics or Relational Aesthetics, two art theories I discuss later). An emphasis on technology through the 'net' in net art is both necessary and deceptive, or in other words, relative. One reason that I keep using the term net art is that there remains a huge black hole when it comes to knowledge and insight concerning important aspects of art in the context of Net cultures.[6]

In this definition of net art, the term 'culture' is used in the broadest sense and includes how culture is reflected, actively and inherently in and through technology, as described by the French philosopher Gilbert Simondon, for instance. Culture and technology cannot be separated, but his approach cannot be identified in terms of 'pure' materialism. In Simondon's 1958 book *On the Mode of Existence of the Technical Object*,[7] he explains how our present-day sociotechnological environment has the strong, intrinsic potential to become a thriving cultural space. He believes that, where machines were once perceived as enemies or the tools of humans, their position changes when both humans and machines interact via a much larger 'meta-machine', or what Simondon refers to as 'an ensemble'. He describes how 'the machine' became an 'individual' in the 'technical ensembles' of the late twentieth century.[8] Simondon's book is a plea for a view of technology and society that avoids and overcomes the duality that exists between humanist and materialist approaches. Internet cultures are a manifestation of a merging of the cultural and technical spheres, an evolution that Simondon had predicted 50 years earlier. The various overlapping histories of Internet cultures reach back to the earliest conception of the Internet in the 1960s. But it was rooted in 'the real', and they also have older and non-technological historical connections that unfold through the various practices within the different cultures involved. To put it very simply: the world and technology fuse in Internet cultures.

Net art involves practitioners who have discovered, internalized and used the Net. Net cultures are the basis, the means and the source of net art. They are *not* predominantly technological. They involve various academic communities, news sites, financial trading, gaming communities, hacker groups, online shops, web logs (blogs), software and hardware developers, social network sites, dating sites, porn producers and porn audiences, media activists, institutional and independent cultural platforms and anything else happening that could be disseminated via the Net. Net art is art that is created from an awareness of, or deep involvement, in a world transformed and affected by elaborate technical ensembles, which are, in turn, established or enhanced through the Net. The Internet itself is the ultimate ensemble, even if it will eventually transform into something even bigger and more pervasive.[9] Net art is the art of this environment. The Internet acts as a vector in a worldwide,

unstable complex of technological and cultural tendencies, and the art produced through or for it is heterogeneous, not uniform.

Net art can be described as an expansion of the entire field of the arts. Net art is, therefore, not a discipline, because it contains and even connects numerous disciplines. In the past, I have jokingly called net art the missing link between media art and a broader contemporary art world,[10] but referring to it as some kind of evolutionary timeline is really inappropriate.

Medium Specificity and the Ghost of Conceptualism

Much like a definition of net art should disable false 'medium specific' or simplistic materialist views on the practice and forms of art in the context of the Net, so should the theorization of art in general transcend the confinement of its antipode: a conceptual art theory as art's alleged 'theory of everything'. In order to bridge the gap that has developed between media art (under which net art is generally ranked) and broader contemporary art discourses, people like Edward Shanken, for example, harken back to the work of American critic and curator Jack Burnham, whose 1968 essay 'Systems Esthetics'[11] has emerged as a landmark in the area of media art theory. Because Burnham's essay deals with novel production systems for art, his theories are an excellent starting point for a re-examination of the critical positions concerning present-day issues regarding art and technology. This is why his work is so often cited and analysed in numerous art and science publications.[12] Shanken and others have proposed a theory of art based on 'Systems Esthetics', presuming that this would automatically include scientific or technological discourses in the more general art discourse.

There is, however, a problem with Burnham's Systems Esthetics – it is highly ambiguous and espouses rigidly anti-technological interpretations of what is, in fact, a deeply interdisciplinary text, in which Burnham speaks of a need for 'precise socio-technical models'. Systems Esthetics is full of internal contradictions, and Burnham seems to have struggled with the core issues in a system. This issue becomes very clear when he describes the system itself: 'Conceptual focus rather than material limits define the system.'[13] Despite a radical description of the art work as it is created in ever-changing and co-developing material and conceptual 'systems', intricate constructs that reach beyond

and between objects, localities, and even beyond time, Burnham leaves room for (and even contributes to) an explicit dismissal of the material properties of a system. It is the Achilles' heel of the theory of Systems Esthetics.

It seems like the dismissal of material properties in art – either involuntarily or mistakenly confirmed by Burnham's approach – has caused a lag of information about the properties and practices surrounding the electronic media in art since the 1960s. The lack of research into new media art practices and the selective, or even ideological, readings of art have led to the evolution of various warped art theories such as the 'Relational Aesthetics' of French curator Nicholas Bourriaud. Bourriaud, writing at the dawn of the World Wide Web, basically hijacks the energetic social discourse of early net art. He strips it of all of its links to technology and reuses it to validate specific social, local, time-based art practices. This would be a legitimate approach had Bourriaud not already dismissed new media in the same essay. I have become convinced of the necessity of art criticism that specifically focuses on art and technology as a direct reaction to Bourriaud's work and his open hostility towards media art at public appearances.[14] This is essentially why, despite a strong desire just to use the term 'art', I keep using the term 'net art'.

Online Discourse and Net Art Reception

Since net art first appeared it has gone through various, sometimes turbulent phases, which probably also hampered its acceptance. The openness of the debates surrounding net art is unprecedented in art history, because of the technological characteristics of the Internet. This openness had (and still has) an important influence on its reception, and its impact has yet to be seriously assessed. Despite the fact that there have been open or participatory art practices in the past, where critics and audiences were deeply involved, the discourse regarding net art is characterized by a very strong tendency towards the levelling of opinions and hierarchies. Artists, critics, curators, and many (sometimes involuntary) bystanders all have had their say in the lively debates. The increased active online presence of art institutions like the Tate and the Guggenheim has changed this tendency somewhat,[15] but this characteristic openness will never lose its significance. One could say that online art is exposed to a multitude of – not always friendly or

well informed – voices. This continues to have both negative and positive implications for net art.

In a positive sense, the online art discourse further democratizes electronic media cultures, a process that began with the camcorder revolution and its role in video art, but which has since expanded, reinforced by the hacker and coder cultures on the Net.[16] In its wake, there was a re-examination of previously 'closed' media. The availability of fairly open online platforms also offers opportunities for participation and collaboration. The Internet has demonstrated its strong community-building potential since its inception. This potential remains relevant in the social Web 2.0 networks. These are often criticized for their alleged limited potential and their commodification of personal media, but this criticism is contradicted by the pro-surfer groups like Nastynets, for example.[17] Artists in these global communities share a blog, which then simultaneously serves as a collective diary, notebook and social space.

On the negative side, a veritable Tower of Babel of criticism threatens to undermine the development of a clear discourse or view on the issues. Net art may have appeared as a cacaphony of conflicting opinions and confusion of art strategies to offline critics, as there was a lot of conflict and competition within net art circles. In his essay collection *Interaction: Artistic Practice in the Network*, American theorist Brian Holmes describes the hustle and bustle of the Eyebeam list (connected to the New York new media art institution of the same name), euphemistically referring to this social dynamic as 'moods'.[18] The 'moods' of various online communities sank to a significant low after some of its representatives started declaring net art dead around 1999, only a few years after its inception.[19] Some strategies to move beyond this negativity in net art theory have included: the annexation or embedding of net art within older terminologies (digital art, media art); a total evasion of terminology in an effort to find something new as espoused by Joline Blais and Jon Ippolito's *At the Edge of Art*;[20] the popular simple renaming of these art practices (Internet art, new media art); or my favourite, which goes one step further and humorously refers to pop star Prince's identity crisis: 'the art formerly known as "new media".'[21] Even if these strategies are completely understandable from the point of view of a practitioner in this field, especially of those striving to move beyond the

limiting views of net art, these evasive theoretical strategies will probably obscure the art itself and the issues involved. My use of the term 'net art' is not only practical but it is also a form of resistance against the conservative forces in art, forces one should not even give the slightest hint of recognition.

Origins and Early Approaches

The term 'net art' was first use in the mid-1990s, at a time when many artists were discovering the Internet. German artist and critic Pit Schultz first used the term during a small exhibition in Berlin.[22] Its success and rapid acceptance in the field, however, suggested that the term also implicitly included the work of many artists who had used the Internet (and even its forerunners) prior to the emergence of the term.[23] Lively and lengthy discussions regarding the wisdom of using a special term for art on the Net, and the debates about what kind of art qualified as net art, could be seen as signs of the term's importance.[24]

What is clear is that net art reaches far beyond the World Wide Web, and that a shared choice of tools does not automatically create a shared aesthetic or practice. If we look at the main net art publications, we see that the question of definition is either avoided or unclear. The most influential books on net art prefer to list a diversity of practices and approaches rather than pinpoint one common denominator, be it conceptual or technical. This tendency was also used during the most influential exhibitions of net art so far: documenta X in 1997 and Net_Condition at the Zentrum für Kunst und Medien (ZKM) in Karlsruhe in 1999.[25] Tilman Baumgärtel's [net.art] and [net.art 2.0], Rachel Greene's Internet Art, and Julian Stallabrass's Internet Art: The Online Clash of Culture and Commerce also share this approach. Even though Stallabrass's book focuses on the political dimensions of net art, the works he describes are all very different, both formally and conceptually. Tilman Baumgärtel is the only one who attempts to come up with a more precise definition, although even this definition can be interpreted in different ways.

Tilman Baumgärtel

The books that best reflect early net art are those of the German historian and writer Tilman Baumgärtel.[26] Other than a few individual

texts, such as Andreas Broeckmann's 'Net.Art, Machines, and Parasites' of 1997,[27] Tilman Baumgärtel and I were the first to do extensive research on net art and write about it as it blossomed all around us. Tilman Baumgärtel did what I refused to do in print,[28] namely, publish the many interviews he did for online platforms.[29] In his introduction to an excerpt for the Nettime book, Baumgärtel writes: 'For me, the interviews were an attempt to escape the well-known rituals of the art world.'[30] This mostly refers to the online publishing of these interviews, which made them part of a very lively cross-disciplinary net art context and practice.

Baumgärtel's books are a beautiful collection of thoughts and visions that have evolved since the earliest days of net art in circa 1980 right up to his last book on the subject in 2001. Compared to other, later books, no matter how insightful they are, Baumgärtel's books still offer the most honest first-hand account of net art in the twentieth century, and they remain a valuable source for current academic net art research.[31] His choice to publish the interviews almost unedited and in all their eclectic variety actually manages to recall those feelings of openness, collaboration, diversity and accessibility that characterized the early online discourse, something that none of the more reflective net art books are able to capture as well.

Baumgärtel defines net.art[32] in his first book, as 'art that deals with the genuine characteristics of the Internet and that can only happen through and with the Internet'.[33] In his second book, he clarifies his position: 'Net art, as I see the term, reaches above and beyond artistic projects that focus on the Internet.'[34]

His first definition characterizes the state of net.art in the mid-1990s, when net art was first being openly discussed. It is how I would have defined it at the time as well. Even if it can easily be interpreted as a technologically determined definition, it also already contains a level of ambiguity because there was never any doubt in the net-critical discourse that the Internet was 'rooted' in the Real. The radical potential of a 'purely' virtual space was (and continues to be) explored by some artists and political experiments such as radical forms of cyberfeminism,[35] but these 'separatist' and strategic gestures are meaningless without their rejection of physical realities. Any quest or claim on a limited medium specificity in net art, which Baumgärtel's definition seems

to express, was based on the basic need to emphasize the difference between art made in- and outside of the context of the Net.

In his further exploration of net art as 'art that reaches above and beyond artistic projects that focus on the Internet' Baumgärtel describes what his first book already revealed. The interview with Robert Adrian, for instance, focuses on his work in the early 1980s, which involved many different media, one of which was the IP Sharp network. The interview with Rena Tangens and Padeluun reveals the influence of hacker networks on artists from the period before the Internet was publicly accessible. Almost all of the other interviews show strong offline influences and activities – historical and contemporary – in the art practices discussed.

Examples of a broader reading of what net art was were already present in Baumgärtel's essay 'Immaterialien', which dealt with the relationship between net art works, earlier art movements and older media art works[36] and is the first historical contextualization of net art. Baumgärtel provides useful material for an understanding of net art that escapes naïve, superficial interpretations based solely on browser traits. Other than the currently oft-used historical references to conceptual art, the Centre Pompidou's 'Les Immateriaux' exhibition in 1985 or Nam June Paik's television experimentations, Tilman Baumgärtel mentions some works and practices that are not commonly associated with net art, but also advance a broader perspective, like Malevich's notion of 'suprematic space', Vladimir Tatlin's *Tower* (*The Monument to The Third International*), Marinetti's 'Radiasta' broadcasts, Lucio Fontana's *Movimento Spaziale* and the 'Art by Telephone' exhibition at the SFMoma in 1969.

Julian Stallabrass

The first net art book by a critic and/or curator from outside the net art world was Julian Stallabrass's *Internet Art, the Online Clash of Culture and Commerce*, published in 2003.[37] Unlike Baumgärtel, Stallabrass keeps it close to the Web, although a broader context seeps in here as well. The work of the British Redundant Technology Initiative, which built large installations out of discarded or obsolete hardware, or the work of the British collective I/O/D that built the first radical piece of software art (a highly experimental Web browser) *Webstalker*, and

American artist and designer Brett Stalbaum's *Floodnet* (software that bombarded specific target sites with requests, to create a kind of blockade or 'virtual sit-in' in cyberspace) all reveal a certain type of net art that moved far beyond the confines of a normal Web browser. *Floodnet* was even used against the Frankfurt Stock Exchange and the Pentagon in 1998, as part of an online action organized by American artist and activist Ricardo Dominguez, in collaboration with American artist activists RTMark (who later became known as the Yes Men).

Stallabrass's book focuses entirely on the political dimensions of net art, and as such contains very specific kinds of art works. His analysis seems inspired by a strong ideological net.art dimension that developed largely in the context of Nettime, the mailing list for net criticism.[38]

Stallabrass does, however, go beyond a limited reading of net art in two ways. First, he avoids a connection to its (at that time) recent history by using the term 'Internet Art' instead of net art. As I described earlier, this was a tendency that occurred shortly after the millennium, as the memory of net.art was still fresh and its legacy was still fairly unclear. Stallabrass had to rely chiefly on the declarations and statements made by artists during this era, which he used to illustrate his views on 'Internet art'. In defining Internet art (in other words, net art beyond net.art), Stallabrass notes that answers 'will emerge throughout [his] account' as to what exactly it is. In the introduction, Stallabrass explains:

> Given the bewildering variety of form, content and technique, the book does not pretend to be a survey; rather it is an introduction that focuses upon one salient aspect of [Internet art] – its relationship to commerce, both the commerce of the online environment and that of the mainstream art world.[39]

The question of what Internet art actually is, however, is not addressed anywhere in the book. Moreover, by combining vague hints of what Internet art is[40] with a very specific focus on the relationship between Internet art and online commerce and that of the mainstream art world, he suggests that Internet art is, by definition, politically sensitive, anti-commercial or subversive technological art. This is ironic, since this kind of political reading of net art is clearly inherited from the mid-1990s net.art debates,[41] an era Julian Stallabrass vehemently claims

he wanted to distance his book from. However, despite the uncertainty about what Internet art is, and the emphasis on the radical political and cultural potential of net art, Stallabrass makes one point quite clear: the diversity of the art works and art practices at hand.

Rachel Greene

The first broadly distributed book on net art was published in 2004: Rachel Greene's *Internet Art*.[42] Greene, who had become familiar with the field through her work as an editor for the online art platform, archive, mailing list, 'magazine' and online community Rhizome was given the slightly ungrateful and difficult task of writing an introduction and overview of net art for a large audience at a time when net art discourse was clearly in a transitional phase.

Greene had to balance her effort between paying homage to the work of a distinctly earlier net art discourse and a 'naturally' and widely expanded net art context in the new millennium, an expanded context that not only manifested itself online, but also in art schools, galleries, institutions and even public spaces through the work of a wide variety of artists who were discovering computers and the Internet as a tool or means of expression.[43] She did not entirely maintain this balance, because she tried to keep everybody happy. This produced a book divided into two parts that just don't really come together: The first consisted of an introduction in which she addresses a more traditional art audience (an audience ignorant of the Internet's history or in how net art relates to pre-Internet art); and the second, the actual heart of the book, which describes a history of net art in elaborate detail, suggesting she felt a great deal of responsibility to the field itself.

Greene's introduction describes examples from art history that resemble certain tendencies in net art, but without using any specific net art works as examples – unlike Baumgärtel's 'Immaterialien' – and refers to Fluxus artist Alan Kaprow's 'interest in the layers of time, space, and interpersonal interaction', the group EAT formed by Bell Labs engineer Billy Kluver in 1966, 'in which an artist could work with programmers, designers and other specialists,' Sherrie Rabinowitz and Kit Galloway's *Electronic Café* from 1984, and the writings of Baudrillard. Net art remains a vague, unidentified terrain, which is only somewhat addressed by the second part of Greene's book via the often detailed descriptions of

33

specific works of art (works that often demand participation, collaboration or lesser forms of interaction to be fully experienced or disclosed).

Rachel Greene is careful not to define net art too precisely. Instead, she describes some of its traits, like: 'Internet art has redefined some of the materials of current art-making, distribution and consumption, expanding notions from the white cube out to the most remote networked computer.'[44] When she is interviewed about her book for a Danish online magazine one year later, Greene does manage to come up with a definition, be it a somewhat traditional one that is entirely focused on the Internet conceptually and physically, noting that 'net art is work that addresses the internet with its content or formal arrangement, or is technically based on the internet and includes software, websites, documentation, performance, email art, etc.'[45] Her definition is left open, whereas, in an online context, the definition is tied to a kind of 'Internet specificity', based on technological traits or conceptual approaches in which the Internet itself is the main focus. I believe that the tension between these two simultaneous positions is precisely where the true definition of net art lies.

It might seem odd that the question of a definition is even necessary after the publication of her book, but I suspect that the lack of a concrete definition is related to Greene's attempt to balance her responsibilities to the net art communities and the audience she was asked to write the book for.[46] Her preference for the term 'net artist', as opposed to the 'Internet artists' of her book's title, is never explained either. It is a pity, because it is exactly the very particular duality and poetic nature of net art discourse, its crossover tendencies in every aspect, which hold so much potential and actual discursive power. By choosing the term 'Internet Art' instead of net art the field can be easily narrowed down to a purely technical definition. But Greene does retain some ambivalence by not letting go of the more open term 'net artist'. These terminological inconsistencies, however, are another indicator that Greene is describing a highly unstable and still developing field in which neither technology nor culture at large can be denied its place.

Other Texts

The simultaneously nonspecific and explicit approaches described above can be found in almost every publication on net art, although

some of its authors might disagree, since there is still quite some insistence on a limited interpretation of medium specificity. There have been numerous net art publications that were never published in English, which considerably limited their audiences. Several early publications appeared, mostly in German, such as, besides Baumgärtels's work, the extensive and informative book *Netz.kunst*, edited by Verena Kuni, published in 1998, or various magazines that dedicated entire issues to net art such as *Kritische Berichte*'s 1998 'Netzkunst' issue or *DU*'s 2000 'net.art. Rebellen im Internet' issue, which begins with a playful text on net art by Russian theorist Boris Groys, in which he ponders the return of the original through the site specificity of the Web address.[47] Newer publications such as Matthias Weiß's *Netzkunst, ihre Systematitisierung*[48] or the collection of essays *Netpioneers 1.0, Contextualising Early Net Based Art*,[49] point to a variety of practices.

Net art unfolds in these publications as a multifarious and slippery subject, in which the erroneous focus is on the browser as the defining medium, which, of course, needs to be challenged. Kuni notes how the term 'Internet Art' contains 'more than just the reach of artistic activities on the World Wide Web.'[50] The introduction to *Kritische Berichten*'s net art issue explains how the editors selected the net art works and texts from a 'context systems' viewpoint.[51] *DU*'s net.art issue editorial is, as its title implied, based on the spirit that dominated the online discourse on net.art at the end of the 1990s, and calls it the 'product' of hacker culture, which narrows it down to ideological considerations. Despite the limitations of this approach, the content reflects the variety of the then-current practices, which included everything from the online art initiative The Thing, to the Redundant Technology Initiative, to the Swiss art collective Etoy's sale of shares, to Heath Bunting's experiments with gen tech.[52]

Matthias Weiß organized an experimental exhibition of net art works called 'Knotenpunkte' (Nodes) that was spread over seven German cities in 2007.[53] His *Netzkunst* is an attempt to build a 'far-reaching taxonomy of net art since the mid-nineties, based on a method spectrum developed for the objects in question'. About defining net art he writes: 'One big/major misunderstanding about the many definitions of net art is that it happens on the Net and nowhere else.'[54] He emphasizes net art's diversity, and, in order to come to grips with the field, he

proposes a set of specific net art subcategories. Weiß's approach is not based on any limited medium specificity of the involved art works. In describing the disparity of form within the net art field, he observed that 'there are just not that many different applications of material properties in net art. Individual works also vary greatly in terms of meaning and intent.'

Not everybody formulates these notions as carefully and as generously as Weiß does. In *Netpioneers 1.0*, editor Gunther Reisinger straightforwardly declares that he and co-editor Dieter Daniels set out to create 'methodological foundations at the source-critical level, using *exemplary studies* of early Net-based art, of the "digital heritage" made necessary by "digital rot", and of *scholarly* source criticism.'[55] This basically means that online and other non-academic publications are discarded. Art works, however, 'can and must also be objects of historical source studies'.[56] Their definition of net art actually clashes with the examples presented in their book., While they state that net art works are said to be 'born digital' and 'experienced by the recipient in the work's own medium', the actual essays describe net art works such as *Public Netbase* (a Viennese publicly accessible media lab), David Blair's *Wax, or The Discovery of Television among the Bees* (an early 1990s film and Web project that Barbara London incorrectly refers to as *History Among the Bees*), or Robert Adrian's *The World in 24 Hours* (a complex multimedia performance including a sponsored commercial computer network, radio, telephone, fax and slow scan TV dating from 1981).[57]

Despite the sometimes contradictory critical approaches, there is no doubt about the diversity of forms and practices in net art. I have decided to limit myself to publications that use the term net art or Internet art. For instance, other publications used different terms ranging from 'digital art' (German-American curator and writer Christiane Paul)[58] to new media art (American curator-writers Mark Tribe and Reena Jana).[59] However, in these books we see the same variety of practices.

Tribe and Jana, for example, prefer a limited definition of net art, even though they recognize that there is a blurring of genres in new media art, noting that:

> Net art played a key role in the new media art movement, but it was by no means the only type of media art practice. Other significant

genres include software art, game art, new media art installation and new media performance, although individual projects often blur the boundaries between these categories.[60]

They could have also included biotech art, which, like the software art and game art they do include, would not have developed as significantly had it not been for the Internet. They each are fairly dependent upon digital technologies. The key to these particular art practices is a specific form of collaboration, in which knowledge, codes and software technologies are generously shared. Without the Internet this would have been much more difficult to achieve. The easy and rapid sharing of information, technology, or code made possible by the Internet stimulates a viral dissemination of these fields and the individual works within them. The Net seems to function almost like an incubator or a shared studio. Software art and game art would not have developed as significantly without the Net.

What Tribe and Jana describe as new media art installations and new media art performances others would probably classify as net art[61] such as Heath Bunting and Kaylee Brandon's *Border Xing Guide*, a documentation/action/net art work in which the artists find and document ways to cross European borders illegally. The art works can only be accessed from a limited number of ip-addresses (a specific computer's address within a network), through which artificial Internet borders are created.[62] In some ways, this reasoning can also be reversed. The definition of new media art performance can actually be expanded to include works that are somehow dependent upon a Web or Internet server. Joan Heemskerk from the Dutch/Belgian artist duo Jodi told me that she calls the Jodi website 'a kind of ongoing performance' because it undergoes constant degradation and alteration via perpetual 'upgrading' Web technologies.

Christiane Paul's *Digital Art* appeared in the same popular series as Rachel Greene's *Internet Art*. Paul's book includes sections on browser art, telepresence, hacktivism and other net art phenomena. Her unique focus on the 'digital' rather than the 'network' enables Paul to readily move between different historical periods and include works that seem 'off the grid'. The different phases and directions in the development of computer networks can make historical net art events appear to be

separate or isolated events, despite their interrelationships. Focusing on the digital domain, however, makes it easy to neglect the many important connections between the analogue and the digital fields. An approach of art in the context of our complex new media environments solely from a 'digital' angle reinforces the notion of a 'new' art medium. This can reinforce the illusion of a shared practice and aesthetic we so desperately need to discard. The network, on the other hand, implies a flow *and* positioning, variety *and* collectivity. It allows for divergences that remain interconnected.

Taking a Few Steps Back

Three experiences deeply influenced my own views on net art. Each of them touched on different aspects of art in the context of the Net. Each of them blew me away, or rather, they obliterated some earlier simple misconceptions and prejudices I had about art and the Net.

The first was meeting Robert Adrian X. It was the summer of 1993 and the Internet was only slowly finding its way into the public consciousness. I was visiting the 'institute for unstable media' V2_, because I was interviewing artists who worked with the body. The body was V2_'s focus for that year. Adrian was introduced to me as 'the initiator of the first e-mail network for artists', a network he had produced as early as 1980,[63] and had served as the basis for the earliest net art projects between 1981 and 1983.[64] I interviewed him about Artex,[65] as it was called, and was introduced to a history of art in computer networks I had never heard of, and I could hardly believe that it had already been in existence for over ten years.

Like so many others, I knew about cyberpunk, the new wave in science fiction made famous by William Gibson and Bruce Sterling, and had even read their books in the 1980s. The 'cyberspace' they described, however, was (and is) largely fictional. Robert Adrian X described a history that was much different from the all-encompassing, seamless immersiveness of Gibson's *Neuromancer* universe. Adrian's was a virtual environment made up of clunky machines and very diverse social groupings that barely fit together, between which connections sputtered and soared forward unevenly, but through which dazzling and moving shapes unfolded. I had been looking for a kind of art that matched the irregularly dispersed but pervasive media landscape of which I felt a part.

The vista that unfolded through the words and works of Robert Adrian X revealed an embodied contemporary and interdisciplinary art practice that hit home. I decided right then and there to focus exclusively on art in the context of the Net. I wanted to learn how art, culture and human nature would develop under these new circumstances.

This learning experience occurred some four years later. The Internet boom had drawn many more artists to the Net, and the development of large online communities led to the emergence of a lot of lively experimentation and topical discourses (that is, net criticism). In this dynamic and productive environment, where *interdisciplinarity* was a basic given for the development of practically everything, a specific terminology and discourse for art developed rather inescapably. Most of the discussions on what is now called net art took place on nettime. Nettime was (and maybe still is) a mailing list that has been very influential on the development of various cultural and political debates around new technologies, of which net art discourse was one. One ever-recurring topic was – and is – the democratizing (or lack thereof) of the media landscape. This is the backdrop for an event that first caused me to consciously withdraw from this new, strong tendency towards a limited medium-specific interpretation of net art.

At the end of a tumultuous year,[66] Alexei Shulgin gave a performance called *Cyberknowledge For Real People* at the Recycling the Future (RTF) festival organized by ORF Kunstradio in Vienna in December 1997. Shulgin, one of the most prominent and influential net.artists on the theoretical and ideological levels, set up what looked like a small booth on one of Vienna's shopping streets, in order to hand out newspapers from the first nettime conference. On the festival's website, Shulgin declared that the 'Internet is not a democratic medium' and 'HTML [the programming language of the Web, JB] becomes just another language of exclusion'. In the tradition of conceptual art, Shulgin published a score, a notation, for this work on the RTF site.[67] With his performance, Shulgin highlighted the interconnectedness of so called 'real' and virtual worlds, while at the same time emphasizing their uniqueness. This performance could not have existed and could not have been understood without the Internet because it relied completely on the existing tensions between certain Internet cultures and the offline world. It was not just some detached commentary or distant criticism of 'The

Internet' common in print or mass media, but a substantial, physical extension of the nettime debates (on critical technological issues in the realm of politics and culture) into the streets of Vienna, without ever using a single Internet connection during his performance.

Earlier live performances in which the Internet played a secondary role (not counting the pre-Internet projects of the early 1980s), never established any active links during the course of the various events. As early as 1995, British net.artist Heath Bunting was already creating beautiful and playful performances that involved only the Internet (or his earlier bulletin board system) as the underlying communication structure. This includes his famous *Communication Creates Conflict*, a title that gave a friendly wink to the German hacker club CCC (Chaos Computer Club). He also produced a subtle work called *Project X*, in which all he did was scribble a URL, a link, in chalk on sidewalks and walls of the places he visited. The audience could copy this address into a browser. Here you found a page where you would be asked to answer a few questions about your expectations about this URL you had found on the street. It was a very effective way to connect the street to the Internet, but it relied on one important prerequisite: only those who could understand the scribbles and had an Internet connection could take part in the piece. Simply stated, the work required a certain level of knowledge and created a sense of complicity among those who had this knowledge in 1996.[68]

Shulgin's action, however, did more than just establish and visualize connections between the Net and physical public space. It extended the hypertext link (this time in the shape of print-outs) outside of the Internet. It criticized and subsequently opened up a relatively closed, intellectually elitist debate on access to media and the democratization of cultural processes ending on the streets. Shulgin's wonderful all-encompassing gesture involved the passersby in a very real 'virtual' environment that could not have happened without the Internet.

By the time of my third mind-changing experience, net art had become a much hyped phenomenon. In October 1998, a conference called 'Net – Art – World, Reception Strategies and Problems' was organized at Künstlerhaus Bethanian in Berlin. Like most other conferences, it was pretty much a procession of lectures and artist presentations, most of which were rather standard, until one artist I had not yet met before

completely surprised me with his incredible fulminations against the notion of 'pure' net art. 'Pure' or 'real' net art was and still is a popular term used to differentiate between works of art that were created for the Internet by artists who use the Internet's properties 'well', and online art by artists who 'merely' use the Net for publication or other 'trivial' purposes. The artist in question was German artist KarlHeinz Jeron, one half of sero.org (a collaboration with Joachim Blank), and one of the initiators of a project called 'Internationale Stadt', a Berlin-based adaption of Amsterdam's 'Digitale Stad'. He did not only object to the term because it was elitist or exclusive, but compared the notion of 'pure' net art to the strategies used by the Nazis, who, in their quest for a pure Aryan culture, burned books, destroyed art, and prosecuted artists.

KarlHeinz Jeron's choice of words was amazing, not to mention shocking, in the context of a net art debate that was usually drenched in political correctness. Not unlike Shulgin, Jeron had managed to put his finger on the drift towards a form of sectarianism, which implied establishing a narrow critical focus on art practices in the context of the Internet. For Jeron, the Internet was (and remains) a domain for all artists to use as they please. I could not agree more, and would never judge a work of art on its 'specific' or 'correct' use of the Net ever again.

These last two experiences functioned as wake-up calls for me. After an initial introduction to a very broad variety of highly interdisciplinary works, of which those of Robert Adrian X were only a part,[69] the fierce discussions that ensued about the purpose, value and legitimacy of net art on the nettime mailing list, for instance, had some effect on my own work. During these discussions some of the participants confused notions of taste, relevance and functionality, while not all of the participants seemed to have been equally familiar with the art works involved. It was easy to fall back onto defensive strategies based on vague notions of innovation or on superficial forms of medium specificity when you became entangled in these discussions. Like so many others (or so it seems), I was drawn to the 'safety' of the simplistic justifications of vulnerable art practices, because they were simply closest to hand. I did so to help explain the heart-felt relevance of both the individual works of art and the unfolding cultural terrain they were part of. It also became clear, however, that there was a discrepancy between this

approach of net art, born out of defending rather than representing it, and the art works themselves.

The Art: Media Art Divide

The issue of medium specificity and the related misreading of art in the context of the Net has thus caused an almost Tower of Babel-like confusion of tongues. This, plus the immense array of net art practices, seems to be enough reason to make one 'only' want to speak about art. About ten years ago, I did briefly consider this option. In 2001, after eight years of reporting and five years of writing about net art, I decided it was maybe time to 'just call it art', a view I presented at the net art community congress (ncc 48) in Graz.[70] However, it soon became clear that by only using the general term 'art', essential fields of knowledge, a rich history and important critical debates almost instantly disappeared along with that deceivingly simple word 'net'. What is the most damaging about this is that some works became almost impossible to discuss at all. They became invisible. That is why it is necessary to investigate what happens to this art once it leaves its specific context and also what this means for art as a whole.

Let me briefly paint the picture as I see it in a few simple, rough brushstrokes. Net art, in a sense, developed in the no-man's-land between the art world and the media art world. The general, so-called contemporary art world tends to see net art as a form of media art, probably (here is that ghost of the probable) because it involves electronic media that have not yet entered the art field as an accepted medium. Krauss goes so far as to suggest that a medium has to become 'obsolete' before it can be effectively used in art, a position I will discuss later.[71] The media art world, on the other hand, seems to find net art a sympathetic, but slightly mediocre form of electronic art. Net art never really fit into the innovation-focused discourse on media art, in which specific forms of technological development and skill seem to have priority over that of cultural relevance.[72] This seems to be the reason why net art is, for example, not a topic in the extensive research project called Media Art Histories led by the German scholar Oliver Grau, which produced a voluminous publication in 2007.[73]

However, this, among other things, is why media art itself has a great deal of difficulty finding its place within a larger art context. American

theorist Edward Shanken has made this one of his key research topics. In his essay 'Historicizing Art and Technology, forging a method and firing a canon' he writes: 'No clearly defined method exists for analyzing the role of science and technology in the history of art.' He even describes '*the wound*' of media art in relation to the gap between a broad contemporary art discourse and that of what he calls the field of 'art, science and technology' or 'AST'. Shanken writes that the analysis of the role of technology in art has shifted from being dominated by art historians 'during the Renaissance, Baroque and modern periods', to a field described almost solely by artists.[74]

The strict academic approach Shanken (and others in this and other academic publications on this subject) adheres to in his very understandable desire to 'fire a canon' at the fortress of a rigidly humanist art history, too easily becomes an obstacle. The writers Shanken was referring to are mostly interdisciplinary researchers and practitioners, people who have worked as artists at some point, but also (and often more influentially) as theoreticians or curators, like the American theorist Alexander Galloway, the German curator and critic Peter Weibel, the Canadian artist and historian Margo Lovejoy and the American curator and critic Jack Burnham. Shanken follows a limited academic doctrine without questioning it, and, in the end, suggests that only art historians can get 'AST' into the art history canon.

Here we see the issues in a nutshell. After what Shanken calls the 'modern periods' of art, for reasons not entirely clear art historians apparently no longer felt a need to deal with specific technological issues in their field. The result is a theoretical and methodological gap, through which a separate field of media art was almost forced to develop. We should investigate and question the reasons *why* art historians stopped researching the relationship between technology and art and look back at the work of those who have done relevant work in this area.

Embodied Knowledge, Grounded Theory

It is this *why* that is also interesting in the context of net art. To understand it we might have to look at the bigger picture. British historian Luke Skrebowski writes:

The failure of art history to relate scientific models to 'scientistic' cultural production arguably has more to do with the ongoing territory battles of the 'Two Cultures' (the traditional division of intellectual labor between the sciences and the humanities), than any fully convincing theoretical rationale for the oversight.[75]

The Belgian philosopher Isabelle Stengers has written extensively about these 'science wars'. She describes the central issue as an opposition that developed after humanities started claiming that science 'was "*only*" a practice, as "any" other, *implying that those rivals and judges possessed the general definition of a practice*'.[76] The resemblance to the notion that concept rather than medium defines an art work is striking, and it only increases when we look at Stengers' arguments.

Isabelle Stengers goes on to explain how many scientists responded to this argument in an almost knee-jerk reaction by adopting what she calls the equally rigid 'eliminativism', which is basically a form of radical materialism where nothing exists except matter. Hard science, they argue, will lead us to the ultimate truth of the universe and the solution to all of our social issues. Similar arguments are heard in the electronic and media art disciplines. However, Stengers notes: 'Materialism cannot be defined in terms of knowledge alone, scientific or other.' The truth can be found in between, and this matter remains unresolved. Scientific practices are related to the social, and the social is, in turn, related to science and matter.

Stengers recognizes the deeply embedded nature of knowledge and science within the larger, complex fabric of society, and extrapolates beyond this by also criticizing materialist dogmas. She observes that 'materialism loses its meaning when it is separated from its relations with struggle'.[77] It is this notion of struggle that ultimately provides the missing link between the 'hard' and 'soft' sciences. It is more than a link in that it serves as a simultaneous expression and representation of an event, a becoming, or 'being' through a specific combination of concept and matter. Stengers also sees a poetic connection via the English language: it's not about matter, but about things that matter. These may be material or conceptual, but in essence they are both. Similarly, all art is not either materialist *or* conceptual, but both, with some practices leaning more to one side or the other, and many even taking a

middle ground. 'What is at stake in a practice, in any practice, cannot be reduced to the generality of a socially organized human activity.'[78]

Stengers believes she has found an escape route for the science debate in the work of Deleuze and Guattari, and her solution may also bridge the art–media art divide. The work of practitioners (including artists) is, as Stengers explains, deeply informed by their specific type of work. Practices generally do not converge because their individual natures prevent it. Their essence is not abstract or conceptual, but hybrid, and can lead to very different outcomes and neither a commonality nor a duality can be forced onto them as a whole. At best, Stengers continues:

> What may happen among diverging practitioners is the creation of what Deleuze and Guattari describe as 'rhizomatic connections': that is, connections as events, the event as articulation *without a common ground to justify it*, or an ideal from which to deduce it.[79]

These 'articulations' are the site or manifestation of struggles that Stengers had identified earlier. In the case of the many diverging art practices, they exist between the formalist and conceptualist 'camps' to various degrees. It is possible and even critical to retrieve the shape of the art work here, and see how matter still matters. Deleuze and Guattari were influenced by the theories of, among others, the French philosopher Gilbert Simondon, who developed a highly unconventional but useful way of thinking about time, experience and materiality, in which a deeply sensual experience of matter informs life and thought, and technologies are a vital co-manifestation of thought and practice.

By 1958, Simondon was already describing the general attitude towards technology as one that was based on fear and a false sense of otherness that needs to be overcome. In his essay 'On the Mode of Existence of the Technical Object' he observes: 'Culture behaves towards the technical object much in the same way as a man caught up in primitive xenophobia behaves towards a stranger.' And this is a familiar sight in the art–media art divide. Simondon describes how the relationship between humans and technology is dominated by two modes of thinking: the first diminishes the role of technology by approaching it as a mere tool that has no influence on what really matters in life, and the second is the radical contraposition of those involved in the production

and implementation of technology, as a response to the first position's 'marked defensive negative attitude'.[80] Technology is glorified and fetishized in this instance.

These two limited modes of thinking, when taken together, evoke a cultural attitude that seems to obstruct any effective debate about the present and future state of art, and of life and culture in general. Whereas one denies technology's significance in history and culture, the other idolizes the machine and bestows upon it 'fictive powers', even going so far as to call the machine a 'duplicate of man'. According to Simondon, these two limited modes of thinking have merged to become one problematic approach to technology. This has been negatively internalized in society as a whole. While significant powers are recognized in the machine, there is little desire or ability to acknowledge them neutrally. Instead of recognizing these powers as an intricate part of ourselves, there is a strong tendency to fear and 'enslave' the machine. The biggest problem with this is that, in a way, it also enslaves us. A strained relationship to technology obstructs a free interpretation and application of it. In the context of art, this leads to tragic circumstances where many can no longer imagine that artists are free to play, invent or create using technology. There is always the fear that the artist has been led by the machine instead of the other way around, while, in fact, this very polarity is problematic. Art practices evolve in myriad ways, also when technology is involved.

The tendency to place technology beyond our bodies and ourselves, instead of as something *through* which invention and creation is effectively played out, has a complex social, economic and political history. Canadian theorist Brian Massumi was influenced by the work of Simondon. In an interview about his translation of the work of the French philosopher, Massumi points out that this history is a living, evolving reality for which we need to constantly redefine our specific practices and strategies. The traditional positions in the technology debate are moot as noted from the general deadlock in the science wars. A similar situation has evolved in the art–media art divide. Massumi, in an interview, described these positions as based on 'artisanal technicity' (tool-oriented) or an 'industrial technicity' (duality-oriented: the machine as a potentially hostile tool).[81] Their historical relations are quite evident and can be traced back to preindustrial, industrial, and

postindustrial (modern, but not postmodern) societies. Both these posi-
tions can still be heard in contemporary art criticism. Curator Nicholas
Bourriaud, in his book *Relational Aesthetics*, for example, notes: 'We feel
meager and helpless when faced with the electronic media . . . like the
laboratory rat doomed to an inexorable itinerary in its cage, littered
with chunks of cheese.'[82]

This kind of paranoid reaction arises when people are unduly
frightened by technology and so they become suspicious of those who
are actually working with technology, easily branding them as tech-
nophiles. Simondon, however, is not overly preoccupied with technol-
ogy, and reading his work from a rigid materialist point of view should
be resisted, Massumi insists. Simondon leaves the self-imposed dichoto-
my between the humanities and the sciences decades before it actually
occurs by focusing on the transient character of all forms, and their
dependence on ever-changing contexts. As Stengers also shows, a rigid
positioning within these contexts, be it either social or materialist, ulti-
mately blocks and even destroys the critical emergence of one's own
practice. This means that any *art theory or art criticism that negates or even
erases the issue of matter and medium from its basic suppositions merely under-
mines itself.*

Interestingly, Simondon's theory and a movement away from the
issue of matter and medium in art developed roughly around the same
time. It was a time when society was going through great technologi-
cal and political changes that did not leave art untouched. It is in this
period that art historians, according to Shanken, stopped researching
art, science and technology. The era in which the Internet was con-
ceived is apparently also the era in which it was pre-emptively under-
mined as a potential actor in art practice. We need to take a closer look
at the murky matter of medium specificity in art.

There Was Never a Post-Medium Condition

Simondon foresaw our current dilemmas. He knew that if we did
not leave our fears behind we would one day find ourselves facing
some very large monsters of our own creation. These monsters are not
predominantly technological. They are mostly products of our awk-
ward relationship with technology. In fact, we created many monsters
of different shapes and sizes, at least one for every aspect of our culture:

the war machine, the economical crisis and the 'crisis' in art. This might seem like an odd line-up, but what these fearsome creatures have in common is our detached feeling towards them. It often seems as if we have no part in their development, that these events just happen. We tend to feel powerless or overpowered by their magnitude. Massumi notes that, by refusing to deal with the way culture is part of technology and vice versa, we have also refused to develop an intelligent and informed attitude towards society as a whole. Society is submitted to a 'lock-in to a relative level of collective ontogenetic stupidity'.[83] By acting dumb, the issues we face only grow.

One smaller monster may be the post-medium condition, which is a by-product of the crisis in art, so much so that Krauss felt the need to actually define and name it. Krauss does not use the term 'post-medium condition' for art she likes. It seems a sarcastic approach of conceptual and postmodern tendencies that emerged in art criticism around 1970. She sees the result of these as a 'condition', an illness even.[84] Krauss works hard to find a new way of perceiving the medium, one that escapes the rigid ways of the conceptualist, 'immaterial' view of art, and its opposite, the highly formalistic modern approach. Her work on medium specificity is an important step towards acknowledging how a work of art might gain shape in electronic media.

Krauss manages to rediscover the inherent openness and structural wealth of the electronic medium, though she still calls it a 'support'. She came to this by paralleling the work of structuralist filmmakers and film theorists like De Lauretis and Heath with the experimental, open structure of early film, and from here she describes the medium of 'film' as an 'apparatus'. As an apparatus, according to Krauss:

> The medium or support of film is neither the celluloid strip of images, nor the camera that filmed them, nor the projector that brings them to life in motion, nor the beam of light that relays them to the screen, nor that screen itself, but all of these taken together, including the audience's position caught between the source of the light behind it and the image projected before their eyes.

Her essay 'A Voyage on the North Sea', in which she introduced the term 'post-medium condition', is an attempt to reach beyond and through her

tutor Clement Greenberg's legacy to disclose the complex layering within the medium and the art work it 'supports'. She quite literally reaches through his legacy in terms of time, as she retrieves the inherent openness and structural wealth of the medium going back to the nineteenth century, when she discovers the origins of film. Rosalind Krauss, in the introduction to her more recent book *Perpetual Inventory*, even manages to dismiss the post-medium condition as a 'monstrous myth'.[85]

To explain the 'new' or actual, complex medium, Krauss describes her encounter with Broodthaers's installation art. Although she describes it as a rather holistic experience in which objects, the artist's arrangement of these objects, her knowledge of the artist's practice and her personal position as audience and critic converge, Krauss maintains a conceptual interpretation of the work as a whole. Despite her desire to define a new medium specificity, Krauss still manages to avoid the materiality of his art installations by observing that Broodthaers's main medium is 'fiction', an interesting leap toward the profound technicity of language, which I am not sure she fully realizes herself. Medium specificity still exists, but the way it is expressed within a work of art ultimately remains very obscure. At the same time, the medium is still there, albeit in a state of what Krauss calls a 'differential specificity'.

What seems like a hopeful theoretical turn (or return) towards all that matters in art unfortunately does not provide any solace for art in the context of new technologies. The position of all media art, including net art, is perfectly illustrated in how Krauss deals with digital media. Tragically, this is representative of the approach to digital media by art critics in general. It is compelling how Krauss seems to be constantly on the verge of fully embracing the inherent 'differential specificity' of the medium, but when she's confronted with electronic media, her sharp deductive reasoning powers somehow collapse, and the medium's inner differentiality is suddenly nowhere in sight. The sight of a computer in particular creates an intellectual gridlock.

She quotes Broodthaers, who died in 1976, to illustrate her own suspicion of digital media, and uncritically adapts his view of the computer, which, according to Broodthaers, produced a 'singleness [which] condemns the mind to monomania'. What he means by 'singleness' is never explained. Krauss, in turn, refers to the writing of the American theorist and cultural critic Frederic Jameson, who considers 'cyberspace'

to be part of 'the perceptual system of late capitalism' in which there is 'a total saturation of cultural space by the image'.[86] By combining Jameson and Broodthaers's limited and inaccurate views, Krauss neatly presents the clichés that haunt the criticism of net art. Still, digital media are included in the larger array of possible artist 'mediums', although quite carelessly.

So, despite a persistent emphasis on the conceptual or social aspect of the work of art, its physical features remain in the critical domain, but recognition remains partial and casual, as the critic moves on to what she believes are the main issues. A deep engagement with matter is not acknowledged as integral to art practice. However, by deconstructing the medium and revealing its openness and fluidity on different levels, Krauss does present her piece of the puzzle in the reassessment of the medium by actually taking an extra step beyond Burnham, who left the various elements of the 'system' largely untouched, creating a floating, ungrounded theory of unwieldy art works – too difficult for art critics of the time, let alone an audience, to grasp. Art criticism that is based on Burnham's Systems Esthetics would always lack substance in a literal sense. When both approaches are combined, something interesting may happen, which is quite ironic considering that Krauss was fairly critical of Burnham's early writings.

Differential Specificity in Sociotechnological Structures
Luke Skrebowski suggests using Burnham's Systems Esthetics 'as a productive methodological framework for considering postformalist art *as a whole*'.[87] Shanken also seems to suggest something similar: 'One of the strengths of systems theory is its general applicability across the sciences, social sciences, arts, and humanities.'[88] But for any of this to happen would require Burnham's theory to be grounded retroactively through a rather forceful projection of a system's relation to matter, whereas Krauss includes the system (without ever admitting she does) when she describes the openness of early films, which she considers to be a model for Broodthaers's installation work. She notes that 'the filmic apparatus presents us with a medium whose specificity is to be found in its condition as self-differing. It is aggregative, a matter of interlocking supports and layered conventions'.[89] Even if there is a distinct tension between the very concrete systems of the works Burnham describes

and his theory, Systems Esthetics does not really come alive, whereas one can almost sense the motion of the film reels (or the merging of the machinic and cultural elements) purring, clicking and rotating away in Krauss's 'differential specificity' of the apparatus.

Wonderful as this re-found physicality may be, it needs further refinement. If individual works of art in the context of the Net are ever to be defined properly, the relation between artist, medium and audience, and the way the art work 'becomes' through it, still needs to be more precisely identified. If we limit it to merely dissecting the medium and breaking it up into its various elements, it remains too rooted in an 'industrial technicity' in which technology is placed at a stupefying distance, and in mere service of man and his ideas. Its role would still not be fully acknowledged. Krauss avoids associating it with the mere dispersion of Greenberg's medium by moving from an open-ended apparatus into the realm of 'fiction', but 'fiction' and 'apparatus' overlap as they 'interlock', and they most definitely do in the art work. Fiction and apparatus or matter co-produce the work as they coexist or collaborate within it. This is the result *and* the basis of the artist's practice.

There may be a simple reason why the desire for a specific language was so strong in early net art. This 'interlocking' happens most evidently, Massumi notes, when 'the technical object under consideration takes the form of the post-industrial network'. This network harbours an infinite range of potential 'becomings', and creates possibilities that have never existed before. It is relatively easy to enlarge a small gesture or to translate complex events into simple 'structures' in ever-varied ways, making the Net a most interesting context for artists. 'The standardization [that] the post-industrial network requires is actually an opening of the technical process to a future latitude of becoming,' Massumi observes, 'through network standardization the technical object in fact accedes to some of the same natural potentials 'harnessed' by psychic individuation.'[90] The computer changes into a sort of collaborator via the network's dynamics and shape. It stands beside you as another actor in the field, and like you it has its own specific physical and immaterial characteristics. This creates a huge potential for new development and activity. Both Simondon and Massumi see this as a potential that is intensified to the extreme, almost beyond our understanding.

The postindustrial network, of which the Internet is one of the most powerful examples, invites and enables reassessments of the medium through this 'opening of the technical process to a future latitude of becoming'. This is the moment at which to redefine the role of the medium, and recognize the full glory of individual works of art. Rather than waiting for 'mediums' to become 'harmless' or – another danger-ously retrograde view – forcing them into a straightjacket that does not fit, they need to be reassessed *now*. Krauss suggests that Broodthaers was only able to reapply the openness of the early filmic apparatus because it was obsolete, and that obsolescence, in fact, is a prerequisite for any inventive media work to occur. It is exactly its obsolescence, she claims, that allows us to see the apparatus for what it really is, in all its dirt and glory. Apart from the oddity of this claim, which seems to suggest that nobody is able to see through media before these media die, it is linked on almost the same page to her disdain for digital media. She apparently sees no obsolescence here. But as Massumi noted, following Simondon, the postindustrial network renders its individual elements obsolete through the assimilation offered by standardization. In fact, in the age of digital media, obsolescence is everywhere, as the eternal flow of net-works also eats its own children: the 'machines' of the digital age – not hardware, but software.

When Artist and Medium Meet

The use of technological standards in art does not mean that the works of art will automatically all look the same. Standardization is a process that, like other technological phenomena such as automation, suffers from prejudice and false assumptions. The postal service stand-ard of demanding a stamp on an envelope does not mean that all mail is the same. Standardization as the technological basis for the postin-dustrial network neither predefines every gesture made in or by it; nor does it have one specific dominant aesthetic. Any move in this direction needs to be strongly resisted, since it would succumb to the dark nostal-gia of outmoded positions subscribing to an all-defining medium.

Unfortunately, despite the various layers of potential of Burnham's theory (especially on the level of a new shape and interdisciplinarity of art works), Systems Esthetics unnecessarily succumbs to this nostalgia. Skrebowski points to a crucial misinterpretation of Austrian biologist

Ludwig van Bertalanffy's systems theory upon which Burnham based his ideas. Van Bertalanffy warned:

> What may be obscured … [in Systems Science] is the fact that systems theory is a broad view which far transcends technological problems and demands. Systems science, centred in computer technology, cybernetics, automation and systems engineering, appears to make the systems idea another – and indeed the ultimate – technique to shape man and society ever more into the 'mega-machine'.[91]

By ignoring or missing the deeper levels of Van Bertalanffy's theory, Burnham created a kind of modernist monster, a mega-medium consisting of the whole world, which he tried to escape (but instead enabled) via the superiority of the 'immaterial' concept. It made the art work formless and therefore endless.

One useful detail that Burnham does bring to the table is the possibility of a constellation of diverse elements that comprise an art work, elements that, in a way, function similar to Krauss's 'differential specificity' of one medium. When these theories are combined, we come up with a kind of kaleidoscopic view of differential specificities within the differential specificity of the sum total of elements of the kind of work Burnham describes in Systems Esthetics. This allows us to zoom in and out of a work, no matter how complex, cerebral or fleeting. The purpose of this exercise is not to create another overarching theory of art, in which either the medium or the concept prevails, but to allow for unique readings of diverse practices. This is essential because, in order for this to function, art theory needs to find its way back to all that matters, and this is achieved by being aware of – loosely paraphrasing Krauss – an 'interlocking' of fiction and the differential specificity of the medium. We need to finally touch base, but without returning to the old medium for support.

If we want to reconsider what the role of a medium is, and how 'fiction interlocks with it', we first need to reconsider matter and our relationship to it. We could look at the work of Simondon and others inspired by him (like Deleuze, French philosopher Bruno Latour, British theorist Adrian MacKenzie, as well as Massumi) to fill the gap that still critically separates us from matter. Instead of focusing on an inside and

outside of technology or machines, these theorists believe that matter and 'medium' are always considered in relation to *movement* and *change*. It is a movement in the sense of emerging, of process, which is 'enclosed' or rather 'embodied' in matter and medium in the form of a potential. Matter is the shared basis of mankind, nature and culture.

Instead of looking at matter, medium and body as static objects, they should be seen as always in motion or 'becoming'. It is an approach to the world in which the conceptual, purely cultural view of bodies, objects and positions is rejected as a sort of freeze-frame. Cultural theory and art theory defined the body by pinning it to a grid of culturally constructed significations: signs and stills instead of experiences. Representation replaced experience. What is missing from this approach is sensation, which is the abstract 'connection' to matter that results from an engaged, embodied presence. Massumi calls a position a 'retro movement, movement residue'. The human body, according to him, 'when in motion, is in an immediate, unfolding relation to its own nonpresent potential to vary. That relation, to borrow a phrase from Deleuze, is real but abstract. There, *abstract means: never present in position, only ever in passing.*'[92] This suggests a kind of slippage between the material and the immaterial, an overlap that is not static but in flux. Practice develops through and in correlation with this slippage. Massumi explains:

> All of the key terms of Simondon's philosophy revolve around the moment of inventive, eventive, taking new effect,, Simondon calls the holism-effect that clicks in at this point a *resonance*. Then he defines matter as this very resonance. Matter is thus defined in terms of a form-taking activity immanent to the event of taking-form. Nothing could be further from the *form-receiving* passivity of matter according to the hylomorphic model.[93]

Artists, like everybody else, live and work within this 'becoming'. Their individual practices develop within the resonating, 'form-taking activity immanent to the event of taking-form'. They are not 'subjects', victims of signs and signification acting upon them. Their practices also cannot escape the influence of the components they work with or think from. Burnham, hinting at a presence of motion and interaction,

claimed that complex works of art – that may include, for example, economic structures – functioned as a 'system', however, he believed that their energy and direction materially originated in the human mind. When Krauss focuses on the medium, she calls it an 'interlocking', when she diverges slightly she begins calling it 'fiction'. Yet a close 'resonating' with the medium and with technology is a powerful state of being, an awareness of which enables us to also develop *responsible* or meaningful strategies for an engagement with matter, technology and the world.

Where Is the Net in Art

What we can glean from how critics and curators like Krauss and Bourriaud describe computers and new media is that, when it comes to art in a digital media context, a careful and precise interpretation of the expanded art field and its practices has yet to arrive, which is especially obvious in the more traditional art context. Edward Shanken's analysis of the field of art history and its relation (or lack thereof) to media art shows that there is a significant gap between relevant theoretical and practical methodologies. This is partly enforced by an all-round resistance to an acceptance of the fruits of interdisciplinary research. Stengers notes that the roots of this resistance can be found in the science wars, where mutually excluding approaches end up eliminating vital practices.

Simondon's theories explain how a deep, culturally embedded, almost instinctive approach to technology could be the basis for those same science wars. Stengers describes this resistance as resulting from a process of mutually excluding fields of science that end up eliminating vital practices.

Despite these limitations and obstructions, practice continues to develop in various directions, along winding roads that will probably never meet or come together. Despite reigning critical discourses, art practice in particular is, and has been for a long time, free of limiting concepts. What this means is that, for nearly 50 years, there have been many art practices and art works involving science and technology that were not recognized or discussed in ruling art-criticism discourses. This is especially in the last few decades when their numbers exploded. So far, this neglect has gone largely unnoticed. Net art, however, is a field

where eliminative critical and curatorial practices do not go unnoticed. Due to the relative openness of the field, in which anybody can have his or her say and in which many artists have already created their own spaces, it is quite clear when, for example, art works are ignored and misrepresented or when audiences are cut off from interacting with them. The fact that wrongful critical or institutional approaches are easily identified does not mean they can also be easily eradicated, but at least these issues are now out in the open.

In this regard, Isabelle Stengers rhetorically wonders about this situation:

> Is it not the case that conveniently escaping a confrontation with the messy world of practitioners through clean conceptual dilemmas or eliminativist judgments has left us with a theatre of concepts the power of which, for [a] retroactive understanding, is matched only by their powerlessness to transform?[94]

Although it may seem that she is being overly pessimistic here, her question can be interpreted as a call for transformative concepts. It is a refreshing challenge to engage in an informed struggle with matter, and, contrary to what Krauss and Bourriaud suggest, new media technologies are easier to access at almost every level than earlier electronic media were. Even the wild days of early radio, by which the openness and 'differential specificity' of early film pales in comparison, did not offer this kind of availability in terms of knowledge and technological components.

At least three major forces are at work here: the large market for consumer technology, an even larger exchange of second-hand parts and machines, and what has been disparagingly referred to as 'user-culture'. The term 'user' is code for a vast array of attitudes and individual practices in the context of new media networks, of which art is one. To fully understand the physical reach in which these practices may unfold can range from traditional media audiences who read their daily newspaper online (or read and send email) to technicians and engineers working at the deepest levels of software, hardware and Internet development. Hackers, crackers and tweakers (respectively specialized in breaking through firewalls and network security, cracking software

copyright protection codes and adapting software or games) also fall into this category and each works at a different level of expertise and legality. Since digital media are in many ways also obsolete or dead media their different technological and cultural elements are pretty much open and exposed. The dazzling speed of hardware and software upgrades makes digital media a field of technology that is always on the brink of collapse and obsolescence. As such, it is as common and malleable as clay.[95]

Though not every 'user' is equally knowledgeable of new media technologies, it is fairly easy to access the necessary information and get ones hands dirty at the hardware, software or networking levels. New media are thus considered heaven for autodidacts, and hell for overprotective experts concerned about their jobs. It is precisely because these technologies consist of complex histories, politics, market forces, and, last but not least, cultural influences in just about every single component ('differential specificity' is running amok and the critic is working overtime), that there is so much potential for artists (and others) to develop genuinely individual practices or original forms within them. In fact, it is in some ways easier, since the accumulation of forces, energies and tools (both technological *and* social) is so powerful that even in the least favourable circumstances something interesting can happen. 'Digital technologies have a connection to the potential and the virtual *only through the analog*,' writes Massumi, and to this potential and virtual they contribute their 'enormous power of systemization of the possible'.[96] The combination of potential and possibility in the context of the Net arouses suspicion about the amount of actual work involved or the levels of knowledge and expertise existing within certain practices. The many interdisciplinary approaches in net art in particular often demand self-education and collaborations across different fields (with non-artists or active audience members). I have been to conferences where painters would remark on how long they worked on a painting, whereas they wrongly assumed a net art work is created with the push of a button. Similar prejudices exist regarding online art criticism or media art theory.

The Net narrows physical and social divides, albeit sometimes slowly, sometimes only temporarily, sometimes in unexpected ways. It has certainly changed the social landscape and destabilized various

traditional systems. Even if its effect still only has a minimal impact on political and economic forces, it may still arouse its share of suspicion and disdain. This is certainly evident in the rants of American entrepreneur Andrew Keen, whose book *The Cult of the Amateur, How Today's Internet is Killing Our Culture* quickly gained a loyal group of followers.[97] The dominating feature of this negative approach is to emphasize how autodidacts and amateurs have allegedly threatened the position of a professional culture of experts. The levelling of traditional hierarchies via the introduction of a multitude of new online 'voices' provokes this type of knee-jerk response. The representation of Internet cultures in 'old' media (magazines, newspapers, radio and television) and in many scientific publications created by these professionals therefore should always be seen from this light.

Seldom are the contemporary autodidacts and amateurs of new media cultures depicted as a positive force, whereas they are at the foundation of the Internet and new network cultures. In this sense they share the fate of interdisciplinary scientists and researchers, and sometimes they are even one and the same: think for instance of the highly Internet-savvy theorists Alex Galloway and Roy Ascott. Respect however is, if only slowly, on the rise. 'Amateurs are not only increasingly professional producers of reality,' writes for instance Dutch art critic Jorinde Seijdel, 'but they are also increasingly professional performers and an increasingly professional public.'[98] Thinking of the indispensible role of the amateur in today's information society this is still an understatement.[99]

Meta-Medium

Dealing with the matter of the Net means coping with its near-obsolescence and accepting autodidactic practitioners. Both are part of the material make up of the Net, and are intimately interrelated: both are abundant while individual elements (technological and human) are constantly being upgraded and replaced, which means a constant state of self-education and experimental practice. The material context of net art is a highly diverse, constantly evolving, technologically and socially variable complex of events. In this context, we have to take up Isabelle Stengers challenge and develop concepts that *are* capable of transforming the various deadlocked and eliminative discourses. We should add

another challenge, one posed by Rosalind Krauss, who has made it her 'preoccupation' since the early 1970s to 'wrestle new mediums to the mat of specificity'.

By exploring the radical diversity within the prominent net art literature, we can already make some observations concerning the differential specificity of the Net: any description of this specificity has to take into account the sociotechnological characteristics and material properties within each layer involved. Both the computer and the Internet consist of numerous layers of technology and 'technicity',[100] which resonate in accordance with the artist's approach. I have long resisted calling the Internet a medium because of this, but Rosalind Krauss's re-evaluation of the term has led me to reconsider my earlier decision. By following Krauss, the Internet can still not really be called a medium; it is more of a meta-medium. It is only after we incorporate Simondon's notion of the ensemble, as a machine made up of many machines, that it becomes possible to carefully begin calling the Net a medium. In the process of defining and analysing the differential specificity of this medium, we end up inside its various subtechnologies and the more fleeting nature of the material: such as computer technologies, the basic Internet protocols plus the Net's incorporation and adaptation of personal media (diaries and photo albums), magazines, newspapers, radio, television and telephones, and, last but not least, its social and cultural phenomena. We end up having to examine the differential specificities of practically the entire media spectrum and how it unfolds or is enabled through the human body and its own 'ensemble', which we refer to as society. We end up in a place that Krauss has no desire to be in, namely very close to a grounded approach to Systems Esthetics.

Luckily this seldom ends up going this far. Not every net art work includes every nook and cranny of the Net, including its users. Most remain within a modest set of parameters and elements. Different critics and theorists have developed their own rough categorizations within these parameters, some of which I already mentioned earlier. I have also developed my own criteria, which consist mostly of guidelines or starting points, not rules to live by. Interpreting net art ultimately means taking the time to explore the shape of each individual work. In this respect, it is 'just' like we approach any art form, assuming we are somewhat informed.

Changing Perspective

One critical difference between net art and 'just' art is that many people cannot even imagine how they would start relating to something that, for example, at first sight seems to be some vague image on a computer screen. The key issue here is *engagement* or participation. Without this, the work will generally not disclose itself. If, in traditional art forms like painting and sculpture, everything revolves around perspective, which basically involves the eyes, in net art as well as media art, perspective has shifted from the point of seeing to what Canadian sociologist Derrick de Kerckhove calls 'the point of being'.[101] It is also reflected in the movement, affect and sensation, which Massumi has discerned as being at the heart of experience. He even speaks of 'the Unbearable Lightness of Seeing' and a co-functioning of the senses.[102] Without physically experiencing what it means to move within a net art work, to *be* there and to 'resonate' with it on a deeper level, its essence will remain undiscovered.

Art needs sensually rewired art criticism (and art theory) in its shift away from the head to an embodied presence. Paradoxically, the Internet also provokes a re-identification with our very own physicality. Online interactivity is at least as varied and complex as its unmediated variant and also requires a specific sensitivity towards interpretation at times that can be utilized far beyond a museum's walls and the many layers of futilities and trash. 'The art formerly known as "new media" alters our understanding of the behavior of contemporary art precisely because of its participation in the creation of a cultural understanding of computational interactivity and networked participation,' observes American curator Steve Dietz, one of the first to present net art in a traditional art context in the USA. 'In other words, art is different after new media because of new media – not because new media is "next", but because its behaviors are the behaviors of our technological times.'[103]

Finally

The development of a satisfactory critical and theoretical canon for net art will remain a challenge and an adventure. The challenge of 'wrestling new mediums to the mat of specificity' is more than just some aesthetic exercise. The disclosure of the variety of works is also not just a formal matter. What unfolds before and around us is a radical

diversity of practices, many of which escape the symbolic and insti-tutionalized prisons of materialism and conceptualism. This does not entail, as was wrongly assumed, that all net art actively seeks to subvert existing traditions and institutions. There is the *potential* for subversion – which is occasionally realized by chance or by force – on different scales and in varying degrees of durability. Net art poses a huge chal-lenge to the fields of art theory and art criticism. It demands an accept-ance of the validity of diverging practices, and for an acknowledgment of its many material and semi-material elements. All this precedes the question of taste, even in art criticism. Taste should not come into play at the elementary level of medium specificity. Taste has very little to hold on to if a work or practice cannot be identified because half of 'why it matters' is misinterpreted (because of ignorance) or discarded (as a result of prejudice). The same holds true for interpretation.

Levels, Spheres and Patterns:
Form and Location in Net Art

What else does a human see in a flower? Besides pharmaceuticals?
Poetry, for one thing. The extension from need to utility can extend
again.
Brian Massumi[1]

Introduction
Net art unfolds in various ways and exploring its shapes and forms
can be a challenge, but it is possible. The shape of net art is indetermi-
nate, yet paths can be found through it, and approaches can be devel-
oped towards specific practices and works. It is not my intention to
prescribe how this should be done. In this text I merely propose some
points of entry from which different works can be understood. They
each in their own way reveal a view beyond the flat surface of the screen
or the mathematics of a process, revealing a reality and art sphere that
reaches far into actual and virtual realms of the machinic and the social.

There are a variety of approaches and methods available in the con-
text of art and technology. In my essay 'Let's Talk Net Art', I described
how different critics reveal a multitude of forms and practices in this
field. These critics each tend to have their own system from which to
analyse practices based on some form of overlap between them. These
systems generally describe highly visible themes or tendencies in net
art and are seldom 'medium specific' in the traditional, modern sense of
the word.[2] Overlaps in net art practices could also be approached from
possibly relevant, older disciplines, but this can easily limit their inter-
pretations, which is why it is mostly avoided. If, for example, a work
is compared to a film this should at least involve a very broad view of
the 'filmic apparatus', and it definitely needs to take into account how
things materialize and contextualize through the multiple complex sys-
tems that make up the Net. Most books on net art therefore include an
introduction to the history and technology of the Internet.

Because so many of these introductions to the Internet have already
been written, it is pointless to replicate it here. If it is indeed necessary
to explore the (socio)technological specifics of the Internet's history,

there are a number of excellent books available, not to mention the wealth of information on this subject available online.[3] Thus, for this broad introduction, it is sufficient to give some indication of the matter, space and process of the works of art described. All I will do here is guide the reader or enable a first step towards more informed and closer encounters with net art works. This introduction to net art will include a rough outline of five levels: code, flow, screen, matter and context. They each have their limitations: flow, for instance, covers the essential, explicit use of active network connections in performance art, sound art and installation art. Since most of net art, if not all, in some way depends on digital processing (and thus embodies a form of flow) this category bares the most evidence of a personal critical approach. For me, an explicit form of flow exists in the installation and performance context, where it connects flows of the body and the machine, of the social and the technological networks.

What is essential in 'flow' is the very direct, 'close contact' and upfront use of what Marshall McLuhan would call an extension of the nervous system, in which a closed, active, 'live' system is created between different locations or spaces. This means that 'flow' cannot take place in one single machine, installation or 'one-way' data stream. The possibilities and poetics of utilizing the connections between spaces in art have been a focus in my work since the very beginning. If I have a preference among net art practices, this would be it. It is also the reason why I have chosen the word 'sphere' to delineate this specific use of form in net art.

My use of the term 'sphere' is derived from the work of the German philosopher Peter Sloterdijk.[4] Spheres are 'spaces of co-existence'. For Sloterdijk, media technology is a way of attempting to restore the initial and very literal physical separation between mother and child after birth, which, in his view, is the basis of our need to connect to others. This technology, like the umbilical cord and the placenta, cannot be evaluated independent of the body. In his first book *Spheres*, Sloterdijk describes humanity as 'space-creating beings'. He describes the small 'sphere' between and around individuals as 'bubbles'. Although Sloterdijk uses these metaphors mostly in metaphysical, cultural and sociotheoretical contexts, they can also be applied in their most basic, semi-material form. They can be appropriated for the hybrid and unsta-

63

ble shapes created by artists on the Net. In a mild and funny criticism of
Sloterdijk, the French philosopher Bruno Latour proposes always using
the more humble 'bubble' instead of 'sphere'.[5] Latour claims that our
influence in the world is not significant enough to ever speak in terms
of the vast dimensions of spheres.

Latour's criticism seems too loaded with cultural pessimism (and
maybe even some machismo) for me. In practice, the amorphous forms
these terms refer to probably range in size from a bubble to a sphere,
but in our case, size is not important (nor is the enduring political or
cultural influence Latour seems to seek). What matters is how these
forms, these often temporary and physically variable architectures of
human and environment, are explicitly used in art. Most net art projects
are about exactly that: the artist constructs a deliberately closed or open
social space (whether sphere or bubble), in which the interactivity that
is inherent and elementary to digital environments is carefully boxed,
subtly controlled or deliberately left 'open'.

As an audience, we are challenged to recognize and define the di-
mensions and shapes of individual 'spheres' in net art. They are formed
by physical as well as social relations, and can be remarkably 'stable'
considering the conditions under which they are constructed. In terms
of 'flow', they are physically grounded in the network by active links
and chains of software, by wires and wireless connections. Here the
flexible structure of the Internet in particular is combined with offline,
local realities in a way that creates a new, temporary space or struc-
ture. The space of net art consists of technological, social and virtual
realities together. It is an open space, much like that of art in public
space offline.[6] In fact, public space extends itself into 'cyberspace', as
American critic and curator Steve Dietz notes: 'The cybrid environment
cannot be ignored – public space is both physical and virtual.'[7]

This cybrid environment has developed rapidly from a rather elitist
digital space in which academics, technicians, governments and hack-
ers were the main residents, to a technological 'skin'[8] performing very
close to the individual human body. How much it pervades everyday
life is illustrated by the near future of the 'Internet of Things'. This
deceivingly simple term is used to describe the increasing commu-
nication between all kinds of devices and tools, or, from the 'Internet
of Things' conference info-blurb in March 2008 in Zurich: 'The term

"Internet of Things" has come to describe a number of technologies and research disciplines that enable the Internet to reach out into the real world of physical objects.'[9] Even if this definition seems to neglect the one 'thing' that connected the Internet to the real world from its very inception – the human being – it does offer a strong indication of the ubiquity of network cultures and the different levels of technicity involved. In this regard, Belgian RFID analyst and critic Rob van Kranenburg noted: 'We are entering a land where the environment has become the interface.'[10] It is not an impenetrable, solid or static interface, however.

Technicity is a term introduced by the French philosopher Gilbert Simondon some 50 years ago. British theorist Adrian MacKenzie more recently used it to describe the varying levels of cultural complexity within tools and technology, and the way these relate to the human body. These levels can be understood as potential or inherent processes rather than given, frozen properties. They invite or incorporate a specific act or use. A hammer, for example, is designed to embody one specific trait or 'application' of the human body: hitting something. It has a singular technicity, which is passed on to future generations as a kind of embodied knowledge or memory of action. A machine, however, whether it is a sewing machine or a computer, contains the potential to perform several of these 'materialized potential activities' simultaneously.

It also is a physical manifestation of the many layers of history that contain various practices, cultures and technologies. The more complex the machine, the more levels of technicity and the more historical layers are contained in that machine. Mackenzie observed: 'As an assemblage or multiplicity, a technical mediation assembles heterogeneous elements from different times, from the Paleolithic to the contemporary.'[11] Thus large machinic 'ensembles' like the Internet should not be approached as simply products of a commercial media industry (as some critics wrongly suggest), but as intricate, active and still-open manifestations of intersecting strands of transferred knowledge, habits and traditions. This is necessary for the machinic realm to open up, creating the potential for a knowledgeable interaction with its various elements.

Net art practices evolve with and through the mesh of technologies, social bodies and local environments at hand. Individual works inhabit or incorporate varying levels of technicity within this environment,

and through an actively engaging human factor (artist and audience), it can create an actual sphere. This is the basic territory in which artists operate today: a newly defined and informed field of activity and potential that exists between humans, humans and machines, or machines and other machines (the latter remains ambiguous theoretical territory). This territory consists of many overlapping and interacting social, cultural and material constructions. The five levels described here represent significant clusters of art works and art practices that cannot be clearly delineated. They are not presented in order of appearance, evolution or importance.

Code: Programming and Software

In the beginning, there was the command line. This ironically popular paraphrasing of the opening line of the book of Genesis, which can be found on many websites, reveals a sense of pride and self-awareness among some writers of our new languages (digital code), but it also points to the power and necessity of instruction in new technologies. Code is language, and this enables a form of communication, be it purely mathematical at the level of its interaction with hardware (the famous zeroes and ones), or the more easily readable language for humans at the level of software. The complex history and application of human languages (its oral traditions and written expression, its many levels of interaction in philosophy, science, literature, poetry, theatre and song) is enriched by the addition of a layer of text that combines communication, signification and memory with immanent process, proactivity and production. The inherent potential of programming languages to enable activity or produce (media) objects makes them a very interesting subject for literary or philosophical analyses indeed. What is at stake in code art and software art is not what the code produces, but how it is constructed, what it means, and what it does.

The relatively new languages of code move beyond the realm of the symbolic and metaphorical, as their actual, deep performative potential connects them directly to the material world. They give a completely new meaning to Umberto Eco's notion of *intentio operis*,[12] the *intention of the text* (as opposed to the intention of the author or reader). This makes working with code a *borderline physical practice* that can reach into the realm of the visual arts.

German theorist Florian Cramer writes in his book *Words Made Flesh* how the notion of programming, of invoking action through a specific implementation of language, has a historical precedent in the Kabala, alchemy and Renaissance permutational poetry.[13] 'Algorithmic code and computations,' writes Cramer, 'can't be separated from an often utopian cultural imagination that reaches from magic spells to contemporary computer operating systems.' Code and computers have, however, produced the possibility for text to not only create conceptually, from the naming of objects to the imaginary conjuring up of spirits, but text now can be the force behind an actual 'movement' or the formation of physically perceptible processes. This has placed writing firmly in the world of matter, moving it away from its predominantly conceptual confinement to also enter the practical realms of art and design. A play with code and programming as a 'new' form of language also changes our approach to software as a whole, and enables a new cultural perspective on computation.

'To no longer define software as just algorithms running on hardware helps to avoid common misunderstandings of software as some kind of genius programmer art,' writes Cramer, 'If software is a broad cultural practice, then software art can be made by almost any artist.'[14] Code and software art therefore also have a very profound impact on the perception of computing among other artists, art students and those surrounding them. The work of code poets and artists enables us to see deep into the machine, or to at least partly understand its inner complexity.

The use of software in the arts is not entirely new. By the 1960s, software had already been discovered as a tool to create works of art. The difference, however, between these early uses of programming and contemporary practices in code art or software art is significant. German curator and critic Inke Arns emphasizes the difference between generative art and software art.[15] Generative art produces art; software art *is* art. Whereas contemporary software art tends to deal with either the shape or production of code itself, early software was created to perform a specific function, be it the creation of a work of art, or enabling a work to unfold as in Hans Haacke's *Visitor's Profile*.[16] In this work, exhibited in the 1970 show entitled 'Software', curated by Jack Burnham, a data compiler produced statistics based on answers provid-

ed by museum visitors to questions posed by the artists.[17] The internal processes of the computer were not really considered as part of what they were made to produce. Contemporary code art and software art, on the contrary, works with the entire system of the computer – both its art concept and art context – in which the internal complexities of the computer are no longer hidden or ignored.

Code 'Slang' Poetry: Mary-Ann Breeze

The scope of art at the level of code is wide; it encompasses executable and non-executable code poetry, browsers, tools, games, operating systems and even viruses. The reason this type of art practice has evolved so fast over the past ten years, and the reason why it should be included in an analysis of net art, is that the Internet and its cultures of sharing and scavenging are its main means of (re)production and its fertile breeding ground. No aspect of new media and art in new media has developed faster as a result of online collaboration and sharing than code and software. Early web art also profited greatly from 'borrowed' HTML code.

Code poetry hovers somewhere between literature and art. Even in its clearest literary form it requires a new way of reading. It is a manner of reading that not only sees and understands meaning in a text, but also its potential to act. American curators Joline Blais and Jon Ippolito call it 'Code-infected writing'.[18] When the Australian artist Mary-Ann Breeze (also known as Mez) sends out her texts to mailing lists, as interventions in their discursive routine, unwitting readers might think her work is either nonsensical or some cyber-romantic style exercise. In reality, her texts reflect actual programming languages as a stylistic phenomenon. She calls her invented language 'Mezangle' and regularly disseminated her early work over the Net in an almost viral way. Mary-Ann Breeze said in an interview:

> The format evolved from a series of emailed collaborative pieces carried out with m@ [Matt Hoessli from the CADRE Institute] on the 7-11 mailing list from '96 onwards. My particular 'angle' was to take the information text tracts m@ would post and 'mangle' them through free/multi-word associative techniques and repost them – hence the term, 'mezangelle'. This technique has developed since

then, with computer code conventions and regular chat/email icono-
graphs contributing to its formulation.[19]

Even if her texts were unable to execute a process inside a computer,
Mez's use of specific programming text styles would conjure up a very
different, multilayered interpretation (an active view) for someone who
understands programming languages, compared to the average reader.
It is this particular artist that Florian Cramer refers to in the title of
his dissertation, 'Exe.cut[up]able Statements – Poetic Calculations and
Phantasms of self executing Text'.[20] Mez's work is a literary crossover
between machine and human languages. In *Words Made Flesh*, Cramer
points out that 'Computer and network codes accumulate into personal
diaries, and build cyborgs in the imagination'. German curator and
critic Inke Arns writes about both Mez and the notorious artist known
as Antiorp/Netochka Nezvanova, who used the same style of writing:
'Depending on the context, useless character strings suddenly become
interpretable and executable commands, or vice versa – performative
programming code becomes redundant data.'[21]

Poetry That 'Works'
Executable code poetry ranges from *objets trouvés* (selected elements
from existing code such as game software) to poetry written in specific
programming languages such as Perl. The latter is a programming
language that can be quite easily read by humans. Texts created with
these languages are called the 'source code' of specific software. Not
unlike a lot of other computer terminology, the term 'source code'
has an inherent poetic quality, a symbolic, cultural significance that
betrays its human origin. It is this origin that also makes a critical ap-
proach to programming and the construction of software necessary.
Code and software actively change, create and co-define our current
cultural climate in a profound way. The use of computers in every layer
of society necessitates an informed criticism of the way these new
languages are formed and how they are applied.

German critic Günther Kress, in his book *Literacy in the New Media
Age*, describes how 'transcription systems are not meaning neutral:
social meanings attach to them'.[22] Artists working with code uncover
these meanings. The purpose of software is to mimic a machine inside

the semi-universal machine (a computer) and execute a specific task or process. Since the computer is a complex, multiapplicable calculator, the form of the hidden, active texts of code is highly characteristic. When read or used as poetic or meaningful text, traditional semiotics is combined with mathematical rigor and signs, simultaneously creating a powerful mix and clash of cultures (social and scientific). Social meanings emphasize the rigid logic of purely rational calculations and vice versa. These texts contain a lot of repetition. It is an inherent part of the mechanism of the abstract machine software that is necessary to run a specific process. It strongly reminds one of industrial or minimal styles in art and music. Meanwhile, the 'cut and paste' method and the cultures of sharing in programmer environments also remind one of musical sampling techniques.

Executable Code Poetry: Graham Harwood

British artist Graham Harwood is known for his rigorous and political application of the Tate database for a (commissioned) alternative museum website, in which the dubious history of the Tate building (site) was exposed.[23] Not only did he use the rhythmic repetitiveness of code as a means of poetic expression but also explicitly involved the inescapable methodical calculus in the mathematical aspect of code to emphasize the pain and horror he found in the existing poem he used as the basis for his work *London.pl*. It is based on William Blake's 1792 poem 'London', which tells the bleak tale of the contrast between rich and poor in eighteenth-century London. This early example of social realist art describes children used as chimney sweeps to clean the chimneys of the homes of wealthy Londoners.

Blake describes how the children often died of lung diseases or got stuck and died in the chimneys they were supposed to be cleaning. Harwood transformed this poem into an executable piece of software that calculates the volume of the children's last breaths, based on their approximated height and weight, adds them up, and uses the result to sound an old-fashioned air raid alarm. The alarm's horn will resound for as long as it takes to move the amount of air produced by the combined volume of the children's dying breaths. The text is a horrifying read. In a recent interview with Matthew Fuller, Harwood stated: 'I need to be scared of what I make. It needs to put me in embarrassing, difficult,

hurtful and potentially violent situations or it's just not interesting.'[24] Harwood, ever the socially engaged and radical artist, created a truly compelling masterpiece with his adaptation of 'London'.

The work can be 'fed' the data of any tragedy, from war crimes to social negligence, and was exhibited as an installation in the 'Making Things Public' show organized by Peter Weibel and Bruno Latour in 2005. Its code was also exhibited in the 'Database Imaginary' exhibition in Banff Canada, where the artist presented the code as a copy of the original black-and-white, eighteenth-century illustrations for 'London' as huge screen prints. These prints presented the poem not only as a mongrel of mathematical and human text, but also beyond its natural habitat in the dark interior of a computer, thus producing an ironic, maybe even sinister comment on art, wealth and hierarchies of power. In a review of Harwood's poem for the software art repository, runme. org, Florian Cramer points out:

> It contains a definition of what in Perl is called an 'anonymous array', i.e., a variable storing several values at once, called '@ SocialClass', a database (or, in programmer's lingo: 'nested hashtable') '%DeadChildrenIndex', and two sub-programs ('subroutines') 'CryOfEveryMan' and 'Get_VitalLungCapacity'. Thus, *London.pl translates what 'London' describes into a symbolic machinery.*[25]

This way also the specific social reality behind the original 'London' poem is exposed as 'inhuman'.

Code Drawing: Jodi

The Dutch/Belgian artist duo Jodi (Joan Heemskerk and Dirk Paesmans) have a reputation for toying with code in the most random, genius and funniest ways. Their work is always pleasantly awkward and highly visual. Since the mid-1990s, Jodi's work has managed to capture the attention of artists, designers, curators and critics worldwide. What makes Jodi's work so appealing is the apparent ease with which the artists switch between disciplines and their total lack of respect for functional design. Their work ranges from physical performance, to photography, installation art, video art, conceptual art and poetry in code. It is their 'cross platform' work in code and the Web that produced

their breakthrough in 1996, after which their work became increasingly influential in both online art and design circles.

A legendary early art work by Jodi is a web page that consists of seemingly random green signs on a black background, like early computer screens without a desktop interface. At first glance, this webpage looks interesting enough as it shows a very fascinating but unreadable text, blinking on and off. But when we use the built-in browser option to see the coded construction of the webpage in front of us (by clicking 'view source'), we are confronted with a completely different image that pops up in a new window. It then turns out that the artists have inverted the purpose of the webpage and its source code as the latter reveals the drawing of a bomb. By using this bomb drawing as the HTML source code for the webpage, something that resembles concrete poetry emerges on the webpage. What this work plays with is the sense of danger associated with code, with hacking, and with the Internet itself. One of the early fears of the Internet era was that anybody could find their own recipe to make a bomb. The green-on-black blinking text on the webpage symbolizes the hacked computer, another new danger introduced to the world. The chaotic, scrambled text on the barren screen frantically turning on and off represents the end of all communication. In this work, Jodi translates popular Internet clichés into radical anti-design.

Jodi combines a very intuitive way of working with a deep exploration of the machine. They chose to work on the Net because of the freedom it offered compared to an institutional art context.[26] Their online activities developed almost parallel to the influential online art communities of the mid to late 1990s, which allowed them to feel completely at ease and free to experiment. Like Mez, Jodi has sent out email art, which Joan Heemskerk compared to concrete poetry in an interview I did with the artists in London in 1997.[27] Many contained a form of ASCII art consisting of drawings made from signs and letters, a very popular pastime in early computer environments. 'Some of Jodi's work consists simply of emails through which the boundary between public art object and personal communication is broken down,' writes British artist and programmer Simon Yuill, 'and which, of course, can always invoke a response from the recipient who effectively, in doing so, generates a new variation in the series.'[28]

Dirk Paesmans used the open mailing list of the New York-based on-line art community Rhizome to spend a whole night drawing nothing but a single, meandering line in an endless chain of mails sent out to the entire list. This kind of minimal, live online sketching is ASCII art taken to the extreme and reflects Jodi's radical attitude in an often-mediocre online art environment.

Poetic Virus: Jaromil

The Italian programmer, artist and activist Denis Jaromil Rojo, better known as Jaromil, is a well-known figure in the European media art scene as well as in open source and free software activist circles. He is one of few that has thus far managed to create works that are relevant in both media and free software activist circles, but also beyond. In her book *Networking: The Net as Artwork*, which extensively describes the way hacker cultures, media cultures and art have mixed in Italy, Italian sociologist Tatiana Bazzichelli points out that: 'In Jaromil's works, the ideas of networking, artistic experimentation, hacking and political activism live together in harmony.'[29] As a programmer, Jaromil has played a major role in the development of open source tools for video and audio streaming, some of which he produced for the Dutch media art institute (NIMk) in Amsterdam. Being a true interdisciplinarian and engaged cultural activist, Jaromil works all over the map, physically from festivals in India to Indonesia, as well as in a more metaphorical sense. Jaromil, for instance, was also involved as a curator in the first exhibition of computer viruses as art works called 'I love you' (after the infamous mail worm virus that caused millions of dollars of damage worldwide in 2000) at the Museum of Applied Arts in Frankfurt in 2002.

His work *Forkbomb*, first featured in the 'I love you' show, is an elegant, minimalist work. It consists of a string of 13 signs that, when typed into a computer as a command line, will start to endlessly reproduce them-selves, ultimately crashing the computer. This particular form of 'virus' is called a forkbomb, as its reproduction resembles that of a fork in the road, or a family tree. 'In considering a source code as literature, I am depicting viruses as *poésie maudite*, *giambi* against those selling the Net as a safe area for a bourgeois society,' writes Jaromil in a text for Poes1s 2004 in Berlin, 'The digital domain produces a form of chaos ... to surf thru in that chaos viruses are spontaneous compositions, lyrical in causing im-

perfections in machines made to serve and in representing the rebellion of our digital serfs.' Jaromil wrote his forkbomb after the British artist Alex MacLean had won the Transmediale 2002 award for another fork-bomb, in which no attention was paid to the shape of the actual (in this case messy) code, but only to its ability to crash a computer.

German critic and curator Armin Medosch called Jaromil a 'lyrical programmer activist' on his blog The Next Layer.[30] Although Medosch emphasizes Jaromil's work as an activist and coder, Jaromil's art reveals an equally sensitive 'lyricism'. *Forkbomb* can be seen as a crossover inter-active poetry-performance work, the unfolding or experience of which starts after somebody types it in on the command line of a basic, Unix-based computer system. From the moment the enter button is hit on the keyboard, an unstoppable, slightly destructive process is activated. Florian Cramer wrote about *Forkbomb* in 2003:

> Using a terse, abbreviated shell scripting syntax as opposed to other forkbombs which need several lines of source code to achieve the same goal, Jaromil's one-liner is arguably the most elegant and effi-cient forkbomb ever written. It has the potential of becoming a secret code of recognition among the initiated, like the stuffed trumpet of the Tristero underground in Thomas Pynchon's *Crying of Lot 49*, or it could even become a popular culture icon to be reprinted on t-shirts.[31]

The latter actually happened: Jaromil's *Forkbomb* has become *the* iconic example of this particular form of executable, and is used as an illustra-tion for websites and even on T-shirts, of which I found stacks handed out for free at a random digital culture event. The artist also receives fan mail with enclosed pictures of new implementations of his *Forkbomb*, of which the photos of tattoos of its 13 signs are probably the most amazing. The popularity of *Forkbomb* could very well be a sign of the persistence and attraction of subversive, counterproductive tendencies in technocultures.

Conceptual Software: Wilfried Houjebek

Imagine walking through a city as a means of running code. The *.walk* project by Wilfried Houjebek turns people into flesh and blood

software executors. It is based on a situationist art practice from the 1950s called psychogeography. Wilfried Houjebek is a long-time advocate of open source and anti-copyright in the arts and beyond, and he takes his interest in opening up code very seriously. By making people walk through a city using computer code as a guideline, the artist uses the body to perform software. Cramer called it 'walkware' in his review of .*walk* on the RunMe site.[32] This work actually won an award in the Transmediale software art competition. The email that announced its nomination said this: '.walk by socialfiction.org is a futuristic project for public spaces, combining the mundane with the exceptional.'[33] Wilfried Houjebek himself says in email: 'I regard it as Do-It-Yourself urbanism, a project like .walk is meant to add a new layer of functionality to cities. As such it is architecture and as such it is engineering.' It might seem like this project actually belongs in the section on performance art, but .*walk* is really all about notation, about a deeply conceptual take on art. This work seems to build a bridge between the approach of early conceptual art exhibitions with titles such as 'information' (1970) or 'software' (1971) and the work of today's artist programmers.[34] Besides his efforts involving the construction of walks from computer code to 'program a pedestrian computer', Wilfried Houjebek is also developing code, a mark-up language that is based on the pedestrian's experiences. This code is called PML: Pedestrian Markup Language. He has also developed something called OOP, Object Oriented Psychogeography, which he calls 'software for landscapes' that 'will crash your sneakers'.

Software Art: I/O/D

Works of art at the level of a more 'traditional', functional software application, are also diverse. The rise in software art practice was provoked by a work called *Webstalker*, a Web browser by the British art collective I/O/D, of which theorist and software art critic Matthew Fuller was part. *Webstalker* was essentially a criticism of the software industry, and of the production and design of browsers in particular. The I/O/D website is one of a few art sites that has survived the turn of the century. The artists at this site note: 'Software is mind control. Get some.'[35]

However, *Webstalker* is not just any old alternative browser; it completely ignores the tyranny of print layout that has so obviously dominated the development of the browser thus far. Instead, I/O/D

chose to have their browser focus on coded content and links in and outside of a specific site itself. The user can choose which aspects of a site he or she can see. The result is a representation of the website as a local, variable structure within a vast network of connected but distinct other sites, visualized as fragile, moving universes or planetary systems floating in clouds of code. *Webstalker*, at the same time, manages to show the uniformity and the fragile (but still existing) individuality of websites, while they are stripped of most of its visually dominant characteristics.

The artists call it 'speculative software'. It provokes a different view of both software and the Net. I/O/D members Simon Pope and Matthew Fuller wrote in their essay 'WARNING! This Computer Has Multiple Personality Disorder':

> This virtual architectural space has been constructed by an unseen author, '[this author's] intention is usually to impose a closure to a narrative, to provide the goal to be reached by means of one of many approaches, the reader/user/participant/player, (choose according to theoretical preference) can wander, but must not stray from the intended thoroughfares.[36]

The artists refuse to accept the narrative enclosed in the representational software of the Web as a neutral or innocent application. Every piece of software contains a specific aesthetic and operability that I/O/D approaches as an executable practice to engage in intimate confrontation with.

The differences between *Webstalker* and early software-based works like Hans Haacke's *Visitor's Profile* are manifold. First of all, *Webstalker* resists standard usability and functionality. Content is displayed as HTML code, while visuals such as pictures have been removed. Surfing requires some effort. The displayed site resembles a blueprint rather than a document or a 'page'. Second, in relation to the first, the *Webstalker* is itself a work of art. It does not produce art, or take part in the process of an art work. It embodies this art as process. Third, *Webstalker* is available for free. The artists distribute it widely by allowing a free download from their site, which is announced through different media, in particular mailing lists. Last but not least, *Webstalker* is

a browser. This means it is much more than a calculator (the compiler in Haacke's *Visitor's Profile*); it is a medium. Browsers are media within the larger Net. Even if present-day browsers are multimedia constructions, carrying or needing various submedia or embedded software to display video, audio or other content, the browser itself acts more like a specific window onto 'the world', on (what its inventor Tim Berners Lee thought) the most 'user-friendly' part of the Internet. *Webstalker* was received with a bang because it was proof that, even on the Web, artists could maintain full control of their content and even get their hands dirty in the process.

'When programmers expose code's perverse possibilities,' write Joline Blais and Jon Ippolito, 'they stretch our minds to accommodate not just the box but what's outside of it as well.'[37] Art in the context of code can be at least as effective as literature or criticism. 'Computers are embodied culture, hardwired epistemology,' note I/O/D members Simon Pope and Matthew Fuller. Code and software can act as a profound, invasive, deconstructive or viral artistic method within this larger hybrid space.

Flow: Experiencing the Network as Physical Space

The use of the network as straightforward connective structure is an often forgotten but essential part of Internet cultures. Its presence is so basic and common that its role is 'backgrounded' in favour of much more unstable objects such as websites. Decentralized performance, real-time collaborations and remote action or network installations offer the strongest experience of the Internet as an actual physical network. Digital technologies have created the possibility to not only see or hear across long distances (as in the case of *television* or the *telephone*), but to actually interfere or act in a distant location. As the Finnish critic Erkii Huhtamo noted: 'We have entered the era of tele-proxemics.'[38] We are far, but also nearby.

The notion of *actio in distans*, an ancient philosophical problem concerning concrete action at a distance without direct physical interference, comes to mind in this context,[39] but we are now dealing with a very real and operational extension of our muscular system (to paraphrase Marshall McLuhan's theory of media as extensions of the nervous system). This is not to be confused with 'tele-presence', which

77

is a term used mostly in installations or events in which participants engage solely via screens and speakers, and which basically refers to different forms of teleconferencing. Tele-proxemics engages the participant more intimately. The interaction is more grounded and its experience more immersive. It requires more than merely talking back to a TV set. It is not a fully embodied involvement, addressing our full sensory spectrum, but an experience that requires a sensitivity of a different kind. American philosopher Jef Malpas notes: 'The Internet can give us no access to things at all except inasmuch as we already have access to what is closer to us.'[40] For Malpas, an engagement at a distance begins with an engagement in our immediate environment. For a meaningful situation to occur it needs to make *sense* close by. The involvement of a distant space or person in this experience will not have the same qualities as someone or something in the same room, but the way these distant actors seem to be close to each other can still result in a powerful experience. Malpas suggests:

> Within such a mediated form of access, we no longer need to engage with things in their full immediacy or with the full range of our perceptual and behavioral capacities – we can focus our attention on specific aspects of things as they relate to specific capacities of our own.

It is in this very intimate field of tension between human, environment and technology that decentralized performance and installations operate.

From mass events and stage performances to playful small, often single-user interactive installations, the works of art that could be classified as 'flow' are relatively rare. There are two reasons for this. The first is that these works need an open Internet connection, and, after a decade of intensive Internet (and security) development, art institutions are still reluctant to permit them. Even artist websites are often presented in offline variations. The other, more interesting reason for the relative scarcity of these works is the amount of engagement and social organization they often need in order to function well. Acting and engaging at a distance, in real time, in an art setting, requires a certain level of intimacy and real human interaction.

Here we see one relationship to earlier art forms like Fluxus (which coincidentally also happens to mean 'flow') or mail art, in which a deep engagement (among artists or between artist and audience) were important factors.[41] American historian Owen F. Smith describes this:

> As the focus of a work in Fluxus shifts from product to process and from producer to shared interaction among artist, performers, and audience, the result is a self-perpetuating process that emphasizes the *totality of materials and participants*, even though either or both may and do change. The resultant focus, based in a self-critical investigation of media, rejects media distinctions and posits a focus or core of activities that exists in the spaces between media (i.e., intermedia).[42]

A more recent and curious parallel connection can be found in the almost anti-medial art projects that have been described under the rubric 'Relational Aesthetics', in which the exclusion of (or disconnection from) media seems key, yet their logic remains. 'A work may operate like a relational device containing a certain degree of randomness, or a machine provoking and managing individual and group encounters,' writes French curator Nicholas Bourriaud about the works he classifies as 'Relational Aesthetics'.[43] The technological network in these works is present as a notable absence.

Since the level of engagement in the works involved depends on local and personal factors, it does not seem to be influenced by the actual distance that needs to be covered to reach another person or another space within the work. As we shall see, distances and real-time situations can also easily be faked, in which case the experience of flow is at the service of theatrical strategies or fictional characters. In any case, flow creates a specific spatial and concrete experience of a specific 'sphere', a quite clearly defined system or structure within the larger network. In the case of installations, the work exists in the Net almost like some architectural object. Its shape in the context of performance moves with the ebb and flow of the event. The durability of such a shape depends on the various layers within the work because it can start large and noisy, activity can go up and down, to ultimately end in the static screen of the work's webpage. There it remains as a mere

trace, or if we are lucky, as a document of the event that was created afterwards.

The poetic nature of real-time mediated art experiences is fragile. It has to compete for attention and understanding (in terms of interactivity and thus also in terms of interpretation) with its solid and less-demanding counterparts in art objects, from painting and sculpture, to film and video. Its shape is therefore most easily recognized through the 'hard' physical interface of an installation.

Flow in Installation: Paul Sermon, Atau Tanaka

If we look at a forerunner of flow and installations in the context of the Net, we see that the strength of the work is its straightforward and simple functionality. The satellite art work *Hole in Space* by Kit Galloway and Sherry Levine from 1980 connected the streets of New York and Los Angeles by projecting sound and video images of shopping pedestrians from one city to the other, and vice versa. The stable installation of a camera pointed at a sidewalk, and a projection in the shop window next to it of a similar scene in another American city, easily enables the audience to get involved. The work literally acts as a hole in space, a large tunnel in which overcoming the distance between the two coasts is almost instantaneous. People called friends or family members in the involved city to arrange 'meetings' in front of the cameras and screens. Conversations between perfect strangers about where they were, what they did and what the weather was like quickly emerged. The work is imbued with a powerful social energy.

Similarly, the installations *Telematic Dreaming* by Paul Sermon in 1993 and *Global String* by Atau Tanaka in 1999 consist of straightforward setups, this time connected via digital networks. Sermon's *Telematic Dreaming* reminds one of *Hole in Space*, but creates a more intimate audience experience by having the cameras and the projectors both aimed at two beds in two separate spaces. Each bed is covered with white sheets. A camera and a projector are hanging overhead, pointing down, and simultaneously converting the bed into a screen and movie set. One is invited to lie on the bed, as he or she waits for someone to join from the other side. The bed on the other side projects video images of the participant moving around. People gently explore the contours of the person projected next to them, or some barely dare to touch them.

Some kiss. Some mimic the movement of the other partner, 'merging' real and projected bodies. The projected body appears like a ghost or a fairytale image. '"Telematic Dreaming" raises and addresses many questions, but above all, it is the question of consciousness that interests me most,' Paul Sermon observed in a 1997 interview. 'The visual image of the bodily form on a bed allows the user's consciousness to race back and forth between the cause and effect of their remote and local body form.'[44]

For the artist, this installation does not come alive without a participating audience, yet, while I do agree that seeing the installation with someone in the bed on both ends is a very powerful image, *Telematic Dreaming* also works as an installation. The work is commonly presented with two beds in one location, always in separate rooms. The beds are positioned in the middle of dark rooms, and are lit only by the light of the projector from above. It is an eerie, magical scene. People come and go; sometimes the beds are filled with people, sometimes there is only one person, sometimes the bed is empty. The purpose or potential of the installation becomes clear quite quickly, which creates a certain tension around each empty bed, an invisible, 'magnetic' field that beckons you to get into the bed, or to withdraw even further away from it. *Telematic Dreaming* would even work as a non-interactive work: the beds, placed in two separate, adjoining rooms in a museum for example. It is an interactive installation that is powerful no matter how many people (or how few) actually get onto the beds. Like *Hole in Space*, it is a comment on human relationships in an unspoken, yet meaningful way. The installation, consisting of the situation at both locations *and* the connection between them, can stand on its own. Actually participating in the piece only makes it more compelling.

The latter can also be said about *Global String*, which makes explicit use of the Internet as a material structure. It is presented as a huge guitar string, of which only the two ends are visible and playable by the audience. In this installation, the illusion of distance and space does not arise from emphasizing some distant human presence. The illusion of space, of a great architecture, is created by a theatrical trick, namely the enlargement of its most important visual element, the 'string', which consists of a 50-foot-long, half-inch cable. It is played through a connection to a networked computer that recreates your touch on a

'virtual string' (via sound software), and sends it to the other location. But the 'instrument' has its own sound, comparable to a traditional, reverberating guitar, the tune of which depends on its body and condition. The digitally rendered sound is influenced by how data is specifically transferred over the Internet, always following the easiest, most available route, which is not necessarily a shortcut. Dutch designer and engineer Bert Bongers, who collaborated on the project, writes:

> The path that the data packages took over the Internet was constantly changing, and this influenced [the] parameters of the sound as well. In a way, it was as if the network became part of the 'resonating body' of the virtual string.[45]

Global String has a similar effect as *Telematic Dreaming* on the participating audience members because the installation rises far beyond the awkwardness of what is commonly understood as 'interfaces' in media art, and easily enters the personal sphere. Form and purpose are familiar and inviting. By drawing the senses nearer, the networked aspect of these installations can also make sense, and a feeling of teleproximity can emerge, enabling a spatial experience of the art work's shape or sphere in the network. Playing and hearing the string deepens this experience. However, interaction is not the work's strongest element by far. *Global String* could work completely on its own as a sculpture. The invitation to touch a musical instrument as big and impressive as this, with the ironic name *Global String* when it looks more like a ship's anchor cable, makes one feel like one of the Lilliputians in *Gulliver's Travels*. Looking up past the 'string' and hearing it resonate makes one wonder along which paths and for how long it will continue, and who or what is at the other end. Even without touching it or knowing its purpose the mysterious cable stretching between the floor and wall is a powerful sculptural object that stimulates wonder and speculation.

Flow and Performance

The strongest experience of flow is established through decentralized performances. The very intensely process- and time-based works in this area require a lot of preparation and social engagement for their *formation* to be realized. This is meant literally. Every work is the

formation of a temporary and highly unstable sphere, in which human and technological participants *form* a large construction. Its dispersed elements are strung together by the wires and wirelessness of the Net (these connections being active elements themselves), while triggering, activating and engaging each other. *Personal media* are an important factor in the development of the practices in this field. 'Personal media' is a term borrowed from the artist Graham Harwood, who uses it to describe any recording media (from scrapbook, to camera, sound recorder or cell phone) used by a private individual. In the context of new media networks, these personal media allow for a radical redevelopment of the open, socially eventful performance works of earlier art practices. They generally do not continue them explicitly or intentionally, but seem to connect to them in a mimetic way. In some important respects, they are unique to our time due to the 'nature' of the hybrid context they evolve in. Referring to the moment that the Internet entered the world of the arts (which is basically since its inception) American art historian Frank Popper observes: 'I call this event, so full of unaccustomed possibilities, neocommunicability. It was an event not only associated with radical technological changes ... but also with *an aesthetic change that concerned artistic intercommunication on a wider and more personal scale.*'[46]

Specific technologies do not serve as mere tools, nor are they technical supports or 'coincidental' media. (Net) art practice evolves in direct correlation to the media involved, and this aspect is felt most profoundly in online performance.

The intense mix of old and new performance strategies makes this a most interesting field. The practice of performance through the Net is indebted to theatre, film, radio art, guerrilla TV, and avant-garde and conceptual art movements. Social art works and collaborative performance have a long, medially complex history that dates back to the early twentieth century. Most predecessors of online performance involving different technologies and practices were already combining unscrupulously to enable novel and timely theatrical interventions or expressions. The Fluxus movement even named this combined space. Fluxus artist Ken Friedman describes how 'for a philosophy that denied the boundary between art and life, there could be no boundaries between art form and art form' either. Fluxus artist Dick Higgins coined the term 'intermedia' for how various media merge in these sorts of practices.

According to Friedman: 'The important distinction between intermedia and multimedia is the melding of aspects of different media into *one form*.'[47]

In online practices, this single form is the most stable, and is often described in terms of 'space'. The work of art resides in and between a temporary media construction and its respective nodes in the larger architecture of 'cyberspace' only for the duration of the performance. Ken Friedman called it 'the space of flows', after a quote by Spanish sociologist Manuel Castells.[48] British artist Roy Ascott called it a 'negotiable space'.[49] It is a space or sphere that creates a very balanced mesh of on- and offline networks. Spaces connect to a space connecting them to other spaces. An intermeshing of social and machinic elements form a volatile structure that 'pops' as soon as its individual elements are unplugged. In it, people and machines act and events evolve.

Performance before 1995: Adrian, Ascott, Station Rose

Early computer networks were not publicly accessible. They were in the hands of the government, universities and private companies. This meant that in order for art works in the context of these networks to reach any significant audiences they *had* to somehow be presented or performed outside of the purely technological network. These projects were not organized out of the blue. They were preceded by significant preparations in terms of social networks and theoretical exchanges, and were influenced by the varied practices and backgrounds of the individual artists involved. The works made during this period were part of a larger context of experimentation with different kinds of sociotechnological networks, as for example those of fax, telephone, radio and even television.[50] These experiments, in turn, were highly influenced by the work of earlier network artists, especially in terms of participatory models involving other artists and audiences, and in terms of alternative publication strategies and economic structures.[51] These would never have happened without the private initiative of the Canadian artists Norman White and Bill Bartlett, who were commissioned to create an art work on a private computer network, and there they recognized its potential. They organized long-term access for a group of artists 'worldwide'.[52] Another important influence in the development of online performance was the work of American artist Carl Loeffler, who

organized the 'Artists' Use of Telecommunications Conference' at the SFMOMA in 1980, an event in which many early experimenters took part, and which helped form an online performance knowledge base.[53]

Robert Adrian, living in Vienna at the time, describes how in 1970 the news about the possible use of the IP Sharp private global computer network for artists arrived via a postcard from Toronto because intercontinental phone calls were simply too expensive. After the artist mailbox on the Toronto server was installed, participation created a high level of energy among those involved. 'Over the past three years I have been interacting through my terminal with artists in Australia, Europe and North America once or twice a week through I.P. Sharp's ARTBOX [later known as ARTEX],' Roy Ascott wrote in 1984, 'I haven't come down from that high yet and frankly I don't expect to. Logging onto the network, sharing the exchange of ideas, propositions and sheer gossip is exhilarating. In fact it becomes totally compelling and addictive.'[54]

This energy is still almost palpable when one reads the documentation of the first projects realized via the IP Sharp network. The photos show artists and technicians working in rooms that resemble war rooms. Studios filled with all kinds of equipment and connections served as the stage for a decentralized performance in which the audience was very close to the action. Most of the people in the room took part in the project at hand.

Faxes, slow-scan TV images, radio signals, email and 'telephone music' all carried but also shaped the actual works of the different artists collaborating long distance. Robert Adrian's *The World in 24 Hours*, organized for the Ars Electronica festival of 1982, was a completely open work, in which artists of different backgrounds from 16 cities could add any content they wanted. The charged mix of artists and technologies created a temporary sphere that was bursting with spirit. Shared authorship was a key element in these events, and this element was also explicitly promoted by Roy Ascott in his work *La Plissure du Texte* for the Musee d'Art Moderne in Paris in 1983.

French philosopher Roland Barthes's book *La Plaisir du Texte* served as the inspiration for Ascott's work of art. Ascott was very charmed by Barthes's description of the joy of writing, but felt that something important was missing – the potential and power of collaborative writing

85

and distributed authorship he had come to know through ARTEX. By replacing Barthes's *plaisir* (pleasure) with *plissure* (pleating), Ascott added the element of movement and flexibility into the experience of text, a movement that allowed a kind of joy that was no longer, like Barthes' *solitaire* pleasure, but shared. However, working with text was not his first choice. It had more to do with the limited capacities of computer networks at the time. He points out that 'To apply telematic processes of distributed authorship to the generating of images is extremely expensive and virtually inaccessible for any sustained creative enterprise . . . When I first used text I saw it as a secondary medium.' This, however, changed when he saw text 'as it emerges, hot off the roll of a thermal printer, or especially inhabiting the electronic space of a VDU'.[55]

Ascott's words not only reveal the way he thinks or the way his work is influenced by the materials at hand, but both his approach and his terminology also reveal the changes (even obsolescence) of some aspects of the technologies involved. Communication technologies have evolved considerably since 1984. Much had changed in just the five years between Ascott's book and the performances by Austrian artists Eliza Rose and Gary Danner, better known as Station Rose. Numerous artist networks emerged after 1984 that used the newer network technology called the Bulletin Board System (BBS). BBS technology allowed anyone to set up a computer that people could dial into by telephone and that could function as a communal space for all kinds of exchanges, from mail to chats to gaming. Rose and Danner were, at that time, part of the WELL, an alternative BBS network that emerged in 1985 in California that (though it changed its technological basis) still serves as a meeting place to this very day for many well-known artists and writers. But another shift was right on the horizon. Station Rose calls its work 'new media arte povera' and the members based their performances on the emergence of the Internet in which they used the flow of incoming emails to trigger a stroboscope during a dance event.[56] This served as an important early example of a much more abstract form of participation between artists and audiences, an approach that would develop more fully after the emergence of the Web and the larger, more varied online communities.

Beyond the Bubble: Van Gogh TV

The boldest art project in the history of online performance, however, was undoubtedly *Piazza Virtuale* by Van Gogh TV (VGTV) for documenta IX in 1992. This amazing, almost megalomaniacal project combined all of the then-available media in an ebb and flow of activity that was broadcast via various media for 100 days. American curator Kathy Rae Huffman remembers the performance: 'I was fascinated with their group dynamics and with their ability to bring performance and television and this whole new network concept of Internet and chats and hackers and coding.'[57] Huffman travelled with VGTV's Mike Hentz to 13 European countries to invite local groups to collaborate in the project. Van Gogh TV was aired live on radio and TV (and, of course, online) in almost all of these countries. Internet access and computer literacy were still minimal back in the early 1990s, so that the audience (mostly via TV) was asked to participate through a specially designed interface that could be controlled by a telephone dial.

Piazza Virtuale was, however, not just a virtual meeting place, as the title may suggest. An important aspect of the work was that its head-quarters was in Kassel, where participants could simply walk in and participate physically, right there at the heart of documenta IX. The project consisted of so many layers and angles that it remains difficult to do it justice in a short description. In one sense, you could simply call it a media and participation 'orgy'. I remember seeing *Piazza Virtuale* live on Amsterdam's local television station, and what a unique thrill it was, exciting in a way that is somewhat comparable to seeing the moon landing with my family in my youth. Huffman describes what happens when she met other viewers years later: 'In some conversations, when I mentioned what my part had been, they [would] say: "Owhaaaaaaooooww, I remember watching that and jumping up and down and thinking: this is great! Calling everybody I knew and telling them about it..."' She went on, 'Nobody knows these things in the art world, but it must have been going on in various places.' Some were so inspired by this experience that they got involved in media art themselves.[58]

Compared to software art or other art media with its proceedings hidden in the depths of a computer, art works involving flow are quite transparent. This makes them more accessible to both passive and

active audiences. Even if the individual works involve various forms of interactivity, participation or even collaboration, this transparency enables a very close engagement with 'the machine'. These types of works remove 'the machine's' protective shell as it were, encouraging an uninhibited, sensitive and sensual involvement with the project. As in non-interactive art, different levels of engagement and understanding of a work exist, but in the context of flow, they have partly materialized. They can be felt and experienced clearly through the different technological and physical interactive possibilities with a work.

In the case of performance, the explicit creation of an open or inviting social space within the network also allows for the development of curiosity and learning among audience members. These spaces of deep interpretation can then begin functioning as educational or instructive environments as well. In the context of art and new media technologies, this aspect is especially beneficial, since art education in this area is lacking, or at best lagging considerably behind contemporary art practice.

Flow in Performance 1995-2000: Fakeshop, Helen Thorington, Debra Solomon

Performance practices and technologies continued to develop at a similar pace over the past 20 years. Real-time video connections and other moving image technologies were added to audio and text messaging (chat) while a new form of online performance art began to emerge. The World Wide Web added a new layer of online experiences and larger, more diverse audiences began being accessed. I need to discuss the technologies involved to explain how this occurred. Two specific 'streaming' or moving image softwares each demanded their own unique audience involvement: VRML (Virtual Reality Markup Language) and teleconferencing software like CUseeme (pronounced 'see you see me'). CUseeme combines instant messaging (chat) and video transmission, and is used for Internet teleconferencing setups. It does not use the Web in any way. VRML was the first three-dimensional environment developed especially for the Web and is generally more refined than Second Life, for example.

The New York-based art collective Fakeshop started doing performances involving teleconferencing tools in 1994. '[What was] important

to the group from the beginning was the transfer of experiential information being collected at the site of production, (namely 'site specific' installation environments), to a remote receiving, or reciprocally retransmitting, audience or collaborational link,' Fakeshop's Jeff Gompertz pointed out in a 1997 interview.[59] Fakeshop's early performances consisted of restaged scenes from films. American artist Ricardo Dominguez, who sometimes collaborated with Fakeshop, called their work *tableaux vivants* that are 'interstaged between several digital platforms – networked actors, CUseeme, synchronous chat, real audio/video, HTML and javascript-based presentations – within a massive old bunker that serves as the off-line staging area. Each platform reiterates the moment that is looping between the various staging zones.'[60] He recalls how, during this performance, accidental 'viewers' would drop in and out, while actors far away would take part in the online dialogue by sending text messages or images. Fakeshop performances had the visual power of (cult) movies and the thrill one might experience at a live event.

At some point, Fakeshop also began collaborating with the American writer, artist and curator Helen Thorington, composer Jesse Gilbert and architect Marek Walczak in a decentralized performance called *Adrift*. This complex, evolving piece was performed on several occasions between 1997 and 2002. I saw Thorington create the text for this piece live on stage during the Recycling the Future conference at ORF Kunstradio, while Gilbert added sound and Walczak orchestrated the spatial dimensions of the work. *Adrift* was created in a VRML environment, in which ethereal sounds accompanied abstract dreamy moving images. Its story centred on a fictional harbour city. There was no audience participation but audience members were able to witness the unfolding of a life in a virtual world. It felt a little like being in a giant zoo aquarium, or watching the crew from the *Star Trek Enterprise* make their way through the galaxy.

A very different and more intimate teleconferencing performance was 1998's *The_Living* by Dutch-American artist Debra Solomon. Solomon used CUseeme for this project, in which numerous small windows on a screen reveal the various participants involved, while a shared chat window enables conversations among them. The artist took part in the video chat sessions, but she replaced the webcam feed with

a video camera and showed prerecorded videos of herself typing away at her keyboard under impossible circumstances, replacing the reality of a standard webcam interface with the fiction of a pre-recorded video. Solomon took part in the live chat sessions. The replaced webcam feed, however, showed Solomon riding a bicycle, steering her boat through one of Amsterdam's canals, climbing a tree or even swimming under water in a pool with her keyboard wrapped in a thin plastic bag.

The_Living was an ironic commentary on the IT industry's unrealistic claims of their products. At the same time, it represented the transformation of the artist into a sort of superwoman. The_Living involved a mythical figure with superhuman abilities, who could use her computer in ways nobody else could. The artist was referring to a future in which the Net became ubiquitous, and where using the Internet outside of one's home was facilitated through wireless networks. This was a future that Solomon was already playing with over ten years ago. Her activities are prescient, and her fellow chatters openly envied her for it. Solomon performed in two worlds: the chat room she was in, and the actual stage she presented her work on.

Flow in Performance 2000-2010: Eva and Franco Mattes, Michael Mandiberg, Constant Dullaart

The last major amendment to the online, real-time performance world is no doubt the introduction of Web 2.0 applications.[61] Second Life in particular is a platform that encourages all kinds of experimentation. Second Life (SL) performances differ from earlier online performances in that there is no connection to an offline stage or performance. The screen is the stage and the space of engagement. The only way to witness performances here is by entering the space itself as an avatar.

The Italian net artists Eva and Franco Mattes used SL in 2007 to re-enact well-known performance art works such as Imponderabilia by Ulay and Ambramovic. This is a work where the artists stood naked on either side of a doorway while the audience had to figure out a way through the doorway. Franco Mattes declared: 'Eva and I hate performance art … We wanted to know what made it interesting, and reenacting these performances was the best way to find out.' Italian critic Dominique Quaranta has described how re-enacting typical 1960s and 1970s performance works in the SL environment alters the work radically: 'The

original energy of the performance, and its power to provoke, dissipates, or turns into something completely different.'[62]

The artists chose works they considered 'paradoxical' when performed in a virtual world. Not only is there no physical body to touch in SL, the image of a naked SL body doesn't have anywhere near the same impact that it does in a physical public space. In effect, they had replaced the uneasy sensuality of the original performance with the awkward synthetic sensuality of Second Life.

Meanwhile, the American artist Michael Mandiberg has created a number of highly interdisciplinary works in the context of the Net, many of which occur on the edge of performance and conceptual art. Mandiberg's 'performance' works tend to be strongly autobiographical, which makes them very vulnerable and delicate. The artist manages to create poetic spaces by using specific materials or tools to enhance his ability to tell a story. He employed the e-commerce strategy of an online store to sell his 'identity', by offering not only all of his possessions, but also his time up for sale in 2001. In 2005, Mandiberg used the capacities of a specific cell-phone subscription with free, unlimited use of in-network calling (more phones in one subscription package) to create a work about long-distance relationships together with his partner at the time, Julia Steinmetz. He recorded the endless, very intimate conversations between him and his lover, and put them online in blog format, as well as including occasional text messages. *The IN-Network* is a work created for the collection of the Turbulence net art institute in New York. This work was not that much about 'flow', although his later work, *31 Acts* is. This collaboration with American artist, curator and critic Marisa Olson was a live 'transmission' of Olson's dissertation on 'the art of protest in network culture',[63] which focused on artists utilizing various surveillance technologies. Webcam images and screen images from Olson's computer were uploaded to a website for an entire month, allowing anybody to monitor Olson's movements.

While Mandiberg's work with Steinmetz called *The IN-Network* is full of tenderness, despite its formal presentation, *31 Acts* revealed a different side of relationships: one that involves humour and teasing but, at the same time, the seriousness of Olson's work gave it a sharp edge. Audiences were able to witness how one partner controls and monitors the work of the other for an entire month. Mandiberg, in an

email interview I did, explains how he works with 'endurance, life-as-art, and simple gestures repeated over time'. The artist is strongly influenced by performance artists from the 1960s and 1970s, and translates their strategies to new network environments. 'Fixed durations are really important to me: counting, and counting-down,' writes Mandiberg. 'Like the way Vito Acconci counted the number of times he can step up on a stool, and tracks it over time. Or the way that Sophie Calle took on the instructions from Paul Auster.'[64]

Dutch artist Constant Dullaart engages in what one could call a ruthless but casual exploration of shared properties of different contexts and media. His *DVD Screensaver Performance* shows the artist physically performing the well-known standard DVD screen, which appears whenever a DVD player has no content to display. Dullaart performs it live as well as on video. The video version fits perfectly into the countless 'amateur' re-enactments and personal videos on public channels like Youtube. It is brilliant in its stupid simplicity. Dullaart has made numerous Youtube works, of which the most impressive is a sculptural interpretation of the buffering icon, a work with the profane title *Youtube as a sculpture*. This work fits in perfectly with my examples of the realized screen, which I describe later on. In the context of flow, Dullaart uses existing live performances of paid porn and 'sex camming' websites to create estranging live situations involving himself or the audience where the work is presented. The artist logs on to a paid live sex site, pays a fee, but ignores the standard interaction (masturbating in front of the webcam while watching others having sex or masturbating) by doing his *DVD Screensaver Performance* live on the webcam.

In another version of this performance Dullaart created an installation of two laptops, where two cameras were aimed at the opposing laptops to create the illusion of standard live sex interactions between two different websites. The artist had logged into two sites, had paid the fee, but let one male and one female performer on the two sites interact with one another. After about five or ten minutes, the artist turned both cameras towards the audience in the room, creating an awkward moment for both the audience and the live sex performers. After a moment of hesitation, the performers continued with their work. Dullaart shows how exhibitionism and voyeurism have both become almost meaningless everyday practices.

Screen: Visual Thinking

There is no such thing as a solid, simple screen. The straightforward, in-your-face visibility of screen-based works is preceded and supported by hidden processes and complex production systems. Facile, simplistic comparisons between painting, photography, film, television and the computer screen, in which a flat surface is the most important commonality, ignore the sophisticated practice of the artist within each specific practice and her dialogue with its materiality and context. The different levels inside the computer and the network are practically all visible on the screen (or can be made so), but not all of them depend on the presence of a screen to exist, and certainly not all new media art works deal with the screen itself. A visualization of 'screenic' worlds does not always need the support of an obvious, traditional interface. Screen-based net art is popular among art curators and traditional art audiences, though, largely because these works take relatively little technical effort to display and are (sometimes deceivingly) easy to interpret. Such works are also easily transferred to video or film, so they can be viewed without any interactive component. In this process, important elements of the work can get lost.

Not unlike the diverse application of other 'screen-based' media, painting included, there is a large variety of artistic approaches to the visual in net art. Most of these have very clear roots in photography, film, collage, painting, games and even design. Russian-American theorist Lev Manovich speaks of three kinds of screens: the classical screen, the dynamic screen (including the vanished screen, which I would have categorized separately) and the real-time screen. The first frames a window between two distinct 'worlds' like in painting, the second displays a moving image like a film (where the vanished screen then is a Virtual Reality (VR) screen in which the viewer is immersed in a scene, rather than watching it through a window from a seat). The third screen shows events and movements as they occur, such as radar or television. Film and video still work with a sequence of pictures that, when displayed in succession at high speed, simulate movement. The real-time screen is technologically 'displayed' like sound. 'Different parts of the image correspond to different moments in time,' writes Manovich. 'What this means is that the image, in the traditional sense, no longer exists!'[65]

93

Before we actually look at net art, I would like to introduce some terms that will create a stronger image of what the screen can be, or how it comes alive. The interactive screen, which Manovich calls a subtype of the real-time screen, comes in different forms. I also need to introduce another type of screen: *the realized screen*. It has largely developed since the publication of Manovich's book. This is a screen that has also vanished, but without the use of Virtual Reality. It develops or manifests itself in real time. One could call it a mild perversion of Rudolf Arnheim's notion of 'visual concepts': the eye does not recognize shapes before the brain does, but conceptual visualizations trick the eye into seeing a new reality.[66] Much like the use of code as language (for instance Mary Ann Breeze's work) or code performance (Wilfried Houjebek's *.walk*) the screen starts to merge with the environment. Works of art created using GPS systems, for instance, remind one very much of land art (as well as the *dérive* as found in psychogeography). Despite Manovich's statement that 'we still have not left the era of the screen'[67] we have definitely started to slip away from it, in a way that is almost undetectable to the camera's eye.

The realized screen can evolve in more than one way. Next to its realization in space through GPS technologies it can also be based on older screen forms (which are, as Manovich also explains, inherent to any newer forms), whereby the artist more or less ignores or erases the boundaries of the classic and dynamic screen. The computer screen and specifically its incessant collaging of different software windows can be perceived as an almost architectural structure to be deconstructed and used in sculptural works. These merge with the space and time of the viewer, and are experiential as well as visible. However, in some cases, the screen is used for a representation of space and location in cyberspace alone, and the browser acts almost like a kind of radar. The old dynamic screen also continues to rear its head: in the Net it presents itself as *the closed screen*, in which navigation and hypertext linking returns to the bare minimum of one click per go. It is mirrored by its opposite: *the labyrinthic screen*. This recreates the screen as a dizzying, multilayered space, like some malfunctioning printer's skewed copies of Escher's drawings in a deformed, collapsed three-dimensional image.

The Closed Screen: Young-Hae Chang Heavy Industries

The image in net art always depends on the existence of a form of interactivity. Sometimes the interaction is reduced to almost nil, as in the flash movies by the Korean-Australian artist duo Young-Hae Chang Heavy Industries, for example. These films (that is what they are, after all) require nothing more than a simple click to start the film, like the switch on a projector. The unusually bold design of the films, in which black-and-white texts flash by while loud music thunders along at every turn of the 'page', has managed to draw a lot of online fans. What is interesting is that these works are incredibly easy to transfer to video or film, but they still work best and have the most psychological impact on a simple desktop or laptop computer screen.

Young-Hae Chang Heavy Industries' strength lies in their use of an extremely pushy visual language, a radical aesthetic that is very unusual for the realm of common website design, home computing or office work, but not film or video. Because of its appearance on a regular computer screen at home or in an office, it looks like the machine has gone out of control. The rapidly flashing texts are experienced as a manic automatic navigation between web pages. Each 'slide' is actually just part of an animation sequence, and no individual user would ever click through webpages as fast and with this particular rhythm (to the beat of the music) as these Flash movies. It creates a feeling of alienation, and of being overpowered and shut out from one's own computer. So they are truly made to be experienced this way, and one could practically say this makes them 'Internet specific'. Works like this are almost literally about capturing an audience. Even upfront screen-based net art works such as these are about creating spaces of engagement, which, in this case, involves an *obstruction* of the freedom of movement.

The Labyrinthian Screen: Jodi

Jodi, whom we discussed earlier, walks a thin line between the empowerment and the overpowering of an audience. Jodi's visual language is often abstract to the extreme. If it isn't, it is absurd, like in Jodi's appropriation of racing games in which cars slip endlessly into appropriated snippets of actual race games. The cars become pencils that make circular drawings on 'virtual' pavement, or in 'virtual' air. Jodi's work is a product of the relentless search for bugs and design

deviations, which the artists see as essential to understanding and working with new media. Bugs, design flaws and maybe even a 'design surplus' (irrelevant, superfluous design) for Jodi reveal the true 'nature' of digital media. Through the artists' use of special browser features, like the 'blinking' of design elements of layered web pages, they create a navigable mixture of collage, concrete poetry, video art and cyberpop visuals (as in games) in bright blocks of colour. Their images are not flat, but somehow 'tilted' in that they layer, enter and cross each other. The image continues in another shape, another page, on another level of the Web interface. The screen opens up into a three-dimensional space that slips from the viewers' grasp with every click, only to reappear in a different configuration.

Jodi is an adamant defender of the idea that the Internet is the only true context for the presentation of art created for the Web. They were not at all pleased when their website was exhibited offline at documenta X. *Jodi map*, one of their oldest, simplest and most beautiful works from 1996, is an example of how they contextualize their own work.[68] *Jodi map* consists of a copy of a schematic drawing of the early Internet, on which the names of corporations and institutions have been replaced by those of (mostly artist) websites they liked. The image is much bigger than the screen, forcing the viewer to scroll and physically navigate the page, which creates the illusion of a vast, impressive space. The page is black, thus emphasizing a sense of space and mimicking an old computer. The map lines and texts are green. *Jodi map* served as a navigational tool for many early Internet art followers in the mid 1996s, when there were still only a few art portals.

The Realized Screen: Olia Lialina, Jan Robert Leegte

The work of Russian artist Olia Lialina is among the earliest examples of something she calls 'net film' or cinematic experiments with the Internet. Lialina was originally a film critic from Moscow who discovered the Internet as a platform in 1996. She was a strong advocate of the political dimension of net art, specifically its democratizing and anticommercial aspects. She, however, was also adamant about developing an Internet specific aesthetic, a 'net language'. From 1996 to 2006, her work developed an archiving function of mostly amateur web design, because this has hardly been documented, yet is influential and reveals

the nature of the Web. Lialina was stimulated by her own work as an artist in which every element of the computer and the Internet counts, and she tries to teach the audience more appropriate ways of 'seeing' net art works.

One of her early works, *Agatha Appears*[69] from 1997, tells the love story between a systems administrator and Agatha, a woman from a small village. Agatha gets uploaded, or 'teleported' to the Internet. Soon she begins literally hopping from server to server, as is (or was, since the work has not been preserved very well, like many online art works) visible in the address bar. This made the address bar (which shows the URL of a web page) an essential element of the work. In the story, at some point, the administrator says to Agatha: 'Internet is not computers, applications, scripts ... It's not a technology but a new world. New world, new philosophy, new way of thinking. To understand the net u must be inside ...'

Her use of the address bar was Olia Lialina's protest against the use of a new feature that was added to browsers in 1998, which allowed web designers to embed content from other sites into frames that did not reveal their original source or location. This design feature is typical of commercial web design and allows websites to make links open under their own address, in an internal webpage window, in order not to lose a potential customer. For artists, this is like their work is being hijacked. It is one of those many moments when art and commercial software design (especially that of the browser) have clashed. By using the address bar as a sort of radar for the Web, Lialina has managed to ground the Web, thus emphasizing its physicality. Web content does not appear out of nowhere, it originates at a specific location, where it was created from a specific combination of human and machinic elements and interactions. She has here re-realized the reality of – and behind – Web content.

Many artists who use the Internet have studied traditional art disciplines. They see the Internet as an opportunity to redevelop their work, or to explore a new material language. Amsterdam-based artist Jan Robert Leegte made an interesting semi-turn from being a trained sculptor to using web-design features, first as sculptural elements online, and then reconstructing and using these same features in the 'real world'. Leegte observed in an interview:

The Net is a highly impatient, click-based environment. Visitors would sometimes interpret my work as an intentional aggravation for the user, a form of crash-art, or even subversive. I decided that it was the effect of the medium Internet that created these unintended connotations. Shifting back to 'real' space was a very effective way of dispensing with this problem.[70]

Leegte's work is not a showy re- or de-location of online art strategies, but is deliberately understated and highly conceptual. Its subtle reshaping of spaces is at times quite funny. Jan Robert Leegte is particularly fascinated by the simplest elements of web design. He likes their shape and their sturdy continuity, which survived numerous software upgrades. He leaves them in black-and-white, and in shades of grey, a reference to the historicity of digital design. His series of moving scroll bars and digital ornaments, produced as floor sculptures and fitted projections on walls, ceilings and doors, offer a subtle yet powerful commentary on postmodern and theoretical media reflections on the concept of reality. Walking into a gallery where one of Leegte's works is displayed always evokes faint echoes of *The Matrix* in my mind. There are no flashy animations or slick transitions between reality and virtual reality here, however. This is the matrix as it truly is: present but largely invisible, of doubtful functionality, forever awaiting 'Neo', waiting for (but deaf and oblivious to) instruction.

The Semi-Realized Screen:[71] *Sander Veenhof and Mark Skwarek*

The past decade has seen a revival of psychogeography, a radical practice developed by the Lettrists in the 1950s in which art and the city 'merged'. This avant-garde approach to the city was first introduced by the situationists, of which Lettrist-member Guy Debord was also a member, as a form of cultural criticism that addressed the increased experience of the urban environment as pacifying 'spectacle'. The development of the Global Positioning System (GPS) and smartphones has inspired artists to use these technologies in unforeseen, almost anti-functional ways, leading to another revival of psychogeography.

Dutch artist Sander Veenhof, Jan Robert Leegte's former student, is intrigued by simulated worlds like Second Life or the smartphone application called Augmented Reality. The latter allows the smartphone

user to see her physical environment and a 'virtual' shape designed to 'stand' in this space (held in place by GPS technology) at the same time. Veenhof has been deeply affected by what British theorist Adrian Mackenzie would call a feeling of 'wirelessness': the sense that all is connected through 'routers, smart phones, netbooks, cities, towers, Guangzhou workshops, service agreements, toys, and states'.[72] Sander Veenhof lives at an intersection of various worlds, and perceives the urban environment from this skewed perspective. Veenhof, in the 'Augmented Reality Art Invasion' press release, notes how 'easy-to-use AR tools such as the Layar AR viewer have led to an explosion of virtual creativity in our public physical space. *Every major city square now hosts numerous virtual sculptures*'.[73] Mackenzie calls this development a state of 'overflow' where different gadgets blur the outlines of what wireless networks were supposed to do.

By using the same technique to create 'virtual' layers that engage with existing *cultural* rather than architectural structures, Sander Veenhof and his collaborator Mark Skwarek took AR to a whole new level. Artist applications of AR, such as, for instance, Juan Oliver and Damian Stewart's *The Artvertiser* include the replacement of commercial billboards by alternative art images.[74] Veenhof and Skwarek, however, went straight to the lion's den, and used AR to invade New York's MOMA. As Mackenzie suggested in a lecture about wirelessness at the University of Amsterdam, the artists use their tools' 'spatial potential to cross borders, both physical and legal'. Veenhof and Skwarek seem very aware of this aspect. In fact, the project was inspired by Veenhof's own joke where he posted a manipulated photo of a sign in the MOMA lobby that read: 'No Augmented Reality Allowed Beyond This Point.'

Veenhof and Skwarek not only added their own 'art' to the museum, but also placed an open call for art works on various sites. The American author and *Wired* columnist Bruce Sterling, himself a radical augmenter of reality, opened the exhibition as seen 'standing' in the lobby via Augmented Reality of a smartphone screen. In her book on the new implementations of Situationist strategies, British philosopher Sadie Plant writes:

As a means of showing the concealed potential of experimentation, pleasure, and play in everyday life, the Situationists considered a

little chaos to be a valuable means to exposing the way in which the experiences made possible by capitalist production could be appropriated within a new enabling system of social relations.'[75]

Veenhof and Skwarek's 'Augmented Reality Art Invasion' shows that a potential for meaningful interactive networks is still here, even (or maybe exactly) in the common world of hypergadgets. There is also a fertile latent chaos, an environment craving for *détournement.*

Matter: The Body of the Computer

It is at the design intersection of hardware and the body that new media technologies are most obviously problematic. Hardware is not just the outer shell covering an obscure or complex digital structure; it is also the surface at which we are forced to interact with this inner world. As such, hardware is a site of desire and angst. It is where human and machinic skins meet. Physical traits are projected onto the machine. For instance, when it stops functioning, it 'dies'; one can put a computer to 'sleep'. A slick hardware design can be 'sexy'. At the same time, the stubborn and awkward functionality of hardware (which often stands in stark contrast to its idealized qualities) is the most commonly mentioned reason for art curators and institutions to shy away from the presentation of new media art works in their exhibitions. This seems largely a faulty interpretation issue, however. In these cases it is wrongly assumed that traditional hardware installations are an essential element of all new media works.

Domenico Quaranta explains that the problems surrounding the presentation of net art at exhibitions are a result of a misinterpretation of the works in question, and further believes they are caused by the active intervention of curators who then reshape these works:

> The curator's priorities are as follows: to transform the work into an object, whatever that might be; to bring technology into the exhibition venue and display it as if it were a key element of the work, and [as if audiences need] to be familiar with technology. As a consequence, curators do little more than complain about the fact that exhibition venues are not suitable containers for New Media Art; that New Media Art cannot be stored or commercialized; that

people don't 'get' it, and that the art system is not interested. Rarely, however, do they get round to thinking that this is largely due to their own inability.[76]

This tendency to mistake the machine for the work of art confirms the powerful image of the computer as an object. Since hardware can so obviously easily be both object and interface, matter and medium, it is also this aspect of new media technology that most effortlessly 'speaks for itself'. The computer as thing is iconic.

More visible than its software, the computer as object has gone through a clear and unmistakable evolution. Its appearance through history tells tales about the development of materials and technology, but also of the economical and social maturation of electronic media in general. The appearance of a computer in a specific film scene, for example, easily betrays the status and time of the people engaging with it. While the design of a computer is almost entirely industrially de-fined (hardware modifications by the public are still rare), the historical production of hardware design provides a wealth of signifiers and pos-sible symbolic applications, despite its mass-produced forms. Here we need to look beyond the cliché. The use of retro software and old com-puters is not always a nostalgic gesture, as much as using the newest technology need not always be a sign of technofetishism. The imple-mentation of specific pieces of hardware is a code, much like fashion is a code, a language of wearable signs.

Hardware design has long been dominated by office and business design. A standard computer is grey, or, slightly classier, black. Computers were literally serious business. Their cost kept them far from the general public's reach for a long time, and thus they did not need to compete visually in a less predictable consumer market. Most PCs are still grey or black, with a hint of silver, today, as if to reflect their alleged compatibility and flexibility on their surface. This is why old game computers and historical Apple Macintosh models are popu-lar in retro-computer cultures: they offer a clear and easy language of signs to work with. These machines were already design statements when they were launched. The dullness and mediocrity of standard computer design is, however, symbolic in itself, and its plain vulgarity

is used to emphasize the incongruities and dirt of the digital revolution.

Both curators and artists use a particular piece of hardware because of its appearance, while also paying close attention to its placement. Since documenta X (dX) in 1997, the first major art exhibition to show net art in which the art works were presented offline in an office-like setting, there have been countless experiments with ways of exhibiting this type of work. This resulted – as it did at dX – in both conscious and accidental play with the symbolic aspects of hardware. The exhibition setup at dX, in which the artists had little or no say, provoked feelings of estrangement.[77] The curator revealed a very traditional view of computers and computer cultures by presenting the art in an office setting, thus associating it with the common dreariness of an office. This was emphasized by taking the works of art off the Internet, which underlined the restrictions experienced 'on the job' at the average office. However, the computer's body first of all speaks for itself, as dead matter and intricate technological history, from which social and cultural contexts reach into the past, present and future.

Discarded Matter: James Wallbank and Peter Luining

At the 1999 'Net_Condition' show at the ZKM (Zentrum für Kunst und Medien) Karlsruhe, the first major net art-only exhibition, some 69 works were exhibited and revealed the diversity of net art through its large variety. Even if there was also this ordinary row of computers in the exhibition, the computer was mostly not used as a sign or symbolic object. However, in one of the most visually stunning installations it was. UK-based Redundant Technology Initiative's *lowtech.org* consisted of a high wall of old computers that stood in the middle of the large exhibition hall, dividing it in two. Here, obsolete, old computers were used as a symbol of electronic waste and political media failures. *Lowtech. org*, which is the Redundant Technology Initiative's Web address, was founded by the British artist activist James Wallbank. Like many other artist media initiatives in the context of net art, this project hovers somewhere between activism, community project and social art work. Wallbank's project was one of many artist initiatives that have made the crossover from 'real' space to the Internet and it operates in both. He actually runs a similar, newer project in Sheffield today, called *Access Space*.

Media (art) activism is mostly about the democratizing of media access. The recycled computer has become a representation of this effort. Even if its appearance is exactly the same, one could say that the recycled computer symbolically opposes the office computer. It symbolizes not only a resistance to consumerist technocultures, but also a resistance to a highly limiting relationship between the individual and the information society. The recycled computer (like almost the entire, largely tax-free, DIY-driven second-hand economy), breaks away from market controls, from the bond between industry and authority. This makes it almost pure, recomposable matter.

Of course, the recycled computer has its cultural and technological origins in the discarded computer. The computer as waste is one of the most powerful and tragic symbols of a problematic 'knowledge economy'. Whereas most art projects dealing with computer waste focus on recycling and re-appropriation, Dutch artist Peter Luining chooses a mere reflective approach. The artist started walking around the city for hours each day, after he discovered he was in bad physical condition from sitting behind a computer basically every day for ten years. His *Obsolete Hardware Walks* is a series of photographs of computer waste that Luining took while walking the streets of Amsterdam. The photos show all kinds of hardware, in various combinations, on the sidewalk, next to dumpsters, bins and grey trash bags. He initially published these photos on his art blog, but he also began physically exhibiting them, sometimes together with video documentation of second-hand computer fairs.

They don't just document the immensity of the electronic waste problem, however. For this photography project, Peter Luining was highly influenced by the photography of the German artists Bernd and Hilla Becher, who became known for their series of black-and-white photos of old industrial sites, water towers and farm houses. Luining rearranges the many discarded monitors as if they were architectural sites: he places the monitors face down on the pavement, while their uniform gray casings, revealing only minor design differences, rise up like modern buildings.[78] Luining's photos are aesthetically eerie, evoking a feeling of melancholy as one computer screen after another lies 'face down' and is lost along some curb or next to a lonely trash bin. There we have the symbol of progress and communication, its cables cut or missing, its greyness almost blending with the colour of the curb.

103

Hardware as Interface: Micz Flor and Florian Clauss, Alexei Shulgin, Stahl Stenslie and Kirk Woolford

In 1996, the German artists and designers Micz Flor and Florian Claus created a conceptual and ironic work called *Cyber Tattoo*. They were also involved in the early experimental web television and radio project *Convex TV*. Flor was fascinated by the references to travel and exploration in Internet software design, which was especially obvious in the icons used by the most important web browsers at that time: Netscape and Explorer. These historical icons respectively showed a shower of stars and a ship's wheel. Ironically, to extend the nautical metaphors of surfing and navigation in web design, they contemplated developing a tattoo machine based on an inkjet printer, which would recreate the experience of a sailor getting a tattoo in every harbour. Besides this humoristic, literal, rather romantic idea, the work also had a grimmer undertone. The machine as tattooist also reminds one of Nazi prison camps. The notion of human skin treated as printer paper evokes nightmares of being mangled by a machine, even by technology itself. By elaborating on the lyrical language of new media industries, its exaggerated promises of motionless travel are revealed as dehumanized, desensitized experiences that barely live up to their promises.

Russian artist Alexei Shulgin created a similar project in 1999. *FuckU-FuckMe* was, like *Cyber Tattoo*, a concept for a hardware interface, which would facilitate direct sexual intercourse with a computer. It is a commentary on the language of desire in software and IT promotional texts and their often exaggerated and unrealistic claims. The project has a rather strange, banal and 'in-your-face' pornographic meets 'user manual' aesthetic. The product supposedly consisted of a male and a female hardware application, which one could slot into the front of the computer's hard drive.

It reminds me of an earlier project from 1993 by two artists, the Norwegian Stahl Stenslie and the American Kirk Woolford, called *CyberSM*. This consisted of two suits that could be connected to the Internet, in which the users could 'stimulate' each other by sending electric shocks to the body of their 'sex' partner. This tongue-in-cheek commentary on porn and unbelievable Internet hypes was first presented in a decentralized performance somewhere between Paris and Cologne, and even featured on a French television show hosted by Jean Paul Gaultier.

Sensitive Matter: Biotech: Critical Art Ensemble, Oron Catts

The Internet is an important catalyst for the dissemination of knowledge and the stimulation of critical reflection on specific scientific topics. There is a strong parallel between the information sciences, the information economy and recent developments in biology, physics, medicine, and other 'hard' sciences. This parallel is embodied in copyrights or patents where one sees the privatization of newly reshaped or newly discovered bits of knowledge. This problematic aspect of our information economy is particularly urgent in the life sciences and biology, as it affects the body directly. There is a critical overlap between the philosophy and technical aspects of the life sciences, communication technologies and media politics.

In this realm, the physical world, including the body, is divided and mapped anew. It is redefined as a cluster of organs, fluids, particles, cells, molecules, genes, and bits. Debates about crucial aspects of the life sciences in particular are almost exclusively academic, corporate or institutional, while many in the public arena considering these issues feel that they are steeped in myth and mystery. Any material engagement with life science issues may easily lead to confrontations, hysteria or dubious legal actions. Thus, any artistic experimentation with 'new', reshaped, renamed or rearranged materials (for instance plant genes or body cells) is sensitive, and is often met with great suspicion, not unlike that which hackers and other critical actors in the context of new technologies experience.

The American artist collective Critical Art Ensemble (CAE) were early explorers of the relationship between information politics and life sciences. Their art is a mixture of theatre, performance and installation, but they also engage in political action and critical theory. The work of this artist collective is a balanced merging of actual and fictional structures. CAE's exploration of biotech started in 1997, when they created *The Flesh Machine*, a performance project in which the artists acted like a biotech company searching for 'suitable' donors. The emphasis was on the silent politics inherent to many biotech programmes. Since then, CAE have created eight biotech projects with various collaborators, including, for example *Molecular Invasion* (2002-2004) with Claire Pentecost and Beatriz Da Costa, and *Marching Plague* (2005-2007). Regarding the latter, the CAE declared: 'We believe that biowarfare "preparedness" is

a euphemism for biowartech development and the militarization of the public sphere.'[79] *Marching Plague* openly questions the US government's anti-terrorist programmes. The project was probably inspired by the intense investigation and long drawn-out legal proceedings (2004-2008) brought against CAE's Steve Kurtz for allegedly engaging in bioterrorism. CAE's work extends far beyond the traditional realm of art and involves the sociopolitical domain and its physical foundation as elements within their work, which are addressed and represented through videos, installations and performances that delve deep into the social fabric, as the legal case against Kurtz seems to confirm. CAE's biotech projects range from hands-on education about genetic research to enabling public intervention in various biotech projects, and further involve strategies not yet recognized as artistic practices.

The work of Australian artist Oron Catts similarly extends into unfamiliar territories. Catts creates sculptures out of living animal and human tissues. He works with the same materials that are used in iotech laboratories worldwide. This material is regulated by strict laws, which have controlled this science over the past few decades. Catts's work utilizes these regulations to more or less co-create his conceptual sculptures. These sculptures are the literal embodiment of more than 50 years of tension between science and politics, as the only cells legally available to both scientists and artists are in fact living animal and human tissue cultures from the 1950s.

Oron Catts's work is obscene and shocking, but only if you know that he is using tissue cultures. The sad little lumps of flesh in test tubes in a mobile laboratory look harmless enough, but once you know what they are, the flesh loses all of its innocence. Catts's work is a contemporary reply to Rembrandt's *Anatomy Lesson* and Damien Hirst's *Mother and Child, Divided.* The meaning of Catts' work is neither in your face, nor is it aesthetically pleasing. Catts' art, like that of other net artists, including the CAE, exists at least partially in a barely tangible, yet real set of systemic social structures.

Context: Identities, Metaphors and Cultural Contamination

A very large, influential level of artistic representation and art practice is that of the political, cultural and social fields connected to and partly redefined by the Internet and digital media in general. This

is the level that has been the most speculated about in cultural analyses of digital media, and the significant theorization of this area started *long before* the public gained access to the Internet.[80] Speculations about the development of a huge, global digital media network that would connect everybody started in the early 1960s, after the earliest efforts involving the exchanging of files between computers occurred, but stories about all-powerful, controlling machines have haunted our culture for at least a century. The first glimpses of a society controlled by communication and surveillance technologies is found in movies and literature from at least the early twentieth century.[81]

'The Machine Stops' is English novelist E.M. Forster's amazing story dating from 1909, which tells the tale of a woman who lives in isolation in a machine that arranges her whole life.

> Then she generated the light, and the sight of her room, flooded with radiance and studded with electric buttons, revived her. There were buttons and switches everywhere – buttons to call for food for music, for clothing. There was the hot-bath button, by pressure of which a basin of (imitation) marble rose out of the floor, filled to the brim with a warm deodorized liquid. There was the cold-bath button. There was the button that produced literature. And there were of course the buttons by which she communicated with her friends. The room, though it contained nothing, was in touch with all that she cared for in the world.[82]

Gradually, various parts of the machine start failing. After the machine finally stops completely, she learns that there is still barely any surviving life outside. Stories like this one have lingered in our cultural memory for more than a century, and they speak volumes about our relation to the machine.

What this story shows is that we do not just make machines, we also invent and produce their contexts. The cultural sphere of the Internet from its inception was influenced by fictional, utopian, realistic and fatalistic speculations about the future of technology and human communications, speculations that explicitly declared the arrival of something resembling 'cyberspace'. Most of these stories represent political and social struggles that are relived and extended in the machinic

realm. The Slovenian philosopher Slavoj Žižek writes about a famous tale that involved a digital network called 'The Matrix':

> What, then, is the Matrix? Simply the Lacanian 'big Other,' the virtual symbolic order, the network that structures reality for us. This dimension of the 'big Other' is that of the constitutive alienation of the subject in the symbolic order: the big Other pulls the strings, the subject doesn't speak, he 'is spoken' by the symbolic structure. In short, this 'big Other' is the name for the social Substance, for all that on account of which the subject never fully dominates the effects of his acts, i.e. on account of which the final outcome of his activity is always something else with regard to what he aimed at or anticipated.[83]

Film Theory and Digital Media

The main influence at the level of context is language and its inherent cultural coding. According to the Chilean biologist and neuroscientist Humberto Maturana:

> Human existence takes place in the biological domain, but occurs in the recursive relational dimensions of languaging which is where time, desires, and expectations arise as ways of being that have properties orthogonal to those of the present under the form of past and future.[84]

Print media and electronic media are crossroads, vectors and saboteurs of these dimensions, due to their ability to record, mediate and construct at the same time. We could draw a parallel between this and the construction of narrative in film, a medium that is often described in terms of its visual shapes rather than based on its dependence on linguistic properties such as signs and syntax.

From French philosopher Jacques Ranciere's notion of the 'sentence-image'[85] to the American media theorist Lev Manovich's 'cinema as code', contemporary theoretical analyses of film not only reveal the continuity of language in film, but they also provide a handle for the construction of narrative, subjects and maybe even a discourse involving new media and the Net. The 'sentence-image' theory de-

scribes how 'the representative relationship' between two forms of expression like text and image (or code and performance), is altered by their specific combination. In *The Language of New Media* Manovich notes that new media open 'existing cultural forms' like cinema up for redefinition.[86] What if an opening up of these 'existing cultural forms' not only implies their purely material properties, but also points to Lacan's 'symbolic order', to notions of identity or political issues as represented in or by these media? Concerning the representation of the real, of actual identities, in the film *The Matrix*, Žižek observed that 'The problem with the film is that it is NOT "crazy" enough, because it supposes another "real" reality behind our everyday reality sustained by the Matrix.'[87] Film and digital networks share certain linguistic properties, but, in some respects, embody entirely different notions of reality, which cannot easily migrate from one to the other constellation of mediums. In film, things can only be *represented*, whereas digital media can enable *experiences*.

The American media theorist and programmer Alexander Galloway, not unknown to the net art community after his work for the online art platform 'Rhizome', also uses literary and film theory terminology. While his book *Gaming* mostly examines games, the subtitle *Essays on Algorithmic Culture* implies a relation to all digital media. Galloway transposes the notions of 'diegesis' and the 'nondiegetic' from film theory, respectively the storyline and any aspect of the film not referring to the storyline, to the analyses of video and computer games. According to Galloway, nondiegetic elements (such as music score, titles, voice-overs by characters not in the story) are substantially more important in gaming than they are in film, as they are elementary to the experience (and thus for the reading and interpretation) of games. An important nondiegetic element is that instant when the game's configuration, a form of individual adaption of the game by the player, becomes an essential and highly influential part of the game's development. Galloway describes 'preplay, postplay, and interplay activity' as nondiegetic gaming elements that establish a special bond between player and game.

Galloway points to one major difference between the understanding of 'realism' in film and in gaming. In film, 'realism' generally points to a raw or explicit depiction of social injustice, or otherwise controversial

issues. As games are experienced through a player's active engagement, a sense of realism is not achieved by creating a 'realistic' looking virtual environment, a high resolution photo-realistic 'stage', but by *injecting the game back into the correct social milieu of available players where it rings true*. The theme and possibilities of the game have to make sense in the actual reality of the player, or as Galloway writes: 'The fidelity of context is key for realism in gaming.'[88] This is a reality as it unfolds, using the player's own worldly experiences, channelled and filtered through the aesthetics of the game; an experience that, in following Maturana, 'occurs in the recursive relational dimensions of languaging', and which is informed by a historically developed, cultural view of the sociotechnological sphere. The language of new media is not filmic, even if both new media and film have linguistic properties. The analyses of film can, however, as shown by Manovich and Galloway, help provide handles for discussing new media properties, by not only emphasizing similarities, but also by assessing the significant differences between the two.

The Role of the Audience

The most significant difference between film and the Internet is (if we use the common definition of film) the shape and role of their specific audiences. Roughly speaking, there is a controlled, local, passive audience for film, and an unpredictable, dispersed and active audience online. The singular term 'audience' is actually problematic in these circumstances. The young but influential tradition of web design speaks of 'users'. Galloway, from his position of describing game worlds, speaks of 'the player'. What these words refers to is 'us', the people working and interacting with computers and the Net or a multitude of individuals with varying interests and needs. The identity of the audience as a whole is the first to collapse in this environment. We could replace it with Italian philosopher Paolo Virno's notion of the multitude, 'composed neither of "citizens" nor of "producers"', occupying 'a middle region between "individual and collective"'.[89] His idea of the multitude is based on the Dutch seventeenth-century philosopher Spinoza's 'multitudo', which, according to Virno: *Indicates a plurality as such* in the public scene, in collective action, in the handling of communal affairs, without converging into a One, without evaporating within a centripetal form of motion.'[90]

The notion of Virno inspired writers such as the post-American[91] culture critic Brian Holmes. In an essay on the work of Brazilian artist Ricardo Basbaum, 'The Potential Personality', Holmes refers to something he calls 'trans-subjectivity'.[92] For its definition he points to Basbaum, who in his work has been developing environments for specific experiences to explore 'that field of meaning which considers it impossible to develop a singular subject without the other's intensive presence'.[93] According to Holmes, the former audience, which he still refers to via the motionless, gawping position of 'the spectator', 'both becomes the substance and the vector of a self-organizing process, a networked choreography'.[94]

One wonders how far such processes could be called 'self-organizing', since their organization depends for a large part on the setting or environment that the artist designs. These processes and 'choreographies', in which the former audience 'becomes both substance and vector', however, do rely heavily on an activity that is more than 'just' participation, especially in firmly context-based net art works. The new audience can be a collaborator, a partner, but it can also be the stage, the raw matter even, without which the work of art cannot perform or cannot be performed. 'What it suggests is a networked form of social tie that expands not through the simple aggregation of identities, but instead through the scalar redistribution of relational forms,' Holmes notes. 'Each person is a singular node, but also a knot in a human mesh; and each group in turn becomes a node-knot in a wider mesh and circuit.'[95] But not everyone interacts so deeply with a work of art. In some cases, the audience only loses its innocent role of 'viewer' or its slightly perverse position of 'spectator' to become '*a witness*', a potential vector, engaged through knowledge. A net art work's eventual 'fidelity to context' is a fidelity to the split and merged realities of audiences whose lives and work simultaneously occur through intimate, local and mediated experiences.

Context: Identity, Role Play and Gender

There is a thin line between play and work, or between fiction and fact, in mediated environments. Any representation in media is a staged event, a constructed reality. Such constructions bear strong conceptual similarities to intellectual, mindful approaches to identity and gender, which is why the techniques involved in this representation are so

attractive in identity games like Basbaum's. Since the Internet is the first communications technology that allows for easy, personal and individual experimentation with these mediated constructions of reality, there is an abundance of role-playing and gender performance online, of which some of the most interesting examples are art projects and performances.

In her essay 'Gender for a Marxist Dictionary, The Sexual Politics of a Word', American culture critic and feminist philosopher Donna Haraway explains how 'gender is a concept developed to contest the naturalization of sexual difference in multiple arena's of struggle'.[96] According to Haraway, gender is mostly an intellectual, cultural approach to sexuality. It sees gender separate from the body, an idea that is both liberating and problematic at the same time. It serves an important function in that it creates a platform for reflection and intervention that is missing from the simple materialism of 'biology', which, according to Haraway, 'tended to denote the body itself, rather than a social discourse open to intervention'.

However, she also points to the imminent danger of 'gender' becoming one of the biological body's unreal, immaterial oppositions. Gender debates have apparently been in part hijacked by conservative feminists, who use the gender-sex separation as a means to discard culturally sensitive sexual practices and experiments as irrelevant or even non-existent. To escape the dichotomy between nature and culture in the sex/gender debate, Haraway proposes appropriating and redefining the term 'cyborg' to apply to an embodied notion of gender, in which technology is understood as relating to both body and gender. Haraway's early acknowledgement of the relationship between body, technology and culture inspired and entered the work of many artists and activists working online. It even inspired an experimental form of feminism online, at the end of the 1990s, called 'cyberfeminism', and is still an active feminist practice today.[97] Artists influenced by or associated with this 'movement' create both fictional and critical, 'documentary' works about gender or identity play. As in Basbaum's work, a semi-formal playing with identity is used to test or provoke alternative definitions of sexuality and gender. Combined fiction and criticism can be a very powerful method, as Shu-Lea Chang's *Brandon* has shown.

Gender and Poetic Intervention: Shu-Lea Chang

In 1998, New York's Guggenheim Museum gave its first Web art commission to Taiwan-born 'nomadic' artist Shu-Lea Chang, who created an elaborate online art work called *Brandon* in 1999, which told the story of the murder of the American transsexual Teena Renea Brandon. The facts and fictions that constituted the work's 'narrative' were scattered across the Internet: parts of the project happened in chat rooms, search engines, web pages, live events and simply in emails. The work manifested itself in the Net much like the 'real' world is manifested online: different traces are left behind everywhere; patterns of behaviour emerge. It was a very ambitious project that happened over the period of one year. *Brandon* was one of the most complex net art works of the 1990s, which simultaneously occurred on different technical and cultural stages, without much concern for the work's long-term preservation, and relied heavily on the process, performance and engagement for its actualization. Brandon's story was linked to cases of 'cyber-rape', a form of sexual assault that occurs mostly in chat rooms, where someone forces him or herself (mostly a 'he') onto a non-suspecting victim. This kind of rape is not just played out in conversation, but is enhanced through how activities are displayed in the chat, and the result can feel astonishingly real. In a press release, the project declared:

> To explore the gender fusion of persona play; to install a narrative structure with net-public engagement; to construct a collaborative platform of hyperlinks and ultimately to investigate gender/body politics and cases of (cyber)rapes in the WorldWideWeb land during the course of one year. Departing from the wired body of sensor attachment, we claim the WWWeb land as a public social space where the notion of a race/genderLESS cybertopia remains to be contested.

The press release reads like a manifesto and reflects the passionate engagement with the social and political dimensions of Internet cultures in net art at the time. The project was the first commissioned net art work that combined the forces of the independent social networks online and the institutional art framework in an effective way. This was mainly achieved through the great personal involvement of

Chang, who managed to create connections to critical discourses in mailing lists and online magazines, and avoided the common mistake of a top down approach in this environment. Initializing a project such as this is more like organizing a political rally or a party than simply designing an online interface. It is all about a true 'fidelity to context', which enables an interactive experience of the most profound kind, a mixture of play and harsh reality, all through the personal engagement of the audience. This is why Chang not only referred to the fate of Brandon, the main character and actual victim of a sex crime, but also to cases of violence and harassment in the form of online character rape,[98] and this is why she allowed the audience to participate in an online court session, a real discussion about the virtual concept of gender.

Russian philosopher and cyberfeminist Olga Suslova, co-curator of an online archive of female avatars in 1997, said in an interview that 'some knowledge constructions, some psychic constructions, discursive and non-discursive practices regulate our physical activity and that's why there is a correlation between our presence in the Internet and our real behaviour outside of the computer screen'.[99] By drawing parallels between the physical world and the Internet the artist was able to address the discrepancies between purely cultural or language-based activism (rooted in near utopian ideologies) and the complexities of actual, physical experiences (infested by culture and tradition) in a poetic way. Technically, *Brandon* was a form of simultaneous hyperfiction, performance and Internet documentary. It combined found footage, existing elements in the form of newspaper stories, with open participation platforms (the court) and texts and visuals supplied by the artist. It could be experienced at various levels: from the purely journalistic or literary to a full-on personal engagement in decentralized events, both physical and mediated.

Artist Activists: Heath Bunting and RTMark/the Yes Men

The relationship between the audience or the individual and technological society undergoes a great deal of scrutiny in the works of American artists Andy Bichlbaum and Mike Bonanno (who have become known as the Yes Men in the past few years), and British artist Heath Bunting. They use role play, pranks and intervention in art activist strategies. But, while Bichlbaum and Bonanno mostly use

identity play purely as a form of political resistance and activism, Bunting seems more interested in understanding and redesigning forms of identity production in general. Bunting's work also includes purely poetic, melancholic and philosophical elements that are not present in the work of the Yes Men. The latter perform a sort of mixture of theatre of the absurd, interventionist art and political activism. What the artists have in common, however, is their heavy use of media networks and especially the Internet.

Servin and Vamos first became known for their extensive online art and activism project called RTMark. This dotcom persiflage used the corporate form as a way of protecting and immunizing one from juridical prosecution, in order to be able to create and maintain a database and organization platform for all kinds of subversive acts. 'We are using corporate effects on the outside to tell a story that attacks corporations,' says Servin (using yet another pseudonym: Ernesto Lucha) in an interview in 1997. 'It is kind of Jiujitsu or a judo move.'[100] RTMark turned into a large collaborative project between several artists and activists, and Heath Bunting was also a member for a while.[101] RTMark enabled a system in which people could suggest a project that would then be posted on their site, inviting realization and maybe even sponsorship by someone.

With the Yes Men, the artists created a new collaborative project, 'a genderless, loose-knit association of some 300 impostors worldwide'.[102] The crux of the work is what they call 'identity correction, which is like "identity theft" except that everyone benefits'.[103] Their interventions made clever use of the media. When they faked a Monsanto press release, claiming that the company was offering to clean up its mess in Bhopal, the company lost millions on the stock market in one day before the prank was discovered. They are, however, best known for their 2003 video that documents a stunt they pulled as representatives of the World Trade Organization (WTO). After they received an invitation to the conference via their satirical fake WTO website, they decided to run with it, and presented the most ludicrous lecture against labour rights and the need for improved surveillance on workers. Even the special gold management suit with a giant penis (the suit's built-in work floor surveillance display) attached to it did not seem particularly strange to many of the conference's participants.[104] The magic of identity creation through the Internet had done its work all too well.

If the Yes Men are about high-level political intervention and media exposure, the work of Heath Bunting is its private, obscure counterpart. Bunting is fascinated by the material and formal structures that divide people into the various classes and the hierarchies that develop from visible and invisible class structures. He dissects their underlying currents or technologies and rearranges them into various categories. His art contains a collection of poetic reflections, escapist methodology and art activist strategies. In his most recent, ongoing[105] work *The Status Project*,[106] the artist aims to map the everyday requests for identity confirmation or representation that we mostly take for granted, but which can present very real obstacles for those who do not have a passport or fixed home address.

Earlier works by Heath Bunting seem to have been sketches or studies that have led to this more ambitious work. Bunting seems intent on finding ways to 'hack' the oftentimes labyrinthine and claustrophobic structures that evolve from the identification pressure in contemporary societies. He announced that he was creating a 'map' for 'the system', which suggests he was looking for either mazes in the net, or, more interestingly in this context, for ways to create the perfect virtual persona, a persona with very real potential. Either way, the project is balanced between genius and paranoia. The systemic drawings of identity tracking that Heath Bunting has thus far created for this project are breathtaking sketches of the magnificent but staggering enormity of the everyday surveillance systems that pervade our lives.

Context and Cultural Identity: Brian Mackern

For some, the definition of a good work of art is that it moves you so deeply you almost want to cry. I have met a few people who, totally self-righteously, claimed that nobody had ever felt this deeply about a net art work, and nobody ever will. I assure you, it is possible. Stories about this kind of emotional reaction to a net art work date back to at least 1997. At that time, I was very excited about certain works myself, but never close to tears of joy. But I did hear of others who had been by Olia Lialina who had created a kind of web poem consisting of black-and-white linked images and hypertext, called *My boyfriend came back from the war*, which was her first Internet work. To be exact, it touched the hearts of many Russians who had known somebody who had fought in

their war in Afghanistan. It is the story of a Russian veteran's girlfriend, who has very mixed feelings when she is finally alone again with her boyfriend after his return from the war. Lialina made this work as a kind of filmic experiment online, and was surprised by its emotional impact, and that it found an online audience she had not even realized existed. Since then, I have been deeply moved myself, but not often. One of the strongest works I ever saw is Graham Harwood's *Lungs*. As I read the Perl poem that runs this work I felt my stomach turn and the ground beneath me sort of give way. This code turned out to be the symbolic site of a horrendous struggle between human and machine, a struggle captured in a poetic mathematical nightmare. Little did I know when Uruguayan artist Brian Mackern gave me a copy of an artist's book with the unpoetic title *netart_latino database* that this book would have a similar emotional power. But, while *Lungs* leaves you in shock or horror about a crude calculation of deaths as a result of child labour abuses or a war, Mackern's book evokes strong feelings of melancholy and loss across a vast history that was never told. It was made in collaboration with the Museo Extremeño e Iberoamericano de Arte Contemporáno (MEIAC) in Badajoz, Spain in 2010.[107] The work takes the reader on a journey through time and space, almost as if he or she is reading a historical travel guidebook. It is still possible to witness *netart_latino database* in the documentation form. It can also be read as a fairly comprehensive history of Latin American net art. Most of all it is a statement and a labour of love.

 Netart_latino database is the history of net art in a Latin American context, which developed almost in complete isolation from the rest of the world, yet in the same timeframe as, for example, European and American net art. It is told through the history of Mackern's online project of the same name, which he developed during the period 1999 to 2005. He created a linked database to just about every Latin American net art work he could find. The result was a portal to a huge 'art collection', a living archive, dispersed over the Net. There was a strategy here because the endless list of art works and artists is consciously overwhelming and Mackern took liberties to make sure this happened. Not all, but most of the artists live and work in Latin America. The one Cuban net artist, for example, lives and works in the USA. Antonio Mendoza was born in the USA after his family was exiled from Cuba.

The reason he is included becomes clear during the interviews with Mackern in the book.

In these interviews, Brian Mackern assumes the role of both prosecutor and defence attorney. He uses the power of numbers to build his dramatic argument with the list of countries, artists and art works seemingly going on forever. Net art links from Argentina, Chile, Uruguay, Venezuela, Peru, Ecuador, El Salvador, Columbia, Brazil, Mexico, Puerto Rico and even Cuba leave the reader overwhelmed: so many works, so few of them known. While I read them an awkward feeling started to creep up inside me. It reminded me of a feeling I get every time I hear a track by the British band Test Department called 'Corridor of Cells', which starts with a sound recording of an underground, illegal Czechoslovakian radio station in the former Eastern Bloc. It was an urgent and desperate call to radio stations in Romania and Yugoslavia to disseminate information about the state of affairs in Czechoslovakia at the time. The fragile but determined female voice begs listeners to translate their messages into Romanian, Polish, German, Hungarian, French, English, Italian, to 'let the whole world know the truth'. The message is so powerful that it chokes me up almost every time I hear it. A similar feeling of urgency swept over me as I explored the content of Mackern's book. It is the power of their arguments that are similarly constructed although their context and messages were completely different.

We learn, as it turns out, that Brian Mackern, who has been involved in making art in the context of the Internet since 1994, served as a catalyst in South America, and feels left out of the influential net art histories. His work, and that of many other Latin American net artists, was not recognized until after the turn of the millennium. Speculations about why this is vaguely reverberate throughout the book. One reason may be that some artists were simply 'excluded'. Whether this is true or not, it portrays the early net.art 'movement' as an impregnable fortress. In this sense, *netart_latino database* is also an important history of net art as a whole, as it shows a view from the 'outside'. It scans the borders of influential net art histories and reveals their limitations. As a witness to the countless and varied works of art and experiments with the Net in Latin America it also shows that a broader view of net art is necessary.

In the book, Argentinean artist and curator Gustavo Romano compares exploring *netart_latino database* with being a passenger on Charles Darwin's ship the *Beagle*, as it sails across the ocean to discover some *terra incognita*. Mackern's project reminds him of a captain's log, as well as a travel journal and a specimen catalogue. There is pride as well as discomfort here. Romano, like most of the rest of the writers in the book, is well aware of Latin America's complex history. Being addressed as Latin American means waking spirits many would rather avoid. It is clear that defining a Latin American identity is problematic and maybe even undesirable to some. Many artists from this region have been labelled exotic or 'typical'. Pagola describes a history of difficult relations between the art worlds of Latin America and 'the North'. The Net, she explains, has redefined these relations without offering a solution for the North-South divide, where it was once mostly a physical divide, and now has also experienced a technological divide. She notes that there is a need for some kind of 'socio-historical-political gps', a device that can calculate one's position on the art map.

It was always well known in early net art circles that access to the Internet was and is not the same everywhere in the world. Projects were designed to specifically address this issue. For example, there was a contest that required that web pages would not exceed the 5k limit (five kilobyte would make an extremely low-bandwidth website today). High bandwidth sites were considered anti-social or even downright ridiculous. It was part of a tactical media approach to art and an attempt to democratize the art world through Internet technology. This awareness did not include being sensitive enough to realize how low bandwidth and bad connections affected the *social* involvement of artists in other non-Western parts of the world. Low tech and slow Internet connections were not a choice but a reality. The speed and availability of Internet connections greatly influence the potential for participation in the ebb and flow of online communication. Looking back on some of the online net.art events, for example, they unfolded in real-time, like a physical meeting between artists, critics and curators, which was enabled by fast and stable Internet connections. Eastern European artists (including Russian) were able to join in largely because of special media labs, set up in institutions funded by the philanthropic Hungarian-American millionaire George Soros, who wanted to stimulate the

economies of the former Eastern Bloc by connecting them to the 'digital highway'.[108]

Latin American countries did not have their own Soros Foundation. But something else was missing as well. Besides the absence of a good technological infrastructure, Latin America also lacked the necessary powerful social infrastructure (like the one that formed the basis of net criticism and net.art, which I describe in my history of net.art) necessary for the development of a strong context for artists to work in. Latin American artists worked in isolation, Mackern notes. Not only were they isolated from their European and American peers but also from their peers in Latin America. It was easier to find information about, say, the work of Alexei Shulgin, than to find information on other Latin American artists. Content on the Internet does not simply emerge by itself, someone has to create these connections. 'Latin American' artists were scarcely engaged in online discussions in the 1990s, for instance, and seldom announced their work in the most active and visible net art networks. This rendered them practically invisible and not just to net artists in Europe and the USA, but also, tragically, to what could have been their own 'local' networks.

The gap between Latin American net art and other net art histories is the tragic result of bad connectivity all around – both in terms of bandwidth and available Internet connections, but also in terms of culture and language. In *netart_latino database* most of the writers mention the dominance of English as a major reason for the North-South divide. Their lack of English skills was one reason why their presence was limited. But this was no doubt the same for artists from other regions. Lila Pagola quotes Spanish curator Laura Baigorri, who observed that 'access is not power'. Indeed, utopian myths of the magical powers of the Internet are still alive, and need to be debunked. What *netart_latino database* shows is that for cultural change within the context of the Internet, more is needed than just technical connectivity. In the context of art, social connectivity is as important as technological structures and economic factors. The difference between Latin American and European and American net art seems to be significant on all of these levels. The 'exclusion' of Latin American net artists from net art histories is therefore not as straightforward as it may seem, and it need not be the case forever.

For many of the works listed in *netart_latino database* any improvement will probably be too late, however, because, although it was the first and foremost portal to Latin American net art for years, it has (like many other net art link sites) become largely a repository of dead links. As of 2010, at least half of the links were non-functional. Brazilian artist Giselle Beiguelman writes about the online version: 'With each "not found" in response to a click I feel like I am walking amidst unburied corpses.' By transferring it physically to this book the state of *netart_latino database*, as well as the urgency of its message, slowly and quite literally unfolds. Mackern's story of Latin American net art is powerfully embodied through his choice of materials which are all highly vulnerable, common and even 'obsolete'. *Netart_latino database*'s binding is made of thick, unprocessed, grey cardboard that feels soft to the hands and which (no doubt) easily stains. The ASCII art used for the front page of the online version of the project is simply punched into the cover. This illustration is a rendering of a famous critical map of South America by the influential Uruguayan artist and theorist Joaquin Torres Garcia. On this map, South America is drawn upside down, putting it at the top of the world, and the USA is imagined somewhere at the bottom.

The book contains essays and stories by Romano, Pagola, Baigorri, Beiguelman and Spanish curator Nilo Casares, printed on extremely thin paper that is quite difficult to handle. Reading the book takes an effort. Pages are hard to separate and turn. A printed version of the original *netart_latino database* (as it is seen online) is carefully folded into the back cover of the book. This print out is done on old-fashioned, nearly obsolete dot matrix printer paper, the kind with the little holes along the sides, and connected at the top and bottom of conjoining pages, creating a long paper roll that one could easily get tangled up in.

Reading the long list of Internet addresses from the almost endless roll of dot matrix printer paper of some ten metres long is a near religious experience. It takes us into a universe that is literally beyond our reach because it is impossible to activate a paper link. Like much of Darwin's universe, this world is strictly ordered, and equally frozen in time. Brian Mackern's history of Latin American net art is a work of art in itself. The lost links of the original database turn into a transcendental text because of their awkward and complete disempowerment

on paper. They have become almost holy scripture that describes a hidden world. As such, they arouse curiosity, and challenge us to become Darwins ourselves. Mackern's *netart_latino database* stretches the notion of the database to include the social relations outside of its direct technological borders. It also shows the database's physical historical relations to print's archival and distribution systems. Most of all, it represents the fact that social mappings in net art tend to mimic that of the art world at large.

Conclusion: Radical Diversity

Whether we are talking about bubbles, spheres, levels, themes, or elements,[109] net art is not produced from one single technological or social starting point. Hopefully this text, which is, by default, lacking in examples, something that is painfully illustrated by Mackern's work, has at least given us a glimpse of the variety of works that are out there. Hopefully it has become clear that the art created in online environments is not separate from the physical world at all, but that its practices also would not have evolved without Internet technology. Even purely Web- (or other software) based works have very real histories and connections in physical, social, political and cultural realms, and, on the other side, radical subversions like those of the Yes Men would be almost impossible to realize without the use of Internet technologies and their broad application throughout society.

In some ways, net art is the revenge of matter, after matter was disapprovingly cast aside in the turbulent transformation of the art world in the 1960s after the appearance of pop art.[110] The computer and the Internet, both in their own ways, approximate Turing's universal machine, and are applied in every possible way for the production, distribution and reception of art. The five levels I have presented here may not cover all aspects of net art, but they do represent a wealth of practices. Code, for example, shows a renewed materiality of language and concept, and the sublevels at which this is applied in net art. It can appear in the shape of software, poetry, 'subversive' code (virus), image or instruction. Each of these forms, however, requires an awareness of the specificity of code and its historical and cultural backgrounds. One does not need to be a coder oneself to understand what most of these works are about, but for a proper interpretation of some (especially

executable code and software) it can help a great deal. For the record: I am not a coder. One does not need to be fully initiated at the deepest level to understand net art. For the specifics of software art, I rely on the testimony of others and humbly take a position on the surface somewhere.

When considering the other levels, I tried to dissect the net art field in accessible 'images' and spaces. We are not dealing with a purely conceptual or immaterial relation between 'viewer' and work of art, but with an actual part-material, part-conceptual structure, in which different elements create, support and enhance each other. We can hardly even speak of viewers in an environment where our part in the construction of a work is often elementary. At the very basic level of matter, the computer still is a world of different colliding and attracting forces, from the mines and sweatshops in Africa or Asia to the branding and obsolescence of machines all over the world. Net art exists across these social, cultural, and economic plains. Understanding where it intersects with them and takes root in them does not just reveal the materiality behind the aloof philosophy that is art today, but it could also unveil the magnificent forms of poetic, critical or inventive works of art that are developed in the vital and diverse art practices of today. The confluence of art and new media networks has only just begun to reveal itself.

Part II

Net.art: From Non-Movement to Anti-History

I check my mail, look at my bank balance, I see myself in the
mirror – and I still don't know what you mean by failure and death?
Olia Lialina, 2001[1]

First Contact
Sometimes everything just falls into place. In the mid-1990s an
international group of artists that was exploring the possibilities of
the Internet and the World Wide Web met through an online forum,
a mailing list to be precise, called Nettime.[2] Some of them had just
discovered the Internet; others had already been working on or with it
for some time already. They became friends, started to lecture, discuss
and link to each other's work and, most of all, they had fun. Some of
them became the faces of a new method of making and approaching art
with the use of computer networks. Their work became known as 'net.
art'.

This group of artists all came from 'old' Europe, in other words,
Eastern and Western Europe. This was largely due to the fact that
they had little opportunity to meet non-Europeans. Paradoxically,
real-life meetings were, as will become clear later, a very important
influence even for this largely online art scene. These physical meet-
ings mostly took place outside (or in the periphery) of institutional
events. The Internet replaced most of the traditional networking that
occurs at conferences, for instance, allowing net.art to avoid the slick
professional media art presentation model and become more of a social
gathering. The Internet was (and still is for the most part) something
of a shared space for these artists. 'It's like me and Heath Bunting and
Alexei Shulgin and Olia Lialina and Jodi had studios next to each other,'
Slovenian artist Vuk Cosic observed in an interview with German critic
Tilman Baumgärtel, 'where we could look at what the others were
doing. You know, it's like Picasso and Braque in Paris in 1907.'[3] Real-life
meetings profoundly deepened the bonds already created online.

What follows is a brief history of net.art, in which I try to stay as
close to the course of events as possible. I do not attempt to be polite

or politically correct because it is basically an eyewitness account. The history of net.art is turbulent, and in some ways it is still unfolding.

Death of a Cult = Star Culture

Net.art was this group of friends, but the term is also connected to a myth about what these artists stood for. Through its connection to a media activist discourse I describe later, net.art had come to be perceived as a political movement, which it was not. When this illusion died, some took the opportunity to declare the whole of net art dead[4] – and then live off its alleged remains. In a 2009 interview with Mexican journalist Damián Peralta Mariñelarena, Russian artist Olia Lialina confronts these death knells, which had already been reverberating through the scene for almost ten years: 'It is not dead, but there was a change in generations in net.art. In general, it was very selfish [of] some people, some artists, to announce that net.art [was] dead.'[5]

She thinks that certain artists and critics benefited from having the influential first net art discourse shoved out of the way. Austrian critic Armin Medosch had already criticized these kinds of declarations from outside the group in his 1999 article in *Telepolis* 'Adieu Netzkunst' by stating: 'Making speculations about the end of something that has barely even begun of course means asking the wrong question.'[6] The death knells seem related to a very strong tendency of viewing net art (or net.art, with a period) as an art movement in a modern art tradition. This view creates expectations and limitations that, in the end, are unsuitable when describing art in the context of the Internet. I hope to show here how net.art was mostly the beginning of a serious debate about online art. The main artists both benefitted and suffered from the close inspection and many misinterpretations their work was subjected to. The story of net.art is an example of a classic art history tale of struggling and strife, and life and death.

Net.art's most prolific representatives were British artist Heath Bunting, Vuk Cosic, Jodi, Olia Lialina and Russian artist Alexei Shulgin. Each of these artists has a very distinctive style, which they developed before the emergence of net.art. Net.artists never shared one aesthetic or one approach.

Other members of net.art include Rachel Baker, Walter van der Cruijsen, Luka Frelih, Pit Schultz and Akke Wagenaar, who, each at

different stages, also created elementary net.art works and projects. From Akke Wagenaar's modified SCUM Manifesto, to the programming work of Van der Cruijsen and Frelih in ASCII video or the 7-11 mailing list, to Baker's Tesco customer card hijack in her Club Card project, and Schultz's conceptual influence in the earliest stages of the 'movement', it should be clear that net.art definitely involved more than just a handful of people. Net.art artists came from Great Britain, the Netherlands, Belgium, Germany, Russia and Slovenia. A kind of grassroots art 'movement'[7] developed around them, which influenced the face of art and culture online significantly.[8]

Most are still working as artists on- and offline today. Their work was an inspiration to many other artists working with the Internet, and, as such, they have become living legends of a sort. I was surprised to see how far this went quite early on because net.art bashing started with an only slightly newer generation of net artists on the Rhizome mailing list as early as 1998, making it possible to be part of its success by latching on to it negatively; a net.art star culture was born.

Legends, Myths and Net.art

There is no doubt that, although most of net.art's history is largely unknown to traditional art audiences until the present day, this 'group' or era had a large impact on online culture. Even today, the history of the group of artists known as net.art is confused with that of net art as a whole. The significance of net.art reveals itself in different ways, some of which are highly personal. Years after net.art as a 'group' had ceased to exist, the core group was honoured in the exhibition 'Written in Stone – a net.art Archeology', curated by Norwegian artist Per Platou, who was honouring what he called the 'heroic period' of net.art.[9] Platou even had little busts made of these artists, which he displayed in a glass box. The artists themselves had mixed feelings about their hero-ification. 'You have to come really close to recognize who's who in the vitrine,' Olia Lialina notes with her usual subtle irony in her online notes of the exhibition. 'They're really small heroes.'[10]

The name 'net.art' represents not only the work of these artists, however, but has also come to refer to a subversive or anti-institutional attitude that arose in online art, an attitude this 'group' became infamous for, or which at least was the most emphasized aspect by critics.

Net.art fostered new independent art organizations and approaches to evade traditional structures, some of which are not unlike hacker practices. One controversial development was the development of spam art and even spam poetry, for example.[11] Because of its rebellious connotation, the term 'net.art' (or net art) is still used to describe a specific, critical online art practice in certain artist-activist contexts (mostly in the area of open source art and software development).[12] Before the term 'net.art' became tainted by the exaggerated declarations of its death, it was also quite commonly used for artists and works of art that were not in touch with the group I describe here. It is impossible to discuss net art in general, or art in the context of the Internet, without touching on the history of this significant subdivision of it, which actually gave it its name.

The artists in this 'group' came from various contexts and disciplines. Evidently it was not their shared art practices that brought these artists together. Somehow, a purported similarity of style and approach was pinned to this group of artists, however, and this caused much friction and confusion. The most difficult issue the artists had to deal with was the tendency of some critics to call net.art a kind of new avant-garde, and, in its wake, make it respond to an outdated, strict political correctness and highly formal approach to art.[13] This forced comparison of net.art to earlier twentieth-century art practices such as the situationists led certain critics to push net.art in a direction it would never have gone on its own, considering its diverse composition. This comparison rapidly became untenable, and the tension between net.art's reality and the critical hijackings of net.art from outside its social group resulted in the first death knells.

Another false assumption about net.art was the misinterpretation of the Internet as one medium with one specific aesthetic, in which net.art was wrongly perceived as Web- or even screen-based. This was a common mistake among video art festivals, for instance, that tried to incorporate net.art into their programming schedules. Net.art was, in some ways, the new century meeting the old. It departed from old notions of art movements and media art, to enter history more as a virus than a discipline. Vuk Cosic sees his training as an archaeologist put to new use: 'How come that an archaeologist is working on the Internet? I think that it is the same apparatus that has just been turned around on

the tripod, looking in the other direction.'[14] He suggests that net.art is an archaeology of the future.

A Deeper View

The most important things net.artists *did* share was an interest in exploring the possibilities of a new, worldwide communication space, and a still rather basic set of software and hardware tools to do this with, which resulted in a lot of collaboration and sharing. 'There are collaborations over the net and group projects,' Cosic said. 'We steal a lot from each other, in the sense that we take some parts of codes, we admire each other's tricks.'[15] This probably strengthened the illusion (of the 'video eye') that net.artists all shared the same style or practices, but when one reaches beyond this surface, one finds different attitudes and highly individual approaches to creating new art forms and art concepts on a 'raw' Internet.

Understanding net art is similar to understanding interactive art because here engagement and experience rather than viewing define the interpretation of a work. This was quite obvious in the early manifestations of the Net. The World Wide Web, the shiny 'shopping mall' on the Internet, only clumsily hid the physical network architecture it is based on, and the Web's structures were still rather transparent. The Internet was not the ubiquitous, slick commercial space it seems to be today. Instead, its reliance on hybrid technologies and social networks was evident.

A down to earth view of the Internet predominated throughout the Internet's first ten years of existence (1989-1999), and this can be derived from the works of all net art pioneers, such as Canadian artist Robert Adrian X (who has also worked with forerunners of the Net since 1980), and later adapters, like Olia Lialina, who first went online in 1995.[16] Both describe the Internet in terms of structural manners and spatial dimensions, as an environment consisting of cables, servers, computers, software and people. The telephone lines necessary for most of the Internet's connections, plus the users who clogged them up or managed to invent new strategies to implement them, were much more visible than in today's illusory, highly visual world of Web 2.0. In short, it was clear that the Internet is made of matter, hybrid matter that is part technology and part people, deeply influencing each other.

This heterogonous environment was tested and used to the limits in the world of net.art.

Introducing the Artists

'The interesting thing about it was that people who were doing it came from very different backgrounds,' says Olia Lialina, 'from photography, from conceptual art, like I [came] from film. If you talk about Jodi they came from design and art studies, many people came from literature.'[17] Lialina created several works that were related to film, but which used Net properties. Her work *Anna Karenina goes to Paradise* (1996) was a typical example, but is now the least preserved of all of her works because of its complexity and the constant changes Internet technology undergoes. This work relies on a connection to different servers and search engines, which together create a story consisting partly of found footage. Today, Lialina is interested in tracking and analysing the amateur Web and its over-the-top iconography. She is particularly enamoured of the vulgar or kitschy kind, and uses it as a kind of resistance to the highly standardized and restricted spaces of Web 2.0.

Vuk Cosic likes to toy around with contemporary iconography in the broadest sense of the word, including web icons and overtly simplistic web design features such as 'blink' (which, as the word indicates, blinks on and off). From his *History of Art for Airports*, in which famous classical art works were reduced to airport sign characters, to *Mira*, a subtle political, satirical, interactive portrait of the wife of Slobodan MiloševiĐ, to his best-known work, the ASCII sign video version of the porn classic *Deep Throat*, Cosic's works of art always combine playfulness, humour and some mild cultural criticism.

Heath Bunting, on the other hand, is deeply interested in the art of networking itself, and in discovering or disclosing new ways of looking at the world through networks and systems. As such, he remains an artist, organizer and activist. He initiated an art server called 'cybercafe', in the shape of a Bulletin Board System, in 1994, which formed the basis for his new online art space, irational.org, in 1995. His mid-1990s work ranged from complex interactive works, such as *Kings X Phone* for the Arthouse gallery, to simpler works like his black-and-white impression of London street signs in *Visitor's Guide to London*. Bunting, in *Kings X Phone*, used public telephones for a performance at a large London tube

station without informing the station managers. 'During the day of
Friday 5th August 1994 the telephone booth area behind the destination
board at kings X British Rail station will be borrowed and used for a tem-
porary cybercafe,' declared the announcement, while it published a list
of numbers from the phone booths in question and some suggestions
on how to use the numbers and the telephone booths. It turned into a
kind of 'flash mob', where people gather at a public place unexpectedly
to perform something, after being organized via a social network sys-
tem. Phones were ringing constantly while people crowded around the
phone booths to pick up the phones and create a party atmosphere in
the immediate area of the booths.[18]

Alexei Shulgin may have worked as a photographer before his net.
art period, but his work online is much more conceptual. Of all the net.
artists, Shulgin is the most interested in group works or collaborations,
even more than Bunting, with whom he shares a strong desire to escape
classification and institutionalization. Together with Cosic and German
curator Andreas Broeckmann, Shulgin created the project *Refresh*, one
of the first major net.art collaborative projects that went far beyond this
small net.art group. It was a so-called 'web ring', where people create
web pages that automatically jump to another page, in this case another
art page somewhere on the Web, resulting in an 'art loop'. Another
work was his *form art competition*, derived from an art form Shulgin had
invented from basic web page elements like the 'button'. One could
say that even his manifesto 'Introduction to net.art', a collaboration
with Natalie Bookchin and a kind of 'how to do net.art' that he later
had carved into stone (with Joachim Blank and KarlHeinz Jeron) was a
way of involving as many people as possible in his work. After net.art,
Shulgin started a repository and festival for software art called runme.
org and readme.org.[19]

Only Jodi actually came from an art background. Joan Heemskerk
and Dirk Paesmans met at the Jan van Eyk Academy in Maastricht, the
Netherlands. Paesmans had some history in video art, and had been
involved in ZAPP TV, a project that appeared as part of the Dutch experi-
mental TV shows Hoeksteen TV and Park TV. Heemskerk was originally
involved in photography and installation art. They travelled together
to Silicon Valley on a whim and ended up being allowed to take part
in CADRE, without actually enrolling in this San Jose new media art

school. They could work there for free, but were not officially students there. Jodi's website was an eclectic collection of radical playing with the language and imagery of web design. It was so extreme that some people had to switch providers a few times, because they had misinterpreted their work as a virus. Jodi was the first winner of a Webby (the Oscars for websites) in the net art category for this work. They were so shocked by the glossy IT crowd at the Webby's that they cursed everybody out during their acceptance speech. Later Jodi created a few game modifications with their unique, ruthless deconstructivist attitude, of which OSS**** was included as a CD-rom with the Dutch *Mediamatic* magazine, and *SOD*, which was distributed along with the British magazine *Mute*. Jodi's work currently includes radical VJ-ing, installation art and performance.

The openness of the discussions and conversations around net.art allowed for the ruthless questioning and undermining of the definition of net.art from its earliest beginnings. Every prejudice and utopian thought one can think of in the context of art entered the debate.[20] The discussions about what is or is not net.art soon turned into 'who is and who is not a net.artist'. Among the artists working with the Internet, the question of what or whom the term net.art actually described has become more of a distraction. Being part of net.art became a matter of inclusion and exclusion, or even of recognition and neglect. Whereas the term net.art could have clearly covered the work of all artists working with or on the Internet (like it was initially intended), the name quite early on became associated with the small group of artists I mentioned earlier, and a specific period in online art. Because of this involuntary exclusionary tendency, which, in the end, hurt any basic understanding of net art in general, it is probably advisable to at least partly shut the door on this net.art era as a chapter in the history of these friends, which might encourage a more accurate 'archeology of the future'.

From Studios to Networks to Tribes: Contexts and Sources

In 1995, various initiatives originating from a variety of academic, media activist and media art backgrounds converged; first to explore and criticize the changing media landscape, later to form new platforms and institutions. These initiatives were mostly connected through collaborative projects such as the aforementioned mailing list Nettime,

which, in some ways, served as a backbone[21] for open-access media labs throughout Europe (most importantly Public Net base in Vienna, desk. nl in Amsterdam, Ljudmila in Ljubljana, later also Backspace in London, and Internationale Stadt in Berlin). These labs performed the important function of Internet provider at a time when such providers were still rare. They had a much broader range of activities than present-day commercial providers and had a very different economic and organizational structure. 'Some activities are not funded at all or are rather self-funded – made possible by the energy and work of participants,' Armin Medosch writes. 'Economically it is insignificant but discursively it is important.'[22]

As a kind of neighbourhood community space they not only gave local communities an insider view into the technology and content of the Net, but they sometimes even made this community a structural part of management. James Stevens, one of the people behind Backspace, explains the open structure behind his initiative:

> Backspace was completely run by those who used it. What evolved out of that was a shifting group of people that were intensely interested in running the space, so at times we had as many as ten different people who took responsibility by opening up the space, looking after those coming in, and building the website. We occupied difficult territory by insisting on this ideal of self-organization and no public funding.[23]

It was a way of working that closely resembled early Internet organizational structures, in which collaboration and shared responsibilities were standard and obligatory.[24]

Nettime was the European answer to California's new media discourses that evolved from the early American online initiative, network and mailing list The Well, and the well-known new media magazine *Wired*, or to what British theorists and critics Richard Barbrook and Andy Cameron dubbed 'the Californian Ideology'. They write: 'Promoted in magazines, books, TV programs, websites, newsgroups and Net conferences, the Californian Ideology promiscuously combines the free-wheeling spirit of the hippies and the entrepreneurial zeal of the yuppies. In the digital utopia, everybody will be both hip

and rich.'[25] The ideology they refer to is strongly represented in an essay by co-founder of the Electronic Frontier Foundation and former Grateful Dead lyricist John Perry Barlow, called 'A Declaration of the Independence of Cyberspace'.

Barlow's essay declares the Internet a space without material proper-ties, of total freedom, which, in the eyes of his critics, was terribly naïve when it came to the influence of the industry and ravaging free-market politics on the development of any media. Still, Barlow's text is fun to read, as he addresses governments and the industry: 'Your legal concepts of property, expression, identity, movement, and context do not apply to us. They are based on matter. There is no matter here.'[26]

This highly romantic view of cyberspace and the Internet as immate-rial or even spiritual space was quite common among those involved in the early Net,[27] and can sometimes produce interesting radical tactics and theories, yet, at the Next5Minutes 2 event in 1996, Barlow revealed more of his special view on Internet romanticism, by joking that the Internet must be feminine, since it is horizontal.[28]

Nettime founders Geert Lovink and Pit Schultz set out to develop a 'net criticism', that would develop an appropriate body of criticism of Internet-related issues, and to oppose the popular belief, which Barlow represented, that the Internet will automatically produce a wonder-ful new world by itself. 'Everything that *Wired* wrote was to us Pure Propaganda and provoked the question for the unofficial Data,' writes Pit Schultz in the introduction to the Nettime publication *ZKP3* in 1996. 'As the *Pravda* of the Net, *Wired Magazine* forces the emergence of dissident thought.'[29] They noticed a reality different from that of *Wired*'s democratic utopia. 'Against the expectations of early adapt-ers, Big Internet is creating a new mass of "users", which just shuts up and clicks,' noted Geert Lovink in his 1998 essay 'Network Fears and Desires'. 'They are "watching Internet," a phrase that would have been impossible to come up with a few years ago.'[30]

Nettime served as a backbone to media labs, while these labs in turn acted as an interface between Nettime's large online 'community' and individual local communities. This is why net.art was first presented and discussed on Nettime because it, in many ways, *was* the Net to many people working in these labs, and even outside them. It was *the* network connecting to the world, outside traditional cultural, national

and institutional structures, as there were very few other such inter-disciplinary, high-quality online meeting places of this size reaching across cultures and continents. In many ways, Nettime itself is a hybrid technology.

There were these kinds of meeting places in older network structures, such as Usenet (where one would log into a group or discussion taking place on a distant server), but for the new Internet users in the media labs, these were too unfamiliar to actually use. A community connected via email trickling into one's own mailbox felt much more utilizable. In a way, these mailing list communities have been replaced by social network sites, but, like Usenet, these lack certain options like creating one's own archive, and owning the content in it.

The labs became concentrated exchange groups, in which artists, activists and others learned not only about the technology of the computer and the Internet, but also about the new social and cultural networks that were developing online. The media labs were a place of learning, inspiration and creation. These were not the high-tech media labs of media art institutions like the glossy spaces at ZKM in Karlsruhe or Ars Electronica in Linz, but almost living-room-like spaces in which social interaction was key. 'Socially and politically aware artists shape the discursive agenda outside the institutional context provided by high-media art,' Armin Medosch writes, and some 'high-media art' institutions, 'just like software giant Microsoft had misinterpreted the relevance of the Internet. Instead of glorification of the products of multinational corporations, net artists highlight the participatory culture of the Internet.'[31] Medosch also refers to the media labs, which were like physical nodes in the participatory culture he describes. These labs were deliberately easy to access and use.

Here, artists who had previously worked alone, in their studios, and who had explored the Internet and other, simpler computer networks (like Bulletin Board Systems or BBSs) without really taking part in a larger online environment due to a lack of knowledge and experience, could easily get the latest news and developments in art, theory and activism, be it through people they actually met or through their own online explorations.

Desk.nl

Let me illustrate: after years of only having interviewed artists working with the Internet,[32] I got my first email account and Internet access at desk.nl in Amsterdam at the end of 1995. Desk.nl's open-access space was financed by commercial jobs, like developing the first online shops for Dutch businesses such as mail order company Wehkamp. Artist Walter van der Cruijsen initiated desk.nl. He had also been involved in the development of the Digital City (DDS, De Digitale Stad), a project that got a lot of mainstream media coverage and generated many new Internet users.[33] Van der Cruijsen had been very active in the art world before, and was one of the co-founders of the well-known independent art magazine *HTV de IJsberg*. Tech-wiz and programmer Reinout Heeck worked at desk.nl doing general technical support. Heeck had previously worked for underground radio station Radio 100, and he had also been part of the Galactic Hacker Party crew in 1989. He was incredibly patient when assisting new or experimental media developers and great at building tools from scratch.

Desk.nl was located on one of Amsterdam's most beautiful inner-city canals, the Oude Schans. In no time it emerged as a hot spot (literally too, because of the high temperatures in this computer geek space) for artists, academics and activists interested in digital media. At desk.nl, people came and went, including, for example, California writer Mark Dery, British theorist Richard Barbrook, Pit Schultz and Japanese media theorist Toshiya Ueno. I usually worked in the 'art-lab' corner of the workspace, between artists like Zvonimir Bakotin, Debra Solomon and Franz Feigl. There was a powerful mix of live art, tech and theory all in one space. One reason for the high level of traffic of influential and upcoming 'digirati' at desk.nl was that one of its board members, Geert Lovink, lived only a stone's throw away, and would send all his guests to go and see this steamy media lab.

Bakotin was developing 3D-imaging techniques, and worked with net art pioneers Van Gogh TV on a project called Merzbau, after the work of Kurt Schwitters, a few years later.[34] Solomon and Feigl were part of the project Netband (also including Dick Verdult and Erik Hobijn), which, due to internal squabbles unfortunately failed to achieve its goal, which was to create an online project where an actual chicken egg would be hatched using the care and warmth of a partici-

pating audience.[35] When they were on the road they acted like digital
Beatles: all four of them were incredibly strong individuals, which, in
the end, led to the group's demise. Feigl, an early digerati extraordinaire,
unfortunately died of cancer a few years ago. In an obituary for Nettime,
Geert Lovink described Feigl: 'Franz could be found, day and night, in
the workspace of desk.nl.' According to Lovink, Feigl was one of a group
of people at desk.nl who 'wanted to be as close as possible to Internet
bandwidth, passionately sharing ideas about the emerging network'.[36]
After his death, a group of artists from KunstLabor in Vienna named
a boat after him. The MS Franz Feigl is used to track all open wireless
networks along the waterways. 'The peaceful goals of the Motorship
Franz Feigl aim at highlighting the possibility of opening up networks
and creating a free infrastructure.'[37]

Netband members also had their own individual art works, of
which I found Solomon's *1:1* especially interesting. *1:1* was a website
that showed a life-sized photo of Solomon's body. It was a successful
attempt to break away from the desktop publishing domination in web
design, which brought the aesthetics and feel of digital space back to a
traditional layout and dimensions more like print media.

Feigl liked exploring the Net for art, and presenting it to people in the
room, to discuss it with them. Feigl was the first to show me the work of
Jodi at the end of 1995. Their very expressive and strange *Automatic Rain
System* totally blew my mind. It consisted of different layers of images,
in which a background would automatically scroll down, and another
image would blink and constantly change over it in the foreground. By
clicking on the cipher rain, the work would change ever so slightly, over
and over again, giving the illusion of great depth.[38] The total effect was a
bit like a blue, and much more complicated, version of the green cipher
rain in *The Matrix*. Despite my encounters with early net art pioneers
like Robert Adrian, Karl Dudesek, Gerfried Stocker and David Blair, this
radical visual approach to the Web was completely new to me – and
to others. My curiosity was piqued even more after Jodi began sending
highly abstract sign/ASCII drawings to Nettime. It was the beginning of
many years of following the work of these artists.

Similar situations in which people shared their work and that of oth-
ers occurred at media labs and similar spaces, like the Soros Foundation
offices in Eastern Europe and Moscow. The energy was enormous and

highly infectious. The human 'interface' of the media lab provided a very different Internet experience from those of most individual users today, whose first online experiences involve coping with the standard Windows settings of their newly purchased computers, while they struggle their way through layers of useless software trials. In 1997, Lialina described how an artist became her first online 'guide'. 'I am very happy now that my first meeting with the Internet itself was in a situation where Alexei Shulgin showed it to me,' she remembers. 'The first things I saw on the net was not [the] home pages of different companies, but work by Jodi [and] the Nettime mailing list.'[39]

The social and critical environments of the labs and Nettime were, in turn, obvious at the Next5Minutes (N5M) tactical media festival. Here, artists, activists and theorists from all over the world came together to talk about art and activism in a rapidly-changing media landscape. This is the background out of which net.art was born. 'Little by little I became part of the international net art community,' Alexei Shulgin stated in 1997. 'I attended a few conferences. The most important one was "Next5Minutes" in Amsterdam in 1996, where I met some people whom I knew before through the Net, like Heath Bunting and Jodi and Vuk Cosic.'[40]

Next5Minutes

In January 1996, Next5Minutes 2[41] occurred as a result of a collaboration between various Dutch institutions such as V2, De Balie, De Waag and a few smaller or underground initiatives, such as Amsterdam's free radio stations. N5M initiator David Garcia likes to call the N5M meetings 'tribal gatherings'.[42] The meeting of many, often very different, minds and the focus on practical issues and grassroots action at N5M created a lot of spin offs in terms of small-scale initiatives and collaborations across borders. However, they mostly created a strong sense of community. 'Meeting in real-life,' Geert Lovink noted in describing Nettime in 1996, 'for me still is the most effective and fastest way to build a network (like V2_east, Nettime or Next5Minutes) and exchange arguments. It's not "just" work (or not yet).'[43]

N5M2 was a sort of chaotic ecstasy of small projects, workshops, performances and panels, with topics ranging from local media strategies to Hakim Bey's Temporary Autonomous Zones (TAZ)[44] and

cyberfeminism.[45] The most important issue was the rise of the Internet. The emphasis on independence and 'hands on' media projects spoke to the artists. Some of them looked for ways to understand and use the technology involved, or to have more control over the representation of their work. The undefined Internet space, with its international communities and broad reach, offered a chance to escape traditional channels.

'The way I was treated by Western art critics,' Alexei Shulgin indicated, in an interview with Armin Medosch, 'as a sort of typical or somehow always as a Russian artist, maybe was one of the motivations why I started to work with the internet.'[46] It was clear that the rise of the Internet would revolutionize many aspects of cultural development, and this appealed especially to the artists who were looking for new ways of working. This is where artists and activists found each other at Next5Minutes. From here on in, however, net.art's relationship with the grassroots politics of N5M and the critical community of Nettime strongly informed its political dimensions.

Net.Art.Per.Se, Digital Chaos and the 'Secret Net Art Meeting'

The bottom-up politics of net.art was an obvious influence on the three meetings that net.artists organized themselves. A very ympathetic aspect of net.art was the lively and productive social environment it fostered. Net.art was the result of a powerful mixture of an almost continuous public *and* private communication involving online collaboration and intimate friendships that would become increasingly stronger via their occasional meetings. The community setting this produced was as important as the individual works of art it spawned.

Many stressed the importance of approaching the Internet as a social space with definite physical dimensions (in terms of both technology and cultural structures), rather than as a virtual or bodiless environment. Lovink often talked about the crucial role of Nettime's 'flesh meetings'.[47] The British magazine *Mute* published the slogan 'Proud to be Flesh' under its logo on the cover, which is now also the title of their first book.[48]

Even if some net.artists were leaning towards a somewhat romantic technocratic approach, net.art's social dimensions were very important. Net.art was about 'friends', says Jodi, it was about 'talking to smart

people interested in the rare thing that interested me too,' Vuk Cosic observed.[49] This intimate and informal setting produced a more conversational exchange of knowledge. There was an emphasis on self-education, sharing and informal teaching. This not only encouraged artists to create their own virtual 'institutions' and platforms,[50] but also resulted in organizing physical meetings that were deliberately different from well-known, big media art conferences such as the Dutch Electronic Media Art Festival (DEAF), Ars Electronica and Siggraph.

What could be more pleasant than getting together with friends, eating Italian ice cream, talking about art and philosophizing about radically changing the world? Net.art.per.se in 1996 seems to have been just that. The ice cream meeting of net.art.per.se is exemplary of how this particular 'scene' came together and stayed together for quite some time. Hakim Bey's idea 'every day a holiday' was very popular back then.[51]

'We were sitting around for two days eating ice cream in Trieste, end of May, which is something you absolutely have to try in life,' organizer Vuk Cosic observed in an interview. When asked about documentation from the event, he said:

I don't really believe in secret societies, I don't believe in mafias and in mercenaries, but it makes a lot of sense to just meet, talk and not think of real academic or whatever other kind of output. We met, there was a lot of quality in [the] exchanges, a lot of dynamics, and it was pretty intense. It was just intense and nobody was thinking of how it will be an essay or a journalistic text.[52]

One person *did* consider how net.art could be described in an essay. Cosic's description does, however, reveal the easy-going, fun attitude that was part of early net.art. 'Andreas Broeckmann came with – how do you say this – a sketch for an essay about net.art,' he continued. 'It somehow coincided in time. He had the opportunity to test his theory. We also had the opportunity to test him.'[53]

Net.art per.se. did produce some documentation, however, besides Broeckmann's statement. Cosic, Wagenaar and one anonymous collaborator who went by the name Guillaume Appolinaire,[54] presented a short essay to conclude the meeting. It shows a great sense of drama and

irony and presents a significant portrayal of their ambitions and need for identity at the time. It reads like a manifesto:

> Net.art can in no way be considered a systematic doctrine; it does, however, constitute a school, and the activists who make up this school want to transform their www art works by returning to first principles with regard to online inspiration, just as the media. artists – and many of the net.artists were at one time media.artists – returned to first principles with regard to interface composition.[55]

A few weeks after the ice cream session in Trieste, another meeting, called 'Digital Chaos',[56] was held in mid-June in sunny Bath, just south of London. Heath Bunting, who makes no secret of the fact that he truly dislikes institutional gatherings in fancy places, organized the event with a small local media lab called Hub. The 'Digital Chaos' event took place in the small billiard parlour above a pub. The contradiction between the space and the event was very funny. Artists, critics and curators had to sit on or stand behind a large pool table to present their essays or speeches, their audience often sitting less than a metre away.

Among the speakers were artist Marc Garrett (who was to initiate 'Furtherfield.org', the European answer to Rhizome some years later), Drew Hemment (now director of the FutureEverything festival), Yve LeGrand (a student from the Frank Mohr Institute who, like Nara Zoyd, was one of the first internationally renowned Dutch net artists), Pit Schultz (conducting a discussion about net criticism) and Cherie Matrix, the host of London's Backspace media lab, and also the editor of *Tales from the Clit*, a book on women and pornography. She moderated a group discussion on feminism and censorship.

The event was so relaxed that it never felt like a conference, and more like a pleasant work holiday. This was exactly what the organizers wanted, without losing any of the urgency inherent to the debates. The subtitle of the event, 'slacker cyber conference', was a criticism of the hypercorporate work ethic that dominated many new media initiatives and events. The Digital Chaos slogan was 'Better Slack Than Whack'.

'There is none of this kind of "heavy structuring", which I know that the next conference I go to will have a lot of,' said curator Kathy Rae Huffman about Digital Chaos in a radio interview. '[At the next confer-

ence] there will be the people who had to pay to get in and the people who got in free. Here it is a bit more like a working session.'[57] One could hear children playing in the background, asking for ice cream.

Later, back in London, I asked Bunting about his motivation behind organizing this conference and the performance he gave there. 'I am very interested in reversing the usual uses of technology,' Bunting explained. 'For instance, technology is usually used for mediation and protection. I'd like to reverse those and make technologies for vulnerability and presence.'[58] Bunting's performance consisted of a tour through Bath's back alleys and secret nooks. One of the things he talked about during this walk was how, during his homeless days in the early 1990s, Bunting was one of very few Brits who carried a mobile phone with him at all times. This is how he stayed in touch and could react to new job offers. He remained on the grid, even if he was living off of it.

Only six months later, in January 1997, the 'secret net art conf' in the 'Anti with E' series[59] at Backspace was organized by, again, Bunting. This mini-conference in an alternative Internet café and media lab in London's Wharf District brought together over 20 speakers on one day, each of whom were allowed only five minutes to present their work or thoughts. 'People were very skeptical about that to begin with,' Bunting remembers. 'But once you sat there for a few hours and had gone through 30 presentations and everybody knew what everybody else did ... it seemed to work, people were surprised that it worked.'[60] It brought together many key people from the European new media art scene.[61]

It was probably the most compact and productive conference I have ever been to. Whereas Digital Chaos lasted four days, most of 'the secret net art conf' was concentrated into a single day. Presentations and talks occurred in- and outside of Backspace's main room almost simultaneously, as the event overflowed beyond its initial space into the hall, stairway and workspace of the offices upstairs.[62] Like most other conferences, the talks and debates would continue until late in the evening in a restaurant and bar. It was different from other conferences because there was a complete lack of formality in the official programming.

The event was so crowded, dense and energetic that, after a few hours, it was impossible to maintain an overview. I still regret not acting fast enough when Jodi started to sell their work on old-fashioned diskettes in a hectic little auction, in an attempt to counter the general

idea at the time that net.art could not be sold. Curator Kathy Rae Huffman bought one for only ten pounds, and then Jodi's five minutes were up. This meeting was the beginning of a crucial year for net.art. It spurred the consolidation of the net.art group, whatever that was, if only for a short period of time. Even if Jodi, against the grain as always, at this 'secret net art conference', said that the 'group [net.art, JB] has already split itself up',[63] this would not really happen for another year or two.

Naming, Branding or Being

Until the spring of 1997, nobody had yet used the term net.art but the artists themselves. After the meeting in Trieste, where Broeckmann had 'tested' his text 'Net.Art, Machines and Parasites', which was published on Nettime in March 1997,[64] 'net.art' (at the time just 'net art') became a kind of 'articulated' meeting ground for artists who had recently started to explore the possibilities of the Internet. There had been art online before; it just did not have a specific name. This means net.art (in the sense of both movement and genre) was not something completely different or separate from what other artists were doing with the Internet.

Broeckmann's text is a little odd because it never mentions any of the net.artists by name in the body of the text, only in the footnotes. He does mention some of their projects but without saying who did what. Broeckmann describes Alexei Shulgin's *WWW gold medal* where non-art websites were given prizes. The project was a mixture of found footage as art and an anti-art statement with Broeckmann playing one of the 'jurors'. Another net.art project he mentions is *Refresh*, a collaborative project by Cosic, Shulgin and Broeckmann himself, which became one of the largest collaborative net.art works ever. The third project Broeckmann describes is *Net.art per se*, in which he, of course, also took part. These projects are then used to support a theory about art and the Internet based on Michel Serres's notion of the parasitic.[65] Broeckmann notes:

[Net.art's] cheerful dependence on and exploitation of the technological dispositive, the mild irritation that it causes at the cost of the apparent functionality and rationality of the network system and the transgression of its symbolic system of sites and homes, suggest that

the parasitic might be a useful metaphor with which to describe the gestures and interventions of Net.Art.[66]

'Net.Art, Machines and Parasites' is a typical early net.art text, in that the writer is also part of the net.art community, and, at the same time, analyses and stimulates net.art's practices. It is a constructive, active essay by an insider. Broeckmann is careful not to mention the artists in the body of the text, because he is one of them. The result is a thinly veiled manifesto, which reads like a study. Broeckmann even denies the existence of the individual artist online: 'The net.artist is a collective that becomes stronger and more beautiful the further disturbed and discreetly interconnected it is.'[67]

Broeckmann's essay provoked a lot of discussion after it appeared. David Garcia started the discussion by pleading for the 'ditching' of the term 'net.art' in favour of 'art on the net' in order to prevent a new generation of artists from taking 'the wrong direction by some residual folk memory of the theoretical somersaults and tedious technological formalism that accompanied debates about what might or might not be real "video art".'[68] His doomsday interpretation was quickly responded to by another British artist, Carey Young, who pleaded for a more precise definition of net art:

It seems to me that there is at present a distinct lack of art activity which actually exposes and explores the Net's possibilities, rather than employing it as a glorified catalogue, a function which may of course be categorized as useful, but hardly scintillating.[69]

Broeckmann, Garcia and Young's texts all have one thing in common: none of them in the end really give credit to the individual artists who actually were already using the Internet in interesting ways and producing quality works, even though Broeckmann does mention some of them in his footnotes. I think it was a mistake to start a critical discussion about net art without clearly acknowledging the artists already involved. For me, this was the moment that I began getting involved and started to publish interviews and an occasional strategic note.

The discussion about specific terminology for art online was to be the beginning of an almost endless cycle of critical and ideologi-

cal debates that at the end of the 1990s completely overshadowed the actual state of art and the Internet.[70] All net art was approached the same way, and judged in terms of political usefulness, an approach that affected most of the net.artists since they were all part of Nettime. Sadly, net.art became entangled in an ideological battle that had little to do with it in the end, and a strong call for political correctness from its own periphery slowly began to stifle creativity.

Radical or provocative statements from individual artists like Bunting or Shulgin were mistaken for group ideology and pure political activism. 'Artists!' Shulgin wrote in his pamphlet 'Art, Power and Communication', which was posted on Nettime in 1996, 'try to forget the very word and notion 'art'. Forget those silly fetishes – artefacts that are imposed [on] you by the suppressive system you were obliged to refer your creative activity to.'[71]

Critics within the sphere of media activism took these statements literally and did not look for nuances, whereas they obviously represent a kind of pose, or part of a play with identity and representation that may be quite serious, but does not have to be.

Shulgin, in a 1997 interview with Medosch says quite the opposite: 'If we get rid of that word art, what shall we have then? How shall we identify ourselves and how shall we find contacts and how shall we create a context?'[72] Bunting explains this contradictory position from his own perspective by stating, with barely hidden admiration:

[Shulgin] fits perfectly in the Nettime rhetoric of charity for impoverished artists. He has successfully exploited that. He comes to these meetings, he says very little, just goes out, eats dinner. He is in another country. He never talks about politics really, he talks a little tiny bit about art issues and that's that. It has been a good zone for him to use.[73]

This playing with political clichés and the dynamics of both activist and institutional discourse was a logical element of the elaborate experimentation with cultural shapes and forms online. But within the context of Nettime and its many devoted academic critics and highly focused activists, it placed a ticking time bomb under the social networks and fragile interdisciplinary collaborations involved. Net.art's

'natural', historical connection to the tactical media field created a bit of a nightmare, and the term 'net.art', as useful as it had been for simply pointing to the art created with or on the Internet, soon became problematic.

Different Contexts, Different Meanings

From the very first public discussion about net.art, some artists revealed their discomfort with the term, because they didn't want to be seen as a group. Lialina, in March 1997, on Nettime, wrote: '[There] is no such group looking for [a] name and group identification.'[74] Dirk Paesmans of Jodi never liked the term at all: 'To cram it in[to] a category, net.art is uninteresting, it's incestuous and limits future developments.'[75] These artists were very interested in exploring the Internet and using it within their individual art practices, but this did not mean they felt like their work was deeply connected on every level. That they did not entirely reject the term net.art, and sometimes only grudgingly accepted its use, is because it did serve an important purpose. It connected a new field of art practices, enabling communication and discussion about shared issues and interests. The discussion it evoked on Nettime is clear proof of this.

At the time when the term net.art appeared, there was no appropriate term for art created with or on the Internet, even though online art projects had already been in existence for a long time. Art created with the Internet would be called media art, telecommunication art or electronic art, terms which are clearly not specific to this new media context.[76] German-American curator Christiane Paul describes the variety of terms: 'The terminology for technological art forms has always been extremely fluid.'[77] The radical ways that the Internet changed production, communication and publishing within the arts as well as in other areas, however, simply needed a more specific descriptive term. This is what net.art offered. Although, not much later, because of its association with Net.Art per se and the group of artists described here, it morphed into the more generic term 'net art'.

The specificity of net.art is charmingly expressed within itself. Net.art is a word with a strange spelling error: a period between net and art, which makes spellcheckers go wild every time. This little 'dot' seems insignificant, but by using it between words or simply in front

147

of a word – for instance, .walk (pronounced dotwalk), or net.radio (pronounced netdotradio) – it creates a kind of 'cyber slang'.

Cyber slang is a form of popular speech (expressed in text); it is part of the new modes of writing that developed among a large group of people working and playing with computers and the Internet. In *Words Made Flesh*, Florian Cramer writes: 'Since ASCII typograms were hacker circumventions of technical limitations, they had an aura of subversion, and were hybridized with slang.'[78] Net.art borrows from this practice. Anything with a dot in front of it represents something that happens on a computer or something that is at least deeply related to computers. This is why the use of the dot made net.art an almost instant success with online communities.

As the dot changes any word it falls in front of, it also changes the meaning of the word art in net.art. Art, that word representing an art world everybody seems fraught with these days. In online circles – but definitely also outside of them – art has become a very uncomfortable word to use. The borders of art have been stretched to their limits and still it seems impossible to cross them. What better way to express a new approach to art through new media than by using a term that reflected this change itself?

The name net-dot-art, however, not only embodied new art practices and environments, but it also introduced the ironic attitude of some net.artists of the name itself. In 1997, Shulgin, in a group discussion, stated: 'For me that dot is also very important because it signifies that it's not that serious. A movement or a group can't have a name like some computer file.'[79]

The term 'net.art' was originally coined by Berlin artist and Nettime co-founder Pit Schultz.[80] He thought up the name for an experimental slide show exhibition he had organized in a club called Bunker in Berlin in 1995. This show exhibited the online works of four artists (or five, since Jodi are two artists): Cosic, Bunting, Shulgin and Jodi. Here the hum of the slide projector was used to create a sort of techno rhythm, by playing it through a sound system and adding a delay. Schultz had met these artists before in totally different contexts and brought them together for the first time. He had been greatly influenced by his experiences with the online platform The Thing, founded by German artist Wolfgang Staehle, which has hosted discussions and art experiments

online since 1992.[81] The mixed feelings that many people had about net-dot-art, however, provoked Shulgin to invent a story about its true origin, in an attempt to mock the ongoing debates about what net. art was, who made it, and whether this practice really needed its own term.[82] He claimed it was a ready-made, created by the incompatibility of a certain email software.

Shulgin's appropriation of net.art's origins shows that the art practices of this era were also very much about pose and play. Net.art added a strong ironic gesture to a previously rather formalistic online art practice. It added the element of humour. The irony was not just applied to art and the art system itself, as in some 'pre-Internet' art, but it was also applied to the ideologies, utopianism and hypes that were associated with new media. The Internet, its content and its (however new) traditions not only served as a kind of medium, but also as material for various, sometimes controversial, art projects.[83]

An early text that refers to this ruthless play with signifiers and presumptions is German artist and co-founder of Internationale Stadt Joachim Blank's 'what is net art? ;)' which was posted on Nettime in 1997, in which he writes: 'Unlike context systems, individual net artists or groups in the net operate without having to take into account the visitors on the websites or the limits of the medium. "Service" is the last thing on their minds.'[84] He further described how some net artists like to play with the expectations of the visitor, creating net art almost as a form of satirical or absurd theatre. A similar irony and satire was applied to net.art itself, as illustrated by Shulgin's story about the origin of the term 'net.art'.[85]

From Context to Audience

In hindsight, the year in which net.art got its name turned out to be a crucial year for net.art, in which the artists created their own mailing list and the first major net.art exhibitions were organized. The naming quite inevitably was the result of a surge of activities that continued for almost two more years, after which the scene dispersed but never really disappeared. The appearance of net.art as a specific group of artists began taking shape during the secret net art conf in London in January 1997, a year after Shulgin, Jodi, Cosic and Bunting met for the first time at N5M2. It is here in London that Lialina also became part of the equa-

tion. Connections and collaborations started to mount. A few months later, in May 1997, the first big Nettime meeting entitled 'Beauty and the East' was organized independent of the other conferences.[86] Cosic was one of the main organizers, as a member of Ljudmila, the media lab located in Ljubljana, Slovenia, and all of the artists now associated with net.art were there. But, what had been a minor disagreement within the Nettime community developed into a real schism, which probably helped strengthen the notion of net.art as a very particular group of artists.

Differences of opinion were already beginning to show in 1996, which precipitated the publication of an alternative Nettime publication, filtered by Cosic and Bunting. Nettime initiators Lovink and Schultz had already published a few publications of interesting content from the mailing list, called *ZKP* (Zentral Kommittee Proceedings, which poked fun at Communist proceedings). The first *ZKP*s were simple Xeroxed booklets. In 1996, Lovink and Schultz produced a third *ZKP* compilation for the Metaforum 3 Conference in Budapest. Lovink and Schultz preferred more academic and activist essays to the art mailing list work, which provoked Cosic and Bunting in November 1996 to create an alternative selection for what they called *ZKP 3.2.1*.[87] This was a friendly yet clear intervention with Nettime policy and a joke on Nettime's own ironic flirt with old communist practices. A group of 'dissidents' had revolted against the 'Zentral Kommittee'.

In Ljubljana, however, it became clear that the artists, on the one hand, and the academics and activists, on the other, had very different interests in the end. There had already been complaints on Nettime about art mailings from the academics and activists, as most of them did not care much about art or simply could not see the poetry of a Jodi mailing, for instance.[88]

Nettime's owners kindly requested that the artists 'tone it down' a bit. This was strange, because Nettime was founded at the Venice Biennale in 1995 by a balanced group of artists, critics and activists. The connection to art, therefore, was initially very strong. A steady move towards academic theory and political activism, however, soon clashed with Nettime's art base.

The big meeting in Ljubljana was to be a turning point for Nettime and net.art. In an interview, Bunting described Nettime as something

that had changed from context to audience.[89] This was an important issue, since a crucial aspect of net.art definitely was an intimate social form of interactivity, through collaborations (in the shape of both technical or theoretical additions to a work) in online communities. The number of (inexperienced) Internet users was growing rapidly, and this had an impact on Nettime. The gulf of 'newbies' this produced disturbed the delicate balance of understanding, sharing and collaboration within existing communities. Many new Nettime subscribers saw the list as a kind of online magazine, rather than as a participatory space. Very soon after Lubljana, Bunting, Cosic and Jodi set up their own mailing list. The list was hosted by Ljudmila (through Cosic and his collaborator and programmer Luka Frclih) and was called 7-11, after the well-known American 24-hour convenience store. First, however, came dX, the tenth documenta. For all of net art (and for the broader Nettime community) this was a crucial event.

dX: Net.art and Workspace

1997 was the year of the first major exhibitions that showed net art. The most important of these was no doubt documenta X, or dX for short. Its chief curator Catherine David had asked the Swiss curator Simon Lamuniere to create an Internet art exhibition, online as well as in Kassel. Of the net.art group only three artists were selected by Lamuniere: Bunting with his *Visitors Guide to London* and the duo Jodi with their site jodi.org.[90]

The artists did not seem very impressed by their invitation. It was constantly played down in conversation.[91] Apart from the minor awkwardness that part of the net.art 'group' was excluded from this exhibition, this disregard for the significance for dX was mostly due to two factors, which together revealed a clear discrepancy between the traditional art world and online art practices. These were the curator's decisions on how to display the exhibition and the experimental installation of something called 'Hybrid Workspace' or Workspace for short.

Lamuniere set up the online exhibition as if it were an ordinary exhibit in a physical space. There was an online opening, which preceded the official opening, and there was a finale. The latter seemed especially strange because temporary net art exhibitions were still an anomaly; they did not exist, at least not intentionally. Art online was

(and really mostly is) a bit like art in public space: available at any time, indefinitely, or until some system crashes, domain names expire, or software is not updated.

The presentation of the works at the dX site in Kassel was another point of concern. Bunting and Jodi's works had always resided in the Net. This was something they were proud of; it was important to them. At dX the works were presented completely offline. The computers that the works of art were shown on were not connected to the Internet, and this truly bothered some of the artists. The online exhibition also showed the works, but as closed structures with no external links.

In an interview, Catherine David points out: 'This was the decision of the curator, Simon Lamuniere, to have frozen screens, and not to have people using the computers as telephones. This was an aesthetic and also an economic decision.'[92] The works were presented as standalone objects, in Kassel as well as online. The dX website only provided a few selected links to outside platforms (separate from the art works), such as Bunting's site irational.org, the website for Adilkno (the writers' collective Lovink was a part of) and äda' web, the first (net art specific) gallery on the Web. Since the whole idea of exhibiting net art in a physical space was alien to most of the artists involved, they largely withdrew from discussions about its display. But there seems to have been another reason, and this was Workspace.

Workspace was a project initiated by Catherine David, who was particularly concerned with documenta's format and its role and identity as an art site. In the introduction to the dX guide she writes:

> The extreme heterogeneity of contemporary aesthetic practices and mediums matched by the plurality of contemporary exhibition spaces (the wall, the page, the poster, the television screen, the Internet) and the very different, even irreconcilable experiences of space and time they imply necessarily oversteps the limits of an exhibition held 'entirely' in Kassel, just as art now oversteps the spatial and temporal but also ideological limits of the 'white cube' which constituted the supposedly universal model of aesthetic experience, a model of which documenta, even in its 'open' version, is a willing or unwilling offshoot.[93]

The inclusion of Internet projects had been one way of dealing with these issues, and the Workspace experiment was another. In an interview at Workspace, David explained:

> My position was clear, to have no art on the walls and not to use the art alibi as an authorization of the Workspace. I know some of my colleagues are not sharing this position. I don't care, because if you look carefully at young artists' works, the radicality stops when they are confined to an art space. The space is now articulating the notion of information and discussion, in connection with contemporary research and positioning.[94]

David had approached the Berlin art institution Kunst Werke to organize the project, which, in collaboration with Hans Ulrich Obrist, decided to ask Lovink and Schultz to develop a programme. Lovink and Schultz decided to split up the 100 days of documenta into ten separate ten-day programmes, all of which were to be filled independently by various groups from the Nettime community. Among these were the Syndicate (Eastern European, also known as Deep Europe) mailing list, the tactical media network (basically a N5M project), the UK magazine *Mute*, Amsterdam's De Waag (their slogan was 'we want bandwidth'), the Cross the Border activist network (with their 'no one is illegal' campaign), The Old Boys Network (which hosted the first Cyberfeminist International) and Vienna's Kunstradio. Apart from the activities in the Orangerie in Kassel, the project also included ten online newsgroups and a radio station.[95] Kassel was a vibrant meeting point for net workers from all over Europe and beyond for the entire summer of 1997. The apartment for Workspace participants was almost constantly filled to the brim, and trips to, for instance, Marko Peljhan's Makrolab (an art project consisting of a hyper-networked mobile home, situated in the hills around Kassel) created a near holiday atmosphere.

The contradiction between the closed space of the net art exhibition and the lively environment of Workspace, in which half of the Nettime community and its periphery participated, made Lamuniere's exhibition seem like a kind of dead-end street, or a social vacuum, for net.art. The action was elsewhere: on the Net, and at Workspace, which personified the network. The documenta curators did not understand

the way that net art is, like art in public space, more deeply embedded in a broader cultural context than simply some white cube. It cut net art off, literally, and presented it in a bland office-like space, where a diligent, traditional art audience studied its documenta X guidebook thoroughly before carefully touching the mouse of a computer.

It is rumoured that Lamuniere had to fight to get every net art project represented separately in the documenta guidebook; David had wanted to give the online projects one single, simple overview page. Misconceptions of net art on the part of both Lamuniere and David made participating in this show a little uncomfortable for many of the artists involved. It was no real surprise, therefore, that when Lamuniere announced that the dX website was closing down, it was hijacked and copied by Cosic.[96] This, at least, allowed its content to go home again, back to its basis.

Ars Electronica Festival 1997: Remote-C

It is striking that a traditional art festival like documenta and other media art festivals would foster interest in net art at the same time. One would expect media art institutions to have been forerunners in this area. The electronic art festival Ars Electronica had launched a prize for works created for the World Wide Web in 1995, when the Web was beginning to become more widely used by artists.[97] In 1997, they opened up the competition for this prize to the entire Internet, which seems like a response to the net.art hype. An indication of the latter was the prize category's name: .net, with obligatory dot. This might have to do with the fact that media art institutions such as Ars Electronica basically approach art from a technological point of view. Armin Medosch calls this the field of 'high media art'.[98]

The Internet is technically almost the same as the computer networks that were used in projects Ars Electronica had been supporting since the early 1980s: in all of these networks (the Internet as well) computers are attached to cables (wireless technologies only became common around the turn of the millennium), and all communication (file exchanges) takes place through coded commands. By more or less ignoring technology's cultural make up and its various social, political and economic applications as an important influence in different art practices and art contexts, 'high media art' institutions missed the

cultural significance of the Internet and net art almost completely and never really recognized it as a new environment.

Media art institutions such as Ars Electronica and ZKM did not get involved in the online art discourses as they unfolded. Like traditional art institutions, they did not recognize the influence and vitality of mailing lists like the American online art institution Rhizome or that of Nettime by taking part in them.[99]

In September 1997, Ars Electronica organized an event that was a kind of cross between Workspace and the net art exhibition at dX. Ars Electronica provided a special space, named OpenX, where artists were asked to collaborate on developing a special art 'web ring' for the festival. This ring was called Remote-C. A web ring is a series of connected web pages (usually on different servers), which are programmed in such a way that a browser will jump from page to page, from server to server, producing a kind of endlessly rotating slideshow. OpenX was an experiment, which was to be repeated a few times by Ars Electronica in subsequent years. It exhibited the network aspect of net art, but did not entirely succeed, according to Broeckmann, who wrote a review of it for the Ars Electronica catalogue the following year.[100]

Broeckmann described how the artists seemed to still be in shock from their dX experience, especially Workspace. Some artists, Broeckmann pointed out, were insecure about how to translate their work for a live audience. This was not my experience at Workspace, where everybody involved worked passionately and had great fun. At dX, the traditional art audience did not know what to make of the unusual workspace presentation format, which required a type of viewing that was different from the typical shuffling past art works in exhibitions. The net artists were, however, not really part of Workspace; their work was represented in Lamuniere's heavily criticized 'office' exhibition.[101] Regarding this unusual exhibition design, Jodi stated:

> We talked to many people standing in the entrance. When they saw the set-up, they said: 'That's not for us; that's some computer world.' In reality we don't work in an office. A lot of people have their computers next to their beds. An office space creates a distance. I don't like to enter an office.[102]

From having no say in the presentation of their work in the documenta 'dead office' design, they were forced to present their work in a 'live office' setting at OpenX. This is probably why 'few were happy about the fact that their processual work was on display as though it was a performance about the artist at work'.[103] It was another alien situation they had little influence on.[104]

After spending a short festival week in Linz, some of the artists held a press conference. It was here that Cosic and Jodi announced the launch of their newest collaborative project, a mailing list called 7-11. The uncomfortable exhibition and collaboration sites they had to deal with that year were replaced by an online meeting place where there was no pressure to perform or behave.

7-11

This mailing list was comparable to other online platforms such as Nettime and Telepolis in the same way as net.art per se was comparable to any institutional conference. 'It was not about posts but about the ways of using the list,' says Cosic, 'Almost like with other net.art – not so much about particular pieces but about new ways of working. We were doing research, not development.' The list can be seen as an experiment in which the dynamics and possibilities of the mailing list format were explored.

At the same time, 7-11 was very much a level social space, for which there was a need after the clash with the Nettime moderators. '[The] honeymoon was over and we needed to separate,' Cosic pointed out. Bunting thought that 7-11 was there to provide a counterargument to 'serious male academic' discourse, after he and 'all of irational.org were thrown off Nettime'.[105] As a reaction to the installing of a moderator on Nettime, which led to the rift, 7-11 was explicitly not moderated.

Over the course of a few months, the membership list grew to about 100. This small crowd made conversation a lot easier than the 1000 or more members on Nettime. Direct access to any list (or other live medium) creates an energetic exchange, which more or less follows the dynamic of actual live meetings. 7-11 was not just an experiment with this particular dynamic, but the artists also tried to incorporate their broader experiences involving the Net.

They did so by creating a virtual persona, a fake identity, that 'acted' as mediator between the list and the rest of the Internet. Emails sent to

this character would appear on 7-11 without the sender being aware of it. Keiko Suzuki, as this persona was called, was portrayed as the author of a fake 'Classics of Net.Art' book series that Cosic had created as a satirical online work of art. Since interest in net.art was soaring, 7-11 members received some charming requests from potential buyers through the book series order form. Suzuki was also used as a fake persona on a kind of dating site, and mails received via this site, often slightly pornographic in nature, also ended up on 7-11.

Bunting and Cosic had created Keiko Suzuki together. They had constructed an administration page from where anybody who was informed could speak as Keiko. Since word about Keiko's reality only spread slowly, her presence caused quite some confusion for a while. After I found out about this prank, I interviewed Cosic acting as Keiko Suzuki, the result of which was posted on Nettime. In his responses to my questions, Cosic clearly injects some of his own experiences, as he switches back and forth between his own experiences and those of the imaginary Suzuki, and makes ironic comments about the net.art hype such as:

> My image fits well with net.art. I *do* do other things, but people choose to ignore them; curators/theorists/audience have their own agendas. It's quite nice to have hidden areas of myself. Do you think a net.art audience would like non-net.art. I doubt it because they want this and only this and they think they're fast if net.art is fast.[106]

The Suzuki character was also a manifestation of a rather sensitive issue: the sexism and male dominance in net.art. Keiko's depiction as a sexy Japanese cyberbabe 'in a shiny short dress and large silver trainers'[107] could be interpreted as a sign of a particular male-female relation in net.art. Because cyberfeminism was a hot issue, this did not go unnoticed. A few 'cyberfeminist' projects had been launched in 1997 (for instance the mailing list 'Faces' for women in new media, launched by Kathy Rae Huffman, and the 'Old Boys Network', founded by German artist Cornelia Sollfrank, who had also organized the first Cyberfeminist International in Workspace).

By 1996, one of net.art's early female members, Akke Wagenaar, produced some ironic works about sexism before leaving the group. She

had presented an adaptation of Valerie Solanas's (the woman who shot Andy Warhol) 'SCUM Manifesto' at Digital Chaos. In this manifesto she states: 'To call a human an animal is to flatter him or her; he or she is a piece of shit, a walking screwdriver.'[108] Her *Radical Playgirls* was a series of fake profiles, which depicted pornographic pictures of women who talked about their favourite cyber gurus. By the end of 1997, the pervasive macho behaviour of some net.artists provoked me to send a fake announcement to 7-11, which included a call for a contest named 'Mr. Net.Art'.[109]

I had created a list of jury members, all of whom were female artists, critics and curators who were well known in the net art scene, and had included Keiko Suzuki in order to re-appropriate her as an actual female. The idea initially was to just poke the men a little bit, and confront them with an impressive all female jury, which would remind the male artists of the presence of many smart women in their midst. The response to the call was overwhelming and funny enough to approach every woman I had listed as a jury member to actually taking part in the contest. All of them said yes.[110] The idea, however, was to promote the jury, rather than the contestants. Mailings about the project contained extensive information about each individual jury member, and very little about the male artist contestants. The jury's decision came in January 1998 and none of the men won. Upon the suggestion of jury member Rachel Baker, the prize was awarded to an art project, the highly influential software art work *Webstalker*, by the British I/O/D art collective.

7-11 continued until January 1999, when Bunting decided to subscribe all of the list's members to a new mailing list on his own server called American Express. He claimed: 'I tried to shut [7-11] down after the software failed, and start afresh as American Express, but people didn't like this.'[111] It was perceived as a private intervention by Bunting, however, and Jodi were particularly unhappy about it. They quickly set up a new version of 7-11, and for a short while American Express and 7-11 were running simultaneously. This incident caused a rift in their relationship.

The American Express mailing list stopped soon after it was launched, after Bunning received a 'cease and desist' letter from the credit card company with the same name.[112] 7-11 had already been

presented with a similar notice in October 1998,[113] but ignored it. It seems that the turmoil led Bunting to shut down American Express but the incident had a dramatic effect on the members of the original 7-11 list, and it went on with mostly new members, ultimately becoming the home of a new generation of artists that engaged in radical experiments with the form and language of mailing lists, such as the Australian artist and poet Mary-Anne Breeze (aka Mez), American artist Matt Hoessli (aka Meta or M@), Lithuanian artist Mindaugas Gapsevicius (aka Mi_Ga) and Romanian-American software artist-rebel without a cause Gheorghe Dan (aka Antiorp, Integer or Netochka Nezvanova). Florian Cramer describes the work of some of these artists in *Words Made Flesh*.[114]

Female Extension

Even if net.art entered the annals of history as a very small circle of friends, these 'net.artists' actually were, as I hopefully have made clear, part of a much larger online art community. One could thus describe net.art as an intimate group of friends. Connections with other artists (outside of the net.art group) were strong, and the work of these artists was generally respected and shared.[115] Collaborations and communication between different groups and individuals occurred from the beginning and continued, even up to the present day (since most of them continue to work as artists).

From the description of 7-11 (and also from the confusion surrounding the term) it may already be clear that the outside perception of net.art was very much dominated by Cosic, Bunting and Shulgin, who were all quite dominant males with a tendency towards theatrical gesture. Even if all three of them had very different approaches, it still made it look as if net.art was basically testosterone-driven. This was only half-ironically toyed with by Cosic years later, when he gave presentations in which he talked about himself and the others as 'the fathers of net.art'.[116]

Donna Haraway's *Cyborg Manifesto* provoked the rise of a new form of feminism called cyberfeminism.[117] The earliest cyberfeminist art group was VNS Matrix, an Australian group of artists that produced texts and interventions during the period 1991 to 1997. They wrote their provocative 'Bitch Mutant Manifesto', which stated: 'We are the

virus of the New World Order, rupturing the symbolic from within, saboteurs of big daddy mainframe, the clitoris is a direct line to the matrix.'[118]

Different cyberfeminist art projects have attempted to focus on countering the typical masculine discourses in new media networks; they subverted the development of digital institutions, on and offline, as it went along, trying to positively influence it in favour of women. Net art, with or without the dot, was one of these institutions.

Cornelia Sollfrank had been part of the particular net.art picture since at least the 'secret net art' conference, which she also attended, but Sollfrank developed her work largely outside of its context. She felt uncomfortable with the way net.art had been presented. In a private email exchange she explains:

> Until today I think that the power of net-based art projects is, or could be, that they do not rely on the traditional art world, but, [being] contrary, could be a powerful way to criticize and circumvent the art world. So, in a way, the anti-institutional aspect is central for me.

In the eyes of Sollfrank, net.art was imitating avant-garde strategies as a way of becoming accepted in the art world, and she felt uncomfortable about this.

Sollfrank started a very elaborate and critical series of projects, which were aimed at subverting certain art institutional tendencies concerning net art and net.art's 'male genius'. One could say her work is doubly critical: with regard to institutions *and* other artists. The first of these projects was finished in September 1997 and was called *Female Extension.* This work was developed to subvert the first major net art prize contest named 'Extension', which had been initiated by the Hamburger Kunsthalle. In a 1998 interview, Sollfrank admitted: 'I wanted to crash the contest. I wanted to disturb it to the degree that it could not be held according to plan.'[119] Net art for Sollfrank had nothing to do with the gallery and museum system, and could therefore not be judged by these institutions.[120] Sollfrank felt that net art was being approached from a far too traditional view of art.

The artist used her extensive list of international contacts to create a huge number of email addresses at servers in different parts of the

world. She ended up with 288 fake female 'identities', which she used to send in 127 individual entries for the competition. These works of art had been generated by a piece of software that was written especially for this task, and which produced web pages not unlike the scrambled looking pages of Jodi at the time. The Kunsthalle proudly boasted about the large number of entries, and particularly the number of women in the contest. But, immediately after the jury announced the winner of Extension, which was not one of Sollfrank's characters, Sollfrank posted the information about her intervention online.[121] From that moment on, to anybody working in the area of net art the obvious, real winner of Extension was Cornelia Sollfrank.

There is more to the story, however. Not only was the competition of the Hamburger Kunsthalle 'hacked', but Sollfrank also commented on the work of some of her fellow artists. She did this via software that generated web pages as works of art (which had been taken seriously enough by the jury that they were mentioned as legitimate entries in press releases). Sollfrank decided to focus entirely on her 'net.art generator', which was an adaptation of the software used in *Female Extension*. 'It is for a good reason that I call the programme "net.art generator",' Sollfrank wrote. 'It is a reference to that group of male geniuses that was simply replaced by a computer programme.'[122] Sollfrank has created a vast oeuvre since 1997, which focuses on the topic of originality and copy, in which she applies numerous techniques from documentary to performance.[123]

Conclusion

Online, life and death are relative terms. Net art, with and without the period, has been declared dead (and alive) many times.[124] Writing a history of it is an evolving and never-ending undertaking. The very definition of net.art alone clearly shifts and changes over time.

In 2003, when I wrote the first version of this text, I asked for definitions from the 'net.artists' themselves. I wondered how they would define net.art almost ten years later. 'The expression net.art signifies a time and a group that was more or less continuously in touch at the time', Cosic wrote in response. Lialina also referred back to times gone by, but she also described a change in her own perception of what net. art is or was.

In the 90s, I refused to use the "." in order to not bring an important phenomenon down to works of a few artists. Now net.art for me means early art on the web, pioneers, a heroic period, interest in the art world, true interest in the public. Not a thousand hits a day because you are listed in a net art category somewhere, but feedback from people who found your website by chance.[125]

Both definitions clearly reveal the importance of the social network in net.art.

Most of the (by now former) net.artists always maintained some distance from the hype around net.art, as I have shown throughout this chapter. Net.art was clearly different from other art movements, if it ever was one, in that the only thing that connected the artists was the Internet. All of the involved artists maintained their own identities and their own practices. The closest any text comes to a net.art manifesto produced was 'Introduction to net.art', a highly ironic, if not self-critical guide for anybody wanting to be a net.artist.

It is a funny and provocative text that is highly characteristic of Shulgin's duplicity, as is illustrated by tips four through nine of 'Promotional Techniques': '4. Do not readily admit to any institutional affiliation. 5. Create and control your own mythology. 6. Contradict yourself periodically in email, articles, interviews and in informal off-the-record conversation. 7. Be sincere. 8. Shock. 9. Subvert (self and others).'[126] The text was written in a personal style by Shulgin and Bookchin, and was certainly not subscribed to by all of the group's members. In any case, 'Introduction to net.art' still reads like an almost biblical or authoritative text, something that is emphasized by the text being carved into stone by the German artists KarlHeinz Jeron and Joachim Blank, like the Ten Commandments.[127]

Net.art, however, still threatens to go down in history as an art movement with consistent properties, despite the lack of a shared manifesto, style or approach. Lialina and Cosic looked for an Internet-specific aesthetic, mainly focusing on the Web. Jodi 'just' deconstructed and toyed with the Internet in every possible way. Shulgin approached the Net mostly as a conceptual space. Bunting incorporated the Net into an art practice that went beyond the technical boundaries of the Internet itself, and made the Internet part of a larger 'network of life'.[128]

I have, of course, asked all of the artists whether they think net.art was misunderstood. 'There are tons of mystifications, starting with the origins of the name,' writes Cosic, 'Most of them were a joke or a strategic hoax. Now they are all perceived as cemented truth.'

Not many people understood what net.art was about, Shulgin points out. In his opinion, there was only some understanding among 'those [who] were involved or around'. Only they 'could appreciate all the fun of it, as it was very much process and communication based'. Bunting has a more exclusive opinion: 'Most people involved did not understand it, so it was hard to explain to others.' Bunting tends to be rather hostile towards critics and curators especially these days, as can be seen in a recent video he made.[129]

Whatever caused it, the confusion around net.art sometimes still leads to a dubious outcome. 'Net.art is taught in universities around the world,' Cosic notes, 'and many young people fall in[to] the trap of net.art mannerism.' It is this tendency towards mannerism that may need to be further scrutinized, such as doing net.art as an empty, radical looking gesture, or, turning to the other extreme, being subversive for the sake of subversion, the net.art clichés. A bigger problem is, however, something Lialina mentions: 'The impression is [created] that there is no continuation.' By declaring net art dead (like it was a movement), artists and critics that had left the field more or less disabled and obstructed the net art discourse for years to come.

In the early years after the millennium this was an especially important issue, and artists working with the Internet were ignored because word had gone around that 'net.art was dead'. There were very few from outside the, by now scattered, small net art communities who understood that this was simply about the ideological myth surrounding the temporary, accidental 'group' we now know as 'the net.artists'. This has only recently started to change, however, gradually, and a genuine interest in the artists who worked with the Internet is on the rise again. And, as it turns out, net.art was quite exemplary of net art in general, exhibiting such a broad variety of styles and practices, despite the clichés that it was stuck with.

The Gap between Now and Then: On the Conservation of Memory

Let's play hide-and-seek with future generations. We hide. The seeker is not among us yet. He or she lives in another era, a time yet to come. We don't know if he or she will be a finder. We are not even sure we want or need to be found. We might simply just jump from our lair one day, reveal ourselves, unexpectedly, to win the game. What triumph would it be, to have the seeker, the finder, an innocent, ignorant player, a victim of our simple game with presence, place-ment and time, be startled by our sudden re-appearance, his jaw dropping, his eyes blinking, his mind racing to understand who or what we are and whence we came from. Yet looking at the reflection in his eyes, would we recognize ourselves?

Embracing the Unpredictable

It is hard to say how a ghost from the past will fit in the future present. Nevertheless, many of us would, despite obvious uncertainties, like to somehow put our mark on the development of history. What part of our heritage remains or continues can never be completely controlled and predicted, however. This is one thing we can say with certainty.

Today we live in a world in which matter consists of bits, cells and molecules. It is not an alien or unnatural place, but it has made saving art for posterity a whole different matter. New institutions and archives have been developed to address the question of how to preserve culture as it 'dissolves' in the digital domain. An abundance of new practices springs up everywhere around these institutions, often with little in-clination to conform to older structures. There is a productive chaos in which amazing inventions and tragic accidents occur almost simultane-ously. We are confronted with an unstable layer of cultural production in which the production of new cultural objects and the production of memory (the archiving of knowledge) merge.

The digital realm is at once a space of possibility and insecurity. This text is, in some ways, about the relationship between conservation and loss. In the area of art conservation, loss is generally defined as physical

decay, destruction or disappearance of the art object, in short: as a nega-
tive event. Over the past few decades however, other forms of loss in-
volving a degradation of material properties have become increasingly
important, and new approaches to art were developed. Practitioners
from the field have offered their insights into this matter, and have
revealed there is already more flexibility in an archive than some may
have assumed. In the context of new media art, net art and interactive
art, a more specific form of loss has started to haunt the conservation
issue: a noticeable loss of control. I will try to show that a loss of control,
despite an understandable psychological, economic and political resist-
ance to it, is elementary for the survival of culture in the context of
digital archives.

The traditional conservator is responsible for controlling the art
object and its environment. This is a logical task when the conservator
must maintain unique and unchanging cultural artefacts in their origi-
nal state. In order to do so, the object is protected from outside influ-
ences. Its contact with the world is carefully regulated, and touching the
work of art is problematic.[1]

With medially diffuse or born digital works of art, however, separa-
tion of the object from the world (that is, the entire complex of media
networks) and creating a closed, controlled structure around it might
not be the best way forward. It may, in fact, lead to the work's complete
demise. The work can wither through a lack of technological support or
disappear due to a lack of context or elementary audience engagement.

Of course, process-based, interactive and participatory net art works
often include a radical change of shape, but the work's identity almost
always depends on *how* this change is provoked or realized. Works that
rely on deep audience participation will evolve from an original work
of art into mere documentation (or notation, with the possibility of
re-enactment) overnight when archived in an environment separate
from the public domain.[2] These works were produced with connectiv-
ity to the network in mind: the network is elementary for both the
form and the content of a work. Without this openness to actual so-
ciotechnological environments, the work is incomplete or, worse yet,
doesn't even really exist. Current digital conservation strategies almost
all focus on the documentation of past events, and not on the support
or maintenance of the 'life' of a work.[3] This strategy evolved out of the

performance field, but even if many of the new media art works are time-based (dependent on interaction plus digital technologies for their existence), their structure is much less fleeting. There is no need to turn these works into documentation before they cease to exist. It is actually undesirable to do so. Experience from the area of conservation (of both art and knowledge) points to a shift in strategies from preservation to co-production, and an altered role for the archivist.

Closing the work off from a living, engaging context and dooming it to a static, shelf existence is, however, not the only issue. Given the known problems with the maintenance of different media systems over the years,[4] the entire disappearance of a work is not unimaginable if only one or a few 'copies' of a work are saved, even if they are stored in specially designed, well-equipped archives.[5] Both openness to a vital context and openness in terms of physical, material and technological accessibility may well be the best way forward in the strategy of conserving art in the environment of new, networked media.

This text is really about conservation *through* loss, through a loss of control, to be exact. We may have a lot to gain from losing control over digital objects. We should consider the ability of some artists to embrace an inherent loss of control over their work less as a challenge to conservation, and more as an inspiration to a solution.

Stretching and Bending Time

In order to illustrate how different approaches to the digital archive can result in very different outcomes, I present two art projects that deal with both memory and its continuation through time. Issues of the conservation and preservation of memory in the digital domain have inspired the collective behind each work to come up with very specific preservation strategies: one looks for permanent, near analogue storage systems that restrict interference, while the other does exactly the opposite: they open their archives to public participation at the core levels of content and information structures. The projects in question have names that clearly reveal their engagement with time: *The Clock of the Long Now* by the Long Now Foundation and *Mission Eternity* by etoy. Both of them are impressive, long-term projects. *The Clock of the Long Now* is hierarchical, closed and authoritative, while *Mission Eternity* is decentralized, unpredictable and anarchic. The consequences of

each approach are significant if we interpret them in terms of cultural politics, social relations, art production and art education.

Whole Earth activist and early Internet adapter Steward Brand, who was one of the founders of the influential online community The Well, initiated the first project, The Long Now. In the early years of the Internet, Brand organized a group of artists and activists to develop ways to deal with the loss of cultural heritage in the digital age. The Long Now Foundation,[6] a kind of think tank, developed several initiatives that ultimately created a more conscious way of handling digital culture. The design of a new clock, a device developed to fit their specific, reflective approach to time, was (and still is) the group's most ambitious undertaking. The basic idea was to stretch our experience of the now, the present, to make us aware of its place in an ongoing history, as it is cradled between past and future.

The clock is connected to The Long Now Foundation's proposal to change the way we count years so that it includes more than just the past, as the present method does. It also includes a large chunk of the ever-approaching and receding future. Instead of saying 'we live in 2010', the Long Now Foundation noted that 'we live in the year 02010', which they called 'deep time'. *The Clock of the Long Now* is constructed to last for centuries or longer: it ticks only once a year, bongs once a century, and only chimes during a millennium change.

To make a clock that lasts this long seems slightly romantic, utopian or sometimes even megalomaniacal, a feeling that is strengthened by the clock's slightly Leonardoesque mechanical, retro-scientific appearance and the current quest for its 'mythical' hiding place. As such, it reminds me of the overprotective archivist caricature, who would rather get lost among his treasures than give them up, making 'his' treasures the basis for legends. I will elaborate on this later. The project has a tinge of arrogance about it, despite its good intentions. But its initial spark made perfect sense.

The Long Now initiatives were established to help us become more aware of the moment, at a time when hyperventilating analyses of the digital highway had confounded many of those involved. They were designed to make us pause, look around, and check to see whether we were not forgetting something in that overwhelming, nervous rush of the Internet boom of the late 1990s. The lack of proper storage

facilities and conservation efforts for digital objects left the Long Now Foundation making a gloomy prediction that we were living in 'the Digital Dark Ages'. Most of us, however, were too wrapped up with upgrading our clunky grey machines, a Sisyphus-like struggle, and followed the hasty white rabbit down the deep dark hole of the dotcom rush.

The second project is by the Swiss-based art group etoy, a group whose first work of art was organizing itself as a corporate enterprise, registered at the Chamber of Commerce in Switzerland. This was a rather different kind of approach than that of the Long Now Foundation, yet etoy proved to be a much more flexible organization. Its corporate appearance is a cloak, a means to infiltrate economic networks that would otherwise remain untouchable or even hostile. It is a strategy that has been employed by more artist and activist groups, some of which worked with etoy, like the predecessor of the Yes Men: RTMark.

At the launch of etoy's *Mission Eternity* in the year '02005', a bit more than ten years after the launch of the Long Now Foundation, not much had improved in the area of digital conservation. Not only digital files and entire histories of digital cultures were lost, but our notions of existence seemed to erode drastically under the influence of ever-more pervasive, variable 'social' media technologies. It was about time that someone should ask about how the increase of the individual voice in these technologies would be integrated (if at all) into the writing of history. Etoy created a radical method for this integration, which combines the recognition of the value of the personal archive with the possibilities and vitality of new media networks.

Mission Eternity is a poetic and provocative work that deals with questions of life and death, and matter and memory, in our highly desensitized technological society. The project's aim was purportedly to realize eternal life, not by prolonging the life of our bodies, but by moving from bio-matter to digital matter at the end of the physical body's lifespan. It blends an often disputed, but powerful logic of digital procreation and conservation with a vivid, deeply interactive and theatrical environment. Etoy combines a symbolic and real actualization of life after death, by transcending death (which they called the 'deadline') through digitization. Etoy designs this transformed life so that it could work independently of forgetful humans and, perhaps one day, reproduce

itself. We have been invited to climb into one of its capsules and set our destination into the distant future.

Traditional archives are in analogue format. They operate in a linear time frame. Digital media are different. In his book *Sync, Stylistics of Hieroglyphic Time*, the American artist James Tobias describes how new media installations can also be seen as 'queer clocks: devices that diagram, express and interpret unfamiliar temporal relations'.[7] Within new media installations, digital 'machines' represent the true origin of this particular experience of time. The variety and malleability of software (those digital machines) creates an extreme temporal non-linearity, which implodes, producing an experience of an overwhelming 'now', especially in a networked environment. The digital time experience is one of immediacy. This has consequences for both the archive and the archivist. Fortunately, experimental art practices over the twentieth century have already provoked conservators and archivists to develop a few highly flexible conservation and preservation strategies.

High-Velocity Decay

Allowing instability and possible destruction by relinquishing control of (at least part of) an art work might seem rather disturbing, but there are plenty of precedents. One could say that what we tend to perceive as a (relatively) stable, 'traditional' modern art archive, is in fact already a carefully maintained balance of contradictory forces, a hidden contestation of the sanctity of the art object. The 'untouchable' status of the work of art has often been challenged, and long before the issue of 'interactive' works of art ever arose.[8] Modern art is also full of examples of works in which the archive seems to have become the battleground – or the stage – of radical or critical art practices in which the boundaries and limitations of the art object were tested. Recent conservation strategies now include an acceptance of varying degrees of change and even loss as part of a work of art.

In his essay, 'The Restoration of Decay',[9] the German-Russian philosopher Boris Groys presents an ironic but useful theory about the interactions between the artist and the conservator through the choice of the materials used for a work of art. Groys writes how 'modern art can be described as a symbolic staging of all possible forms of decay, which are [in turn] prevented by the museum's preservation work'. As such 'the

169

work of conservator and artist are complementary'. He notes that the complementary activities of conservator and artist create 'a bewildering vision of the slow death of the art work through physical decay, a decay that is continually delayed and pushed forward, so that each stage of this decay remains fixed and visible'.[10] The work of art, therefore, is subjected to a kind of continuous, manifested re-composition.

More recently, however, the development of new contexts and uses for the art object has increased the level of engagement necessary for the restoration of works of art. Referring to the rise of the artist-curator Groys writes that 'the museum has been transformed into a stage for . . . temporary exhibits and installations', which are perceived and presented as 'events we call art'.[11] In order to restore this complex compilation of art works, Groys suggests the conservator should become an active interpreter of the highest degree, like a film director or the conductor of an orchestra.

This is confirmed by a recent study by Dutch cultural heritage researcher Vivian van Saaze of such a compilation work. The placement of Philippe Parreno and Pierre Huyghe's *No Ghost Just a Shell* (a work consisting of a collection of works that fit into the 'No Ghost Just a Shell' theme, produced by a number of different artists) in the Van Abbemuseum's collection in Eindhoven created many new challenges for the existing division of tasks within the museum, in which the conservator actively needs to enable the identity of a work to succeed. Van Saaze observed: 'Rather than being "passive custodians", those responsible for contemporary art collections are now considered to be an interpreter, mediator or even a co-producer.'[12]

Other voices from the field have suggested something similar, even if in a slightly different context. Groys's observation about the role of the conservator as a kind of director or conductor is not just applicable to non-mediated compilations and installations that need reconstruction. In fact, in her essay for the Variable Media Initiative book about the conservation of physically highly unstable works of art, Carol Stringari, the senior conservator at the Guggenheim contemporary art department, observed that 'the preservation of specific materials such as video, slides or digital art requires that certain preservation decisions be made shortly after the work is acquired'.[13] This obviously suggests that some materials deteriorate faster than others, or that works created with them may

immediately need to undergo some type of re-composition. One could say that, with certain materials, like software or code art, the struggle against decay is moving in the direction of a real time, live intervention/action by conservators. They demand a lot of insight into individual works and an eagerness to intervene or reconstruct the works.

In keeping with Groys's notion of the conservator as an active interpreter, this specific type of conservation is generally hindered by the absence of a score or a script, which informs the work of the conductor and the director. In order to preserve art that is produced using unstable media, or to restage any process- or time-based works, it is necessary to know the artist's intent and work process. Several institutions have started to use the Variable Media questionnaire, a very specific interview with the artist, as a kind of score or documentation form for unstable works of art. Stringari speaks highly of this new art conservation tool. According to her, 'this interaction will help define acceptable degrees of change in an effort to preserve essential components that must remain fixed for a work to retain its integrity. Defining acceptable degrees of change, however, inescapably implies that one also has to define what Stringari calls 'acceptable loss'.[14]

The notion of 'acceptable loss' establishes a connection between the reality of new media art conservation and Groys's description of the visible, fixated stages of decay inherent to earlier modern art. Here the visualization and fixation (of loss, the ultimate form of decay) is of a different nature, however. If decay was part of the dialogue between artist and conservator in their complementary roles (emphasizing and visualizing anti-institutional, critical practices and other tensions inherent to art discourse), then an agreement on acceptable loss may suggest that the complementary roles Groys describes have already turned into basic collaboration.

Stringari notes that the meaning of a work 'may lie in its inherent transformation or degradation'.[15] This suggests a total acceptance of what were once problematic characteristics within the professional practice of the conservator. Accepting that the meaning of a work may lie in (or is best represented through) its transformation, its degradation even, or some other kind of loss of original form (if the work ever had an original form in the first place) seems contradictory to the essence of conservation. It could be an indication that a door has been opened for

highly unstable works of art to enter that most conservative bulwark of art, the institutional archive, on their own terms.

The Variable Media Questionnaire is only one of several strategies or tools for this kind of conservation, and the solution is mostly sought in notation, suggesting that Groys was right, and the conservator becomes a kind of director or conductor. As media art works are 'unstable', the thought of saving them for posterity by 'capturing' them through an open and flexible conservation strategy like that of notation makes perfect sense. The American artist Ron Kuivila suggested using the notation/realization strategy at a presentation at V2 Rotterdam in 2000 as a solution for new media art conservation. In the interview I did with him, he stated: 'I mean notation in a "prescriptive" sense that sets ground rules for a complementary activity – realization – rather than in a "descriptive" sense that specifies a work fixed in every detail.'[16] The Variable Media Questionnaire had already been launched by then, but it had not yet reached Europe.[17] It is used as an inspiration and possible element in another notation/realization strategy, that of the Media Arts Notation System (MANS) established by the American artist and curator Richard Rinehart.[18] This, in turn, inspired a notation system for performance art called the Performance Art Documentation Structure (PADS), developed by the British scholar Paul Clarke.[19] These projects not only show a broad recognition of the potential of notation/realization in the conservation process, but also the high level of sharing and collaboration that is already in place in the field of variable media art research.

MANS is a kind of extended version of the Variable Media Questionnaire, in that it also incorporates or suggests systemic approaches on a software or database level. In an essay for *Leonardo* magazine, Rinehart observes: 'A notation system for media art is distinct from [books and 'analogue' artworks] in that it needs to include the level of detail necessary not just to describe but to recreate them.' He continues, 'It should allow varying levels of implementation, from minimal scores to complex scores that are expanded upon at various points in the life cycle of the work.'[20] With so called 'born digital' art, conservation and recreation are more interrelated than even Groys suggests, because there is an actual potential to keep the work 'alive'.

Despite significant interest, the incorporation of MANS and other such systems into institutional settings has been slow. In email cor-

respondence, Rinehart suggests that the reason for this is that there are no ready-made software tools for, in his case, MANS. Instead, Rinehart recommends adapting existing software and code, like the XML metadata mark-up code that is used for high-level database searches. The main issue, however, may be an institutional lack of insight and involvement in the DIY cultures of software development. Institutions simply have to get their hands dirty, or at least reach out to someone who does. The conservation of variable and digital media demands structural changes within the institutional organization, and one of these changes involves higher levels of collaboration with outside parties. Closed systems are the death of art in the digital and hybrid digital domain.

Crossing the Deadline

Transformation where it is essential for survival is the central issue in etoy's *Mission Eternity*. The project consists of many elements, all of which are presented in a full package deal by a corporate enterprise that offers a new approach to the afterlife. Philosophical issues are mixed with urgent political questions; playful theatrics are mixed with deadly serious media development. It is an example of a net art work that actually exists across both traditional physical platforms and digital arenas simultaneously, spreading out over different 'worlds' and spaces without so much as a glitch.

One of the traditional (some would say real) physical elements of Mission Eternity is the Sarcophagus, which is a transport container that has been converted into a kind of high-tech mausoleum. It contains the ashes of the Pilots, or the people who become involved in the project with the intention of becoming immortalized or, from etoy's viewpoint, to become truly immortal. The Pilots leave their biological remains in the Sarcophagus and upload their immaterial life into an Arcanum Capsule. This Capsule is, in fact, the Pilot's digital file, which includes data, texts, sound, photos or videos submitted by the Pilot and his or her friends and family. The story of the Pilot, the Arcanum Capsule and the mortal remains unfold like a science-fiction movie.

His were the first ashes to enter the sarcophagus. Timothy Leary, rebel, new media avant-gardist and ever-controversial theorist from the 1960s until his last breath in the new century, became a Pilot in

173

the *Mission Eternity* project in 2007. He has a new body now, a shape-less, living cluster of data. He has entered the data sphere and he lives on through the Angel Application. The Angel Application is a kind of file sharing software, designed to keep his memory alive, beyond that of humans and traditional archives. Timothy Leary's memory is now a 'living memory', a 'working memory' even. It recreates itself. It migrates from machine to machine, endlessly. Even in death, it is hard to tell whether Leary is a bug or a blessing.

Etoy deals with the afterlife through its *Mission Eternity*, and takes that term very literally. Its slogan 'Crossing the Deadline' suggests that it deals with a form of activity beyond death that is planned and prepared in life; Timothy Leary being an appropriate exception.[21] Death imag-ined as a deadline, a symbolic border that can quite easily be crossed, a term most often used in reference to the completion date of a project, suggests our lifespan is not only flexible, but also part of something bigger.

Mission Eternity adds a relatively new idea to an already quite sophis-ticated set of conservation practices. It suggests a radical use of open networks or networked servers as a means for not just ensuring easy access, but to provoke the duplication and migration of files, even to the point of total obscurity, as files may also only be readable by machines, and inaccessible or irretrievable by humans. Etoy suggests looking for 'archivists' outside of the professional realm and accepts loss, in the sense of a potentially complete loss of control that leads to an unpre-dictable outcome.

The Angel and the Machine

You, me, anybody can be an Angel, protecting and saving Pilots in their afterlife, helping them move through space and time. Imagine a digital version of body and soul, the essence of you represented by chunks of data, a cluster of information, travelling freely from machine to machine, from carrier to carrier, copying itself in the process; this is a 'Capsule'. The Angel Application software enables the Capsule to migrate and reproduce. It runs on shared disc space, on hard drives of computers owned and run by volunteers who are interested in the project. Donating disc space to the project and running the Angel

Application on your computer is what makes you an Angel. *Anybody can be an Angel.*

Etoy offers the active audience the opportunity to collaborate at the deepest level of their project. They are not only asked to both store and share the Capsules; they are also invited to co-design, maintain and improve the Angel Application. At the moment of this writing, the Angel Application is said to be in a 'test phase', and, in some ways, it always will be. A project like this, dependent on many variables and collaborators, remains unstable from beginning until the (endless) end. Another reason for its eternal 'test phase' state is that its development is based on open source, which means that anybody can add changes, modifications and upgrades to the core of the *Mission Eternity* project. Etoy allows participants, the active audience, to continue the *Mission Eternity* in any way they see fit. In many ways, the work can develop far beyond any one artist's influence.[22]

Mission Eternity does not wait for one or two designated, institutional archivists to maintain the work, but actually includes its possible conservation in its design. It does so in two very distinct ways: one, by handing out the core of itself and its recipe, its idea, or even its authorship (through its open-source development strategy); and two, by calling on the most powerful human emotion, that of the desire to cheat death. *Mission Eternity* is therefore the ultimate 'game'.[23] It combines fabulous fiction with the physical reality of the 'gamer'. It engages its collaborators, its participants in a powerful play with the actual edges of reality and life. Dedication to the project is emotionally provoked.

Etoy developed a very clever, seductive way to promote the open-source approach to new media design: it suggests open source literally as a means of survival, the only viable strategy for the continuation of not only individual digital objects, but maybe of cultural development at large, beyond inescapably limited commercial interests as well. It tempts every 'Angel' to become an inventive archivist and offers each participant the enticing role of co-conspirator.

The strategy is reminiscent of the notion of resistance in Francois Truffaut's film *Fahrenheit 451* (1966), which tells the story of a society in which books are banned and burned. To save the content of each book from oblivion it is memorized by willing participants. But, with the *Mission Eternity* project, content is liberated from the confinement of

'The Book', and released as code. In today's digitized society, the physical book, the book as object and as the armour of a text, easily becomes a symbol of a dictatorial copyrighted culture, of repression rather than freedom.[24] *The Pilot's life hangs by a thread, by a string of code, and it is in your hands.* But, like in *Fahrenheit 451*, this survival is a group effort, an almost guerrilla approach to knowledge, in which sharing is ultimately essential.

The analogies between book and code, and between culture and life, can continue. Both book and code have a dark side. Each can contain information or a form of instruction that is controversial, subversive, or even dangerous. They can contain secret knowledge and hidden messages. Having control over their publication can be a means of maintaining power. *Mission Eternity* is rife with symbolism and irony. Just as the Angel Application does not only prolong the life of the Pilots in their Capsules, it also prolongs that of *Mission Eternity* itself. This reflects how open source is not just a strategy to preserve individual art objects, but how it may ensure the vitality of art itself as well.

In his lecture 'Learning from Mario: How to Crowdsource Preservation', the American curator and critic Jon Ippolito describes how amateur archivists managed to save their favourite games from obsolescence by collaboratively developing emulator software that mimics the behaviour of ancient computers. He writes how frowning upon the amateurs 'banging out code in their underwear in a room in the basement of their mother's house' is a gross misjudgement of the work of these individual, independent software developers. 'Such amateurs,' writes Ippolito, 'have kept their culture alive without any institutional mandate or managerial oversight, while highbrow electronic artworks decay into inert assemblages of wire and plastic in their climate-controlled crates.'[25] The word 'amateur' actually seems unfitting and disrespectful, even if this is absolutely not Ippolito's intent. 'Amateur' could be replaced by etoy's 'Angel'.

Ultimately, it remains unknown what any one individual Angel will do, how he or she will alter the application, and in what environment the Pilot and his or her Capsule will end up. But, the project continues, even when individual Angels give up on it. It is always part of a bigger whole, as it slowly spreads and dissolves within the Angel Network, from where the Capsules and their content are accessible online. It is

developed for what has been called 'the archive of the real', the mesh
of near 'oral' cultures and media systems that have evolved through
the Internet. Here, memory is a living entity, shared and stored by the
active audience and transformed in the process. German media theorist
Wolfgang Ernst puts it like this: 'The new kind of memory might not be
caught by institutions, but rather rhizomes within the net itself.'[26]

The Living Archive

For many archivists, the idea of memory rhizoming within the Net
instead of within a closed database may seem unrealistic. What etoy
does with the Angel Application may seem like a mere ideological, even
utopian approach to the creation of archives, in which the creation and
continuation of knowledge is taken out of the hands of an elite group
of archivists and controlled by the public. A sidestep to the world of
copyright research in relation to the construction of databases shows
how etoy's strategy is not that far-fetched, but is, in fact, an appropriate
course of action for preserving cultural heritage in the context of digital
archives.

During the acquisition of a digital work of art, buyer and seller have
to arrange more than just the price. In fact, the conservation that we
have seen has to occur as soon as the work is acquired and is already
underway at the level of the contract negotiations between the institu-
tion and the artist. Copyright is an important foundation of the shape of
digital archives. It defines the role of the archive with regard to both the
artist and the audience. The rights to ownership an institution demands
or suggests for a work of art affect its continuation in different ways. As
the (co-) producer of both *archive* and *work of art*, the archivist's respon-
sibility and power is extended. The responsibility that combines the
often-conflicting interests of an individual work, the collection it is in,
and users of the archive makes conservation a highly delicate matter.

The Greek economist and lawyer Prodomos Tsiavos, among many
others, stresses the importance of the implementation of open-source
strategies as the basis of renewed institutional structures, such as
libraries.[27] He explains how libraries 'operate as the cultivators of the
necessary associations between existing and future creators.' In other
words, they bridge generations and basically ensure the continuity
of cultural development. Since the library becomes database driven,

Tsiavos describes how 'particularly the specialized art library consti-
tutes a portal which provides access primarily to creators rather than
end-users'. These particular archives, therefore, are not solely a source
of information, but also of artist material.

Tsiavos describes how the changing technological structure of the
library assigns the librarian three often-simultaneous roles: 'First, that
of being a licensee (user); second, that of suggesting a set of licenses
(facilitator); and third that of choosing a set of licenses for its own use
(creator)'.[28]

The archivist may well find herself drawn into a work not only
aesthetically, but in an ethical and juridical way as well. The unstable
digital work of art needs proactive conservation at the level of copyright
licensing to remain functional within and outside of the archive. The
work of art is both object and meme; it is an artist's work and a possible
source of inspiration for other artists. Its juridical status thus not only
affects the artist who initiated it, but also the works' archivist (its pro-
creator) and its future users (artist assemblers, creators).

Thinking back to the evolving act of conservation, which Groys com-
pared to the work of a movie director or an orchestra conductor, it now
becomes clear that the conservator's role reaches even further. With
the construction of digital archives, she is not just collaborating closely
with the artist in order to decide on conservation strategies that are
to be implemented immediately (and which will be repeated or main-
tained by future conservators and archivists). In a situation where col-
laboration occurs at the level of digital archiving, those who construct
and maintain this archive deeply inform the basic premises of the work,
its relation to its context and its future cultural position.

In an environment where borders between digital objects, their
environment and the networks that are connected to that environment
consist largely of code, the conservator needs to actively engage in the
negotiation, creation and guarding of these borders, and thus becomes
an important author of the work herself.

Tsiavos mentions two aspects of digital technology that are generally
ignored in the creation of libraries, because they are unfamiliar. This
does not mean they cannot be useful: the possibilities they offer simply
still need to be explored. They are especially interesting in relation to
Mission Eternity. These two are 'technologies of decentralized dissemina-

tion of digital content and communication between individuals sharing common interests (social networks software)', and 'the embedding of digital networks into analogue environments and hence the creation of hybrid environments'.[29] *Mission Eternity* implements both social networks and hybrid environments, in an aesthetic mix of effective physical and immaterial interfaces and collaborative design processes.

Tsiavos seems to prefer to stay within the limits of closed social networks, which builds on the actor-network implementation of Van Saaze, in which a complex of actants within one institution collaborates in the conservation of an unstable work of art. He only opens this up to specific actants outside the institution. Etoy implements the more diffuse and unpredictable social environments of open-source networks, using what is called the GPL license.[30] It is clear, however, that new digital technologies offer chances for archives to develop in ways unthinkable before, namely beyond the specific locations (museum archives) and the on-site conservators.[31]

Intimate Bureaucracies

There are, however, some differences between Tsiavos and etoy's approaches. While both realize the importance of open-source strategies for the continuation of art and the conservation of memory, Tsiavos still aims to design an archive as a site of power and control (a digital, only slightly more open form of the physical archive), whereas etoy, via its Angel Application, leaves this site behind altogether.

Etoy, in effect, has set the Angel Application free. They placed it in the network, maintaining only minimal control. Any user of the software is bound by a GPL license, which stands for GNU General Public License.[32] It is a free software license that prohibits using the Angel Application in a way that would make it inaccessible or inadaptable for others. It is not totally left up for grabs, as one might share something; it is accompanied by a suggestion to change it according to one's needs. This radical invitation and exposure to the audience resonates with early net.art idealism,[33] in which collaboration and an emancipation of the audience were at the core of many projects.

The artists' generosity is at least as important as the work itself (in this case, the Angel Application), and so is the intimate bond it creates with any receiving party, whether the invitation to further develop

the software is taken up or not. If the invitation does not result in collaboration, at least there is a bonding, a conspiracy, even in the case of sensitive works. Audience and artist can potentially share a deep knowledge of something, and knowing the work results in an expansion of it. Participation is not dependent on technicalities or levels of expertise. There are no rules of engagement. The work spreads out like an oil stain and everyone involved forms a kind of community of invitees. In any such work, artist and audience together generate works that have been called 'social sculptures', freely after an idea of Beuys's.[34]

This particular form of bonding with the audience has, of course, already happened in different settings before, but the particular materiality of code and its omnipresence in every layer of the network creates a whole different ball game. Whether it evolves on the level of computer coding or of social coding is ultimately irrelevant: the core communication structure that holds everything together is made up of both. The Internet's crossbreeding of technological and social networks as well as private media (the diary, the family photo album) creates a fundamentally participative audience.

If the possibility to engage is created at the level of core values of an open net art work, whether at the level of the code it needs to survive (as with *Mission Eternity*) or at the level of the content it needs to thrive (as with for example new media art institute Rhizome, which developed from a deep collaboration with its active audience), then audiences have fundamental powers. It would, therefore, also be possible to describe these works as an 'intimate bureaucracy', a term coined by Craig Saper in his book *Networked Art*.[35] In intimate bureaucracies, works of art 'are about the interactions among distribution systems, a community of participants, and the poetic of artisanal works'. The term social sculpture does not completely describe the situation. Again, we need an expansion of conceptual approaches to art that includes the materiality of communication structures, in order to grasp the full aesthetic of the work involved.

By combining the strengths of intimate networks and social relations with the power of bureaucratic structures, etoy manages to emulate these structures to fit their own purpose. It is a strategy that was earlier applied by mail artists, in which artists mimicked administrative procedures (like placing approval or rejection stamps and using

standard exchange procedures) as a way of constructing art works out of networks. This time, however, instead of fake logos or stamps, the artists use actual code and Internet protocol, 'tools' that not only allow mimicking, but also the creation of *operable* bureaucracies.[36] Works are created that manage to survive and be effective in both art contexts and the worlds beyond them.

The result is unstable, flexible works of art that 'float' or reside in larger, institutional and public networks, without losing their identity. These works 'function' in their own self-created universe and in 'ours'. It is a functionality that simultaneously blends with common societal structures and escapes them. As Saper describes artists using the Internet for this type of work: 'It is not only performance art mocking business, but the emergence of an alternative politics.'[37] In the case of the Angel Application, and the entire *Mission Eternity* project, this politics is about grassroots archiving, and about the survival of personal, smaller histories in an age of global uniformity and forgetfulness. It is also about escaping time itself. Time is an authoritarian bureaucracy that needs to be subverted and undermined.

What makes *Mission Eternity* so different from most other archiving projects, despite its aim of immortality, is its fearless, disrespectful approach to time. Through its grandiose and absurd philosophy of life as a recordable matter, etoy manages to redefine the very measure of life (the most intimate dimension of time) as a remixable substance, something that can be cut, copied, compressed, enhanced, rewound and forwarded. Time and life may even be paused, even if only temporarily. As they are processed, they inevitably lose some of their consistency. It is as the French philosopher Bruno Latour notes in an interview: 'There is only transformation. Information as something that will be carried through space and time, without deformation, is a complete myth.'[38] Data leakage and loss will form the inescapable, intrinsic gaps in history, a history in which the grand narrative is that which survives emulation and migration, with 'the archival paradigm being replaced by permanent transfer'.[39] Death is the bits that continue to fall between the cracks. For etoy, this is the technological equivalent of forgetting, and since forgetting is part of life, it should be part of the eternal life they offer as well.

Forgetting is part of etoy's aesthetic, but it is only a partial forgetting that is balanced or countered by technological means. It is a form of

relinquishing, in which memory, like life, is passed on to the machine. The files travelling into the future through the Angel Application are fairly obscure. They do not have clear names written in human languages, which easily reveal their content to human readers. This is where etoy takes a completely different position from that of Richard Rinehart, for instance, who writes about an integration of human- and machine-readable languages in MANS. Etoy's strategy seems a fearless adaptation of British psychologist and writer Susan Blackmore's 'third replicator' or 'temes' theory, in which she describes the possible development of independently acting technological networks through humanly inaccessible and artificially evolved machine languages.[40]

Mission Eternity's aim is long-term preservation through a self-adapting, ever-growing network where human interpretation may become an obstacle; etoy considers it neither efficient nor logical. Therefore, each file is tagged or labelled with a hexadecimal sequence of characters, which form the code of the Pilot it represents. These codes, Etoy points out, have been designed for long-term functionality. For this reason, the first two test *Mission Eternity* Pilots, the Austrian Sepp Keiser, who is still alive, and the aforementioned Timothy Leary, are not just Pilots one and two. They are not even Pilots 00001 or 00002. They have been given the puzzling and absurdly long individual ID codes F71834AA6A9A6586 and F71806059E4A2EC3.

Mission Eternity is supposed to be exactly what its name implies: a mission that could last forever. Etoy says that its goal is millions rather than mere hundreds of years of longevity for these two Pilots. Their other goal is for a proliferation of many Angels, Pilots and Passengers who will follow in Sepp Keiser and Tim Leary's digital 'footsteps'. Hexadecimal codes provide more opportunity for expansion and inclusion. However, these long, rather random codes do not serve human memory very well. *Mission Eternity* challenges human memory systems. It does not facilitate an easy recall of stored items. The question is whether it even should.

In the traditional archive, time is an awesome entity, and we are its humble servants. The striving for immortality here feels more like a betrayal of life, the temporality of which always needs to be affirmed in order to glorify history. This affirmation, in the shape of sacred objects that have survived many human generations, creates a meta-experience

of life, in which we are simultaneously small and part of something much bigger than us.

Grandiosity is the barely hidden subject of these archives. It inevitably informs the attitude of the archivist, regarding the archived object, but most of all regarding outsiders. History and the passage of time and life are things to be experienced in a state of awestricken immobility, and the archivist works hard behind the scenes to make this happen.

This caricature of the traditional archive, in which time is at best reflected, in which history is only visible and barely tangible, is magnified in *The Clock of the Long Now*. *The Clock of the Long Now* is as ambitious a project as *Mission Eternity*. At first sight, the projects seem to share much common ground. What connects them is a desire to escape the epidemic of amnesia that haunts the era of digital communication. Both projects are, however, radical opposites because of their specific methodologies, in which the passage of time is emphasized or diminished, admired or fought.

Big Time: The Clock of the Long Now

Over the past 15 years, a mere spit in the ocean of time, the Long Now Foundation has been developing their idea for a 10,000-year clock. In some sense, this Clock is just a theatrical tool, a prop, that tells a story and facilitates the ability for that story to be told for centuries to come. Two versions, an actual clock and an orrery (planet-tracking display) were constructed, of which the first is on display in the Science Museum in London. Museums generally don't last for 10,000 years. This is why the Long Now Foundation has been looking for a site that will continue to exist for at least as long as the clock is supposed to go on ticking. They have decided to construct it inside a mountain in eastern Nevada.

On the Long Now website the idea of this particular clock is said to pre-date the founding of the Foundation of the Long Now itself.[41] The clock is supposed to be part of 'a remote monument'. In order to provoke discussions on long-term thinking, 'it would lend itself to good storytelling and myth'.[42] The construction of *The Clock of the Long Now* and the quest for its monumental site seem to be essential pillars of the Long Now Foundation's project to establish a cultural and political environment in which long-term thinking is fundamental and paramount.

The motivation to build the Clock and establish the Long Now Foundation is clearly based on a deep sense of humility as well as a hint of heroism. As Danny Hillis, one of the founders and the inventor of the Clock puts it:

> I know I am a part of a story that starts long before I can remember and continues long beyond when anyone will remember me. I sense that I am alive at a time of important change, and I feel a responsibility to make sure that the change comes out well.[43]

Here is an individual, or a group of individuals, who want to leave their own, specific, defining mark on history. They suggest that it is not vanity that drives them, but a sense of responsibility. You can almost hear a crescendo of violins in the background.

Leaving aside one's judgment of whether or not it is important that long-term thinking is a part of our daily social, political and economic routines, which is the message the Long Now Foundation wishes to convey, the question here is whether *the way* an object, message or activity is 'transported' through time *itself* needs to be considered as part of this object, message or activity. Not only our choice of 'heritage', of what is important to pass on to future generations, defines our cultural climate, also the manner in which we save this heritage leaves its defining mark on not only things to come, but on the present as well.

The Clock of the Long Now, and its development as a monumental site in particular, is the ultimate example of a conventional, albeit somewhat theatrical form of conservation. In this approach, heritage is something untouchable, unchangeable, even incomprehensible, while it simultaneously demands respect and admiration.[44] One simply cannot ignore the religious undertones of the choice of a mountain as the Clock's site because they are barely hidden. In a TED talk, Steward Brand, the initiator of the Long Now Foundation, even describes any future visit to the site as a 'pilgrimage'.[45] Time itself is worshipped, and our relationship to it is one of great servitude and submission.

At a presentation of *The Clock of the Long Now* in Amsterdam in 2000,[46] Alexander Rose (Clock Project Manager) and Brian Eno (the one who gave the Long Now Foundation its name) discussed how the idea of the clock was developed during a time that could be called the

'Digital Dark Ages'. In fact, those Digital Dark Ages were already well underway. Given the unstable carriers of digital information, much, if not all, of that which has been produced digitally from the earliest days of computerization would be lost for posterity.

Canadian database architect Terry Kuny was the first to mention this gloomy 'dark ages' scenario, at a librarians conference in 1997.[47] In his presentation, he stated that when it comes to the preservation of knowledge and the survival of archives 'there are new barbarians at the gate',[48] without ever explaining who exactly these barbarians were. In the theory of the Digital Dark Ages, the loss of data is presented as a dramatic event, which takes us back to pre-printing press days, when the preservation of knowledge, and, more specifically, texts, depended on the efforts of monks and monasteries.

One of the assertions Kuny makes in this essay is that 'the problems [with preserving digital information] are not technological, but socio-logical'.[49] He basically states that, even if there are no easy technological solutions for long-term digital preservation, they can be developed. The main issue in preserving digital heritage, he says, is one of organization, which involves a choice of content, of authorship, of collaboration, and of the standardization of all structures across the entire field of libraries.

Without wanting to play down the issue, it might be interesting to look at the choice of terminology involved. What seems at stake is civilization itself, which is threatened by barbarians 'at the gate'. These barbarians are humans, not machines. The issues are described as socio-logical, not technological. His repeated use of these metaphors through-out the text makes it sound like those barbarians have already entered the fortress of the archive. It sounds like the monks themselves have lost faith. Civilization crumbles from within: human apathy and confu-sion results in technical memory loss, which, in turn, spawns cultural amnesia. In order to bring back the light, the novices in the monastery of information need inspiration. Someone or something has to inspire them enough to believe in the good cause again.

This is where *The Clock of the Long Now* comes into play: it serves as an encouragement to think about culture in the long run, by offering a mystical experience of a grand perspective in an era where everything starts to flow, and all that we seem to be left with are quickly spiralling versions of a brief now. The Clock helps archivists snap out of the shock

caused by the 'archive of the real',[50] as the Internet (and any related technologies) seems to assimilate everything without any discernable method or target.

The Clock of the Long Now, like *Mission Eternity*, magnifies and mystifies an actual, predominant fiction of time and memory. Through this elaborate and stunning performance, the Long Now Foundation, like etoy, attempts to lure its audience into an involvement in the preservation of memory. In the case of the Long Now, this involvement is not one based on knowledge, however, but on a distant sense of awe, an awe that might inspire a reinstatement of the role of the Grand Archivist. Here, there is no such thing as 'acceptable loss'; there is no trace of transformation, let alone degradation.

The Clock project is actually 'supported' or accompanied by another Long Now project, *The Rosetta Disc*, which is an object that contains 'a durable archive of human languages'.[51] The goal is for this object to remain the same for centuries to come.[52] The myth and reality of the Long Now barely permits any interaction with what it carries and protects. Everything in it is beyond us. The Clock in the Mountain and the Stone in the Archive await our admiration and contemplation. In their presence we feel rich, but humble.

No Time: Boarding the Capsule

Try to compare the awesome steadfastness of a mountain to the durable versatility of a freight container: the greatest geomorphologic 'fossil' meets the most common transport and architecture module. The huge metal boxes that are used on ships and trains have served as etoy's mobile workstations in a few of their projects.[53] In *Mission Eternity*, a freight container is used to house the Sarcophagus. Unlike a mountain, the Sarcophagus travels to meet us. Like the Capsules, which are transported, distributed and saved through the Angel Application, the Sarcophagus does not have a fixed location. And much like the Angel Application, its banal material shape seems to be in stark contrast to its precious content: memories, life forms and 'people'.

An intrinsic duality of movement and enclosure marks almost every aspect of *Mission Eternity*, from the basic Capsules (the files that hold the Pilots memory), to the Angel Application (the software that enables the Capsules to travel), to the Sarcophagus (basically a collective memorial

site). It seems as if etoy is attempting to escape time by slipping into all of its many manifestations simultaneously, eluding death in a complex technological labyrinth of constructions, projections and processes. They use this aspect of standard objects as a kind of Trojan horse to infiltrate elitist cultural economies, a kind of reversed Bauhaus tactic: instead of designing objects in a way that undermines exclusivity, key economic standards are used to produce highly unpredictable (uncommon) and unique results.

British software critic Matthew Fuller gives a very comprehensible explanation of the cultural meaning and usage of standard objects in his essay 'How This Becomes That',[54] where he uses the freight container as an example. He shows how the standard object is not so much about sameness, but that it is mostly about movement and context. 'The standard object implies exchange, trade, command, communality, "otherability," a difference in state from one location to the next,' he writes. 'It demands that something is not individualized but composed in part by the necessity of relations.'[55]

Etoy calls the Sarcophagus a 'Bridge'. The *Mission Eternity* 'Bridges' are described as linking 'physical and memory spaces as well as life and death'.[56] It is a minimal sculptural interpretation of being inside 'the screen', inside a virtual space. The Sarcophagus bridges not just life and death, but it also bridges new and old network spaces. It links the Net with the basic social body. In order to place the Terminus cube (containing the pilot's ashes) in the Sarcophagus, a square hole is literally cut into the screen, making the two worlds (digital and 'real') merge painfully. The Terminus is inserted into the screen as a dead pixel, which then kills a speck of its light. This elaborate ritualistic space not only bridges real and virtual spaces of memory. After more and more dead pixels begin to appear, it becomes clear that *the death of the screen does not imply the death of the computer, let alone of the network.* The Sarcophagus is also the magic eye into the network. Standing between the dead pixels, which contain the dust that remains at the end of physical life, life is celebrated as itself. Life is activity, life is a process.

The screen, the world of appearances, is just a replaceable interface for the structures and processes that run 'beneath'. Instead of relying on the fully controlled visual theatrics of the immersive screens of the 'cave',[57] Virtual Reality goggles, or other 3D projections, networked

screens such as that of *Mission Eternity* present an unpredictable (highly subjective), but no less spectacular view by (paradoxically) leaving the barrier between audience and network as rudimentary as possible. By simply making the connection, an awesome vista unfolds in every direction. The audience is not immersed in the world of the screen, but in that of the network.

The Sarcophagus and the Angel Application serve a similar purpose, even if it is on an entirely different plane. The Sarcophagus reaches that part of the audience that does not understand the Angel Application. The Sarcophagus is designed to entice and engage. The Sarcophagus and the Angel Application are related to each other like a cemetery to a community, each creates a sense of closeness and emotional attachment. By connecting the two, even a semi-monumental (mobile) memorial site like the Sarcophagus is a gateway into deeper knowledge. *Awe is replaced by power.*

Despite Mission Eternity's ironic, light-hearted methodology, etoy presents us with a radical approach to memory as a site of struggle. Through the archive, political and economic dimensions unfold. Wolfgang Ernst has emphasized that the issues concerning the digitization of cultural archives do not just revolve around digitized documents, but also affect audiovisual material. Web 2.0, which almost completely downgraded a pluriform Internet to a few huge proprietary databases, adds the *personal archive* (the photo album, the diary, the home video) to this list of endangered historical information systems. Ernst declared that 'memory will be commodified; let us be political about this'.[58] It is not just an institutional, public memory that is in anger of being lost, but personal heritage as well. The audience has found a certain, but very limited, democratization process of the media that ultimately produces no lasting residue of its presence or input. Both the personal heritage and historical influence of the new audience will be virtually *non-existent.*

This is the strength of *Mission Eternity*: artists and audience meet and bond through their mutual interest in the survival of their legacies. Tools are shared and co-created. Time and history appear as malleable entities, and not as threats to almost every aspect of personal heritage. The ironic game of cheating death turns out to be a very real and effective tactic that can influence cultural memory in the long run.

Towards an Endless Ending (Conclusion)

Decay is not death, but a form of change. As the shape of art evolves, from an object to a compilation or process, so does the notion of decay. The conservation of works of art has, as Groys, Van Saaze and Stringari seem to suggest, transformed into a collaborative or at least creative performance or re-composition, one that never completely produces or reproduces the original work.

The environment in which this performance or re-composition takes place is rapidly becoming a volatile, combined sociotechnological, economic and political space. Here the material properties of the artistic media involved tend to invite undesirable, extremely proprietary and exclusive economic models. These models not only threaten the future appropriation of various aspects of a cultural object (as emphasized by Tsiavos), but they also jeopardize the very continuation of the work by using unnecessarily protective, limited archiving strategies.

Conservation strategies until now rely on the individual engagement of human 'actants'. This is no different in the digital domain, but here this engagement needs to be immediate and proactive. Such a deep involvement in the continuation of a work requires motivation, something that makes someone do a job immediately. 'The economy of timing becomes a short-circuit.'[59] This kind of involvement is fundamental to new media environments, and specifically to the Internet. In fact, the Internet has itself developed out of active 'user' participation. Developing new, digital archives *away* from this vital framework does not make any sense at all, in terms of technological innovation, new public contexts and even ordinary economic results. On the contrary, online social networks offer a vast array of possibilities for both experimental and institutional enhancements of the archive. As Ippolito notes: 'Millions of dollars and countless hours of staff time are spent squirreling data away in private silos inaccessible to a broader public.'[60] Not involving the audience means wasting valuable resources.

By counterposing *The Clock of the Long Now* and *Mission Eternity*, I wanted to show two things. First, it takes some degree of emotional investment and human interest before any form of long-term thinking takes hold and becomes productive. Something has to be at stake for the conservator, which creates the dedication and commitment it takes to

act quickly or even proactively. Social or emotional bonds can be used to engage outside coders, collectors and archivists.

Both projects create an emotional re-bonding with the self and its embedded history, even if it is through opposing strategies. They each present a near mythical view of what it means to be alive in the here and now, and how this reflects on both the past and the future. By emphasizing this moment, the volatility and vulnerability of new media presences seems to be at least temporarily lifted. New media cultures are in dire need of ways to express and further disseminate their specific identities. Storytellers and artists like the members of The Long Now Foundation and etoy provide not only the means, but also the inspirational spark to create this.

There is, however, a world of difference between their approaches. No matter how good their intentions, an awareness of the conservation issues surrounding new media technologies does not automatically lead to new working methods or revolutionary cultural approaches. The Long Now's *Rosetta Disc*, for example, may seem like a step forward in preserving contemporary immaterial heritage (that is, languages), but its technology harks back to ancient transcription methods, which leave little or no room for interaction or change. It creates what Richard Rinehart, the creator of MANS, might call 'tombstone data'.[61]

Even if this preserves things in some 'original' form for the longest possible period of time, the economy of these objects can only be predominantly hierarchical and exclusive: who gets to deal with the thing in question will always be a matter of physical access. In order to preserve contemporary cultures, this project, like the Clock, falls back on very conservative strategies. The question is whether we even want to fall back on such methods, or if, in order to preserve unstable cultural objects such as digital works of art, there might be other alternatives to existing practices.

I am, of course, in some way turning the two poetic projects, *The Clock of the Long Now* and *The Rosetta Disc* into caricatures. As caricatures, they reveal a stunning lack of faith in the conservation of the cultural heritage within the realm of digital technologies. The possibilities of new media and the Internet for serious cultural production and distribution have, however, not at all been fully explored. For example, Van Saaze describes the expanded group of actants involved in the

conservation of a work of art within one institution that could be further expanded to include various levels of collaborators outside of the institution. These collaborators don't necessarily need be human.

Etoy provides a strategy for this on a silver platter. Their position is firmly within the network. *Mission Eternity* lives in the future expanded archive and feeds back into traditional archives. 'The sculptures called M∞ Bridges [like the Sarcophagus and the Terminus] exploit the traditionally stable and well organized structure of art collections, libraries and museums to display Arcanum Capsules in the long run.' While it makes use of every possible strategy within the open spaces of new media networks, etoy continues to engage old cultural systems as well. This engagement occurs from a reversed point of view, however, since the traditional archive is, at the very least, approached from a position of equality. The traditional archive is confronted with how the economies have changed all around it, and cannot remain untouched, literally.

In a sense, *Mission Eternity* as a whole is a bridge that connects old and new methods of survival. The view from the top of this bridge is endless.

The Source and the Well:
The Intimacy of Sound Spaces

Listening can be disconcerting. The ear, always ready to receive, extends deep into the mind. Like the eye, it is only an instrument for disseminating information. In order to understand what we hear, we depend on the brain for filtering and interpretation. For our listening to create meaning, to recognize music, for instance, we depend on our knowledge and analysis of what we have heard before. It depends on the properties we attach to a sound and the circumstances in which we hear it. It depends on the way our personal and shared experiences with sound have influenced the way we listen. We are trained to listen, which is perfected during the course of our lives and for each of us, with the exception of the deaf, this begins in the womb. Our experience of music depends almost entirely on a never-ending exercise.[1]

Listening, therefore, is a skill. It might be based on the 'simple' ability to hear, but grows from hearing to profound listening through endless trial and error, through seeking challenges of understanding and developing almost unheard of sensitivities. Listening is like tasting: the senses are carefully provoked and maintained, in order to be able to experience fleeting moments of bliss, at the sound of a violin in the distance, or butter melting on the surface of the tongue. Music is always an acquired taste.

Introduction

John Cage's 4'33" of 'silence' totally changed our perception of music. His intervention in the set of expectations the listener brings to a musical performance changed the roles of both performer and audience. From the first time 4'33" was staged, these roles have slowly evolved, each in their own distinctive way. For the audience, the change has been the most dramatic. By challenging the unpredictable ears and mind of the individual listener to compose the piece, Cage's 4'33" revealed a power inherent in listening that the audience had barely been aware of previously. American theorist Seth Kim-Cohen describes this as the 'composing mind of the listener', producing an 'unauthored content'.[2]

Since then, the environment in which music is performed and received has changed considerably. The noisy city, which is always mentioned as a source of inspiration for early sound artists from the futurists to Cage, is steadily being pushed into the background by a source of sound much closer to the skin. Headphones and mobile phones carry the speed and overflow of bits from online and other digital universes to the inner ear with every glitch, bug and viral intact. Listeners as well as musicians inhabit colliding sound spaces, by which the neatly layered space of broadcast radio pales by comparison.

In the area of computer music, from experimental and improvisational to more mainstream dance, the work of the musician has almost completely disappeared from the scene. Lit only by the glow of his laptop, the music the artist produces seems conjured up like spirits from, what the American sound artist Kim Cascone calls, this performer's 'laptop ghost box'.[3] The skill of the performer is not just hidden, but can even appear shallow as the audience becomes used to exploring its own ability to compose beyond listening alone. The layer of gadgets and tools that creeps up around the body of the listener is not just for play, but always contains elements for performance as well. The listener's composing tools reach beyond his mind alone.

The music download culture has further changed the way we listen. For example, Dutch critic Arie Altena claims that he only listens to every song or CD in his collection once. It makes perfect sense: many people have several gigabytes, if not terabytes, of music. In order to be able to enjoy everything, Altena's strategy is logically the only viable one. His main reason for playing every track just once is, however, that 'there is so much else out there', which gives it a slightly different twist. His own collection seems too limited to him, no matter how vast it is. Listening to its content is a task to fulfil, not a moment of pleasure or relaxation. In order to get to everything else 'out there', a possible positive experience of an individual track is not followed by any kind of reward. All music is treated the same, and excellence is not honoured with replay.

Even if this approach is too radical for most, it is clear that the abundance of available music on the Internet (and the control we have over its duration) is changing our relationship to music, especially the recorded kind. Recorded music is now almost the equivalent of Muzak. It has little or no value. It has entered the sphere of Cage's silence as a

193

steady noise in the background. All music made after *4'33"* rises from the flexible silence of this short but infinite piece.

In the murky, chaotic soundscape that surrounds us today, the peaceful disquiet of *4'33"* seems hard to retrieve, and even more difficult to surpass. In order to enable the listener to hear more profoundly into silence, 'hidden' sounds are explored, conjured up and amplified. The human ear's limitations are surpassed through the use of technology, or they are manipulated to create new acoustic horizons. The music and the sound art in this area provoke and engage mind and body.

We enter the world of deep silence, of an experience of 'microscopic', attentive listening that the artist controls, or even enforces. The artist is among the listeners; she or he is a super listener. In some of r a d i o - q u a l i a and Joyce Hinterding's works the enhanced ear is aimed at natural phenomena: the radiation of the sun, or the electromagnetic static produced by our daily environment. The world of sound is enlarged, growing literally to galactic proportions. However, some turn the ear inward instead. The artists Mark Bain and Jacob Kirkegaard broaden our horizon by distorting it. In two very different works, these artists hijack and confuse the senses. An intimate performance of deep silence is the fascinating result. Here, the listener becomes both the origin and the composer of sound. She becomes both the source and the well.

The Listener as Reader and Composer

Contemporary silence pieces have been influenced and informed by the development of the listener since John Cage's *4'33"*. Many critics have described the influence of Cage on music.[4] Seth Kim-Cohen adds another perspective, which is especially interesting from a listener's point of view and can help us understand the positions of contemporary artists and audiences. He proposes listening from another mindset, namely that of repetitious music, rather than from the structure of Western music. Applying James Snead's *Repetition as a Figure of Black Culture* he suggests that approaching *4'33"* from the perspective of repetitious music 'allows us to hear the "cut"'. According to Kim-Cohen we project the cut into the 'silence' of *4'33"*; we structure the sounds of 'silence' intellectually in a very specific way.

Since the environmental sounds 'used' in this work are background sounds, we tend to 'unhear' them in ordinary circumstances.

They don't stand out. They don't draw our attention. They are like a monotonous hum or drone, and, as such, a composition of 'silence' can be experienced as repetitious music, with its trance-inducing monotony. Describing Snead's theory, Kim-Cohen writes: 'The importance of the repetitious work is in how and when the cut occurs, and in how the meaning of the whole is affected with each cycle, each cut, each return.'[5] Recognizing the cut (where the repetition begins and repeats over and over) evokes all kinds of responses in the listener: expectations build on memory, again and again for the entire duration of the piece, and they are influenced by specific circumstances and capacities of the individual listener. Repetitious music needs to be experienced; like an interactive work of art it is only completed during the process of engagement and observation.

Hearing a 'cut' in silence requires a real-time interpretation of, what Kim-Cohen calls, 'sound-as-text'. This is a term Kim-Cohen uses to counter the notion of 'sound-in-itself', in which sound is perceived as having meaning without any human memory or projection influencing it.[6] It is the notion of 'sound-as-text' that allows Kim-Cohen to develop his view of Cage's invitation to the listener further. Seth Kim-Cohen:

> As with the act of reading . . . the act of listening jumps back and forth in time. . . . Different sections and different modes of absorption of the text are folded together in the listening/composing mind of the listener. The result is an unauthored content produced by elision and collision.[7]

By disclosing the act of listening as an integral part of music, and making it a priority, Cage handed the listener the first step towards musical creation – the act of composing. Working with silence (the absence of sound)[8] as sonic matter, this composition becomes more than a conceptual exercise. The listener actually produces a work. The American composer Michael Nyman describes the new positions of both artist and audience as 'an unprecedented fluidity of composer/performer/ listener roles.'[9]

The comparison to reading is important in the context of new modes of music and art, and the changing role of the audience. In his influential text *Art in the Age of Mechanical Reproduction*, Walter Benjamin

had already made a similar comparison. Besides being one of the first analyses of the meaning or value (the aura) of the art object in a time when reproduction techniques were becoming more and more refined, this text also focuses on the role and perception of the audience. Benjamin suggests that the loss of the so-called 'aura' of a work of art is not so much caused by the material properties of new technologies (their ability to create copies), but more by the way these technologies enable the audience to at least *feel* like they could easily be artists themselves. To hypothesize how audiences arrived at this impression, Benjamin went back into the history of reading.

He describes how the ratio of readers to writers had changed considerably by the end of the nineteenth century, with the rapid increase in publications came more and more writers. The expansion of the printing press created a dire need for content, a need that was met by inviting many more people to write. This had a strong levelling effect on the previously vast difference between writers and readers. Unlike the pre- and early days of the printing press, writing was no longer completely out of reach, something far beyond the reader's ability and only for expert writers. Newspapers and magazines even encouraged this development by creating special sections like 'letters to the editor', to which readers could send in their comments and opinions. Benjamin noted that at that particular moment, 'at any moment the reader is ready to turn into a writer.'[10]

By developing music that consists of what is heard and read into 'silence', Cage levelled the difference between composer and listener in a similar way. As an 'open' work, *4'33"* can exist in an endless number of variations. These versions not only need to be 'filled' by listeners, but Cage also knew that they were capable of doing so. By entrusting the listener with the final composition of the work, the position of that listener changed. The listener is now ready to be a composer at any time.

The Shaping of Silence

Silence is a very relative notion. What silence is, is largely defined by the listener's expectations and physical traits. If silence can be music, music can be silence. Since *4'33"* we are aware that composing is an act of reading and the placing of sound in space and time. This requires a valuation and interpretation of individual sounds, and of their relation

to specific contexts. Similar methods to the ones we use to compose music are easily applied to negate music even if subconsciously.

Our relationship to sound is defined by two factors: the physical, 'technical' ability to hear combined with the psychological, intellectual interpretation of what is heard. They are inseparable. In his book *Acoustic Communication*, Canadian composer and music scholar Barry Truax describes how the ear itself adapts to sound levels, much like the iris adapts to light. In composing a piece of silence, this is combined with an ability for selective listening humans also possess. We can physically and mentally focus our hearing. Truax writes: '[Listening] can produce categories of perceptual immediacy such as "background" and "foreground", which do not necessarily correspond to physical distance; that is, a distant sound may seem more prominent in an environment than a closer one.'[11]

Not only can we focus our hearing but the way we listen is also influenced by the way certain sounds are stored in our memories. It seems that acoustic memory works based on, among other things, 'keynote sounds', which are remembered background sounds that can evoke powerful memory experiences, much like smells can. The memory of these keynote sounds is imprecise, which is why these sounds are remembered in 'holistic' patterns that include their entire surrounding context. These patterns, or what Truax calls a 'gestalt', have an emotive quality that words can hardly describe. Truax notes that poets (with their musical use of language) and composers play on these patterns.

Truax has expressed some fear that the increasing amount of 'noise'[12] produced by the relentless expansion and repetition of advertising may interfere with this type of memory formation, and thus with the arts that thrive on it as well. Music could become meaningless, and without meaning there is no communication, only 'silence'. He further notes: 'The long-term effects of noise . . . can be seen within the present model as the *obscuring* of auditory images that define the listener's long-term relationships to the environment.'[13] Since the ability to understand music is related to speech[14] and dependent upon significant interpretation, music then easily becomes 'unheard' in a sea of 'noise'. Our relationship to sound and music is not a given; it evolves. Truax fears the worst: 'The *meaninglessness* of noise becomes the long-term auditory image that pervades the psyche of the individual, and ultimately of society.'[15]

What Truax is basically saying is that an abusive excess of certain acoustic patterns could make us 'deaf' to them. Truax blames the world of advertising for the deafening effect of sonic overkill on music, but his analysis easily applies to our current situation, which is characterized by a hyper-commodification of music.

The Production of Silence

The commodification of music, music as a marketable product, is a result of the ability to transcribe or record it in some way, enabling it to be reproduced and sold. This 'fixation' of music, which allowed the establishment of systems of ownership or authorship for music as well, first manifested itself through the market around the publication of sheet music.[16] The development of sound recording techniques and speaker systems created a much more profound change in our relationship to music, however, one that became divorced from any relation to context, where it could be endlessly manipulated. The separation of sound from context and then boxing it in had two important effects: one, the possibility of recording and physically owning a sound; and two, it ushered in a completely new sonic experience. Aspects like reverberation and other sonic elements that betray the source of a sound were carefully eliminated. Sound ended up having 'little to say about the places in which it was produced and consumed'.[17] It is, in many ways, the sonic equivalent of the universal modern building, which bears little or no relationship to its environment. In modern sound, specific elements of sound and music were elevated or favoured to create a specific clean or crisp sonic experience that does not exist in reality, eliminating or 'unhearing' other elements of sound in the process.

Without this commodification, the meaninglessness Truax has pointed out could never arise. German philosopher and critic Theodor Adorno describes both the commodification and the deformation of sound through new technologies in his famous essays on music.[18] He already makes note of the emerging notion of the utter meaninglessness of music, as he not only discusses the distancing of and between audiences, but also some important changes in listening 'techniques'. Adorno notices a development of 'atomized listening',[19] which is encouraged by the (in his opinion, bad) quality of music reproduction and radio transmissions. 'Atomized listening' basically means only 'listening

for the good parts',[20] while the rest is ignored or goes unheard, pushed to the background, out of focus. The emerging youth consumer culture of the early twentieth century that shaped Adorno's criticism, however, seems innocent and modest compared to the rapidly expanding music markets and ravenous audiences of today.

Our contemporary acoustic environment is not only commodified on an analogue level, but digitally as well. The expansion of music markets over many different intersecting media creates a kind of endless layering of echoes of similar music that appears everywhere, turning it into background noise, and causing 'silence' to expand. As licensed and/ or unlicensed sound files pile up on external hard drives, music cultures have transformed rapidly. The commodification of sound in modernity has been surpassed by a 'totalizing pulverization of culture into flows of communication', in what Australian media theorist McKenzie Wark calls 'third nature'. He describes 'third nature' as 'a landscape comprised not of relations of production and consumption but of communication and interpretation'.[21] It is the media landscape, as it evolved from broadcast media to the intimate, ubiquitous networks of today. Here all traits of modern, commodified sound are amplified to the extreme: its alienation from context, its homogenous sound quality, and its drowning in the 'noise' of endless copies and musical applications.

But McKenzie Wark warns us that an amplification of commodification *itself*, as licensed information and intellectual property – a super-commodification as it were – has a kind of silencing effect on all of culture. The ownership of information (the 'immaterial' content of communication), implies that 'the means of realizing its value'[22] are also owned. When we translate this into the realm of music we could say that even its communication, its 'airplay', the means by which its value is realized, is (or will soon be) no longer free. If it were up to the media industry, the 'free' radio days would soon be over because you would have to pay to listen. The fight against file sharing and the downloading of free music is a struggle about who will control the communication of the form of communication that is music. Maybe this is why Wark has observed that 'file sharing is a social movement in all but name'.[23]

File sharing is emblematic of today's music cultures, and, as such, it is also a new source of 'silence'. Even before webcasting and podcasting

became popular, there was the explosion in the sharing of all kinds of media files (from sound to video). Peer-to-peer networks were a natural addition to the existing sharing cultures that the industry has tried to appropriate for decades, most successfully through additional copyright taxes on recording tools like tapes and cassettes. Wark describes these sharing cultures as a 'gift relation in culture and knowledge [that] has been alive and well and resisting commodification for centuries'.[24] Download cultures have further thrived on a demand for individualized and rare media content as well.[25]

There seem to be differences between early and more recent download cultures, however. The early stages, roughly 1998 to 2003, were mostly about reinstating or affirming individual or subcultural musical experiences (as opposed to the standardization of the music industry and broadcast media).[26] The pressure from the industry to prosecute 'illegal'[27] downloads that arose in 2003, and the various forms of new copyright legislation that followed, seems to have triggered complete download frenzy. To illustrate this: since about 2003, I have received endless warnings from my own circle of friends to download as much as possible, 'because it might be over soon', 'it' being sharing (and thus also downloading) music for free.

These warnings echoed the news bulletins (about impending prosecution of 'illegal' downloads) in blogs, newspapers, magazines and broadcast media that have appeared regularly, up to the present day. Though I have only modestly followed their advice, it is not unusual to hear about people who have built their own vast musical archives, scattered across several external hard drives, CDs, DVDs and whatever other recording devices were at hand at the time. In a certain sense, the pressure placed upon online sharing practices has had the opposite effect of what they were intended for. It turned downloading into an act of subversion, rebellion, conscious theft, and into a relentless hoarding of sound files.

If we apply Truax's theory about the way advertising's expansion and repetition of sound patterns could 'obscure the auditory images that define the listener's long-term relationships to the environment' to the landscape and type of economy Wark describes, where the private sound archive is endless and listening is embedded in a myriad of data flows, a deafening noise emerges that could potentially silence the

sound of 'third nature'. Ironically, the 'noise of advertising' has been brought into our homes like a Trojan horse, which was either unwittingly or carelessly created by the industry as it turned 'airplay' into a commodity. Adorno's 'atomized listening' is transforming into a casual indifference to music, in which meaninglessness and silencing have both gained ground. Both 'atomized listening' and the silencing of today developed into physical, technological interventions in acoustic space, from the side of both artist and listener.

Artist and Listener Merge in Silence

In order to understand the way artists work with 'silence' today, we not only need to reinterpret silence, we also need to re-examine the position of the listener. Listeners have never endured the development of acoustic space in a completely passive mode, but today, they are more active than ever before. The composing listener of *4'33"* in some ways was also doing more than just simply arranging and executing music intellectually, but the physical acts of musical composition were still in a foetal stage, one could say. It took several steps of technological development to reveal the listener's active role in composing his or her own sound space as clearly as we see today, a role that reaches far beyond a readerly, real-time composition alone. It all started about 100 years ago, with playing a record on a gramophone or turning the knob of a radio.

When recorded music first appeared, important elements of music were lost, elements that involved the meeting of the artist and the audience in one shared physical space and included the possibility of participation. Even if there is no (unspoken) invitation for on the spot or future collaboration, witnessing a musical performance is still a form of education, as techniques and styles of the individual musicians can be observed first hand. With recorded sound, the medium replaces the original sound source. The medium, in fact, becomes the instrument, turning the listener into a potential performer. Today's digital technologies – the MP3 player, telephone, laptop or desktop computer – have taken over the function of the musical instrument, as the radio and the gramophone did in their heyday.

By simply cranking the handle of the gramophone and selecting records to play, early-twentieth-century listeners, who would probably not consider themselves artists in any way, managed to consciously

sculpt their own acoustic space according to their own tastes. It was the beginning of the listener becoming involved through his or her technological interventions involving sound and silence. A well-known example of a listener who began intentionally converting the medium of commodified music into an instrument is, of course, the DJ. 'DJing is both consumption and producing,' British music writers Bill Brewster and Frank Broughton noted in their book *Last Night a DJ Saved My Life*. The DJ generally spins other people's records, merging them into one, new, larger composition. The turntable (formerly known as a gramophone or phonograph) is the DJ's main instrument and is used for more than just nice arrangements of music for a dance crowd.

The turntable can be applied to any kind of performance, musical style or composition. 'There are now several ensembles who play multiple Technics 1200 turntables as bands,' Brewster and Broughton continue, 'some have even created systems of turntablist musical notation.'

They quote John Cage as having described the phonograph as an instrument as early as 1937. He talked about how the turntable could create rhythms 'within or beyond the reach of [the] imagination'.[28] As the creative practices of the DJ evolve, it becomes increasingly clear that, when applied scrupulously and in unimagined ways, the media of modern sound can be used to subvert it. Instead of being distanced from sound, in ways Truax and Adorno each in their own way describe, an active use of media can also create a new sensitivity. The British music critic and theorist Kodwo Eshun writes: 'Sonically speaking, the posthuman era is not one of disembodiment but the exact reverse: it's a hyperembodiment, via the Technics SL 1200.'[29] Even if the average listener does not consider herself a DJ, the record player is her own personal connection to music, a connection that is constantly re-evaluated by that listener herself.

The Pirate Listener
A similar observation could be made about radio, even if this medium has gone through more technological, political and economical transformations than the turntable, ending up looking like a fairly simple medium. In a sense, the knowledge of how to use radio has gone underground, after its initial broad application within different

experimental professional and amateur settings. In the late nineteenth century, the simple basic technology of radio transmission and reception and the lack of standard equipment made radio a playground for anybody with the slightest knowledge of how to tinker with a horn and a copper coil, making early (pre-broadcast) radio a paradise for 'ham operators and ersatz Teslas, pranksters and protohackers'. The atmosphere became 'a writing surface through the technology of radio', notes American writer and media artist Joe Milutis in his wonderful tale of the ether.[30]

These earliest days of radio were exciting times, in which noise and meaningful sound had to be redefined in more ways than one. Both early radio and telephone technology were very 'noisy' and 'leaky' and it was common to involuntarily eavesdrop on other people's telephone conversations, to pick up natural static or radio transmissions via your telephone, or to accidentally intercept military messages and pick up all kinds of experimental transmissions through your radio.[31] Refined, shielded equipment and especially the militarization and commodification of the ether put an end to most of this, but this kernel of knowledge and the taste for participation (to use radio in any way possible) had been planted. Broadcast radio, bound to a specific, clean and defined frequency, so as not to interfere with military and other sensitive frequencies, has perhaps attracted artists from the very beginning for this very reason. In fact, 'the radio eye saw the substance that was inaudible or overaudible even in the most common broadcast event'.[32] This was expressed not only through radio art, but also through pirate radio and micro radio (pirate radio that used very small, 'weak' transmitters) broadcasts.[33]

The vague terrain of amateur broadcasters and that of their listeners overlap. The subversive listener should not be underestimated: someone can control a radio with the simple turn of the dial. It was not only those who produced the broadcasts who were the 'subverts' on pirate, micro or free radio stations but also those who were listening (tuning in) generally actively chose to wander beyond the legal radio spectrum with its limited playlists. Hinting at the location of pirate radio ships transmitting from outside of the territorial waters in the 1960s and 1970s, sound artist Brandon LaBelle describes what he calls 'pirate listeners' (listeners to illegal radio stations) as 'kinds of marooned

islanders awash in the greater medial environment seeking out signals from isolated ships'.[34]

These 'marooned islanders' have now become isolated ships of a sort themselves. Through the Internet, listeners are no longer bound to local or even real-time broadcasts; they are not even bound to some radio station's selection and programming. As personal media players (turntables, radio, television) have moved into the same little box as music-making and editing tools, the listener floats in a self-constructed acoustic environment. The specific technology of 'sound on demand', which any music received through the Internet ultimately is, completely destroys the paradigm of broadcasting. In fact, the American noise artist G.X. Jupiter-Larsen aptly notes that in order to create anything close to the unpredictable, widespread reception created via a broadcast in an online setting, a radio maker would have to use a computer virus. He proposes the creation of a sort of podcast worm virus, which 'could actively go around looking for accidental listeners'.[35]

However, being one's own 'radio station' and creating one's own playlists from downloaded music have long ceased to be a listener's-only activity. Apart from doodling with their MP3 players, listeners and artists are increasingly using the same professional tools to produce their own music. The very popular Ableton Live software, for example, is used by vast numbers of largely anonymous Internet users, who leave their happy testimonies on various blogs and music sites, while famous musicians like the Prodigy or Daft Punk have also used it. The names of other software tools reveal the way sound can also be totally reduced to unidentifiable bits when processed: they have names like MetaSynth, Audiomulch, Crusher-X or Soundhack.[36] Sound samples from all kinds of sources end up in new compositions. In the listener's sonic space, downloaded music and homemade music have increasingly merged in an almost inseparable mix, the first often serving as raw material for the latter.

British sound writer David Toop already notes in his 1995 book *Ocean of Sound* how 'music in the future will almost certainly hybridize hybrids to such an extent that the idea of a traceable source will become an anachronism'.[37] 'Sampladelia', however, has extended to sound bites the size of entire songs or compositions. As the listener compiles her own sonic 'space', these serve as 'sound-in-itself' or as musical

elements, tones, sounds stripped of many layers of meaning. The sonic swamp that emerged from a combination of decades of industrial music production, massive downloading and the steady rise of highly professional home music tools redefines silence anew, and the listener is right smack at the centre of this. Adorno's 'atomized listening' is definitely still a valid view, and it is spreading like an oil stain, but not necessarily in a negative sense. It is a selective way of listening that is a combination of conscious and subconscious filtering mechanisms. The criticism of the category of 'sound-in-itself', sound without any significant connection to an identifiable source, which Kim-Cohen brought to the fore, is very relevant in this context. His position that 'sound-in-itself' does not exist is, nevertheless, wrong. 'Sound-in-itself' is silence. It is an acoustic void filled with sounds that only become significant and heard when selected and used for composition. Making music or sound art in this sonic void requires a clever application of its properties.

Sonic Performance beyond the Void

The musician as artist finds herself in this void. In a way, this was always her space. French economist and scholar Jacques Attali calls music 'the organization of noise'[38] in his influential book on the Western music tradition.[39] Following Attali's theory, one could also say that all music is the transformation from meaningless noise to meaningful noise. Noises are lifted from the void; they are selected and arranged in a way they can be consciously heard. The instruments and techniques to create this transformation vary and evolve, but, ultimately, whether meaningless noise (floating in the world of silence) turns into a meaningful sound shape depends on a selection of producible sounds and their subsequent arrangement.

Ironically, the repetitive noise of mainstream music may offer some new sonic perspectives for those working with sound today. Through the extreme amplification of its objectifying properties, by turning its music into a mass product, the music industry also inescapably undermines its very means of existence. Attali shares the same concerns about the commodification of music as Adorno and Truax, but he derives hope from the inherent self-destructive characteristics of this commodification, those elements of it that provoke 'atomized listening' or even a 'deafening' of the listener. In the eyes of Attali, this destruction

is a prerequisite for the composition of new music. In the swamps of commodified music 'the loss of meaning becomes the absence of imposed meaning' as well.[40] The key to the freedom of a commodified music environment, the path to new creativity and meaningful sound experiences, can at least partly be found in our detachment from this music through its endless repetition and over-promotion.

Although Attali was referring to a classical tradition of music, his theory can be applied to specific underground music as well. Underground music cultures have found ways to resist or at least temporarily evade commodification, even if it is often a by-product of the rejection of the previous generation's culture.

In reference to an evolving active audience in music, the punk movement is a most compelling example. In punk, both the development of music from noise and its strong do-it-yourself attitude (which were actually deeply connected) formed an apt remedy for commodification, even if punk promulgated a specific marketable anti-aesthetic itself. One genre of music and sound art that developed from punk that largely escapes commodification is noise music. One could call noise music a condensed or ultimate form of punk music and the punk attitude. Noise music is generally, but not always, very loud. It differs from the earlier experimentation with noise as music by the Italian futurists' noise orchestra, in that it opposes rather than affirms the 'merits' of modernity and industrialization. Rather than silencing or attractively reinterpreting the meaningless noise of repetition in commodified music, noise music emphasizes and uses the 'negative', most protruding aspects of noise in its favour, and celebrates them as new forms of beauty and musical freedom.

Silence and noise may seem like opposite concepts, but as Cage and Truax have shown, both are very relative notions based on involuntary and conscious forms of filtering and preference. They are deeply related. In an analysis of silence and music, noise music therefore needs to be taken into account as well. Whereas Cage left the sounds of silence untouched for the listener to hear, noise artists present the listener with explicitly 'unhearable', deafening sounds. In noise music, *sound* (and not language, as in *4'33"*) becomes a tool to *enforce* new ways of listening. A quote from noise artist Kimihide Kusafuka, aka K2, explains how: 'Noise can not be refused by either ears or heads.'[41] Noise music not

only pushes the boundaries of music by obstructing or attacking the composing listener's filtering mechanisms, noise artists also cross the boundaries between art and music by creating their own instruments (sometimes even for both performances and recordings), or developing complex theatrical performance settings and installations. Noise music is a quest for authenticity, away from existing codes of music and conduct.

'What actually is *my* sound? What is the one sound that is mine and no one else's?' Noise musician G.X. Jupitter-Larsen of The Haters says. 'These are the questions every *noisician* has to ask himself.'[42] In a recent publication of essays on the politics of noise, the British experimental musician Edwin Prévost writes: 'If we – as musicians and listeners – have any choice when confronting the morality of capitalism, then it must be to do rather than to be done to.' The noise artist and her peers actively confront a commodified music environment with their unique sound. It is, of course, not just the noise artist who looks for his or her own sound, the audience of noise also seeks out new listening experiences, new ways of 'perceiving the world', as Attali says we do through music.[43] Prévost continues: 'We search for sounds. We look for the meanings that become attached to sounds.'[44] Artists and listeners have become very close.

Music is, as Attali would also say, a herald of things to come, in both future music and society. Noise music in the 1970s already contained some defining elements of the music and sound art of today, and we could ask ourselves if it will hold more messages in the future. One such element is the active role of the audience. Whereas Cage more or less created the 'composing' listener from scratch, the contemporary performer and composer expect her and depend on her. Whether it is a dance music DJ or a laptop musician, the listener's involvement is often an anticipated and fundamental part of the sonic experience, even if in very different ways. In the dance music genre, a DJ works with the physical movement of the audience to shape her mix.[45] Music created entirely in and with a laptop, however, requires a more intellectual bond with one's audience, since both source and author can seem obscured or vague. It needs an environment of trust and maybe even of conspiracy.

Electronic music composer and initiator of the Microsound music network Kim Cascone became interested in the relationship between

—

artist and audience when the laptop started to appear in the perform-
ance of contemporary music. In a lecture he gave at a conference about
art and interfaces in 2003, Cascone described how an audience could
feel 'cheated' if a performer used what is perceived to be a business tool
as a musical instrument. According to Cascone, laptop musicians have
to find ways in which to 'show the audience how to differentiate "rep-
resentation by the machine" from "repetition of the machine".'[46] One
might say that the listener has to be given a way 'into' the machine. For,
in the words of Cascone: 'The laptop acts as a direct connection to the
mind of a composer, and bypasses most of the apparatuses that have
been put into place by pop culture over the past 100 years.'[47] In order to
truly enjoy the performance, the audience needs to find a place in this
'bypass'.

The 'direct connection' between laptop and the mind of the compos-
er is not as farfetched as it might seem. Cascone and other laptop musi-
cians play their laptops as an instrument rather than as a 'controller' or
'interface'. It is also not as impenetrable for the listener as it may seem.
The virtual space created by the temporary alignment of hardware, soft-
ware and artist in laptop performances resembles that of *4'33"*, in that
it is visually much like the way David Tudor used his piano. The laptop
musician opens and closes her laptop; Tudor merely opened and closed
the lid of his piano. If the listeners feel cheated in any way it is probably
similar to the discomfort the audience of *4'33"* felt. As in *4'33"*, a huge
potential lies in this 'invisibility' of the author and the obscurity of the
sound source, a potential space of interaction and engagement.

The laptop, as selection, combination, notation, performance and
publication machine, is as much a 'ghost box' as a stage, an open plat-
form residing within a virtual space. 'I like the fact that tools have
become part of the message,' says Cascone, paraphrasing McLuhan. 'It
can create very complex surfaces upon which to work.' He describes his
performances as creating a 'density of information, multiple channels
all turned on at once, while listeners position themselves in this field'.[48]
The listener has, however, changed from being a mere passive audience
member to a potential actor, in the sense of someone actively compos-
ing or participating. The 'search for sounds' and their meaning is a trait
shared by artist and listener, and the artist creates his or her work with
this in mind.

The technology and methods Cascone uses also allow for much deeper audience engagement. The practice of 'livecoding' in music is one example. In a text with the visionary title 'All Problems of Notation will be solved by the Masses', artist and programmer Simon Yuill speculates how changes on the level of the production of code or music notation could solve issues concerning shared property and authorship in collaborative works. Livecoding, however, is also definitely a way 'into' the laptop, that bypass of pop culture Cascone described. In livecoding, the writing of what Yuill calls 'software code'[49] is part of a work of art's make up, and the audience can either follow the live development of code on a screen or can actively take part in its production. It is a practice that reaches beyond music making alone,[50] but, in live music performance, it can be a very compelling way to engage audiences. In an article about the 'livecode trio' Slub on the Wired.uk website, 'livecoder' Dave Griffiths recalls: 'One audience member explained to her partner after a performance that she finally understood why he spent so much time programming.'[51]

Yuill describes livecoding as 'a form of production that is itself "live" and living, that enables the possibility of production by others for their own purposes'.[52] The engagement of the audience, of the listener, extends beyond the time frame and situation of the performance alone. The artist not only creates a work, but also enables its intimate contextualization, its merging with and integration in a living and fluctuating composing activity of the listener. By gaining access, on various levels, to the code, the basis of digital sonification, the audience develops far beyond Cage's intellectually composing listener. Thinking back to Benjamin's reader as potential writer, the audience, which now consists of both composing listeners *and* reader/writers, through livecoding is also involved in music creation at the level of its most basic conceptualization. This pulls music production into the political sphere of open-source and free-software movements. The creation of meaningful sound that escapes (or is protected from) the sonic void of commodified, flat, repetitious music environments could at least partially be organized and realized this way.

For now, the sonic void is still expanding. A vast amount of music goes unheard, ignored, atomized (cut up), ravaged and plundered as acoustic 're-source'. Much 'home-made' and independent music risks

209

the chance of being treated the same way. In an interview with Brendan Dougherty for the Berlin magazine *Pulse*, Cascone points out: 'The Internet and new ways of sharing music has created a deluge of material. You have to sort through terabytes of music until you get to a piece that might be good.'[53] The question is whether this is really a matter of quality, or of our changing attitude towards music in general, because being a composing listener with too much meaningless noise on hand, too much 'silence' to choose from is quite an ordeal.

Zooming in on Silence

Another way of escaping the void is leaving it behind altogether. A decade before punk and noise music, and with Cage's silence already transcending beyond the realm of the music hall, Canadian composer Raymond Murray Schafer developed the 'soundwalk'.[54] In this more classical experimental music approach, listeners create a sound composition by moving through a specific landscape. The route is the score, if there is one. In a soundwalk, 'music' is created where there was once only 'noise', meaningless sound or silence. The soundwalk is a kind of enhancement of the listener's powers, as an escape from the concert hall frees her from the music tradition it represents, enabling a broader range of possible interpretations. *4'33"* and the soundwalk, however, both tend to still expect or affirm a distance between listener and sound, whereas this distance is relative or at times even nil in the context of contemporary media.

In 'third nature', listening is a matter of a more hybrid act of focusing, in which the borders between human and environment, human and machine are more fluid. This means that a profound listening experience of environmental sound has to be more than a mere attentive form of listening. The ear is helped, guided or manipulated into a specific direction by technological means. In order to successfully steer a technologically supported and enhanced focus, however, a very conscious choice has to be made beforehand on what to listen for, even if the final result is not entirely predictable. In a way, this also happens with laptop music, when the musician, in the words of Cascone, creates a 'density of information, multiple channels all turned on at once, while listeners position themselves in this field';[55] the artist creates a kind of 'scene' for the listener to dwell in.

Compared to *4'33"*, this approach to silence is simultaneously both a step out of the sonic void and a placing of a different limitation on the listener's powers. The specific route into silence the artist chooses takes the place of the stage or the concert hall. It is a way 'into' the performance of the artist, while leaving room for broader interpretations. The artist is a kind of super-listener, and she leads an audience of fellow listeners to far corners of silence they were never able to hear before. A listening composer leads the composing listener: what is heard is delimited by the artist's specific method and means of focus into silence. The setting of *4'33"* (the concert hall, the announcement, the unmoving pianist) is replaced, or rather: fragmented. The audience is placed within a particle of it; the composing listener can only hear into that 'microscopic' element of silence she is guided to by the artist. We listen to a space within a space, silence within silence.

Amplification seems the most straightforward and simple way of listening far into silence. Sonic amplification is commonly understood as the act of 'enlarging' sound as if one were hearing through a kind of magnifying glass, although it is actually a form of translation. While the magnifying glass enlarges a visual detail quite literally, sound is first translated into electrical currents before it is transformed back into acoustic vibrations that the ear can pick up. The way we approach our acoustic environment is, in some ways, outdated. Since the development of telephony and radio, this environment has consisted of more than just 'traditional', reverberating sound waves. Certain phenomena that were not part of sonic space before, like magnetic waves or solar static, became part of our acoustic environment because they are siblings of the phenomenon that enables radio and telephony: electricity. As such, they appeared quite naturally in the human acoustic spectrum after the application of electrical currents for the amplification and transmission of sound.

Different objects can function as 'microphones', as receivers or amplifiers through 'simple' laws of physics. In the late nineteenth and early twentieth centuries, when telephony and radio were still in their infancy, electronically conjured-up sounds created a whole new perception of the world. Douglas Kahn writes how, in these early days, the telephone, for example, not only acted as a new communication device, but also as 'a scientific instrument of great sensitivity and versatility'. 'It revealed hitherto unheard-of phenomena' through the

cross-pollution of both man-made and natural sounds that occurred in its network of wires. Unexpected amplification of the telegraph and radio sound also erupted from metal fences or even railroad tracks, as these sometimes surprisingly functioned as combined large antennas, receivers and amplifiers.[56]

Unwanted crackles and noises needed to be explored and explained before they could be eradicated in the quest for 'perfect', undistorted signals. These unwanted sounds thus were meaningless and meaningful at the same time. The development of various techniques for their control pushed these sounds into very specific sonic realms, namely those of scientific research. The general public deemed them useless and disturbing. These sounds therefore have a double 'identity': they are both highly meaningful sound and lost in 'silence'.

Some artists explore this ambiguous space of 'sound-that-isn't-sound'. By using this part of the sonic spectrum, these artists take Cage's exploration of silence even further, and expand it into the realm of electric acoustic space. This is by definition a layered space, consisting of different physical and cultural structures. It is sound *and* not sound, since non-vibrating electromagnetic waves and digital code are translated into 'traditional' vibrating sound waves. It is immaterial *and* physical. It is meaningful *and* meaningless noise, depending on the context and the listeners. In his text 'John Cage's Early Warning System' British theorist Charlie Gere writes how Cage's *4'33"* taught people how to interpret noise as signal.[57] But what Cage really did was re-appropriate a form of listening that had been limited or confined to the scientific realm, without using its tools. These tools have, however, become part of the daily environment of many contemporary artists, and the legacy of Cage is continued into the hybrid landscape of a sociotechnological society.

By moving into this part of the sonic spectrum the political dimension of *4'33"* (its empowerment of the listener and its subversion of the realm of commodified music) is, therefore, also expanded in another way. Acoustic spaces that have been artificially separated or divided are re-united and their borders are blurred. The sonic void of a commodified musical experience is circumvented, escaped from or ignored via a different strategy than that of *4'33"* because the focus is not on the silence that is meaningless noise. Today's silence consists of sound that did not exist or was not discovered before the age of electricity.

Joyce Hinterding's Aeriology

Electromagnetism translated into audible signs is one example of sound-that-isn't-sound, and Australian artist Joyce Hinterding uses this in some of her works. Hungarian artist, curator and critic Nina Czegledy describes Hinterding's work as a method for questioning and better understanding our environment as 'a living medium'.[58] *Aeriology* seems to overlap with the soundwalk, in the sense that Hinterding's work explores our everyday environment as a place of possible musical wonder. After experiencing her installations, the world definitely seems like a different place. Most people are already aware of the 'hard' architecture of our daily environment in which buildings, roads, sewerage systems and cables of all kinds create the tangible modern city. 'Soft' structures like those of radio, television and wireless networks are also familiar, even if their presence is much more obscure. Hinterding has, however, created a number of works in which she discloses how full of magnetic radiation, both natural and man-made, from electrical storms to power stations, this environment is. As Czegledy notes, this tends to create a feeling of being in a living, deeply connected, vibrant environment, which functions as a medium as well as a basic exhibition space.

Hinterding's best-known work *Aeriology* taps into the VLF (Very Low Frequency) range of the radio spectrum, by constructing technologically very simple devices that pick up and amplify any signals in this part of the spectrum, where one can hear the hum and crackle created by all kinds of electromagnetic activity, both natural and human-made. In the city, this means we hear the magnetic radiation of electrical appliances and the electricity grid itself, while the same installation may pick up thunderstorms and other natural magnetic phenomena in the countryside. 'This section of the spectrum is so noisy that it is really only used to transmit a global navigational signal called the Omega tracking signal,' says Hinterding in my 1998 interview with her. 'But the noise in this frequency range is very interesting, consisting mainly of quite beautiful pinging and popping sounds.'[59]

Even if Hinterding does not set out to create educative or politically charged works, a piece like *Aeriology* may end up functioning that way. As such, *Aeriology* can be compared to *4'33"*, because, besides being an absolutely stunning installation visually, consisting of huge lengths of shiny red copper wire wound metres high around a set of pillars (or

some other core part of a building) connected to a few pairs of head-phones, *Aeriology* shows how easy it is to 'collect' or create electricity from thin air, like a kind of self-sufficient 'radio' plus headphones. The *aha-Erlebnis* that John Cage created for his audience is recreated with a twist: while the audience can choose to remain at the level of the 'composing listener', exploring the amplified deep silence of electromagnetic noise through the headphones, the audience is also given the insight into how to build their *own* instrument to hear deep into the silence. Even if, with *Aeriology*, the artist steers the audience's path into silence, limiting it in the process, she also enables the audience to become super-listeners themselves.

R a d i o q u a l i a's Radio Astronomy *and* Free Radio Linux

In a text called 'Voice and Code' I pondered whether we needed an Alan Lomax of computer languages to capture the riches of code in different contexts and eras.[60] Computer languages are an interesting mix of human and mathematical linguistics, and, as such, they are – like music – related to speech. Through its vast, global multidimensional networks, the Internet has created a sensitive social and political dimension for the writing and use of code, which is reflected in the works of many different artists and even philosophers.[61] Code may in some ways be regarded as obscured or silenced voice.

If any art group explored the possibilities of sound and the Internet it is r a d i o q u a l i a, a collaboration between the New Zealand artists Honor Harger and Adam Hyde, that has produced a number of works in which the boundaries between art, music and radio were crossed. R a d i o q u a l i a aims to deeply engage the listener, and even identify people as 'radios' themselves, as they move around the landscape picking up alternating radio signals at various locations instead of turning the dial, creating their own technological version of the soundwalk. The Latin word *qualia* is used in philosophy to refer to qualities of experience. Hyde states that 'r a d i o q u a l i a is the experience of radio in all of its different amorphous forms'.[62]

Their *Free Radio Linux* is a symbolic work in which the artists created a computer-generated voice that read the code of the open source operating system Linux out loud. This sound was played both on air and online. Code is generally hidden deep inside a computer, since

most desktops and laptops now run operating systems with interfaces that hide the inner communication of and with the machine. Most operating systems (Apple or Microsoft) even attempt to prevent the owner of the machine their software runs on to intervene, change, or correct their code in any way. As such, Linux is an open communication system between human and machine. By literally voicing Linux, the artists have emphatically positioned it in the midst of the public sphere, allowing it to be 'heard'.

The project became significant through its development of the commodified sphere of Web 2.0 during this period. The battle over open source software is often compared to the battle over free speech, and the proprietary platforms of Web 2.0 severely limit the possibilities of the Internet in the public sphere. *Free Radio Linux* invites the listener to not only compose (create a musical interpretation of the monotonous beat of the synthetic consonants and vowels), but also to 'code', much like the audience of livecoding. But the reading of the Linux code takes a long time, so this invitation was presented in the shape of an 18-month performance. 'The Linux kernel contains 4,141,432 million lines of code,' the announcement of Free Radio Linux points out. 'Reading the entire kernel will take an estimated 14253.43 hours, or 593.89 days.'[63] There is no 'atomized listening' here, only a listening for the 'cut' in the repetitive sounds of the stream. Tuning into the sheer endless line of code, the listener is both encouraged to 'hear' its environmental significance and to take part in its 'composition'.

Harger and Hyde also explore the new sounds we receive from the galaxy. Moving from the depths of the computer to the 'silence' of outer space, r a d i o q u a l i a created *Radio Astronomy*. Canadian artist Jacques Perron writes how r a d i o q u a l i a declared this work to be a kind of tribute and reference to Cage and other early experimental composers. For those who think *Radio Astronomy* needs justification as music, Perron writes:

> Stockhausen affirmed that technological instruments such as microphones, transmitters and recordings are effectively musical instruments. In other words, sounds that are usually perceived as being non-musical can be transformed into music thanks to the intervention of a musician or a sound artist.[64]

With *Radio Astronomy*, the artists collaborated with various scientists and researchers worldwide and hooked up to their instruments and the end result is similar to playing with the radio dial, or scratching and mixing records.

Harger describes some of these encounters in a text for the book on radio art *Re-Inventing Radio*. Her stories reveal how the various noises heard in *Radio Astronomy* serve as something between music and communication for the people who study them. Researchers like being able to monitor space for sound, as it allows them to do multiple tasks at once, like working in a factory with the radio on. The announcement of a cosmic storm is greeted with the same excitement and preparations as a live broadcast of an important sports event. She quotes Hawaii-based engineer Richard Flagg as saying: 'You could spend all night listening to static at the radio observatory.'[65] This hidden world of sound is brought to the fore by *Radio Astronomy*. The silent universe is only still for those who are not listening.

Radio observers are like 'soundwalkers' in space – r a d i o q u a l i a enables us to walk with them. Through a profound, attentive listening, an unfathomable landscape unfolds, an endless space filled with all kinds of phenomena, most of which are invisible to the naked eye or ear. The 'music of the spheres', as Renaissance astronomer Johannes Kepler would have called it, was picked up by radio telescopes and streamed live online. Kepler's 'third law of planetary motion, outlined in his celebrated treatise *Harmonices Mundi* from 1619, related planetary movements to musical scales and intervals.'[66] R a d i o q u a l i a presents this 'music' the way it is received, translated and passed on via radio telescopes, the huge hearing aids of planet Earth.

Sonic Takeover

Audiences attending 'silence pieces' have an active role in the composition of the work. Artist and audience typically engage in a voluntary collaboration, even if the first performances of *4'33"* created a bit of a stir. The fluid 'composer/performer/listener roles' Michael Nyman describes seem to, at least theoretically, eliminate a hierarchy between artist and audience, between artist and composing listener.[67] This is, however, by far not the case in every work. There are very distinctive varieties in how an artist approaches an audience, even in the creation

of 'open works', and particularly when 'silence' is performed: sometimes a composition of silence is forced upon a listener. We could say that two basic models exist: the invitation (which, once accepted, makes one move into a shared space, acoustically or conceptually) and the invasion (something enters the personal sphere). In the first, an audience is invited to join in the composition. In the second, it has no choice.

Mark Bain's Acoustic Space Gun

Audiences are used to a certain level of 'captivity'. One could say traditional audiences seek this capacity out. Involuntary, captive audiences also exist, however. The police or the military often create captive audiences at demonstrations, soccer matches, or political gatherings, through the use of crowd-control techniques. The public is addressed with amplified and somewhat distorted voices through megaphones or it is attacked with 'sonic weapons' thrusting disturbing or even sickening sounds into their midst.[68]

American artist Mark Bain has studied these techniques. He applies a mixture of crowd control and playback in some of his works. Bain was inspired by notorious underground writer William Burroughs's 'The Electronic Revolution'. In this raging, poetic, paranoid, but also tactically accurate text, Burroughs propagates the use of what he calls 'playback', which is comprised of an insertion of previously recorded and mixed sound into a specific location or situation in order to create a massive disturbance. Burroughs's technical description of 'playback' involves the use of three recorders: the first records the sound of a given situation, the second contains a carefully chosen disturbing sound, and the third is used to play back a mix of the first two, causing an actual disturbance through sound alone. Tape recorder 3 thus becomes 'playback, 'reality' and 'God'.[69] According to Burroughs, anybody can be God because anybody can have the power to change reality and thus erode authority. Sound interventions can indeed be powerful. 'Playback' subverts existing acoustic spaces with the unpredictable violence of a nasty rumour or virus. Playback can mix meaningless and meaningful sound in a way that creates an uncomfortable or explosive situation.

In a text for the Dutch art magazine *Open*, Bain writes how Burroughs' subversive tactics overlap with present-day crowd-control technology. Both share a 'shifting of public space, a scrambling and

reorganizing of information and location through acoustic means'.[70]
The use of sonic weapons or 'playback' disrupts familiar acoustic spaces
and injects them with the unfamiliar, with noise, with interference.
The environmental sonic material tapped into with a soundwalk and
other 'silence'-based compositions loses its predictability and becomes
alien territory. Instead of enabling new forms of aesthetic listening, as
Schafer attempted to do, the listener's ears are under attack. It reminds
me of the strategies of noise music. Bain's street installation in Istanbul
called *Action Unit: Instant Riot for Portable People* caused an actual small
riot within minutes, after which the police rushed in and shut the work
down. His *Acoustic Space Gun*, however, is of particular relevance here,
as it does not so much 'playback' but dislocate sounds, sounds that are
often considered background noise. The *Acoustic Space Gun* not only
disturbs, but also displaces silence.

Acoustic Space Gun is 'a linear sound shifter'. Supported on the artist's
shoulder, it looks a bit like an inverted anti-tank weapon: the front
of the gun is a long thin microphone that absorbs the sound 'bullets',
while a large parabolic sound emitter points out and away from behind
the 'shooter's' back. Bain calls it 'an absurd spatial megaphone', as
it delays the sounds it projects considerably, producing not only a
displacement but also an echoed distortion of common city sounds.
Environmental sound is thrust out of orbit, but is strategically not
overly amplified, so as to create a subtle confusion among involuntary
listeners. When wandering into the reach of the sound emitter, this
mild distortion of 'silence', of generally unheard and ignored sounds,
startles and bewilders street audiences. Learned listening techniques
are no longer valid when the acoustics of ordinary situations suddenly
collapse and convulse. Twisting the listener's sense of sound, Bain pro-
vokes conscious hearing, but distorts the listener's ability to compose.
By aiming his gun at innocent passersby, Mark Bain acts as an attacker
or a hijacker of personal acoustic spaces: the border between artist and
listener is crossed, subtly and violently at the same time.

Jacob Kirkegaard's Labyrinthitis

From being performed on to being the performance is a small step.
It was only a matter of time before the listener was transformed into an
instrument, a source, as well. The listener had already served as a 'stage',

the place of performance, as the 'composing listener', but it turns out the listener's ears can also be used as musical instruments: in the late 1970s, scientists discovered that the ears not only receive, but also emit sound.[71] In 2007, Jacob Kirkegaard created *Labyrinthitis* on a commission from the Copenhagen Medical Museion based on this discovery. It is a work in which the ears of the audience co-produce the sounds when it is performed live. The sounds are actual sounds emitted from the ears; they are not illusions, and they are not the disturbance of the inner ear we know as 'tinnitus', even if they sound a lot like it. They arise from the movement of hair cells within the fluid chambers of the inner ear's labyrinth. They can spontaneously erupt, but they can also be provoked by an interference of two separate tones played into the ear, to produce so-called 'cubical difference tones' or 'Tartini tones'. Here two different sound frequencies create a reaction in the inner ear that in turn produces a third sound. The sounds created in the ear are called DPOAEs (distortion product otoacoustic emissions).[72]

In an essay for a limited edition CD of *Labyrinthitis*, Douglas Kahn points out the obvious connection to Cage. One story about *4'33"* is that Cage was inspired to produce this work after visiting an anechoic room, a completely echoless, resonance-free space used for all kinds of acoustic experimentation and recordings, and here he discovered there is no such thing as silence. Cage heard two distinct sounds where he expected none: one high pitched, one low. He was told they came from his own body, from his nervous system and from his circulating blood. Kahn implies that Cage might very well have heard otoacoustic emissions, which were not discovered until decades later.[73]

The sounds Kirkegaard 'plays' in *Labyrinthitis* were recorded from the artist's own ears in an anechoic room. They are then aimed at the audience's ears where they provoke the eruption of new Tartini tones. Two sounds creating a new reality, the artist playing 'God' inside the listener's ears. Silence as sound-in-itself, a background noise or 'meaningless' sound pool we move in and out from, the very matter *4'33"* is comprised of, is technologically enhanced, recorded and used for playback, for creating a response. In a way, Kirkegaard uses Cage's groundbreaking experience of silence in a work that adds a new dimension to the fluid role Nyman described so that we can now speak of the composer/performer/listener/instrument.

In another essay for his CD, Kirkegaard's friend and colleague, British composer Anthony Moore, describes how he and Kirkegaard had been discussing 'the idea of reversing the normally accepted direction of information streams . . . for many moons'. It seems like Kirkegaard and Moore were looking for a way to create a physically interactive sound work that required only a listening audience. While Cage still invited an audience to become composing listeners, Kirkegaard completely bypasses the free will of the audience. The interactivity requires no pushing of buttons, no – or very little – movement in the room. For instance, for an installation version of *Labyrinthitis* at Sonic Acts XIII in Amsterdam it was necessary to move to a specific part of the space, but the work was originally designed to be performed in a large auditorium. In an interview with British writer and curator Daniel Campbell Blight, Kirkegaard explains how 'this work is indeed interactive, but in a way that you don't decide for yourself'.[74] *Labyrinthitis* surpasses the listener's ability to focus with her ears the way that is possible in *4'33"*, by manipulating the hair cells in the listener's cochlea during a concert or during a playback of the actual recording.

Labyrinthitis, being a form of 'playback', can have a dramatic affect on the listener. The responses the artist gets from his audience speak volumes, as listeners report hearing sounds passing through their heads, feeling their heads resonate, or hearing different things in their left and right ears.[75] These subtle otoacoustic emissions are amplified and distorted to kaleidoscopic, or as Kirkegaard calls them, 'labyrinthic' experiences. Kahn also refers to Burroughs in connection to *Labyrinthitis*, but more in reference to his cut-up novel *The Ticket that Exploded*, in which a patient is manipulated through the playback of sounds recorded from his own body.[76] We literally resonate during the performance, and we not only listen to silence, but we become it. Moore writes emphatically:

> It is as if our sense of the world is no more nor less than the resulting interference patterns of information streaming into and out of our bodies, that the medium is simply nodal densities of content becoming both the cause of – and simultaneously being displayed upon – an ethereal skin of interference.[77]

Kirkegaard forces us to listen in a new way, in which the traditional, captivated audience is mixed with the composing listener, while involuntarily also acting as musical instrument, as sound source. Making the active ear a conscious element of composition shifts the interpretation of silence from 'readerly' to experiential, creating an unstable, process-based, deeply physical rather than psychoacoustic music. Still, the musical movements of *Labyrinthitis* are minimal, and very much open to interpretation and even a listener's 'meditation'. Guided by the artist, the listener's intellectual experience of the 'cut' completely merges with her bodily rhythm. It is as if *4'33"* had been translated into trance music, making the body subtly sway to its own beat. Engaging the listener's body in active composition, Kirkegaard achieves the ultimate, deeply intimate convergence of composer and listener, a convergence in which the sonic void dissolves, at least temporarily, like an autumn fog on a sunny day.

The Source and the Well

One could say that the sonic void emerged when Theodor Adorno found himself practicing 'atomized listening', a way of listening that focuses on the good parts in between the crunched sounds of early recordings and radio broadcasts. Even if one questions Adorno's conservative taste in music, or his judgment of the specific acoustic qualities of the new media carrying music, it is clear he was desperately trying to listen for authenticity, for the specific qualities that connect listener and sound in a highly meaningful way. But he was also trying to listen for it as a traditional listener, and his criticism of the music industry was rather rigid and nihilistic because of it. Instead of *unhearing* the products and 'noises' of third nature, new ways of listening needed to develop for new music to evolve.

In third nature, authenticity is not found in an object or original source. It is created through relations, between things, in processes. Silence and noise are both highly unstable and ambiguous cultural constructs. Upon closer scrutiny, the construction of silence and noise also overlaps to a significant extent. They seem to serve a special purpose in the definition of art, politics and society, something that is reflected in the many critical readings of Cage's *4'33"*, and in those of noise music. By employing the ambiguity of silence and noise, art-

ists not only question given definitions of silence and noise, but they challenge the very structures that define these notions.

Even if Cage opened up musical and listening practices to include 'silence', his work did not include the unheard or third nature noises. The resounding silence John Cage created *4'33"* from was separated or shielded from these, because *4'33"* was deeply informed by Cage's choice of venues (concert halls) and the audience's musical expectations. Still, John Cage managed to realize a new form of listening that was to transform the understanding of music and create new audible vistas for artists and listeners. The 'composing listener' could be seen as a powerful, positive alternative to Adorno's bereft or even victimized audience. The fluidity of roles Nyman mentions allows for a wide variety of practices to evolve and thrive, which, each in their own way, creates an (at least temporary) escape from the sonic void.

These practices range from the composing listener being led far into silence to 'forced' audience engagement. In the first, the artist creates a technologically enhanced path into deeper layers of silence, which the audience can enter and explore as they did with *4'33"*. Hinterding's *Aeriology* and r a d i o q u a l i a's *Free Radio Linux* or *Radio Astronomy* are examples of this. In the latter, the artist establishes a more complex and dynamic relationship with the composing listener, by inviting or introducing her into an open live composition, or by making her an involuntary part of it. The work of Kim Cascone, livecoders Slub, but also Mark Bain's *Acoustic Space Gun* and Kirkegaard's *Labyrinthitis* all fall into this category. In these works and practices, the relationship between artist and listener is very close, to the point of intimacy.

The answer to the question of how to escape the sonic void can be derived from both Adorno and Cage: it lies within the individual listener. Whether she withdraws into a rejection of certain sonic forms, engages in their composition, or is made part of them, a personal engagement is at the heart of acoustic space today. The listener is the source and the well. Everything else is part of the void. Everything else waits to be selected, used, and heard.

Notes

Introduction

1 Only the text describing .walk by Wilfried Houjebek remains unaltered. It first appeared in the essay I wrote for the catalogue of an online exhibition of Media Art Net called 'Constructing Media Spaces – the novelty of net(worked) art was and is all about access and engagement'. In: Rudolf Frieling and Dieter Daniels (eds.), *Media Art Net, Key Topics 2* (Vienna and New York: Springer, 2005).

2 Per Platou (ed.), *Skrevet I stein. En net.art arkeologi* (Oslo: Museum for Contemporary Art, 2003).

3 This is the only data on the Next5minutes2 produced by the V2_ organization in Rotterdam, Web: http://www.strano.net/town/meeting/next5min/prog.htm (accessed September 2010).

4 'Good Times' is the title of an art work by the artist duo called Jodi, who were – and were not – part of net.art, which was taken from the name of a computer virus hoax that spread across the Internet in 1994 until some years later. I saw it in my own email in-box in 1996. From Wikipedia: 'The Goodtimes virus was supposedly transmitted via an email bearing the subject header "Good Times" or "Goodtimes", hence the virus's name, and the warning recommended deleting any such email unread. The virus described in the warnings did not exist, but the warnings themselves were, in effect, virus-like.' Web: http://en.wikipedia.org/wiki/Goodtimes_virus (accessed November 2010). Meanwhile, well-meaning 'netizens' passed the warning email on to all their friends.

5 Brian Mackern (ed.), *netart_latino database* (Badajoz: Museo Extremeno e Iberoamericano de Arte Contemporaneo [MEIAC], 2010).

6 Seth Kim-Cohen, *In the Blink of an Ear: Toward a Non-Cochlear Sonic Art* (London: Continuum, 2009).

Part 1

Let's Talk Net Art

1 Martin Heidegger, *The Question Concerning Technology, and Other Essays* (New York, NY: HarperCollins Publishers, 1982).

2 Tilman Baumgärtel, *[net.art]: Materialen zur Netzkunst* (Nürnberg: Verlag für moderne Kunst, 1999) and *[net.art 2.0]: New Materials towards net.art* (Nürnberg: Verlag für moderne Kunst, 2001).

3 Rosalind Krauss, *A Voyage on the North Sea, Art in the Age of the Post-Medium Condition* (London: Thames and Hudson, 1999) and *Perpetual Inventory* (Cambridge, MA: MIT Press, 2010).

4 Dieter Daniels and Gunther Reisinger (eds.), *Netpioneers 1.0: Contextualising Early Net Based Art*, (Berlin: Sternberg Press, 2010); Oliver Grau (ed.), *MediaArtHistories* (Cambridge, MA: MIT Press, 2007).

5 Edward Shanken, 'Reprogramming Systems Aesthetics: A Strategic Historiography', *Proceedings of the Digital Arts and Culture Conference* (University of California Irvine, 2009), Web: http://escholarship.org/uc/item/6bv363d4 (accessed January 2010).

6 Some of these myths include:
'The Internet is a medium for delivering miniature forms of other art mediums.
Internet art is appreciated only by an arcane subculture.
To make Internet art requires expensive equipment and special training.
Internet art contributes to the Digital Divide.
Internet art = Web art.
Internet art is a form of Web design.
Internet art is a form of technological innovation.
Internet art is impossible to collect.
Internet art will never be important because you can't sell a Web site.

Looking at Internet art is a solitary experience.'
Jon Ippolito, 'Ten Myths about Internet Art', *Leonardo Magazine* (2002) no. 35,
Web: http://www.three.org/ippolito/writing/ten_myths_of_internet_art/ (accessed October 2010).

7 Gilbert Simondon, *Du Mode d'Existence des Objets Techniques* (Paris: Aubier, 2001).

8 Simondon writes about a collaboration, or a form of solidarity, between man and machine, after the machine stops replacing man, but becomes an ally in the struggle for a continuation of life: 'The machine, as an element in the technical ensemble, becomes the effective unit, which augments the quantity of information, increases negentropy, and opposes the degradation of energy. The machine is a result of organization and information; it resembles life and cooperates with life in its opposition to disorder and to the levelling out of all things that tend to deprive the world of its powers of change. The machine is something that fights against the death of the universe; it slows down, as life does, the degradation of energy, and becomes a stabilizer of the world. Such a modification of the philosophic view of technical objects heralds the possibility of making the technical being part of culture.' John Hart, 'Preface', in: Simondon, *Du mode d'existence*, op. cit. (note 7), 16.

9 Maybe this is just splitting hairs regarding the name 'Internet'. The history of the Internet generally goes back to the MIT's Arpanet, created at the end of the 1960s. Even if the Internet were to be replaced, it would have to be with a similar technology. This is actually one reason why I prefer the name 'net art' over 'Internet art'.

10 Josephine Bosma, 'Net Echt, Kleine geschiedenis van de netkunst', *Metropolis M* 22 (2001), 12-17.

11 Jack Burnham, 'Systems Esthetics', *Artforum* (1968), VII:I, 30-5 September, Web: http://www.arts.ucsb.edu/faculty/jevbratt/readings/burnham_se.html (accessed December 2009).

12 Shanken, 'Reprogramming Systems Aesthetics', op. cit. (note 5). Shanken mentions many of these in *Reprogramming Systems Aesthetics*, specifically Marga Bijvoet, *Art as Inquiry: Towards New Collaborations Between Art, Science, and Technology* (New York, NY: Peter Lang publishing, 1997); Mitchel Whitelaw, '1968/1998: Rethinking a Systems Aesthetic', *ANAT News* (1998), Web: http://creative.canberra.edu.au/mitchell/pubs.php (accessed November 2010); and Simon Penny, 'Systems Aesthetics and Cyborg Art: The Legacy of Jack Burnham', *Sculpture Magazine* (1999), vol. 18, Web: http://ace.uci.edu/penny/texts/systemaesthetics.html (accessed November 2010).

13 Burnham, 'Systems Esthetics', op. cit. (note 11).

14 In the case of Bourriaud, his position was informed by hostility rather than unfamiliarity, which was revealed at his lecture on interactivity in art at the University of Amsterdam in 2005. After a general question from an audience member, asking why none of the speakers had talked about media art when the theme of the event was 'interactivity', Bourriaud grabbed the microphone and hissed without interruption: 'Have you ever seen any good media art? No. Neither have I. That is why we don't talk about it.' The 'Right about Now' lecture series, without Bourriaud's rant, was published in *Right About Now: Art & Theory since the 1990s* (Amsterdam: Valiz, 2007).

15 Julian Stallabrass, *Internet Art, The Online Clash of Culture and Commerce* (London: Tate Gallery Publishing, 2003).

16 Tiziana Terranova, *Network Culture: Politics for the Information Age* (London: Pluto Press, 2004).

17 Pro surfer stands for professional surfer. Pro surfers or surfing clubs have been described by the German-American artist Marisa Olson, and American artist Marcin Ramocki, who for instance writes: 'While a more traditional blog is a journal of an individual artist, who posts images of his/her work, research and thoughts, a surf club imposes certain practice dynamics, which is conductive to a very fast-paced conceptual exchange based on treatment and analysis of online material, or using the online material as a base for any kind of investigation.' Marisa Olson, *Lost Not Found* (2008). No longer available online. An excerpt is available in the Networked_Performance archive: http://turbulence.org/blog/2008/09/24/lost-not-found-the-circulation-of-images-in-digital-visual-culture/ (accessed December 2009); Marcin Marocki, *Surfing Clubs* (2008), Web: http://ramocki.net/surfing-clubs.pdf (accessed November 2009).

18 Amy Scholder and Jordan Crandall (eds.), *Interaction: Artistic Practice in the Network* (New York: Distributed Art Publishers, 2001).

19 Josephine Bosma, 'Net.art: From Non-Movement to Anti-History', in: Matthias Weiß (ed.), *Netzkunst, ihre Systematisierung und Auslegung anhand von Einzelbeispielen* (Weimar: Verlag und Datenbank für Geisteswissenschaften, 2009); Armin Medosch, 'Adieu Netzkunst', *Telepolis* (1999), Web: http://tuija.net/netart/telepolis/adieu.htm (accessed December 2009).

20 Joline Blais and Jon Ippolito, *At the Edge of Art* (London: Thames and Hudson, 2006.)

21 This term is used by Steve Dietz in his preface to: Beryl Graham and Sarah Cook, *Rethinking Curating* (Cambridge, MA: MIT Press, 2010).

22 For the origin of the term, see my history of net.art: 'Net.art - From Non-Movement to Anti-History', op. cit. (note 19).

23 This is expressed in Tilman Baumgärtel's book *[net.art]*, which included interviews with Robert Adrian, Rena Tangens and Padeluun, Wolfgang Staehle and Stelarc. Adrian established the first artist mail network in 1981 on a commercial computer network (IP Sharp); Tangens and Padeluun ran an artist Bulletin Board System (BBS) in the 1980s; Staehle set up The Thing (an online art initiative) as a BBS in 1991 and added a website in the mid 1990s; Stelarc used a telephone network to allow audiences to manipulate his mechanical third arm in the 1980s. Baumgärtel, *[net.art]*, op. cit. (note 2).

24 An edited version of the first discussion about net art can be found in Bosma et al. (eds.), *ReadMe! Filtered by <nettime>* (Brooklyn, NY: Autonomedia, 1999).

25 Even if documenta X (dX) had not focused on net art entirely, and Net_Condition had called itself an exhibition of 'net culture', these exhibitions still left their unique marks on net art. dX brought net art into an institutional art environment, while Net_Condition, the largest net art exhibition to date, rather strangely refused to mention art. To me, this seemed like a cowardly act at best, and symbolic of the approach to net art by the 'high media art' institutions at worst. Net.artist Vuk Cosic even placed a bunch of roses at the site to mourn what he saw as the death of net art.

26 Baumgärtel, *[net.art]*, op. cit. (note 2).

27 Andreas Broeckmann, 'Net.Art, Machines, Parasites', *Nettime* (1997), Web: http://www.nettime.org/Lists-Archives/nettime-l-9703/msg00038.html (accessed December 2009).

28 I am quite stubborn; I think that the viral space of the Net offers sufficient publication space. Writing a book feels almost counterproductive.

29 *[net.art]* has thus far only appeared in German, but most of the interviews in this book were published on *Nettime* and in the online magazine *Telepolis* in English as well. The second book, *[net.art 2.0]* is published in both German and English.

30 Bosma et al., *ReadMe!*, op. cit. (note 24).

31 For example, Weiß, *Netzkunst*, op.cit. (note 19); and Daniels and Reisinger (eds.), *Netpioneers 1.0*, op.cit. (note 4).

32 Though the terms net.art and net art, respectively, with and without the dot, have very different meanings today, they were used indiscriminately in the period from 1995 to 2000. Even today, they continue to be confused, and not entirely without reason. For more background information, see Bosma, 'net.art: from non-movement to anti-history', op. cit. (note 19).

33 My translation from the original German: 'Es geht um Kunst, die sich mit den genuinen Eigenschaften des Internets auseinandersetzt und die nur im und mit dem Internet stattfinden kann'. Baumgärtel, *[net.art]*, op. cit. (note 2).

34 Baumgärtel, *[net.art 2.0]*, op. cit. (note 2).

35 Donna Haraway, 'A Cyborg Manifesto', in: *Simians, Cyborgs and Women: The Reinvention of Nature* (London: Free Association Books, 1991); Claudia Reiche and Verena Kuni (eds.), *Cyberfeminism: Next Protocols* (Brooklyn, NY: Autonomedia, 2004).

36 Tilman Baumgärtel, *Immaterialien, aus der Vor- und Frühgeschichte der Netzkunst* (Telepolis, 1997). Web: http://www.heise.de/tp/r4/artikel/6/6151/1.html (accessed December 2009).

37 Stallabrass, *Internet Art*, op. cit. (note 15).

38 Bosma et al., *Readme!*, op. cit. (note 24).

39 Stallabrass, *Internet Art*, op. cit. (note 15).

40 The statement that comes closest to a definition is probably: 'The most fundamental characteristic of this art is that it deals with data, and can be thought of as a variety of database forms', which is part of the introduction. This is influenced by Lev Manovich's *The Language of New Media*, which becomes clear in the course of the book. I think this definition is too formalistic, since the Internet is both a technological and cultural basis for net art. Net art can exist outside of the Net. Other suggestions I would not subscribe to include: 'Like graffiti, Internet art tends to be swiftly recognizable, and not only because of where it is seen.' This statement is based on the similarities in style and form that Stallabrass claims dominated the work of net.artists. The styles of the work of the five most influential net.artists (Bunting, Cosic, Jodi, Lialina and Shulgin), however, vary greatly. There is some friendly borrowing of themes, especially by Cosic (the use of Bunting's street signs, Shulgin's formalism), but most of the similarities regarding form in early net art are very superficial and, if present at all, are often the result of the limitations of early browser versions. Recognizing this requires a knowledgeable eye like noticing the work beyond the superficial similarities of abstract works of art.

41 These debates can be found online and have been spread across the *Nettime.org*, *Rhizome.org* and *Telepolis.de* archives. An edited version of the Nettime discussions is available in Bosma et al., *Readme!*, op. cit. (note 24).

42 Rachel Greene, *Internet Art* (London: Thames and Hudson, 2004).

43 Greene's somewhat reveals her own position at the time when she explains how her approach developed: 'Whereas I felt a pressure in earlier years to come up with fresh critical approaches to new media or give them "cyber" sensibilities, now it is possible to write a more open history for a wider audience, one that is in dialogue with other related art-historical and oppositional movements.' It sounds almost as a relief. It is a pity though that Greene does not elaborate on the pressure she mentions, where it came from and what caused her change in attitude. Still, her book pays tribute to the period of net.art (roughly 1995 to 1998), most of all by marking it as the beginning of net art as a whole, thus still following certain '"cyber" sensibilities'.

44 Greene, *Internet Art*, op. cit. (note 42).

45 See: http://www.artificial.dk/articles/rachelgreene.htm (accessed December 2010).

46 In the *artificial.dk* interview, Greene states: 'I wrote the book because I was asked to do so by an editor and publishing house I really wanted to work with. I was honored to be asked by Andrew Brown at Thames and Hudson. I was aware that writing a book about an ever-evolving field would be difficult, and that the Thames and Hudson World of Art format was also a specific structure to work within. It was really challenging to write about net art within those particular economies.'

47 Donna Ferrato and Marco Meier (eds.), 'net.art, Rebellen im Internet', *Du* (2000) no. 11.

48 Weiß, *Netzkunst*, op. cit. (note 19).

49 Daniels and Reisinger, *Netpioneers 1.0*, op. cit. (note 4).

50 Verena Kuni (ed.), *netz.kunst* (Nürnberg: Institut für moderne Kunst Nürnberg, 1998).

51 Christoph Danelzik-Brüggemann, Hans-Dieter Huber, et al. (eds.), 'Netzkunst', *Kritische Berichte: Zeitschrift für Kunst und Kulturwissenschaften* (1998), 26:1.

52 Ferrato and Meier, 'net.art, Rebellen im Internet', op. cit. (note 47).

53 *Nodes/Knotenpunkte, An Experimental Exhibition with Seven Artists at Seven Venues in NRW / Ein Ausstellungsexperiment mit Sieben Künstler an Sieben Orten in NRW* (Kultursecretariat NRW Gütersloh, 2007).

54 Weiß, *Netzkunst*, op. cit. (note 19).

55 My emphasis.

56 It makes me wonder about how far this highly academic enterprise thinks it can reinvent the wheel while ignoring relevant non-academic publications and discourses, on and offline. An analysis of net art without any engagement or respect for online discourses seems especially contradictory and a farce. It is, therefore, with some evil pleasure that I discovered how also here, among self-proclaimed true experts, the definition of net art also clashes with the actual examples in the book.

57 Daniels and Reisinger, *Netpioneers 1.0*, op. cit. (note 4).

58 Christiane Paul, *Digital Art* (London: Thames and Hudson, 2003).

59 Mark Tribe and Reena Jana, *New Media Art* (New York/Cologne: Taschen, 2006).

60 Ibid.

61 Weiß, *Netzkunst*, op. cit (note 19). Franz Thalmair (ed.), *Circulating contexts: Curating media/net/art* (Norderstedt: Books on Demand, 2007).

62 Bunting and Brandon's *Border Xing* was commissioned via the Tate's net art programme.

63 Heidi Grundmann (ed.). *Art+Telecommunication* (Vienna: Vertrieb für Europa, 1984); Baumgärtel, *[net. art]*, op. cit. (note 2).

64 Examples would be 'The World in 24 Hours', organized by Robert Adrian X in 1982, or 'La Plissure Du Text' organized by Roy Ascott in 1984.

65 Artex (initially called Artbox) ran on the IP Sharp Associates (IPSA) network, a pre-Internet corporate dial-up computer support system outside military and university pre-Internet structures. The company liked to sponsor art projects.

66 Bosma, 'Net.art', op. cit. (note 19).

67 The notation says 'action: distribution of "Beauty and the East"/ZKP4 (a "Nettime" publication) to passers-by on streets of Vienna' and 'technical requirements: a computer with printer, copy machine, cardboard (2 pieces 1 by 1.5 m), glue, Scotch tape'. *ZKP4* was the name of the Nettime newspaper publication for the mailing list's first conference called 'Beauty and the East', organized in Ljubljana, Slovenia in the spring of 1997.

68 Greene, *Internet Art*, op. cit. (note 42).

69 At about the same time that I met Adrian, I also interviewed Gerfried Stocker about his decentralized musical performances, David Blair about his *Wax or the Discovery of Television among the Bees* project, and Van Gogh TV and Karl Dudesek about *Piazza Virtuale*, a very complex project involving numerous media outlets, a media lab and vast audience participation that occurred at documenta IX in 1992. Robert Adrian X also noted the work of many others, especially Roy Ascott's *La Plissure du Texte*, a 'distributed authorship project' from 1983. Web: http://alien.mur.at/rax/ARTEX/PLISSURE/plissure.html (accessed December 2009).

70 A quote from my lecture (which was never published): 'The only reason I persist in placing "net" in front of "art" for the moment is that we need to embrace present-day media criticism and media theory within art theory. To me it is actually a transitional term for the changes that are brought to both our culture and the art world by the developing technologies of today.'
Ncc 48 was organized by the net art platform mur.at and Ortlos architects in Graz, October 2001. Web: http://1.ncc.mur.at/index_aa_e.shtml (accessed December 2009).

71 Krauss, *A Voyage on the North Sea*, op. cit. (note 3).

72 Armin Medosch, *Technological Determinism in Media Art* (MA Thesis, Sussex University, 2005). Web: http://www.thenextlayer.org/system/files/TechnoDeterminismAM.pdf (accessed December 2009).

73 I can illustrate the latter with an anecdote involving a surprising scuffle I had with this influential media art theoretician at a conference about the interface in art in Denmark in 2004, where Oliver Grau presented his book *Virtual Art: from illusion to immersion* (Cambridge, MA: MIT Press, 2003). The book deals with a very specific form of visual technologies and visual art, namely that of the creation of a sense of immersion through different forms of visual illusion. My attention piqued when he said: 'The greatest invention of the twentieth century surely must be the CAVE.' CAVE stands for Computer Aided Virtual Environment, and the object itself, a small room comprised of walls, a floor and ceiling made of screens, acts as a very particular visual space that is activated through additional interfaces like objects or sensors. Only a few CAVES exist worldwide. They are practically impossible to access for artists and audience alike and have thus more or less become symbolic for a very aloof form of media art. My experiences with the vast, erratic, yet blooming, interdisciplinary space of the Internet led me to raise my hand during the question and answer session afterwards. I asked whether the Internet, considering especially its huge cultural impact, wasn't a much more important invention for art than the CAVE. While Grau may have thought this was a provocation, it wasn't. His statement had genuinely surprised me, and it seemed to be a relevant issue. Grau rudely brushed me off twice with a snarled 'I don't want to discuss that'.

74 Grau, *MediaArtHistories*, op. cit. (note 4).

75 Luke Skrebowski, 'All Systems Go: Recovering Jack Burnham's "Systems Aesthetics"', *Tate Online Research Journal*, 2006. Web: http://www.tate.org.uk/research/tateresearch/tatepapers/o6spring/skrebowski.htm (accessed December 2009).

76 My emphasis. Isabelle Stengers, 'Diderot's Egg, Divorcing materialism from eliminativism', *Radical Philosophy magazine* (2007), July/August, 7-15.

77 Ibid.

78 Ibid.

79 Ibid.

80 Simondon, *Du Mode d'Existence*, op. cit. (note 7).

81 Arne De Boever, Alex Murray and Jon Roffe, '"Technical Mentality" Revisited: Brian Massumi on Gilbert Simondon', *Parrhesia* (2009) no. 7.

82 Nicholas Bourriaud, *Relational Aesthetics* (Dijon: Les Presses du Réel, 1998).

83 De Boever, Murray and Roffe, '"Technical Mentality" Revisited', op. cit. (note 81).

84 Rosalind Krauss, *Perpetual Inventory* (Cambridge, MA: MIT Press, 2010).

85 Ibid.

86 Krauss, *A Voyage on the North Sea*, op. cit. (note 3).

87 Emphasis by the author. Luke Skrebowski, 'All Systems Go', op. cit. (note 75).

88 Shanken, 'Reprogramming Systems Aesthetics', op. cit (note 5).

89 Krauss, *A Voyage on the North Sea*, op. cit. (note 3).

90 De Boever, Murray and Roffe, '"Technical Mentality" Revisited', op. cit. (note 81).

91 Skrebowski, 'All Systems Go', op. cit. (note 75).

92 My emphasis. Brian Massumi, *Parables for the Virtual: Movement, Affect, Sensation* (Durham, NC: Duke University Press, 2002).

93 Ibid.

94 Stengers, 'Diderot's Egg', op. cit. (note 76).

95 Bruce Sterling, 'Digital Decay', in: Alain Depocas, Jon Ippolito and Caitlin Jones (eds.), *Permanence Through Change, The Variable Media Approach* (New York, NY: Solomon R. Guggenheim Foundation and Montreal: Daniel Langlois Foundation, 2003), 11-22.

96 Emphasis by author. Massumi, *Parables for the Virtual*, op. cit. (note 92).

97 Andrew Keen, *The Cult of the Amateur: How Today's Internet is Killing Our Culture* (New York, NY: Doubleday/Currency, 2007).

98 Jorinde Seijdel, 'Wild Images, The Rise of Amateur Images in the Public Domain', *Open* 8 (2010), 62-64.

99 To name just two influential amateurs in the context of Internet technologies: both Bill Gates and Steve Jobs started their careers tinkering and hobbying away in their garages. The important issue is that influential amateurs are not exceptions, but the rule, in net art as well. It is a logical result of the novelty and accessibility of the technologies involved. The speed at which these technologies develop is why new media art education in particular lags behind, which means one will always have to rely on the amateur and the hands-on practitioner. One of the corporate members of the Internet of Things network even admitted in an interview that the Internet would never have existed if it had been developed through corporate channels. Corporations do not collaborate; they compete. Web: http://www.theinternetofthings.eu/ (accessed December 2009).

100 Adrian McKenzie, *Transductions: Bodies and Machines at Speed* (London: Continuum, 2002).

101 Derrick de Kerckhove presented this view at Sonic Acts 2010 in Amsterdam.

102 Massumi, *Parables for the Virtual*, op. cit. (note 92).

103 Beryl Graham and Sarah Cook, *Rethinking Curating* (Cambridge, MA: MIT Press, 2010).

Levels, Spheres and Patterns: Form and Location in Net Art

1 Brian Massumi, *The Evolutionary Alchemy of Reason*, lecture at 5cyberconf, 1996, Web: http://www.fundacion.telefonica.com/at/emassumi.html (accessed November 2010).

2 Rosalind Krauss, *A Voyage on the North Sea, Art in the Age of the Post-Medium Condition* (London: Thames and Hudson, 1999).

3 Alexander Galloway, *Protocol: How Control Exists after Decentralization* (Cambridge, MA: MIT Press, 2004).

4 Peter Sloterdijk, *Sphären* (Berlin: Suhrkamp Verlag, 2004).

5 Bruno Latour, 'Air Condition – our new political fate', *Domus* (2004), March. Web: http://www.bruno-latour.fr/presse/presse_art/GB-03%20DOMUS%2003-04.html (accessed November 2010).

6 Tom Finkelpearl, *Dialogues in Public Art* (Cambridge, MA: MIT Press, 2001).

7 Steve Dietz, 'Public_Sphere_s', in: Rudolf Frieling and Dieter Daniels (eds.), *Media Art Net 2* (Vienna/New York: Springer, 2005), 260-263.

8 Derrick de Kerckhove, *The Skin of Culture: Investigating the New Electronic Reality* (Toronto: Somerville House Publishing, 1995).

9 Web: http://www.the-internet-of-things.org/ (accessed November 2010).

10 Rob van Kranenburg, *The Internet of Things: A Critique of Ambient Technology and the All-Seeing Network of RFID* (Amsterdam: Institute of Network Cultures, 2008), Web: http://www.networkcultures.org/_uploads/notebook2_theinternetofthings.pdf (accessed December 2010).

11 Adrian McKenzie, *Transductions: Bodies and Machines at Speed* (London: Continuum, 2002).

12 Umberto Eco, *Interpretation and overinterpretation* (Cambridge: Cambridge University Press, 1992).

13 Florian Cramer, *Words Made Flesh* (Rotterdam: Piet Zwart Institute, 2005), http://cramer.pleintekst.nl/oo-recent/words_made_flesh/words_made_flesh.pdf (accessed November 2010). This text was originally written for the Piet Zwart Institute in Rotterdam, and made available through Piet Zwart Institute and several text share sites, like scribd and netzliteratur.net.

14 Ibid.

15 Inke Arns, 'Read_me, run_me, execute_me, code as executable text: software art and its focus on program code as performative text', in: Frieling and Daniels, *Media Art Net 2*, op. cit. (note 7), 194-207.

16 Lucy Lippard, *Six Years: the Dematerialization of the Art Object from 1966 to 1972* (Berkeley and Los Angeles, CA: University of California Press, 1973).

17 The title of the 'Software' exhibition referred to Burnham's metaphorical use of the term 'software', in which art is considered a form of software acting on the world. 'By shifting the concept of program toward an artistic field, Burnham tried to draw parallels between projects relying on devices for transmitting information (fax machines, teleprinters, audiovisual systems), and those that used language as material without resorting to technology.' Web: http://www.fondation-langlois.org/html/e/page.php?NumPage=541 (accessed November 2010).

18 Joline Blais and Jon Ippolito, *At the Edge of Art* (London: Thames and Hudson, 2006).

19 Josephine Bosma, 'Interview with Mary-Ann Breeze', *Rhizome* (2000). Web: http://rhizome.org/discuss/view/28784/#1630 (accessed November 2010).

20 This dissertation won the Ars Electronica prize for theory in 2007.

21 Arns, 'Read_me, run_me, execute_me', op. cit. (note 15).

22 Günther Kress, *Literacy in the New Media Age* (New York: Routledge, 2003).

23 This work is called 'Uncomfortable Proximity' and can still be found on the Tate website. Web: http://www.tate.org.uk/netart/mongrel/home/default.htm (accessed November 2010).

24 Matthew Fuller, 'Pits to Bits: interview with Graham Harwood', *Nettime* (2010). http://www.mail-archive.com/nettime-l@kein.org/msg02426.html (accessed November 2010). This interview has actually been copied to many different websites.

25 My emphasis. http://www.runme.org/feature/read/+londonpl/+34/ (accessed November 2010).

26 Tilman Baumgärtel, *[net.art]: Materialen zur Netzkunst* (Nürnberg: Verlag für moderne Kunst, 1999).

27 Josephine Bosma, 'Interview with jodi', in: Pit Schultz et al. (eds.), *ZKP 4: Beauty and the East* (Ljubljana: Ljudmila Digital Media Lab/Nettime, 1997), 14-16.

28 Simon Yuill, *Jodi Talk*, presentation at California College of the Arts, 2002, http://www.mail-archive.com/ambit@mediascot.org/msg00721.html (accessed November 2010).

29 Tatiana Bazzichelli, *Networking: the Net as Artwork* (Aarhus: Digital Aesthetics Research Center, Aarhus University, 2008).

30 Web: http://www.thenextlayer.org/node/421 (accessed November 2010).

31 Florian Cramer on the software art repository website Runme.org:, Web: http://www.runme.org/feature/read/+forkbombsh/+47/ (accessed November 2010).

32 Florian Cramer, '.walk', *runme.org* (2003), Web: http://runme.org/feature/read/+dot-walk/+31/ (accessed November 2010).

33 *Transmediale Press Release*, January 2004, Web: http://www.transmediale.de/page/whatis/detail/detail.0.releases.1.html (accessed November 2010).

34 Tilman Baumgärtel, 'Experimentelle Software II', *Telepolis* (2001), Web: http://www.heise.de/tp/deutsch/inhalt/sa/11107/1.html (accessed November 2010).

35 Web: http://bak.spc.org/iod/ (accessed November 2010).

36 They also observed that: 'From any point it is possible to look back along your path, holding on to Ariadne's thread, taking solace in the fact that all you have seen is recorded, marked, referenced and ultimately retraceable.' Web: http://bak.spc.org/iod/WARNING!.html (accessed November 2010).

37 Blais and Ippolito, *At the Edge of Art*, op. cit. (note 18).

38 Erkii Huhtamo, 'Twin-Touch-Redux: Media Archeological Approach to Art, Interactivity and Tactility', in: Oliver Grau (ed.), *Media Art Histories* (Cambridge, MA: MIT Press, 2006), 72.

39 This problem dates back to Greek philosophy and concerns the cause of an effect at a distance, without affecting anything between actor and effect. For instance, it is described and questioned by Schopenhauer in *Parerga and Paralipomena*, Vol. 1 (first published in 1974). Arthur Schopenhauer, *Parerga and Paralipomena: Short Philosophical Essays* (Oxford: Oxford University Press, 2001).

40 Jeff Malpas, *Acting at a Distance and Knowing from Afar: The Robot in the Garden* (Cambridge, MA: MIT Press, 2000).

41 Annmarie Chandler and Norie Neumark (eds.), *At a Distance: Precursors to Art and Activism on the Internet* (Cambridge, MA: MIT Press, 2005).

42 Ibid.

43 Nicholas Bourriaud, *Relational Aesthetics* (Dijon: Les Presses du Réel, 1998).

44 In the interview, the artist also stated that: 'The bodily form encapsulates our consciousness. I believe it is possible to extend our consciousness beyond it, as in a telephone conversation or email message, but we are a long way off the conception of it. The bodily form as a signifier is still necessary to identify and locate our consciousness at a distance. Therefore I am not concerned with escaping my form but rather to look back and observe it at a distance from the outside.' Web: http://telematic.walkerart.org/telereal/sermon_sermon.html (accessed November 2010).

45 Bert Bongers, *Interactivation: Towards an e-cology of people, our technological environment and the arts* (Utrecht: SIKS Dissertation Series, 2006).

46 My emphasis. Frank Popper, *From Technological to Virtual Art* (Cambridge, MA: MIT Press, 2007).

47 My emphasis. Ken Friedman, 'The Wealth and Poverty of Networks', in: Chandler and Neumark, *At a Distance*, op. cit. (note 42), 412.

48 Manuel Castells, *The Informational City: Information Technology, Economic Restructuring, and the Urban Regional Process* (Hoboken, NJ: Wiley-Blackwell, 1992).

49 Roy Ascott, 'Art and Telematics: Towards a Network Consciousness', in: Heidi Grundmann (ed.), *Art + Telecommunication* (Vienna: Vertrieb für Europa, 1984), 27.

50 It has to be noted that television experiments were rare, due to the closed structure of television networks and the costs involved. In the Netherlands, however, there was a particular kind of art practice that evolved from the underground and squatters' scene. Artists in this scene broke into cable television signals to broadcast their own programmes after official broadcasting had ended for the night. The most important art group was PKP TV, a collective made up of Dutch artists including Peter Klashorst, Reinier Kurpershoek, Maarten van der Ploeg and Rogier van der Ploeg. After the demise of PKP TV, Kurpershoek continued this practice with Menno Grootveld under the name Rabotnik TV. These experiments fostered the emergence of two local open TV channels, which are still on the air under the SALTO logo. David Garcia, 'A Pirate Utopia for Tactical Television', ZKP 2, 5cyberconf, 1996; a biography of Reinier Kurpershoek at: http://www.kurpershoek.net/Biografie.htm (accessed November 2010).

51 Chandler and Neumark, *At a Distance*, op. cit. (note 42).

52 Global access remains a relative term. The artists in this network were located in North America, Canada and Europe. Mail art has thus far still crossed more borders than net art, both physically and socially.

53 Ibid.

54 Grundmann, *Art + Telecommunication*, op. cit. (note 50).

55 Ibid.

56 Station Rose, *Private://Public: Conversations in Cyberspace*, Edition Selene (Vienna: Taschenbuch, 2000).

57 Josephine Bosma, 'Kathy Rae Huffman: Vernetzung ››face-to-face‹‹, Josephine Bosma im Gespräch mit Kathy Rae Huffman', *netz.kunst Jahrbuch 98/99* (Nürnberg: Verlag für moderne Kunst Nürnberg, 1999), 194-197.

58 Ibid.

59 Josephine Bosma, 'net, 'radio' and physical space: FAKESHOP', *nettime* (1997), Web: http://www.net-time.org/Lists-Archives/nettime-l-9712/msg00026.html (accessed November 2010).

60 Ricardo Dominguez, DIOGENES ON LINE 2.0· Gestures against the Virtual Republic, undated. Dominguez also writes: '"Multiple Dwellings", a 1998 *tableau vivant* of "Coma", staged a two story installation of wires, pipes, and bodies alluding to the scene in the film of the endless row of floating bodies ready to be organ harvested. The bodies within the bunker were scanned with CUseeme cameras and the images transmitted in real time to the other network actors who were buying and selling the organs they were seeing. Fakeshop has used networked images and sound exchange software like real audio/video to add another plane of repetition to the phantasmagoria of the already-seen segment. In one of the multiple CUseeme windows, a remote actor in Tokyo sends sounds and images in response to the scene. Individuals who know nothing about the performance drift in and out of the reflector site Fakeshop has squatted for the night's performance. Some of the Cuseeme audience participate, others just drift on or pay no attention to the actors or the scene.' Web: http://subsol.c3.hu/subsol_2/contributors/domingueztext.html (accessed November 2010).

61 Web 2.0 refers to the use of commercially developed social platforms and networks, such as LinkedIn, Facebook, Second Life, MySpace and Youtube, in contrast to the network of individual, often amateur homepages that dominated the Web before. The most important aspect of Web 2.0 is the loss of control of the individual user over his or her content, plus the inability of individuals to track or influence policies of the owner of the specific Web 2.0 application they use.

62 Quote from the website of the 'Re:akt' exhibition curated by Dominique Quaranta in 2010, http://www.reakt.org/imponderabilia/index.html (accessed November 2010).

63 Régine Debatty, 'Interview with Marisa Olson', *We Make Money Not Art* (2008), Web: http://we-make-money-not-art.com/archives/2008/03/how-does-one-become-marisa.php (accessed November 2010). Olson, for instance, says: 'My dissertation is on The Art of Protest in Network Culture. So I've read, loved, and taught the classic McLuhan, Benjamin, Kittler, Flusser, Baudrillard, Jameson, etc. over and over again. The aim of this class was to consider the cultural and political forces behind the evolution of technology and the broader concept of "change" (which most certainly also incorporates social/ political change). So we read these classic historiographies but tried to read them from the present context as well as the original one. And we read them beside Alex Galloway, Henry Jenkins, Clay Shirky, and other great contemporary writers. I mean, this stuff can never be pinned down long enough to be considered in an isolated temporal context, but it's still important to consider the personal and political forces that compel media change – the desires and impetuses.'

64 Josephine Bosma, *Interview with Michael Mandiberg* (unpublished ms., 2009).

65 Lev Manovich, *The Language of New Media* (Cambridge, MA: MIT Press, 2000).

66 Rudolf Arnheim, *Visual Thinking* (Berkeley and Los Angeles, CA: University of California Press, 1969).

67 Manovich, *The Language of New Media*, op. cit. (note 66).

68 Web: http://map.jodi.org/ (accessed November 2010).

69 The following link shows a website reconstruction of the original work from 1998, but unfortunately it is also outdated, see Web: http://www.c3.hu/collection/agatha/ (accessed November 2010).

70 Peter Luining, Interview with Jan Robert Leegte, NetArtReview, 2004. About his online work, Leegte says: 'The fact that I worked directly in source code was very important. I had some earlier experience with WYSIWYG software creating HTML files but this hadn't inspired me at all. It wasn't until I typed my first lines of HTML directly in a text editor that I got interested. It had a totally different impact on me. When typing a code and seeing its effects later you address an existing object and command it to act in a certain way, after which you yourself have to move to its space to see what has happened. By using code you give a validation of autonomy to the final work. And in my case, I would say even a physical validation. Code introduced me to a new environment in which I could create sculptural installation as I had done previously.' Web: http://www.netartreview.net/weekly-Features/2004_03_21_archive.html (accessed November 2010).

71 Here we have a hybrid of the real-time and realized screen.

72 Promotional text from MIT Press for Adrian Mackenzie's *Wirelessness: Radical Empiricism in Network Cultures* (Cambridge, MA: MIT Press, 2010), Web: http://mitpress.mit.edu/catalog/item/default.asp?ttype=2&tid=12285 (accessed November 2010).

73 My emphasis. Web: http://www.sndrv.nl/moma/?page=press (accessed November 2010).

74 Web: http://www.v2.nl/events/artvertiser-walks (accessed November 2010).

75 Sadie Plant, *The Most Radical Gesture: The Situationist International in a Postmodern Age* (New York: Routledge, 1992).

76 Domenico Quaranta, 'Lost in Translation. Or, bringing Net Art to another Place? Pardon, Context.' *Vague Terrain* (2008), 11, Web: http://vagueterrain.net/journal11/domenico-quaranta/01 (accessed November 2010).

77 Ibid.

78 More at: http://obsolete.ctrlaltdel.org/ (accessed November 2010).

79 Quote from the CAE website, Web: http://www.critical-art.net/mp.html (accessed November 2010). The artists also write: 'New funds for research and the centers that house it, contracts for materials such as vaccines and symptom-arresting pharmaceuticals, security contracts, and so much more flood the marketplace to such an extent that almost every apparatus of production and service has an interest in keeping the spectacles of fear and threat in play. Whether an actual threat exists or not is irrelevant to this network of exchange. The threat of future crisis and the solution of preemptive action marches forward, gaining momentum as it goes, until it becomes a system in which so many institutions are so deeply invested that it can no longer be critically appraised. This system becomes a naturalized transparent given – a necessary fact to which all must submit lest they lose the riches that have been gained.'

80 Gilbert Simondon, *Du Mode d'Existence des Objets Techniques* (Paris: Aubier, 2001), first published in 1958; Marshall McLuhan, *Understanding Media: the Extensions of Man* (London: Sphere, 1967), first published in 1964; Gilles Deleuze and Felix Guattari, *A Thousand Plateaus* (London: Anthlone, 1988).

81 Ranging from a short story about a total, voluntary human submission to media connectivity that replaces physical presence in 'The Machine Stops' (1909) by E.M. Forster, to movies like *Metropolis* (1928) and *1984* (1956).

82 E.M. Forster, 'The Machine Stops', in: Neil Spiller (ed.), *Cyber_Reader* (London: Phaidon Press, 2002), 30-33.

83 Slavoj Žižek, 'The Matrix, or Two Sides of Perversion', *Philosophy Today, Celina* (1999), 43, Web: http://www.egs.edu/faculty/slavoj-zizek/articles/the-matrix-or-two-sides-of-perversion/ (accessed November 2010).

84 Arjen Mulder, 'Interview with Humberto Maturana', in: Joke Brouwer and Arjen Mulder (eds.), *The Art of the Accident* (Rotterdam: NAi/V2 publishers, 1998).

85 Jacques Rancière, *The Future of the Image* (Brooklyn, NY: Verso, 2007).

86 Manovich, *The Language of New Media*, op. cit. (note 66).

87 Žižek, 'The Matrix', op. cit. (note 85).

88 Alexander Galloway, *Gaming: Essays on Algorithmic Culture* (Minneapolis: University of Minnesota Press, 2006).

89 Paolo Virno, *A Grammar of the Multitude* (New York, NY: Semiotext(e), 2004).

90 Ibid. Emphasis by original author.

91 The description of 'post-American' for Holmes was taken from the 2006 catalogue of the German media art festival Transmediale, and was no doubt suggested by himself.

92 Brian Holmes, *The Potential Personality*, Web: http://brianholmes.wordpress.com/2007/04/08/the-potential-personality/ (accessed December 2010).

93 Ricardo Basbaum, 'Differences between us and them', *Ludlow 38* (New York, NY: Goethe Institute New York, 2009), Web: http://www.ludlow38.org/index.php?/events/meyou-choreographies-games-and-e/ (accessed December 2010).

94 Holmes also writes: 'What happens if I give the word choreography the wider signification of a group interaction, an orchestration of bodies in their movement through space; and if I conceive the action of the self as a more complex reflexivity, exercised by a plurality of actors on each other?' Holmes, *The Potential Personality*, op. cit. (note 94).

95 It has to be said that, because of the way Holmes describes it, Basbaum's approach wrongly appears first and foremost sociopolitical, and separate from technological discourses. But in the 'nós nós statement', a text that explains the conceptual background of Basbaum's work that Holmes is referring to, the artist follows a highly mathematical routine to create new identity experiences. In fact, he seems to apply a form of code or software to 'wetware' (humans). A game with external appearances, simple rules and calculations enables a type of re-examination of identity and social life. 'One single individual, dressed with a "me" (red) or "you" (yellow) shirt, actually embodies a multi-layer "pronoun chain": me (or you) as its external interface (the shirt), followed by a he or a she (the one who wears the shirt: "Alan or Jane?"); and a third layer is composed by the subject who performs, I ("I am me, I am you"). These several layers bring to the outside (make visible) the complex circuit embodied by the participant of the me-you games and exercises, indicating how the shirts happen to be just the most external layer from a newly triggered flux of significants.' It continues by showing how the artist envisions the social realm in this context: 'From the point of view of the circuit framework – a structure that exists as a consequence of its "will to connect" – the other just exists during the time that preceeds the act of linking. It lasts only for the necessary fraction of time that it takes to connect.' Therefore, to me, Basbaum's work is also net art because it is positively drenched in discursive features of new media networks. Holmes, *The Potential Personality*, op. cit. (note 94); Basbaum, *Differences between us and them*, op. cit. (note 95).

96 Donna Haraway, *Simians, Cyborgs and Women: The Reinvention of Nature* (London: Free Association Books, 1991).

97 Projects and practitioners commonly associated with cyberfeminism include, for instance, the early Australian artist group VNS Matrix, who produced both online and offline art projects (1991-1997); the mailing list for women in new media Faces (1997-present), and art projects like *Face Settings* (1996-1999) initiated by American curator Kathy Rae Huffman and Austrian artist Eva Wohlgemuth; several on and offline projects by Russian artists and curators in St. Petersburg, including Alla Mitrofanova, Olga Suslova and Irina Aktuganova; the Old Boys Network (OBN) (1997-present) and several editions of the Cyberfeminist Internationale conferences (1997, 1999, 2001) initiated by German artist Cornelia Sollfranck; the texts, exhibitions and presentations of the American collective subRosa (1998-present). It was and is, like 'traditional' feminism, a highly diverse practice.

98 One of the first documents on this form of sexual violence was a text called 'A rape in cyberspace' in New York's weekly newspaper *The Village Voice* in December 1993 by Julian Dibell. A more recent article is Regina Lynn's 'Virtual Rape Is Traumatic, but Is It a Crime?', *Wired Magazine*, April 2007, Web: http://www.wired.com/culture/lifestyle/commentary/sexdrive/2007/05/sexdrive_0504 (accessed November 2010).

99 Josephine Bosma, 'Interview with Alla Mitrofanova and Olga Suslova', in: Igor Markovic (ed.), *Cyberfeminizam [ver 1.0]* (Zagreb: Centar za Zenske, 1999). Published online in English, Web: http://www.nettime.org/Lists-Archives/nettime-l-9706/msg00107.html (accessed November 2010).

100 Josephine Bosma, 'Interview with RTMark', *nettime* (1998), Web: http://www.nettime.org/Lists-Archives/nettime-l-9809/msg00034.html (accessed November 2010).

233

101 Collaborations in and among net art projects are very common, due to the technical specifics of the Internet, which invites and amplifies both social and material connectivity.

102 Quote from the Yes Men website. Web: http://theyesmen.org/ (accessed November 2010).

103 The Yes Men, *Update from the Field* (2004), Web: http://www.landmarktheatres.com/mn/yesmen.html (accessed November 2010).

104 The Yes Men, *The Yes Men: The True Story of the End of the World Trade Organization* (New York, NY: The Disinformation Company, 2004).

105 'The Status Project is an expert system for identity mutation, says Heath Bunting about his project, which he estimates will take him another seven years to complete.' Quote from website text created in 2007: http://www.trampoline.org.uk/tracingmobility/heath-bunting (accessed December 2010).

106 Commissioned by Tate Britain: http://www.tate.org.uk/intermediaart/a_terrorist.shtm (accessed November 2010).

107 Brian Mackern, (ed.), *netart_latino database* (Badajoz: Museo Extremeno e Iberoamericano de Arte Contemporaneo [MEIAC], 2010).

108 Geert Lovink, *Dark Fiber* (Cambridge, MA: MIT Press, 2003).

109 Rachel Greene divides her book into 'net art elements' and 'net art themes'. Rachel Greene, *Internet Art* (London: Thames and Hudson, 2004).

112 Arthur Danto, *Beyond the Brillo Box: The Visual Arts in Post-Historical Perspective* (Berkeley and Los Angeles, CA: University of California Press, 1992).

Part 2

Net.art: From Non-Movement to Anti-History

1 Olia Lialina, 'Re: Re: net art history', *Nettime* (2001), Web: http://www.Nettime.org/Lists-Archives/nettime-l-0102/msg00200.html (accessed February 2009).

2 Nettime was originally one international (English language) mailing list for net.criticism. It now has spin-off lists in various other languages. Dutch media critic Geert Lovink and German artist and media theoretician Pit Schultz initiated it in 1995, during the first Nettime meeting at the Venice Biennale.

3 Cosic, drawing parallels to how artists collaborated in Dada, noted: 'There were two guys in Berlin, four guys in Paris, two in Russia, and they all knew each other, and they were all 25 years old. How did they get in touch? It was because of the strength of their beliefs and the good communication channels, because there were a few guys traveling. What we have now is the same: We have some strengths, we have some qualities – even though that's really up to others to say – and most of all we have a good communication system. This time it's the Internet. Earlier, it was Picabia who had the money to buy an expensive car and travel and print one issue of his magazine in every town he came to.' Tilman Baumgärtel, 'Art was just a substitute for the Internet: Interview with Vuk Cosic', *Telepolis* (1997), Web: http://www.heise.de/tp/r4/artikel/6/6158/1.html (accessed February 2009).

4 In Lialina's text that includes this quote, she refers to the utterings of American artist and critic Mark America who had always mainly worked outside of net.art discourse, and had even been the target of an occasional prank, in which anonymous artists sent emails to journalists and critics in America's name, denying he wrote a certain essay about art on the Internet in *Telepolis*. It was, thus, slightly suspicious that it was this critic who declared net art (in general, so no period) dead. Lialina: 'My students came back from Transmediale in Berlin and said there was a speaker, Mark America, who was announcing that net art is dead. From Mark America's CV: "America was recently appointed to the Fine Arts faculty at the University of Colorado in Boulder where he is developing an innovative curriculum in Digital Art." I can already see the development, innovation and result. We'll get a bunch of experts from Colorado writing necrologies.' Lialina, 'Re: Re: net art history', op. cit. (note 1).

5 Lialina also points out that: 'They announced this, because they are not doing net.art anymore, but net.art doesn't belong to particular people.' Damián Peralta Mariñelarena, 'Net Art Is Not Dead:

Interview with Olia Lialina', *Damianperalta.net* (2009), Web: http://www.damianperalta.net/es/teoria/38-entrevistas/52-interview-with-olia-lialina (accessed November 2010).

6 Translated from the German by the author. Medosch also notes that: 'Maybe net art discourse simply became boring, because there is not enough of it in the sense of exciting, informed debates. The artists are the least to blame for this; it is more the fault of the curators, critics and institutions. They have failed so far to build a framework in which net art could flourish and find buyers in the end. When challenges are lacking, one moves on and finds them elsewhere.' Armin Medosch, 'Adieu Netzkunst', *Telepolis* (1999), Web: http://tuija.net/netart/telepolis/adieu.htm (accessed December 2009).

7 Net.art is generally approached as an art movement of sorts, but since there was no real group manifesto or shared aesthetic, only individual attempts at manifestos that were not supported by the entire group, the term 'art movement' is somewhat problematic here.

8 Julian Stallabrass, *Internet Art: The Online Clash of Culture and Commerce* (London: Tate Gallery Publishing, 2003); Rachel Greene, *Internet Art* (London: Thames and Hudson, 2004); Joline Blais and Jon Ippolito, *At the Edge of Art* (London: Thames and Hudson, 2006).

9 Per Platou (ed.), *Skrevet I stein. En net.art arkeologi* (Oslo: Museum for Contemporary Art, 2003).

10 Lialina writes: 'There is a myth that net art belongs to a small group of artists, heroes. Legend has it they invented net art and then killed it. Or it was just an accident. Or they all died. Or they're already in their 90s … Or they've just retired. Some people say they'll come back. Per Platou erected a monument, a group of sculptures to the myth and its heroes. Six plaster busts. Jodi in the middle, Cosic and Shulgin in front, Lialina and Bunting on the left and the right. But the artist's heads are not that big, about 20 cm. with a pedestal. You have to come really close to recognize who's who in this vitrine. They're very small heroes.' Web: http://art.teleportacia.org/observation/oslo/oslo.html (accessed February 2009).

11 The first spam engine was probably built by French artist and writer Frederic Madre and was called 'STOP ascii INANITY SPAM (200x)'. It was preceded by something called the 'off-line spa-am night', Web: http://www.modukit.com/off/ (accessed February 2009). The Latvian artist Mindaugas Gapsevicus was deeply involved in spam art. He and an artist known only as d2b conceptualized other spam machines and called them 'spa-am'. There were nine versions of those at asco-o.com. They haven't changed since then and are still available. The only thing that doesn't work is a sendmail function to subscribers. It has a very nice old-school website, Web: http://www.asco-o.com/ (accessed February 2009). More info about spam art on Web: http://www.modukit.com/off/index_more.html (accessed February 2009).

12 An interesting account of the influence of this aspect of net.art on Italian net culture can be found in Tatiana Bazzichelli, *Networking: The Net as Artwork* (Aarhus: Digital Aesthetics Research Center, Aarhus University, 2008), and revealing its connection to South American net art can be found in the catalogue of Gustavo Romano, *Net Art 0.1 Desmontajes* (Badajoz: Museo Extremeno e Iberoamericano de Arte Contemporaneo [MEIAC], 2009).

13 *Mute* editor Josephine Berry was one of net.art's fiercest ideological critics. She generalized about 'the ways in which net art tried and failed to elude the art market' in her PhD thesis, which was published on Nettime. Josephine Berry, *The Re-Dematerialisation of the Object and the Artist in Biopower* (PhD thesis, 2001), Web: http://www.Nettime.org/Lists-Archives/Nettime-l-0102/msg00085.html (accessed February 2009).

14 Ibid.

15 Baumgärtel, 'Art was just a substitute for the Internet', op. cit. (note 3).

16 Tilman Baumgärtel, *[net.art]: New Materials Towards Net Art* (Nürnberg: Verlag für moderne Kunst, 1999).

17 Mariñelarena, *Net Art Is Not Dead*, op. cit. (note 5).

18 The announcement suggested:
 Please do any combination of the following:
 (1) call no./nos. and let the phone ring a short while and then hang up

(2) call these nos. in some kind of pattern

(the nos. are listed as a floor plan of the booth)

(3) call and have a chat with an expectant or unexpectant person

(4) go to Kings X station watch public reaction/answer the phones and chat

(5) do something different

Web: http://www.irational.org/cybercafe/xrel.html (accessed February 2009).

19 Shulgin started both with his wife, the Russian new media critic Olga Goriunova.

20 Not all of these are 'recorded', but one edited version of this debate can be found in *ZKP4* (Nettime publication, 1997), Web: http://www.ljudmila.org/nettime/zkp4/ (accessed February 2009).

21 The term 'backbone' is used for the core structure of the Internet. The closer one is to the backbone (preferably on it) the faster ones Internet connection will be. The backbone is like a highway, and taking this metaphor further most of the world is connected through B-roads and dirt roads.

22 Armin Medosch, *Technological Determinism in Media Art* (MA Thesis, Sussex University, 2005). Web: http://www.thenextlayer.org/system/files/TechnoDeterminismAM.pdf (accessed December 2009).

23 Baumgärtel, *[net.art 2.0]*, op. cit. (note 16).

24 Alexander Galloway, *Protocol: How Control Exists after Decentralization* (Cambridge, MA: MIT Press, 2004).

25 Richard Barbrook and Andy Cameron, *The Californian Ideology* (London: Pluto Press, 1995).

26 Barlow starts his declaration with: 'Governments of the Industrial World, you weary giants of flesh and steel, I come from Cyberspace, the new home of Mind. On behalf of the future, I ask you of the past to leave us alone. You are not welcome among us. You have no sovereignty where we gather.' Web: http://w2.eff.org/Censorship/Internet_censorship_bills/barlow_0296.declaration (accessed December 2009).

27 See Erik Davies, *Techgnosis: Myth, Magic, and Mysticism in the Age of Information* (New York, NY: Three Rivers Press/Random House, 1999). Armin Medosch describes how this spiritualism defined a specific form of media art, most notably represented by the British artist Roy Ascott. Medosch, *Technological Determinism in Media Art*, op. cit. (note 22).

28 Matthew Fuller, 'People Would Go Crazy: Introduction to Word Bombs conference "techno"-panel', in: Vuk Cosic and Heath Bunting, (eds.), published in *ZKP321*, (Ljudmila: prexeroxed at KGB∗ZOD, 1996), 30-31.

29 *ZKP3*, non-profit publication project by Nettime (1996).

30 Geert Lovink, *Dark Fiber* (Cambridge, MA: MIT Press, 2003).

31 Medosch, *Technological Determinism in Media Art*, op. cit. (note 22).

32 In 1993, I was introduced to art on the Internet at the institute for 'unstable media' V2, which was still in Den Bosch at the time. I did interviews and saw the work of many artists who worked with the Net, long before I went online myself. The Net is, first of all, a creative and social space for me, intricately linked to and embedded in all kinds of media networks *and* physical space, because of this.

33 An interview with Van der Cruijsen can be found in Tilman Baumgärtel's first collector of interviews. Baumgärtel, *[net.art]*, op. cit. (note 16).

34 From the Merzbau website: 'Bakotin well known for his tendencies of ∗pushing the envelope∗ in digital media and beyond, reached demand to make an evaluation of possibilities to bring Merzbau online as interactive environment suited to performances of the contemporary consumer range computers well optimised for low bandwidth such as modems on phone lines.' Web: http://www.merzbau.org/Bakotin.html (accessed November 2009).

35 Very little remains of netband. Most web pages referring to it have ceased to exist. It is, however, mentioned in, for example: Stephen Wilson, *Information Arts: Intersections of Art, Science, and Technology* (Cambridge, MA: MIT Press, 2002).

36 'Even though he was obsessed [with] computers, Franz wasn't that . . . interested in clean virtuality,' notes Lovink, referring to Feigl's history in the Amsterdam punk movement. 'The clash between the heavy 1980s' post-industrial culture (as described in Mark Dery's *Escape Velocity*) and much more spiritual mindset of the Internet and its geek engineering did – and did not fit together.' Geert Lovink,

'Franz Feigl is dead', Nettime (2001), Web: http://www.nettime.org/Lists-Archives/nettime-l-0109/msg00291.html (accessed November 2009).

37 Medien.KUNSTLABOR, 'The Myth of Bolshevik: In Memory of Franz Feigl', *Turbulence* (2005), Web: http://turbulence.org/networked_music_review/2005/08/09/in-memory-of-franz-feigl/?author=4 (accessed November 2009).

38 The title of Jodi's 'Automatic Rain System' was based on the sprinkler system at Cadre, the school in San Jose they had studied at. It was made obsolete by design changes (towards a more traditional layout) in the browser it was developed for. Remnants of it can still be found at Web: http://wwwww-wwww.jodi.org/betalab/rain/index.html (accessed November 2009).

39 Lialina also says: 'I was influenced in a very good way. I am very happy I knew before what were [the] works of not-commercial people. Only after the BMW site and so on. I knew what net.art was before I knew what webdesign was.' Josephine Bosma, 'Interview with Olia Lialina', *Nettime* (1997), Web: http://www.nettime.org/Lists-Archives/nettime-l-9708/msg00009.html (accessed November 2009).

40 Tilman Baumgärtel, 'Interview with Alexei Shulgin', *Kunstradio* (1997), Web: http://www.kunstradio.at/FUTURE/RTF/INSTALLATIONS/SHULGIN/interview.html (accessed November 2009).

41 N5M2 had the most art projects of the N5M festivals. Later N5M3 focused more on activism. There is very little online material of N5M2, in part due to the privatization of DDS, Amsterdam's Digital City. Some impression of a (preliminary) programme can be found in an essay by Andreas Broeckman, who was at that time working for V2, one of the organizing institutions of N5M2: 'What I regard as crucial for the assessment of tactical media practice as it is being attempted by the Next 5 Minutes, is the realisation that the relative structural weakness of a tactical approach and the absence of a unified political goal among media tacticians has its strengths in the flexibility, in the compatibility with other initiatives, and in the ability to form alliances notwithstanding political and ideological differences. . . . [T]his does not only account for guerilla-style media activism, but for any practical approach to choosing one's path through and making one's mark on the media ecology.' Web: http://www.strano.net/town/meeting/next5min/prog.htm (accessed November 2009).

42 See, for instance, transcription of panel discussion between David Garcia, Geert Lovink and Andreas Broeckmann at Transmediale 2001, Web: http://www.uoc.edu/artnodes/espai/eng/art/broeck-manno902/broeckmanno902.html (accessed November 2009).

43 Lovink also noted that: 'It prevents us from making small but fatal mistakes, the most common cause for flame wars, which have destroyed many personal relationships on the Net. One clumsy e-mail can have fatal consequences, a mechanism which can easily be corrected during a gathering on location. At meetings we get a much faster grasp of the context of people's works and intentions.' Geert Lovink, 'New Media and the Art of Debating, Second Thoughts on the Organization of Conferences', *Nettime* (1996), http://www.thing.desk.nl/bilwet/TXT/conf.txt, Web: (accessed November 2009).

44 Hakim Bey is a pseudonym for Peter Lamborn Wilson. His book *T.A.Z.: The Temporary Autonomous Zone* (New York, NY: Autonomedia, 2003), is one of the early beacons of anti-copyright. The book can be found online at various locations, including Web: http://www.to.or.at/hakimbey/taz/taz.htm (accessed November 2009). More information and work by Hakim Bey at Web: http://www.hermetic.com/bey/index.html (accessed November 2009).

45 The term 'cyberfeminism' is derived from the work of American feminist and theorist Donna Harraway *The Cyborg Manifesto*. Her slogan 'rather a cyborg than a goddess', a materialist critique of conservative feminist groups, gave rise to a specific revival of feminism online. Early cyberfeminist voices included VNS Matrix (an Australian group of artists, consisting of Francesca Da Rimini, Josephine Starrs, Julianne Pierce and Virginia Barratt) and a group from St Petersburg, Russia, whose main representatives were Alla Mitrifanova and Olga Suslova. Mitrifanova was present at N5M2.

46 Shulgin also notes that 'maybe trying to overcome this I am going to start a project with different projects based on different servers throughout the world; so it will be like a distributed server. And it's not just about escaping this cliché, it's about escaping any cliché and any identity, because at a certain point, when I have a certain identity, it leads to stagnation.' Armin Medosch, 'Interview with Alexei Shulgin', *Telepolis* (1997), Web: http://www.heise.de/tp/r4/artikel/6/6173/1.html (accessed November 2009).

47 Geert Lovink, *Dynamics of Critical Internet Culture (1994-2001)* (Amsterdam: Institute of Network Cultures, 2009), Web: http://networkcultures.org/_uploads/tod/TOD1_dynamicsofcriticalinternetculture.pdf (accessed December 2009).

48 Josephine Berry, Pauline Mourik Broekman and Michael Corris (eds.), *Proud to be Flesh: A Mute Magazine Anthology of Cultural Politics After the Net* (London: Mute Publishing Ltd, 2009).

49 All quotes from private email exchanges with the artists.

50 All medialab websites also served as online institutions, but some online platforms did not have physical spaces or institutions and only existed online, like Bunting's irational.org and Mark Tribe's rhizome.org.

51 Bey, *T.A.Z.*, op. cit. (note 44).

52 Josephine Bosma, 'Vuk Cosic Interview: net.art per se', *Nettime* (1997), Web: http://www.Nettime.org/Lists-Archives/Nettime-l-9709/msg00053.html (accessed December 2010).

53 Ibid. Cosic also stated: 'I go to conferences. That's net.art actually. That is an art practice that has to do a lot with the net. You come to the conference. You meet one hundred and a few people from abroad. That's a net. Art is not only the making of a product, which then can be sold in an art market and praised by an art thinker or mediator. It's also a performance. When you are having a good time, it's pretty much like when you are creative and you are producing something. When you have a good dialogue, when you are stimulated to come up with new argumentation, with new ideas, that is creativity for me, thus art. When it is about this type of meeting, like this Nettime meeting [the Beauty and the East, where this interview was held, JB] was, that's net.art for me. The whole form of this conference can also be defined as a piece of net.art, as a sculpture. A net.art sculpture if you wish.'

54 This third writer was probably Croatian critic Igor Markovic.

55 Vuk Cosic et al., 'The Net.Artists', posted by Pit Schulz on *Nettime* (1997), Web: http://www.Nettime.org/Lists-Archives/Nettime-l-9606/msg00011.html (accessed December 2010).
 Another quote that reveals their provocative humour, especially Cosic's: 'However, the public, accustomed as it is to the brilliant but practically formless daubs of the post-modernists, refused to recognize at first glance the greatness of the formal conceptions of the net.artists. People were shocked to see contrasts between dark backgrounds and light hotlinks, because they were used to seeing only www art works without shadows. In the monumental appearance of compositions that go beyond the frivolities of contemporary art, the public has refused to see what is really there: a noble and restrained art ready to undertake the vast subjects for which post-modernism had left media artists totally unprepared.'

56 A quote from the Digital Chaos website: 'We have the tricknology to incite fuelled discussion during DIGITAL CHAOS – a gathering of active minds, a battle to fight, some beer, indoor and outdoor locations. It is planned that – over the dinner table, on the dance floor, in the park and in the pub garden – some of the greatest Net minds from the cyber underground will find time to argue bombastically with each other. The conclusions and planned projects drawn from such informal encounters will then be brought back in to lecture theatres, board rooms, multiplex conference centres, websites, and film sets of the world for development and inception. It will be a clean fight between the innocent body and the "civilised" mind.' Web: http://www.irational.org/cybercafe/chaos/.

57 Josephine Bosma, 'Digital Chaos Report', *VPRO Radio* (summer 1996).

58 Ibid.

59 Web: http://www.irational.org/cybercafe/backspace/ (accessed November 2009)

60 Bunting also said that 'People had to formulate their ideas and present them very concisely and clearly in five minutes. Some people couldn't manage that at all. The worst thing is when you go somewhere and someone rambles on for an hour and you forget what they said and they forgot what they said and you're bored and then you want to leave. If a group of people makes an interesting presentation, very short and snappy, you remember it. I won't say there aren't problems with this form, but for me it worked very well.' Josephine Bosma, 'Interview with Heath Bunting', *Telepolis*, 1997, Web: http://www.heise.de/tp/r4/artikel/6/6176/1.html (accessed November 2009).

61 Participants included: Pit Schultz, Alexei Shulgin, Olia Lialina, Luka Frelih, Jodi, Kathy Rae Huffman, Andreas Broeckmann, Cornelia Sollfranck, Rachel Baker, Graham Harwood, Daniel Pflum, Rasa and Raitis Smite, Carey Young, and Diana McCarty.

62 Backspace was a side project of Obsolete, a web design company that had its offices upstairs in the same building. The company's managing director James Stevens initiated Backspace as an Internet Arts Space in late 1996.

63 Josephine Bosma, Interview with Jodi, *Nettime* (1997).

64 Andreas Broeckmann, 'Net.Art, Machines, and Parasites', *Nettime* (1997), Web: http://www.nettime. org/Lists-Archives/nettime-l-9703/msg00038.html (accessed December 2009).

65 Michel Serres, *The Parasite* (Baltimore, MD: The Johns Hopkins University Press, 1982).

66 Broeckmann, *Net.Art*, op. cit. (note 64). Broeckmann also indicated that: 'It is important to remember that the parasite is always dependent on a host. It can leave and search for new hosts, and it can flee from danger, but it will have to return to a host, "its outside is always the inside of something else." [Serres] The pact that the parasite has to make is to convince the host, again explicitly or implicitly, that the inequality of exchanged goods is for the mutual benefit.'

67 Ibid.

68 Garcia writes: 'I believe that those of us who love the net and love art, and want to work in both should learn from the past and avoid the simplistic device of marrying these two terms. The term net-art (as opposed to art that happens to appear on the net) should be quietly ditched.' David Garcia, 'Art on Net', *Nettime* (1997), Web: http://www.nettime.org/Lists-Archives/nettime-l-9703/msg00060. html (accessed November 2009). See also Josephine Bosma et al. (eds.), *ReadMe! Filtered by ‹nettime›* (Brooklyn, NY: Autonomedia, 1999).

69 Carey Young, 'Net Art is Not Art?', *Nettime* (1997), Web: http://www.nettime.org/Lists-Archives/ nettime-l-9703/msg00063.html (accessed November 2009). Young also wrote: 'What I feel is missing from this argument is the fact that Net art has a very particular location which, we might say, offers a new location for art experience.'

70 Josephine Berry, *The Re-Dematerialisation of the Object and the Artist in Biopower* (PhD thesis, 2001), Web: http://www.Nettime.org/Lists-Archives/Nettime-l-0102/msg00085.html (accessed February 2009).

71 Shulgin's early text is a plea against professionalism, which concludes: 'How to turn the very natural will for power into an artistic tool instead of the banal use of it for obtaining power itself? Answer:
 a. Forget about past and future, because they don't exist, concentrate on the present that can't be described and therefore possessed by anybody.
 b. Change your occupation just before you become well-known in your sphere, and before the movement you are in starts to create its own history. Then, when you start something else as a beginner, your will for power and for recognition will give you a strong creative impulse.
 c. Don't be dependent on the medium you are working with – this will help you to easily give it up. Don't become a Master.' Alexei Shulgin, 'Art Power and Communication', *Nettime* (1996), Web: http://www.nettime.org/Lists-Archives/nettime-l-9610/msg00036.html (accessed September 2009).

72 Shulgin further elaborates: 'Also when we talk about net.art and art on the net some people say that we should get rid of the very notion of art and that we have to do something that is not related to the art system, etc. I think it's not possible at all, especially on the net, because of the hyperlink system. Whatever you do it can be put into an art context and can be linked to art institutions, sites related to art.' Armin Medosch, 'Interview with Alexei Shulgin', *Telepolis* (1997), Web: http://www.heise.de/tp/ r4/artikel/6/6173/1.html (accessed November 2009).

73 Bunting further notes: 'That is the problem with investment, a lot of people come to these media just as a temporary thing, just as a temporary tactic. They devote a lot of energy to that and taking up investment. Then they stay and then they somehow lost their original intention. Someone like Alexei is succeeding I think, he has jumped from many things, from the video art context to the computer context and he will go to the next context. Each time being the impoverished Moscow artist. When he used to sell images, you know, things on walls, it was because he was from Moscow

that he would get them sold. People go: "O Moscow, that must be a very interesting place!" "Those pesky soviet union types ..." He does the same now. I am the same as well. People think that I am from London and that I must be very interesting, because there is a good music scene at the moment.' Josephine Bosma, 'Interview with Heath Bunting', *Telepolis*, 1997, Web: http://www.heise.de/tp/r4/ artikel/6/6176/1.html (accessed November 2010).

74 Lialina, 'Re: Re: net art history', op. cit. (note 1). She elaborates: 'It's more like [a] community (I know several ones) of artists who support each other or simply communicate.'

75 Josephine Bosma, 'Independent net.art', *Nettime* (1997), Web: http://www.Nettime.org/Lists-Archives/ Nettime-l-9707/msg00014.html (accessed November 2009). This was a recording of a discussion between me, Jodi and Alexei Shulgin during the Nettime 'Beauty and the East' conference in Ljubljana. Shulgin commented on the topic of net.art as a group: 'We are in a way privileged unlike artists from older generations. With the net we don't have to form any specific group to declare some specific manifesto and to do similar stuff or collaborative stuff. We all live in different cities in different countries. All we do is direct communication to each other, because we respect each other's work and we have something to discuss there. We'll have some shows together, but again I want to say we are privileged that we can go on with our own work and not be dependent on other people, other artists' opinions, ideas or aesthetics. Everybody is going on with their own work. There will be situations in the future were we can meet and discuss things directly. It's nothing about working on joint projects, we don't need that. We are all individuals; we can just remain ourselves. Not from some artificial groupings or whatever.'

76 See, for instance: Heidi Grundmann (ed.). *Art+Telecommunication* (Vienna: Vertrieb für Europa, 1984).

77 Hans Beder and Klaus Peter Busse (eds.), *Intermedia: Enacting the Liminal* (Dortmund: Dortmunder Schriften zur Kunst, 2005).

78 Cramer also writes: 'The cracker slang and graffiti were a source of inspiration for net artists like Jodi. When net cultural mailing lists started to filter out their disruptive codework around 1997, Jodi co-founded a mailing list 7-11 which had no editorial restraints of artistic E-Mail experimentation, and even let through all commercial spam. On this and other lists, artists like mez (Mary Anne Breeze) and Alan Sondheim transformed the former disruption aesthetic into new hybrid computer-English poetic vocabularies and languages.' Florian Cramer, *Words Made Flesh: Code, Culture, Imagination* (Rotterdam: Piet Zwart Instituut, 2005), Web: http://www.pzwart.wdka.hro.nl/mdr/ research/fcramer/wordsmadeflesh/ (accessed September 2009).

79 Bosma, 'Independent net.art', op. cit. (note 75). Shulgin further noted: 'If you look at the history of all art movements, it was always like this: you had some local initiatives, like Fluxus or NeoGeo or Trans-avandgardia or whatever with one leader, everybody would share certain ideas, do similar works, form a movement, usually with just one or two ideas behind it. People would join it. Then they would become recognisable as a group. It was important to be a group: to have a name, manifesto and whatever. But in the end, when you look at what happened, it very soon becomes routine. Those artists become famous, recognised, but it very soon becomes a very boring routine ... With the Internet it's a little bit different ... We got to know each other only because of the net. After that we met together and got acquainted. It's theoretically not possible for us to create some kind of movement. It's very different and I have no idea what can come out of it.'

80 I attributed the origin of the term net.art to Cosic in earlier essays, because he first published the term for net.art per se. He, however, recently confirmed that Pit Schultz actually came up with the term.

81 Joke Brouwer et al. (eds.), *aRt&D: Research and Development in Art* (Rotterdam: V2_/Nai Publishers, 2005).

82 Shulgin clearly wanted to disrupt any writing about net.art because he even addresses future historians: 'Actually, it's a readymade. In December 1995, Vuk Cosic got a message, sent via anonymous mailer. Because of incompatibility of software, the opened text appeared to be practically unreadable ascii abracadabra. The only fragment of it that made any sense looked something like: ... J8~g#\;Net. Art{-`sı ... Vuk was very much amazed and excited: the net itself gave him a name for activity he was

involved in! He immediately started to use this term ... Sorry about future net.art historians – we don't have the manifesto any more. It was lost with other precious data after the tragic crash of Igor [Markovich]'s hard disk last summer.' It was a playful subversion of net.art discourse, something Shulgin is infamous for: saying "a machine did it all". When the mail first appeared I immediately contacted Cosic to check the story, which I would have expected to have heard from the talkative Cosic's mouth if it were true, and was told with a wink to let it be. Years later I contacted Cosic about a story on wikipedia where the origins of the term was said to be Pit Schultz. This Cosic confirmed. Prank mail by Alexei Shulgin about the origin of net.art: http://amsterdam.nettime.org/Lists-Archives/nettime-l-9703/msg00094.html (accessed November 2009).

83 See the books on (Inter)net art by Baumgärtel, Greene and Stallabrass.

84 Blanc also writes: 'The art market has discovered the net for the distribution of art. It uses the net to promote art just like ordinary companies. Gallerists, museums and other art brokers provide information about their artists, exhibitions and events. For them, the net is nothing more than a big telephone book in which they too want to (have to) be represented.' Joachim Blanc, 'what is net art? ;)', *Nettime* (1997), Web: http://www.nettime.org/Lists-Archives/nettime-l-9704/msg00056.html (accessed November 2010).

85 Shulgin's prank story is one of those tales that is now almost perceived by some as 'cemented truth' as Vuk Cosic would say, because it is quoted in numerous publications. I have tried to talk to critics personally about this mistake, but was told in all honesty that the story was simply too good not to use as fact. The truth is not important in art history, only what sounds good, apparently.

86 The name of this conference was a joke on the platform for art and media in Eastern Europe, initiated by the Dutch media art institute V2, called V2-East. In a recorded discussion in Ljubljana, Jodi's Dirk Paesmans even mentions a Ljudmila-West residency in Ljubljana, completely turning the Western point of view around. See: Bosma, 'Independent net.art', op. cit. (note 75).

87 Only a few texts from this publication are still available at the Ljudmila server, among which is the Cosic's introduction: 'The *ZKP3.2.1* is a book that is trying to filter the Nettime postings all over again, and offer those that are of interest to the net.artists community that's in the process of articulating their own doing, but the texts published here should also be intriguing for the broader audience of art theorists, critics and historians, since it tells the story of where art went when it left the galleries and the art system. ... This book is a work of art.' Web: http://www.ljudmila.org/zkp321/ (accessed November 2009).

88 Jodi's mails often consisted of abstract ASCII drawings or resemble concrete poetry. An example is Jodi, '*yeeha!*', *Nettime* (July 1996), Web: http://www.Nettime.org/Lists-Archives/Nettime-l-9607/msg00061. html (accessed November 2009).

89 Bunting says, for instance: 'We all make reference to each other's work and I couldn't do my work in isolation, so it is important to have people around you that you can communicate clearly with and see their work. I thought originally that was the point of Nettime, for people to somehow exchange those things. Now it seems it's a bit too big for that and its intentions are other than that ... Nettime has gone from a context to an audience. In the past I would post something to Nettime and people would respond to it. They would know who I had done it and they would make comments and take the work forward. If you post something to Nettime now: you get silence. Maybe you even get an angry message from the moderator stating that you have made an inappropriate post. It has gone from something very informal to a very rationalized, academic textual environment.' Josephine Bosma, 'Interview with Heath Bunting', *Telepolis*, 1997, Web: http://www.heise.de/tp/r4/artikel/6/6176/1.html (accessed November 2010).

90 Other artists in this exposition included Huber, Pocock, Noll and Wenz with *Equator,* Joachim Blank and KarlHeinz Jeron with *Without Addresses,* Holger Friese with *unendlich, fast...,* Wohlgemuth and Baumann with *Location Sculpture System,* Martin Kippenberger with *Metronet,* Matt Mullican with *Up to 625,* Antonio Muntadas with *On Translation,* Johan Grimonprez and Herman Asselberghs with *beware,* Hervé Graumann with *l.o.s.t.,* Jordan Crandall and Marek Walzcak with *suspension,* and Marko Peljhan with *Makrolab.*

91 Bunting in an interview notes: 'This year I am in Ars Electronica and Documenta X, which is interest-ing to go to, but I don't want to become a commodity artist. I am listed in the top whatever 100, 200 artists in the world this year, which means I am a good investment: I don't want to be a good invest-ment. I just want people to see what I am doing and not think about how much it costs.' Bosma, 'Interview with Heath Bunting', op. cit. (note 89).

92 David also made a very strange remark, which reveals she did not really research the selected artists very well: 'Secondly, there is also a problem with artists working with the Net: why [do] they so easily restitut[e] [she means substitute? JB] the museum and the object imitation in such a mobile medium?' The choice of, for instance, Bunting's *Visitors Guide to London* as a web art work was not representa-tive of his practice at all. Lamuniere probably chose Bunting's slide show of London street signs and graffiti BECAUSE of its easy depiction as an object in an art show. Jodi's site at first glance might have seemed like CD-rom material, a closed circuit hyperlink structure, but its construction as a kind of dynamic labyrinth with the *Jodi map* (http://map.jodi.org/) as a half hidden door into Wonderland means it is firmly embedded in an online community or network. As I noted earlier in this book, this social aspect is crucial. The *Jodi map*, in fact, was one of the first influential portals into the realm of online art. Marleen Stikker, 'Interview with Catherine David', *Nettime* (1997), Web: http://www.nettime.org/Lists-Archives/nettime-l-9707/msg00095.html (accessed November 2009).

93 Catherine David, 'Introduction', in: Paul Sztulman, *Documenta X: The Short Guide* (Ostfildern: Hantje Cantz Verlag, 1997), 9.

94 Stikker, 'Interview with Catherine David', *op. cit.* (note 92).

95 The newsgroups were set up by the programmer of Internationale Stadt in Berlin, Thomas Kaulmann. In Kassel Herbert A. Mayer ran the Workspace radiostation from FreiesRadioKassel.

96 Cosic's copy of the dX website was posted on the Ljudmila server, and appeared as an illegal copy on CD-rom with the Polish magazine *Cyber* in 1998: http://www.ljudmila.org/~vuk/dx/ (accessed November 2009).

97 Other categories in 1995 were computer animation and interactive arts.

98 Medosch, *Technological Determinism in Media Art*, op. cit. (note 22). Medosch writes: 'Histories of media art are put into a trajectory of the genealogy of media technologies rather than art history. . . . In the decade between 1985 and 1995, high media art developed its forms, its milestone works and its narrative strategies, which altogether were successfully deployed in institution building. . . . By making [a] tabula rasa, traditional categories are abolished. Consequently, high-media art can only be judged by its own criteria. But those criteria seem to be neither aesthetic nor socio-political ones but technological only. . . . A new paradigm unfolded with the mass popularization of the Internet. . . . Socially and politically aware artists shape the discursive agenda outside the institutional context provided by high-media art. . . . High media art with its high-tech visions has won a pyrrhic victory. At the same time, the technologisation of society continues and a strong critical art movement dealing with issues surrounding technology and society is as urgently needed as ever.'

99 The American new media art platform Rhizome was founded in 1996 and became increasingly important in 1997. It ran one unmoderated mailing list until 2002, when it was divided into an unmoderated Rhizome Raw and a weekly Rhizome Digest list. These days, Rhizome consists of multiple sections, including a large new media art archive, and is one of the most important new media art resources. http://www.rhizome.org (accessed November 2009).

100 Andreas Broeckmann, 'Are you online? Participation and Presence in Network Art', *Ars Electronica Festival Catalogue* (1998), Web: http://www.nettime.org/Lists-Archives/nettime-l-9806/msg00082.html (accessed November 2010).

101 The main criticism of this space is also voiced by Domenico Quaranta, in his essay 'Lost in Translation. Or, Bringing Net Art to another Place? Pardon', *Context* (2008), Web: http://www. vagueterrain.net/journal11/domenico-quaranta/01 (accessed November 2010). His analysis reveals how some issues with exhibiting net art simply arose (and arise) from inexperience with art on the Internet. False presumptions about both net art and the Net itself can stand in the way. He writes: 'At *Documenta X* . . . the French curator Simon Lamunière came up with an office-like space, with

works accessible from various terminals not hooked up to the Net. It is significant that the main criticism of Documenta X concerned the office metaphor and this lack of connection: at that time no one believed that these works could be "translated" into forms suitable for real space. Foreignisms were regarded as necessary not only by curators, but also by artists, critics and the public. What was challenged was the way in which it was incorporated into the target language: the frame, or, if you will, the notes in the margin.' The text is accompanied by a photo of the dX net art site, which looks like an average office.

102 Jodi also discloses some of the ways this set up came into being. Baumgärtel asks 'Were you approached by the documenta people at all about the presentation of your work in the show?' Jodi responds: 'No. At first we heard that the net art works would be upstairs in the documenta Halle [the exhibition space 'documenta hall']. They changed this plan one and a half weeks before the opening. Now the room with the net art is downstairs behind a cafe, and they asked some designers to make blue walls and strange furniture. There was never any contact with the artists about this.' Tilman Baumgärtel, '"We love your computer" – The Aesthetics of Crashing Browsers, Interview with Jodi', *Telepolis* (1997), Web: http://www.heise.de/tp/r4/artikel/6/6187/1.html (accessed November 2009).

103 Broeckmann, 'Are you online?', op. cit. (note 100).

104 Ibid. Broeckmann also writes: 'Unlike the Hybrid Workspace, OpenX had a smaller and probably more online audience, with many of the visitors having their own, often-extensive experiences with the networks.' The comparison between dX and OpenX therefore seems slightly unfitting to begin with. Broeckmann's eyewitness account nevertheless is interesting. He writes for example: 'Artists who sometimes know each other in person and sometimes not, work together in smaller communities which overlap with other such communities. More communication and creative potential are derived from the contacts between these groups, mutual contamination and transformation guaranteed. In practice, this concept worked only in part.'

105 Ibid.

106 Josephine Bosma, 'Interview with Keiko Suzuki', *Nettime* (1997), Web: http://www.nettime.org/Lists-Archives/nettime-l-9711/msg00038.html (accessed November 2009). When asked 'How would you describe net.art?' Cosic/Suzuki replied: 'It is many things to many people. I like the immediacy and transient nature of it, plus nobody controls my distribution.'

107 Ibid.

108 Even though this manifesto was announced on Nettime, it was only posted as a link. 'The SCUM Manifesto' is now only available through *ZKP321*. Wagenaar also comments: 'Completely egocentric, unable to relate, empathize or identify, and filled with a vast, pervasive, diffuse desire for interfacing, the human is psychically inanimate. He or She hates his or her inanimateness, so he or she projects it onto machines, defines the human as alive, then sets out to prove that he or she is ("prove he or she's a human").' Akke Wagenaar, *SCUM!!! Manifesto: humans‹ ›machines* (Ljudmila: ZKP321, 1996).

109 Rachel Baker later created a website for it: http://www.irational.org/tm/mr/.

110 The jury included: British artist Kass Schmitt, American artist Natalie Bookchin, Belgian curator Sandra Fauconnier, American festival curator Diana McCarty, Keiko Suzuki, German artist Cornelia Sollfrank, British artist Rachel Baker, Russian artist Olia Lialina, Serbian curator Vesna Manojlovic, American critic Rachel Greene, British artist Carey Young, American curator Barbara Strebel and me.

111 Charlotte Frost, Internet Art History 2.0, in: Chris Bailey (ed.), *Revisualizing Visual Culture*, (Leeds: Leeds Metropolitan University and London: King's College University of London, 2009), 125-138.

112 The end of the letter reads: 'Our client is amenable to resolving this matter in an amicable fashion. However, if this replication of the American Express website is not removed within five days from the date of this letter, we will have no choice but to recommend that our client seek prompt, effective and complete judicial relief.' Web: http://www.irational.org/american_express/ (accessed November 2009).

113 The 'cease and desist' letter warned: 'Unless we receive from you undertakings in the form attached to this letter within 10 days from the date of this letter our clients will take all steps open to them in the English High Court to prevent the misuse and misappropriation of their intellectual property

rights, without further warning to you.' Web: http://www.irational.org/7-11 (accessed November 2009).

114 Cramer, *Words Made Flesh*, op. cit. (note 78). He writes for instance: 'Jodi's aesthetic of contingent codes and user interfaces has been contrarily adapted as outright user enslavement. Using a comparable aesthetic of contingent and unintelligible code, the antiorp / integer / Netochka Nezvanova project turned the notion of proprietary software [in]to its ultimate extreme.'

115 This is one reason why I was quite shocked to find that a long list of South American net artists had felt left out of net art history. They would have been most welcome to join, but somehow this never happened. See: Josephine Bosma, 'Levels, Spheres and Patterns: Form and Location in Net Art', elsewhere in this publication.

116 This was mentioned in an email to Nettime by former VNS Matrix member Josephine Starrs. She also objected to the name net art, since, in her opinion, many net.artists made web (browser-based) art. Starrs overlooked the many conceptual works, mail art, interventions, and live performances that were also part of net.art. She pointed out that 'i was recently at an event where some of these artists were calling themselves "the fathers of net.art".... i guess the "father's of web.art" doesn't sound quite as sexy, but I think you art historians should maybe point out the difference in your texts as you assign male authorship in your art discourses as you have throughout history.' Josephine Starrs, 'Re: net art history', *Nettime* (2001), Web: http://www.nettime.org/Lists-Archives/nettime-l-0102/msg00158.html (accessed November 2009).

117 Donna Haraway, *Simians, Cyborgs and Women: The Reinvention of Nature* (London: Free Association Books, 1991).

118 Their manifesto also states: 'corrupting the discourse we are the future cunt.' http://lx.sysx.org/vns-matrix.html (accessed November 2009). Their manifesto, for instance, can be found at the Old Boys Network website: http://www.obn.org/reading_room/manifestos/html/cyberfeminist.html (accessed November 2009).

119 Translated from the German by the author. Tilla Telemann (German critic Tilman Baumgärtel's name was feminized for this occasion), '"Hacker sinds Künstler – und manche Künstler sind Hacker", Gespräch mit Cornelia Sollfrank', *netz.kunst Jahrbuch 98* (Nürnberg: Verlag für moderne Kunst Nürnberg, 1998), 82-86.

120 Ibid. Sollfrank explains how her attitude was also informed by the sloppy and faulty approach to net art by art institutions: 'If a museum would seriously challenge itself to collect net art, I would accept that. I think they are not serious. One could see this at the Gallerie der Gegenwart [which organized Extension, JB]. They only wanted to briefly jump on the net.art hype, and take a bit of the cream from Cyber and the Net. That they were not aware what it actually meant to start such a project is clear from the fact that after this competition they have not made any more attempts in this direction. The website has not been altered since 1997. When competent people in collaboration with a potent museum would take the idea of collecting net art seriously I would not mind.'

121 In her announcement, Sollfrank indicated: 'Apart from improving her chances to win a prize, the artist tried with FEMALE EXTENSION to take the topic of the competition "internet as material and topic" particularly serious[ly]. What do the gender differences male/female mean on the Internet? Who can proof, if an email address belongs to a man or a woman? And in how many virtual identities can a net artist split herself up? FEMALE EXTENSIONS asks these questions, and at the same time contradicts common prejudices about woman and technology. In addition to this FEMALE EXTENSION shows that art on the Internet isn't limited to the creation of web pages, but can also deal with the technological dispositives of the net.' http://www.nettime.org/Lists-Archives/nettime-l-9709/msg00039.html (accessed November 2009).

122 Private correspondence with the artist, March 2010. She also notes: 'My understanding of net.art has been formed in 1996/97 when I had a DAAD fellowship in New York to do research in net-based art. The works I got to know there (The Thing, moo-theatre etc.) were very complex in the sense that it was mainly collaborative projects and sometimes open platforms rather than finished art works. This kind of net.art took place on the net, sometimes with links to the real world, and most projects

included, critical, social, and/or political aspects. Although some of these projects were related to art venues, their existence and presence was independent from the art world. . . . Unlike Geert Lovink who writes that net.art (media art) failed because the artists were not successful on the art market, I would say, the art market is driven and dominated by a bunch of brainless and corrupt art managers, and the best thing an artist can do is to stay away as far as possible. Benjamin's "The artist as producer" is still a useful theory in this context . . . Female Extension was meant to be a warning of the institutionalization of net.art that seemed to take place, incl. the usual filtering mechanism, inclusion/ exclusion etc., which for me meant a banalisation and disempowerment of net.art.'

123 Cornelia Sollfrank, *net.art generator* (Nürnberg: Verlag für moderne Kunst Nürnberg, 2004) and *Expanded Original* (Oldenburg: Edith Russ Haus and Ostfildern: Hantje Cantz Verlag, 2009).

124 Armin Medosch, 'Adieu Netzkunst', *Telepolis* (1999), Web: http://tuija.net/netart/telepolis/adieu.htm (accessed December 2009). He was already pointing to the difference between net.art and net art in 1999: 'To speculate about the end of something, that barely even started, means, of course, one is asking the wrong questions. First of all, it must be emphasized that the artists categorized under the name net.art never represented the entire field of net art, but instead formed a specific group within it.' Translation from the German by the author.

Alexander Galloway, 'net.art Year in Review: State of net.art 99', *Switch* (1999), Web: http://switch.sjsu.edu/web/v5n3/D-1.html (accessed December 2010). He commenced with: 'What an exciting year it's been in the world of net art!' to continue later in the text: "Net-dot-art is dead." Or, as Tilman Baumgartel has noted, it's "the end of an era. The first formative period of net culture seems to be over".'

Matthew Mirapaul, 'Internet Art Survives, But the Boom is Over', *New York Times* (2004), Web: http://www.nytimes.com/2004/03/31/arts/digital-internet-art-survives-but-the-boom-is-over.html?sec=&spon=&pagewanted=1 (accessed December 2009). He quotes Rachel Greene: '"The ranks have expanded",' she said. "It's a very different landscape from the scene Net art was in the late 90's – then it felt like an intimate, avant-garde movement. The challenge now is to deal with the numbers and the diversity, to seek out artists who are melding art and mass media in ways that are provocative and intriguing".'

125 All of the quotes in the last two paragraphs are from 2003 email interviews.

126 Alexei Shulgin and Natalie Bookchin, 'Introduction to Net.art', *Nettime* (1997), Web: http://www.nettime.org/Lists-Archives/nettime-l-0003/msg00007.html (accessed September 2009). Excerpt: 'Appendix (After net.art) A. Whereby individual creative activities, rather than affiliation to any hyped art movement becomes most valued. 1. Largely resulting from the horizontal rather than vertical distribution of information on the Internet. 2. Thus disallowing one dominant voice to rise above multiple, simultaneous and diverse expressions. B. The Rise of an Artisan 1. The formation of organizations avoiding the promotion of proper names 2. The bypassing of art institutions and the direct targeting of corporate products, mainstream media, creative sensibilities and hegemonic ideologies a. Unannounced b. Uninvited c. Unexpected 3. No longer needing the terms "art" or "politics" to legitimize, justify or excuse one's activities C. The Internet after net.art 1. A mall, a porn shop and a museum 2. A useful resource, tool, site and gathering point for an artisan a. Who mutates and transforms as quickly and cleverly as that which seeks to consume her b. Who does not fear or accept labeling or unlabeling c. Who works freely in completely new forms together with older more traditional forms d. Who understands the continued urgency of free two-way and many-to-many communication over representation.'

127 Images of the stone installation by Blanc and Jeron accompany the text at Shulgin's website: http://www.easylife.org/netart/ (accessed November 2009).

128 In an unpublished 2001 interview I did with Bunting in Glasgow, he even talks about the nervous system and other bodily systems as networks we should take into consideration.

129 Tilman Baumgärtel describes this video in the introduction to a catalogue of a net art exhibition held in the Museo Extremeno e Iberoamericano de Arte Contemporaneo in Badajoz, Spain: 'At the beginning of the video, Bunting talks in a dry, matter of fact fashion about his work, but his tone

becomes increasingly aggressive and diffuse. Bunting thanks his audience, the art world, the curators with "fuck yous" and declares himself, among other things, "the best video artist of all time" and "the king of Internet art", who once got all the money and women, but is now faced with ruin.' Tilman Baumgärtel, 'Internet art and net.art', in: Gustavo Romano (ed.), *Net Art 0.1 Desmontajes* (Badajoz: Museo Extremeno e Iberoamericano de Arte Contemporaneo [MEIAC], 2009), 6-14.

The Gap between Now and Then: On the Conservation of Memory

1 Erkii Huhtamo, 'Twin-Touch-Redux: Media Archeological Approach to Art, Interactivity and Tactility', in: Oliver Grau (ed.), *Media Art Histories* (Cambridge, MA: MIT Press, 2006), 72.

2 A work that changes into documentation when it's taken offline is *Mouchette.org* by Martine Neddam, an elaborate site that in parts depends substantially on audience participation, like a teenage suicide discussion forum. An example of a 'living' work of art that devolves into nothing more than notation is *Listening Post* by Mark Hansen and Ben Rubins, which relies on real-time feeds from chatrooms used by stockbrokers. The temporality of the value of their exchanges emphasizes the ephemeral state of a live connection. For a description of *Mouchette.org*, see Annet Dekker, 'In Search of the Unexpected: Martine Neddam in conversation with Annet Dekker', in: Cathy Brickwood and Annet Dekker (eds.), *Navigating E-Culture*, (Amsterdam: Virtueel Platform, 2009), 65-73. For a description of *Listening Post*, see Jolie Blais and Jon Ippolito, *At the Edge of Art* (London: Thames and Hudson, 2006), 198-199.

3 An example would be the Digital Economy Research programme at the University of Exeter, where a work by the new media performance group Blast Theory was used as a test case for archiving in the digital realm. From the Blast Theory website: 'Using Blast Theory's recent work "Rider Spoke", the project partners are utilising recordings from the work to investigate a range of methods for archiving and playback of the recorded materials.' http://www.blasttheory.co.uk/bt/work_research_creator.html (accessed December 2009). The tendency towards documentation is also described in Anne Laforet's 'Preservation of Net Art in Museums' in: Anna Bentkowska-Kafel, Trish Cashen and Hazel Gardiner (eds.), *Digital Visual Culture: Theory and Practice* (Bristol: Intellect Books, 2009), 109-113.

4 See, for instance: *Preserving the Digital Heritage* (The Hague: Netherlands National Commission for UNESCO, and Amsterdam: European Commission on Preservation and Access KNAW ECPA, 2007), Web: http://www.knaw.nl/ecpa/publ/pdf/2735.pdf (accessed December 2010).

5 It has to be noted that these archives still do not exist for net art to this very day, even though a few strategies are currently under development. See, for instance, Christiane Paul, *The Myth of Immateriality: Presenting and Preserving New Media*, in: Grau, *Media Art Histories*, op. cit. (note 1), 251-274.

6 Web: http://www.longnow.org (accessed December 2010).

7 James Tobias, *Sync: Stylistics of Hieroglyphic Time* (Philadelphia, PA: Temple University Press, 2010).

8 Huhtamo, 'Twin-Touch-Test-Redux', op. cit. (note 1).

9 Originally 'Die Restaurierung des Zerfalls', in: Boris Groys, *Logik der Sammlung* (Munich and Vienna: Carl Hanser Verlag, 1997).

10 Ibid.

11 Ibid.

12 Van Saaze also writes: 'The museum building, its administrative procedures, the curator, director, conservator and technicians all take part in the process of changing coalitions and the coming into being of museum artworks.' Vivian van Saaze, 'Doing Artworks: An ethnographic account of the acquisition and conservation of *No Ghost Just a Shell*', *Krisis – journal for contemporary philosophy* (2009), I, 20-33, Web: http://www.krisis.eu/content/2009-1/2009-1-03-saaze.pdf (accessed December 2010).

13 Carol Stringari, 'Beyond "conservative": The conservator's role in variable media preservation', in: Alain Depocas, Jon Ippolito and Caitlin Jones (eds.), *Permanence Through Change, The Variable Media Approach* (New York, NY: Solomon R. Guggenheim Foundation and Montreal: Daniel Langlois Foundation, 2003), 55-59.

14 Ibid. Stringari: 'When an artwork is restored we attempt to reconcile the change with what we know about the meaning of the work. Defining acceptable loss when we are dealing with highly intel-

lectualized works and sophisticated technological parameters is key to safeguarding these cultural artifacts. As we move further away from their initial conception, we may have fewer tools to reconstruct the intention. By doing this in an open forum and across disciplines, with the artist as an active participant, we can minimize the chances that we will significantly alter or misinterpret an artist's intention.'

15 Ibid.

16 Josephine Bosma, 'Interview with Ron Kuivila', *V2 Web site* (2000), Web: http://framework.v2.nl/archive/archive/node/text/all.xslt/nodenr-132496 (accessed December 2010).

17 Jon Ippolito, 'Edge Conditions, or Building a Better Cookie Cutter', lecture at the *Digital Object* conference (New York: American Museum of the Moving Image, 2000).

18 Richard Rinehart, 'The Media Art Notation System: Documenting and Preserving Digital/Media Art', *Leonardo*, vol. 40 (2007) no. 2.

19 Paul Clarke initiated the research fellowship 'Performing the Archive: The Future of the Past'. A draft of a talk with the same title can be found here: http://insidemovementknowledge.net/events/lab-3 (accessed December 2010).

20 Rinehart, *The Media Art Notation System*, op. cit. (note 18).

21 Mission Eternity was developed after the death of Timothy Leary, so Leary could not have prepared for it during his lifetime. Permission for the use of Timothy Leary's legacy was granted by his estate and family, who are convinced Leary would have been eager to join had he known about the project. They even allowed etoy to use some of Leary's ashes.

22 There is a wiki developer page for the Angel Application at http://angelapp.missioneternity.org/ (accessed December 2010).

23 'The fidelity of context is key for realism in gaming' notes Alexander Galloway in his book *Gaming, Essays on Algorithmic Culture* (Minneapolis: University of Minnesota Press, 2006), 84. It refers to an altered version of the term 'realism' as it shifted in film from social realism to a more intimate form of engaging realism in new media. The audience is not engaged through empathy, but because they have been invited to participate in an actuality.

24 One could say that, since its adoption in digital culture is so much more difficult than that of film and music, the book could easily serve as the symbol of a new cultural paralysis. This time knowledge is threatened not by the burning of books, but by the enforcement of rigid copyright laws and a commercial lockdown of public knowledge.

25 Jon Ippolito, 'Learning from Mario, How to Crowdsource Preservation', lecture at *DOCAM 2010* (Montréal, 2010), Web: http://three.org/ippolito/writing/learning_from_mario/ (accessed December 2010).

26 Geert Lovink, 'Archive Rumblings: Interview with Wolfgang Ernst', *Laudanum.net* (2003), Web: http://laudanum.net/geert/files/1060043851/ (accessed December 2010).

27 Tsiavos talks about libraries, but the technological and cultural appropriation of digital artefacts by libraries, museums and other institutional databases is more or less the same. Prodomos Tsiavos, 'Common(s) Issues for Digital Art Libraries: From Open Licensing to Open Collaboration', in: Aymeric Mansoux and Marloes de Valk (eds.), *Floss + Art* (Poitiers: GOTO10/OpenMute, 2008), 154-169.

28 Ibid.

29 Ibid. The other two that are easily implemented are 'technologies allowing the production of digital works', and 'technologies allowing the reproduction of existing digital works and digitization of analogue works'.

30 GPL stands for General Public License. It is a copyleft license invented by open-source guru Richard Stallman. Copyleft is basically the opposite of copyright. Anything distributed under a GPL license can be appropriated by anyone, as long as they extend the same rights to others who want to use the application created from the original software. Web: http://www.gnu.org/copyleft/gpl.html (accessed December 2009).

31 Annet Dekker (ed.), *Archive 2020: Sustainable Archiving of Born-Digital Cultural Content* (Amsterdam: Virtueel Platform, 2010).

32 Lawrence Liang, *Guide to Open Content Licenses* (Rotterdam: Piet Zwart Institute, 2004).

33 This is extensively described in so many texts and books that I will only mention a few that were particularly influential: Tilman Baumgärtel, *[net.art 2.0]: New Materials Towards Net Art* (Nürnberg: Verlag für moderne Kunst, 2001); Julian Stallabrass, *Internet Art, The Online Clash of Culture and Commerce* (London: Tate Gallery Publishing, 2003); Rachel Greene, *Internet Art* (London: Thames and Hudson, 2004).

34 Online works of art, especially those that significantly involve online communities, have been called 'social sculptures' by their initiators. A famous example is the online institution Rhizome, founded by Mark Tribe in 1996. Tribe used this term to describe Rhizome in a presentation at ISEA 2002. Also etoy, via one of its collaborators, Reinhold Grether refers to its work as social sculpture in an article for the online magazine *Telepolis* (2000), Web: http://www.heise.de/tp/r4/artikel/5/5843/1.html (accessed December 2010).

35 Saper describes a continuum of practices from concrete poetry to conceptual art and mail art that extends into net art. His main focus is the practice of creating intimate bureaucracies, which evolves and changes depending on the different media and cultural settings involved. The introduction notes that: 'An intimate bureaucracy makes poetic use of the trappings of large bureaucratic systems and procedures . . . to create intimate aesthetic situations, including the pleasures of sharing a special knowledge or a new language among a small network of participants.' Craig J. Saper, *Networked Art* (Minneapolis, MN: University of Minnesota Press, 2001), xii.

36 Saper describes intimate bureaucracies in earlier forms of networked art that actually also manage to blend in or actively use standard systems, like the work of the American artist J.S.G. Boggs who drew and spent his own money. The fact that the US government seized his work as counterfeit currency proves how effectively Boggs used the monetary system to stage this work of art. The authorities didn't care about the fact that the recipients of the counterfeit money knew it was fake. An important difference between intimate bureaucracies' pre- and post-digital networks, however, is the level of penetration of the technological systems involved in the construction of a work of art. The Internet in particular facilitates the construction of effective alternative bureaucracies that are practically indiscernible from 'official' structures.

37 Saper, *Networked Art*, op. cit. (note 37).

38 'There is no information, only transformation', interview with Bruno Latour by Geert Lovink, in: *Uncanny Networks* (Cambridge, MA: MIT Press, 2002), 154-160.

39 Wolfgang Ernst, 'Archival Phantasms', *Nettime* (2000), December, Web: http://amsterdam.nettime.org/Lists-Archives/nettime-l-0012/msg00115.html (accessed September 2009)

40 Susan Blackmore, 'Evolution's Third Replicator: Genes, Memes, and Now What?', *New Scientist* (2009), issue 2719, July, 36-39.

41 The idea of the clock was presented in *Wired* in 1995 by Danny Hill, a year prior to the launch of the Long Now Foundation. Web: http://www.wired.com/wired/scenarios/clock.html (accessed December 2009).

42 Web: http://www.longnow.org/clock/ (accessed December 2009).

43 Hill, *Millennium Clock*, op. cit. (note 43).

44 It might be helpful to note that the Long Now Foundation is not solely interested in this form of conservation or preservation. It also publishes information on the preservation of memory in oral cultures, for instance. For the purpose of comparing two opposite approaches of conservation, however, I focus on *The Clock of the Long Now*.

45 http://www.ted.com/talks/stewart_brand_on_the_long_now.html (accessed December 2010).

46 Brian Eno, 'The Big Here and Now'; Alexander Rose, 'Lightness in the long Term, the Clock and the Rosetta Disc', both available at the Doors of Perception, Lightness, 2000. Online archive: http://museum.doorsofperception.com/doors6/doors6index.html.

47 Terry Kuny, 'A Digital Dark Ages: Challenges in the Preservation of Electronic Information', Lecture at the *63rd Annual IFLA General Conference* (Copenhagen, 1997), Web: http://archive.ifla.org/IV/ifla63/63kuny1.pdf (accessed December 2010).

48 Ibid.

49 Ibid.

50 Scott Lash and Manuel DeLanda referred to the Internet as 'the archive of the real' several times at the conference of the 2003 'Data Knitting' edition of the Dutch Electronic Art Festival.

51 Web: http://rosettaproject.org/disk/concept/ (accessed November 2010).

52 From the Rosetta Project website: 'For the extreme longevity version of the Rosetta database, we have selected a new high density analog storage device as an alternative to the quick obsolescence and fast material decay rate of typical digital storage systems. This technology, developed by Los Alamos Laboratories and Norsam Technologies, can be thought of as a kind of next generation microfiche. However, as an analog storage system, it is far superior. A 2.8 inch diameter nickel disk can be etched at densities of 200,000 page images per disk, and the result is immune to water damage, able to with-stand high temperatures, and unaffected by electromagnetic radiation. This makes it an ideal backup for a long-term text image archive. Also, since the encoding is a physical image (no 1's or 0's), there is no platform or format dependency, guaranteeing readability despite changes in digital operating systems, applications, and compression algorithms.' Web: http://rosettaproject.org/disk/technology/ (accessed November 2010).

53 For instance, etoy Daycare, a project that educates and trains children, is described in Josephine Bosma, 'Constructing Media Spaces – the novelty of net(worked) art was and is all about access and engagement', in: Rudolf Frieling and Dieter Daniels (eds.), *Media Art Net 2* (Vienna and New York: Springer, 2005).

54 Matthew Fuller, *Media Ecologies: Materialist Energies in Art and Technoculture* (Cambridge, MA: MIT Press, 2005), 85-108.

55 Ibid.

56 Web: http://missioneternity.org/bridges/ (accessed November 2010).

57 'The CAVE is a surround-screen, surround-sound, projection-based virtual reality (VR) system. The illusion of immersion is created by projecting 3D computer graphics into a 10'x10'x9' cube composed of display screens that completely surround the viewer. It is coupled with head and hand tracking systems to produce the correct stereo perspective and to isolate the position and orientation of a 3D input device. A sound system provides audio feedback. The viewer explores the virtual world by moving around inside the cube and grabbing objects with a three-button, wand-like device.' Web: http://www.evl.uic.edu/pape/CAVE/oldCAVE/CAVE.html (accessed November 2010).

58 Lovink, 'Archive Rumblings', op. cit. (note 26).

59 Ibid.

60 Ippolito, 'Learning from Mario', op. cit. (note 25).

61 'Tombstone data' is a term Rinehart uses for archives where content is left solely in the shape of a artist's name and artwork, plus the date it was created. Rinehart, *The Media Art Notation System*, op. cit. (note 18).

The Source and the Well: The Intimacy of Sound Spaces

1 Barry Truax, *Acoustic Communication* (New York, NY: Albex Publishing Corporation, 1984); Juan Roederer, *The Physics and Psychophysics of Music: An Introduction* (Vienna and New York: Springer, 1973).

2 Seth Kim-Cohen, *In the Blink of an Ear: Toward a Non-Cochlear Sonic Art* (London: Continuum, 2009).

3 Kim Cascone, 'Laptop Music – counterfeiting aura in the age of infinite reproduction', *Parachute: Contemporary Art Magazine* (2002), 53-55. Web: http://www.itu.dk/stud/speciale/auditorium/ litteratur/musik/Kim%20Cascone%20Laptop%20Music%20v2.pdf (accessed September 2009).

4 For instance: Michael Nyman, *Experimental Music: Cage and Beyond* (Cambridge: Cambridge University Press, 1999), which was first published in 1974; Douglas Kahn, *Noise Water Meat: A History of Sound in the Arts* (Cambridge, MA: MIT Press, 1999).

5 Kim-Cohen, *In the Blink of an Ear*, op. cit. (note 2).

6 Ibid. Kim-Cohen uses the theories and practices of sound artist Francisco Lopez to explain the notion of the uses of 'Sound-in-itself'. Apparently, Lopez is influenced by Pierre Schaeffer's 'acousmatism' (as opposed to Cage's intellectualism), and he explores the 'pure' materiality of sound. The term 'sound-in-itself' is also used by Kahn in *Noise Water Meat*, op. cit. (note 4).

7 Ibid.

8 One of the influences that inspired Cage to create *4'33"* was his experience in an anechoic chamber, in which all sound is absorbed in the room's resonance-free construction. Instead of hearing nothing, Cage heard two sounds, one high, one low. He was told that these were the sounds of his nervous system and his blood circulation. He concluded from this that there is no such thing as silence. Cage's composition of silence therefore is based on the sounds we *consider to be* silence. The anecdote is described in many texts and books. For example in Kahn, *Noise Water Meat*, op. cit. (note 4).

9 Nyman, *Experimental Music*, op. cit. (note 4).

10 Walter Benjamin, *Das Kunstwerk im Zeitalter seiner technischen Reproduzierbarkeit* (Berlin: Suhrkamp Verlag, 1963). Also available online: http://www.marxists.org/reference/subject/philosophy/works/ge/benjamin.htm, Transcription by Andy Blunden 1998, proofed and corrected Feb. 2005 (accessed November 2010).

11 Truax, *Acoustic Communication*, op. cit. (note 1).

12 It should be noted that Truax uses the word 'noise' to mean sound that is meaningless, maybe also superfluous, in terms of sound, music (and sound art) as a form of communication. This is different from how the term in the noise music genre, in which 'noise' very clearly is communicative, as it is, for instance, described in: Mattin and Anthony Iles (eds.), 'Noise & Capitalism', *Arteleku* (2009), Web: http://www.arteleku.net/audiolab/noise_capitalism.pdf.

13 Ibid. Italics by original author.

14 Roederer, *The Physics and Psychophysics of Music*, op. cit. (note 1).

15 Italics by original author. Truax, *Acoustic Communication*, op. cit. (note 1).

16 Jacques Attali, *Noise: The Political Economy of Music* (Minneapolis, MN: University of Minnesota Press, 1985).

17 Emily Thompson, *The Soundscape of Modernity: Architectural Acoustics and the Culture of Listening in America, 1900-1933* (Cambridge, MA: MIT Press, 2002).

18 Theodor W. Adorno, *Essays on Music. Selected, with Introduction, Commentary and Notes by Richard Leppert* (Berkeley and Los Angeles, Ca: University of California Press, 2002)

19 Adorno mainly refers to the experience of listening to music on the radio. Radio, of course, offers the possibility of 'live', real-time listening, which was the most common use of radio broadcasting before the Second World War. In terms of commodification, radio, however, goes one step further than gramophone music. Even if the listener does not own the music on the radio, she is still a music consumer, from the least favourable position. Any physical connection to the music is lost, there is no possibility for replay, sound quality is poor, and programming (choice of music and content) is almost completely out of the listener's hands.

20 Richard Leppert, 'Commentary on Adorno's Culture, Technology and Listening', in: Theodor W. Adorno, *Essays on Music* (Berkeley and Los Angeles, CA: University of California Press, 2002).

21 McKenzie Wark, 'Post-Human? All Too Human', *NeMe* (2005), 20 December, Web: http://www.neme.org/main/290/post-human (accessed November 2010).

22 McKenzie Wark, 'Information wants to be free (but is everywhere in chains)', *Cultural Studies* vol. 20 (2006) nos. 2 and 3, March, 165-183.

23 Ibid.

24 Ibid.

25 The struggle against downloading, therefore, is also an attempt to minimize diversity and ensure higher profits. Swedish historian, journalist and spokesman of the filesharing site Piratebay, Rasmus Fleischer, in a lecture at the Wizards of OS conference in Berlin in 2006, said: 'During the second half of the last century, [the industry] adapted business models that were all about finding more and more sophisticated methods for predicting and controlling tastes... In a larger perspective, the ongo-

ing war against file-sharing networks is more a war for [the] securing [of] this predictability, market synchronization and control, than it is about defending copyrighted works against their unauthorized reproduction.' His lecture was published on Nettime: http://www.nettime.org/Lists-Archives/nettime-l-0612/msg00035.html (accessed November 2010).

26 In the Netherlands, the increase in download practices interestingly overlaps with an increased prosecution and the near extinction of pirate radio stations, and the auctioning off of the FM-band to the highest commercial bidders.

27 I use the word 'illegal' in quotes because the music industry and mainstream media started using it long before there was any legislation to back it up. One can only wonder about the legitimacy of the use of this term in relation to downloading and online sharing.

28 Bill Brewster and Frank Broughton, *Last Night a DJ Saved My Life: The History of the Disc Jockey* (London: Headline Book Publishing, 1999).

29 Kodwo Eshun, *More Brilliant Than the Sun: Adventures in Sonic Fiction* (London: Quartet Books Limited, 1998).

30 Joe Milutis, *Ether: The Nothing that Connects Everything* (Minneapolis, MN and London: University of Minnesota Press, 2006).

31 Bernhard Siegert, 'Escalation of a Medium: The Emergence of Broadcast Radio during the High Frequency War', in: Heidi Grundmann (ed.), *On the Air: Kunst im öffentlichen Datenraum* (Innsbruck: Transit, 1993).

32 Milutis, *Ether*, op. cit. (note 30)

33 Micro radio is pirate radio that uses very small, 'weak' transmitters. Tetsuo Kogawa, 'Free Radio in Japan: The Mini-FM Boom', in: Neil Strauss and Dave Mandl (eds.), *Radiotext(e)* (Brooklyn: Semiotext(e), 1993), 90-96; Jesse Walker, *Rebels on the Air: An Alternative History of Radio in America* (New York, NY: NYU Press, 2004).

34 Heidi Grundmann et al. (eds.), *Re-Inventing Radio: Aspects of Radio Art* (Frankfurt/Main: Revolver Books, 2008.)

35 Ibid.

36 Kim Cascone, 'The Aesthetics of Failure: 'Post-Digital' Tendencies in Contemporary Computer Music', *Computer Music Journal* (2000).

37 David Toop, *Ocean of Sound: Aether Talk, Ambient Sound and Imaginary Worlds* (London: Serpent's Tail, 1995).

38 Jacques Attali, *Noise: The Political Economy of Music* (Minneapolis, MN: University of Minnesota Press, 1985.)

39 In his book 'Silence' John Cage writes something similar. He says we could replace the word 'music' with 'organization of sound'. John Cage, *Silence: Lectures and Writings* (Middletown, CT: Wesleyan University Press, 1961).

40 'Is it to be hoped, then,' Attali writes, 'that repetition, that powerful machine for destroying usage, will complete the destruction of the simulacrum of sociality, of the artifice all around us, so that the wager of composition can be lived?' Attali, *Noise*, op. cit. (note 38).

41 G.X. Jupitter-Larsen, 'Noise and the Noiscian', lecture at *Recycling the Future – ORF Kunstradio Conference*, (Vienna, 1997).

42 Ibid.

43 Attali, *Noise*, op. cit. (note 38).

44 Edwin Prévost, 'Free Improvisation in Music and Capitalism: Resisting Authority and the Cults of Scientism and Celebrity', in: Anthony Iles and Mattin (eds.), *Noise & Capitalism*, (San Sebastián: Arteleku, 2009), Web: http://www.arteleku.net/audiolab/noise_capitalism.pdf (accessed November 2010), 38-59.

45 Brewster and Broughton, *Last Night a DJ Saved My Life*, op. cit. (note 28).

46 Kim Cascone, 'Laptop Music', lecture *Art at the Interface conference* (University of Aarhus, 2003).

47 Jeremy Turner, 'The microsound scene - an interview with Kim Cascone', *CTheory* (2001), Web: http://www.ctheory.net/articles.aspx?id=322 (accessed November 2010).

48 Ibid.

49 Simon Yuill, 'All Problems of Notation will be solved by the Masses', *Mute* (2008), Web: http://www.metamute.org/en/All-Problems-of-Notation-Will-be-Solved-by-the-Masses (accessed December 2010).

50 Live coding is also used in the creation of visuals, for instance. It has a history in both hacker battles and html battles, in which the writing of code is either a way of gaining control over a computer or server, or a means to outshine another coder in a live collaboration in the construction of web pages. Both can be performed in front of a live audience. A hacker battle was, for instance, performed at the 10th anniversary party of the Dutch Internet provider XS4ALL (founded by a group of former hackers called 'Hacktic') in front of a large and enthralled audience. HTML battles have been performed in various art venues. 'Infomera is basically a live 48-hr wrestling matches were two net-artist fling mostly HTML code around on an open access server that acts as a virtual wrestling ring. Viewers at home would have to refresh their browsers to see the hour-by-hour progress.' From: Muserna, 'Code Warriors, HTML-wrestling on the Wild Wild Web', *petiteMort.org* (2005), Web: http://www.petitemort.org/issue03/24_code-warriors/index.shtml (accessed December 2010).

51 Tom Armitage, 'Making Music with Live Computer Code', *Wired.co.uk*, 24 September 2009, Web: http://www.wired.co.uk/news/archive/2009-09/25/making-music-with-live-computer-code-?page=all (accessed October 2010).

52 Yuill, 'All Problems of Notation', op. cit. (note 49).

53 Brendan Dougherty, 'Kim Cascone: One Man Orchestra', *pulse berlin* (2007), no. 2, Web: http://www.pulse-berlin.com/index.php?id=118 (accessed November 2010).

54 Raymond Murray Schafer, *The Soundscape: Our Sonic Environment and the Tuning of the World* (New York, NY: Random House, 1977).

55 Turner, 'Interview with Kim Cascone', op. cit. (note 47).

56 Heidi Grundmann, Elisabeth Zimmermann et al. (eds.), *Re-Inventing Radio: Aspects of Radio Art* (Frankfurt/Main: Revolver Books, 2008).

57 Charlie Gere, *Art, Time and Technology* (Oxford: Berg Publishers, 2006).

58 Nina Czegledy, 'Bio-magnetism: Discrete Interpretations', in: Roy Ascott (ed.), *Engineering Nature: Art & Consciousness in the Post-Biological Era* (Bristol: Intellect Books, 2006), 47-52.

59 Josephine Bosma, 'Sound art: interview with Joyce Hinterding', *Nettime* (1998), Web: http://www.nettime.org/Lists-Archives/nettime-l-9808/msg00074.html (accessed November 2010).

60 Josephine Bosma, 'Voice and Code: Hidden Voices Still Speak', *Intelligent Agent* vol. 6 no. 2, 2006.

61 A wonderful example of code as political text was the reading by Italian philosopher Franco Berardi (aka Bifo) of the code of the infamous 'I Love You' computer virus that created millions of dollars worth of damage worldwide. This 'loveletter' performance took place at the D.I.N.A. (Digital Is Not Analogue) festival in Bologna in 2001. Grundmann, Zimmermann et al., *Re-Inventing Radio*, op. cit. (note 56).

62 Zita Joyce, Phonic Interview with r a d i o q u a l i a, *Log Illustrated* (2002), issue 15: 'The X Issue', Web: http://www.physicsroom.org.nz/log/archive/15/pHonic/ (accessed December 2010).

63 The announcement also states: 'In the hierarchy of media, radio reigns. There are more computers than modems, more phones than computers, and more radios than phones. Radio is the closest we have to an egalitarian method of information distribution. Free Radio Linux advocates that radio is the best method for distributing the world's most popular free software.' Web: http://lwn.net/2002/0207/a/radio-free-linux.php3 (accessed November 2010).

64 Jacques Perron, 'Radioqualia: Radio Astronomy', *Langlois Foundation website* (2003), Web: https://www.fondation-langlois.org/html/e/page.php?NumPage=383 (accessed September 2010).

65 Grundmann, Zimmermann et al., *Re-Inventing Radio*, op. cit. (note 56).

66 Web: http://www.radio-astronomy.net/ (accessed November 2010).

67 Michael Nyman, *Experimental Music: Cage and Beyond* (Cambridge: Cambridge University Press, 1999).

68 Associated Press, 'Israel May Use New Weapon on Settlers', *Foxnews* (2005), Web: http://www.foxnews.com/story/0,2933,159127,00.html (accessed November 2010).

69 William Burroughs, *The Electronic Revolution* (Saint Louis, MO: Left Bank Books, 1971), Web: http://www.ubu.com/historical/burroughs/electronic_revolution.pdf (accessed November 2010).

70 Mark Bain, 'Psychosonics and the Modulation of Public Space: On Subversive Sonic Techniques', *Open* (2005), no. 9, 'Sound'.

71 Martin S. Robinette and Theodore Glattke (eds.), *Otoacoustic Emissions: Clinical Applications* (New York, NY: Thieme Medical Publishers, 2007).

72 Web: http://www.ku.dk/satsning/Biocampus/ArtandBiomedicine/LABYRINTHITIS_english.pdf (accessed November 2010).

73 Douglas Kahn, 'Active Hearing: Jacob Kirkegaard's Labyrinthitis', *Limited edition CD Labyrinthitis*, CD sleeve (Touch # Tone 35, 2008).

74 Daniel Campbell Blight, 'Jacob Kirkegaard's Labyrinthitis: Object Enters Subject', *3mm Foamex blog* (2009), Web: http://3mmfoamex.blogspot.com/2009/07/jacob-kirkegaards-labyrinthitis-object.html (accessed November 2010). Kirkegaard also says: 'So, with *Labyrinthitis*, you don't even have the entire piece of music on the CD, like you have on all the other CDs. Here, some of the tones that are part of the composition do not exist on the CD. They only appear and are only heard when the CD is being listened to.'

75 Tobias Fischer, 'Jacob Kirkegaard: Labyrinthitis Makes you Hear your Ear', *Tokafi music blog* (2008), Web: http://www.tokafi.com/news/jacob-kirkegaard-labyrinthitis-makes-you-hear-your-ear/ (accessed December 2010). Kirkegaard also says: 'An old man with only 10% hearing told me that he heard my tones clearer than he had heard anything for many years.'

76 Kahn quotes from *The Ticket that Exploded*: '"A Cockney attendant leads Nova Mobster Bradley into a specialized room 'with metal walls that smelled of ozone and flash bulbs . . .' and then, after mapping a line down the center of his body, into a booth where "small microphones were attached to the two sides of his body and the sounds recorded on two tape recorders – He heard the beating of his heart, the gurgle of shifting secretions and food, the rattle of breath and scratches of throat gristle – crystal bubbles in the sinus chambers magnified from the recorders – The attendant ran the tape from one recorder onto the other to produce the sound of feedback between the two body halves – a rhythmic twang – soft hammer of heartbeats pounding along the divide line of his body . . ."' Douglas Kahn, 'Active Hearing', op. cit. (note 74).

77 Anthony Moore, *Limited edition CD Labyrinthitis*, CD sleeve liner notes (*Touch # Tone* 35, 2008).

Bibliography

Theodor W. Adorno, *Essays on Music. Selected, with Introduction, Commentary and Notes by Richard Leppert* (Berkeley and Los Angeles, CA: University of California Press, 2002)

Rudolf Arnheim, *Visual Thinking* (Berkeley and Los Angeles, CA: University of California Press, 1969)

Inke Arns, 'Read_me, run_me, execute_me, code as executable text: software art and its focus on program code as performative text', in: Rudolf Frieling and Dieter Daniels (eds.), *MediaArtNet* (Vienna and New York, NY: Springer, 2005)

Roy Ascott (ed.), *Engineering Nature: Art & Consciousness in the Post-Biological Era* (Bristol: Intellect Books, 2006)

Roy Ascott, 'Art and Telematics: Towards a Network Consciousness', in: Heidi Grundmann (ed.), *Art + Telecommunication* (Vienna: Vertrieb für Europa, 1984), 27

Associated Press, 'Israel May Use New Weapon on Settlers', *Foxnews* (2005), Web: http://www.foxnews.com/story/0,2933,159127,00.html (accessed November 2010)

Jacques Attali, *Noise: The Political Economy of Music* (Minneapolis, MN: University of Minnesota Press, 1985)

Tom Armitage, 'Making Music with Live Computer Code', *Wired.co.uk*, 24 September 2009, Web: http://www.wired.co.uk/news/archive/2009-09/25/making-music-with-live-computer-code-?page=all (accessed October 2010)

Richard Barbrook and Andy Cameron, *The Californian Ideology* (London: Pluto Press, 1995)

Ricardo Basbaum, 'Differences between us and them', *Ludlow 38* (New York, NY: Goethe Institute New York, 2009), Web: http://www.ludlow38.org/index.php?/events/meyou-choreographies-games-and-e/ (accessed December 2010)

Tilman Baumgärtel, 'Internet art and net.art', in: Gustavo Romano (ed.), *Net Art 0.1 Desmontajes* (Badajoz: Museo Extremeno e Iberoamericano de Arte Contemporaneo [MEIAC], 2009), 6-14

Tilman Baumgärtel, *[net.art 2.0]: New Materials Towards Net Art* (Nürnberg: Verlag für moderne Kunst, 2001)

Tilman Baumgärtel, 'Experimentelle Software II', *Telepolis* (2001), Web: http://www.heise.de/tp/deutsch/inhalt/sa/11107/1.html (accessed November 2010)

Tilman Baumgärtel, *[net.art]: Materialen zur Netzkunst* (Nürnberg: Verlag für moderne Kunst, 1999)

Tilman Baumgärtel, 'Art was just a substitute for the Internet: Interview with Vuk Cosic', *Telepolis* (1997), Web: http://www.heise.de/tp/r4/artikel/6/6158/1.html (accessed February 2009)

Tilman Baumgärtel, '"We love your computer" – The Aesthetics of Crashing Browsers, Interview with Jodi', *Telepolis* (1997), Web: http://www.heise.de/tp/r4/artikel/6/6187/1.html (accessed November 2009)

255

Tilman Baumgärtel, 'Interview with Alexei Shulgin', *Kunstradio* (1997), Web: http://www.kunstradio.at/ FUTURE/RTF/INSTALLATIONS/SHULGIN/interview.html (accessed November 2009)

Tatiana Bazzichelli, *Networking: The Net as Artwork* (Aarhus: Digital Aesthetics Research Center, Aarhus University, 2008)

Hans Beder and Klaus Peter Busse (eds.), *Intermedia: Enacting the Liminal* (Dortmund: Dortmunder Schriften zur Kunst, 2005)

Walter Benjamin, *Das Kunstwerk im Zeitalter seiner technischen Reproduzierbarkeit* (Berlin: Suhrkamp Verlag, 1963). Also available online: http://www.marxists.org/reference/subject/philosophy/works/ge/benjamin. htm, transcription by Andy Blunden 1998, proofed and corrected Feb. 2005 (accessed November 2010)

Anna Bentkowska-Kafel, Trish Cashen and Hazel Gardiner (eds.), *Digital Visual Culture: Theory and Practice* (Bristol: Intellect Books, 2009)

Josephine Berry, Pauline Mourik Broekman and Michael Corris (eds.), *Proud to be Flesh: A Mute Magazine Anthology of Cultural Politics after the Net* (London: Mute Publishing Ltd, 2009)

Josephine Berry, *The Re-Dematerialisation of the Object and the Artist in Biopower* (PhD thesis, 2001), Web: http://www.Nettime.org/Lists-Archives/Nettime-l-0102/msg00085.html (accessed February 2009)

Hakim Bey, *T.A.Z. – The Temporary Autonomous Zone* (New York, NY: Autonomedia, 2003)

Marga Bijvoet, *Art as Inquiry: Towards New Collaborations Between Art, Science, and Technology* (New York, NY: Peter Lang publishing, 1997)

Joachim Blanc, 'what is net art? ;)', *Nettime* (1997), Web: http://www.nettime.org/Lists-Archives/ nettime-l-9704/msg00056.html (accessed November 2010)

Susan Blackmore, 'Evolution's Third Replicator: Genes, Memes, and Now What?', *New Scientist* (2009), issue 2719, July, 36-39

Joline Blais and Jon Ippolito, *At the Edge of Art* (London: Thames and Hudson, 2006)

Bert Bongers, *Interactivation: Towards an e-cology of people, our technological environment and the arts* (Utrecht: SIKS Dissertation Series, 2006)

Josephine Bosma, *Interview with Michael Mandiberg* (unpublished ms., 2009)

Josephine Bosma, 'Voice and Code: Hidden Voices Still Speak', *Intelligent Agent*, vol. 6 (2006) no. 2

Josephine Bosma, 'Constructing Media Spaces – the novelty of net(worked) art was and is all about access and engagement', in: Rudolf Frieling and Dieter Daniels (eds.), *Media Art Net 2* (Vienna and New York: Springer, 2005)

Josephine Bosma, 'Net Echt, Kleine geschiedenis van de netkunst', *Metropolis M* (2001), 13-17

Josephine Bosma, 'Interview with Mary-Ann Breeze', *Rhizome* (2000), Web: http://rhizome.org/discuss/ view/28784/#1630 (accessed November 2010)

Josephine Bosma, 'Interview with Ron Kuivila', *V2 Web site* (2000), Web: http://framework.v2.nl/archive/archive/node/text/all.xslt/nodenr-132496 (accessed December 2010)

Josephine Bosma et al. (eds.), *ReadMe! Filtered by ‹nettime›* (Brooklyn, NY: Autonomedia, 1999)

Josephine Bosma, 'Interview with Alla Mitrofanova and Olga Suslova', in: Igor Markovic (ed.), *Cyberfeminizam [ver 1.0]* (Zagreb: Centar za Zenske, 1999). Published online in English, Web: http://www.nettime.org/Lists-Archives/nettime-l-9706/msg00107.html (accessed November 2010)

Josephine Bosma, 'Kathy Rae Huffman: Vernetzung ››face-to-face‹‹, Josephine Bosma im Gespräch mit Kathy Rae Huffman', *netz.kunst Jahrbuch 98/99* (Nürnberg: Verlag für moderne Kunst Nürnberg, 1999), 194-197

Josephine Bosma, 'Interview with RTMark', *nettime* (1998), Web: http://www.nettime.org/Lists-Archives/nettime-l-9809/msg00034.html (accessed November 2010)

Josephine Bosma, 'Sound art: interview with Joyce Hinterding', *Nettime* (1998), Web: http://www.nettime.org/Lists-Archives/nettime-l-9808/msg00074.html (accessed November 2010)

Josephine Bosma, 'Is it a commercial? Nooo . . . Is it spam? Nooo – It is net art!', *Mute* (1998), issue 10, 73-74

Josephine Bosma, 'net, "radio" and physical space: FAKESHOP', *Nettime* (1997), Web: http://www.nettime.org/Lists-Archives/nettime-l-9712/msg00026.html (accessed November 2010)

Josephine Bosma, 'Interview with Heath Bunting', *Telepolis* (1997), Web: http://www.heise.de/tp/r4/artikel/6/6176/1.html (accessed November 2010)

Josephine Bosma, 'Interview with Olia Lialina', *Nettime* (1997), Web: http://www.nettime.org/Lists-Archives/nettime-l-9708/msg00009.html (accessed November 2009)

Josephine Bosma, 'Independent net.art', *Nettime* (1997), Web: http://www.Nettime.org/Lists-Archives/Nettime-l-9707/msg00014.html (accessed November 2009)

Josephine Bosma, 'Interview with Keiko Suzuki', *Nettime* (1997), Web: http://www.nettime.org/Lists-Archives/nettime-l-9711/msg00038.html (accessed November 2009)

Josephine Bosma, 'Vuk Cosic Interview: net.art per se', *Nettime* (1997), Web: http://www.Nettime.org/Lists-Archives/Nettime-l-9709/msg00053.html (accessed December 2010)

Josephine Bosma, 'Interview with jodi', in: Pit Schultz, Diana McCarty, Geert Lovink and Vuk Cosic (eds.), *ZKP 4: Beauty and the East* (Ljubljana: Ljudmila Digital Media Lab / Nettime, 1997), 14-16

Arne De Boever, Alex Murray and Jon Roffe, '"Technical Mentality" Revisited: Brian Massumi on Gilbert Simondon', *Parrhesia*, (2009) no. 7, 36-45

Nicholas Bourriaud, *Relational Aesthetics* (Dijon: Les Presses du Réel, 1998)

Bill Brewster and Frank Broughton, *Last Night a DJ Saved My Life: The History of the Disc Jockey* (London: Headline Book Publishing, 1999)

Cathy Brickwood and Annet Dekker (eds.), *Navigating E-Culture*, (Amsterdam: Virtueel Platform, 2009)

Andreas Broeckmann, 'Are you online? Participation and Presence in Network Art', *Ars Electronica Festival Catalogue* (1998), Web: http://www.nettime.org/Lists-Archives/nettime-l-9806/msg00082.html (accessed November 2010)

Andreas Broeckmann, 'Net.Art, Machines, and Parasites', *Nettime* (1997), Web: http://www.nettime.org/Lists-Archives/nettime-l-9703/msg00038.html (accessed December 2009)

Joke Brouwer, Sandra Fauconnier, Arjen Mulder and Anne Nigten (eds.), *aRt&D: Research and Development in Art* (Rotterdam: V2_/NAi Publishers, 2005)

Joke Brouwer and Arjen Mulder, *The Art of the Accident* (Rotterdam: V2_/NAi publishers, 1998)

Jack Burnham, 'Systems Esthetics', *Artforum* (1968), VII:I, 30-5 September, Web: http://www.arts.ucsb.edu/faculty/jevbratt/readings/burnham_se.html (accessed December 2009)

William Burroughs, *The Electronic Revolution* (Saint Louis, MO: Left Bank Books, 1971), Web: http://www.ubu.com/historical/burroughs/electronic_revolution.pdf (accessed November 2010)

John Cage, *Silence: Lectures and Writings* (Middletown, CT: Wesleyan University Press, 1961)

Daniel Campbell Blight, 'Jacob Kirkegaard's Labyrinthitis: Object Enters Subject', *3mm Foamex blog* (2009), Web: http://3mmfoamex.blogspot.com/2009/07/jacob-kirkegaards-labyrinthitis-object.html (accessed November 2010)

Kim Cascone, 'Laptop Music – counterfeiting aura in the age of infinite reproduction', *Parachute: Contemporary Art Magazine* (2002), 53-55, Web: http://www.itu.dk/stud/speciale/auditorium/litteratur/musik/Kim%20Cascone%20Laptop%20Music%20v2.pdf (accessed September 2009)

Kim Cascone, 'The Aesthetics of Failure: 'Post-Digital' Tendencies in Contemporary Computer Music', *Computer Music Journal* (2000), 24:4, winter issue, 12-18

Manuel Castells, *The Informational City: Information Technology, Economic Restructuring, and the Urban Regional Process* (Hoboken, NJ: Wiley-Blackwell, 1992)

Annmarie Chandler and Norie Neumark (eds.), *At a Distance: Precursors to Art and Activism on the Internet* (Cambridge, MA: MIT Press, 2005)

Vuk Cosic et al., 'The Net.Artists', *Nettime* (1997), Web: http://www.Nettime.org/Lists-Archives/Nettime-l-9606/msg00011.html (accessed December 2010), posted by Pit Schulz

Florian Cramer, *Words Made Flesh: Code, Culture, Imagination* (Rotterdam: Piet Zwart Instituut, 2005), Web: http://www.pzwart.wdka.hro.nl/mdr/research/fcramer/wordsmadeflesh/ (accessed September 2009)

Nina Czegledy, 'Bio-magnetism: Discrete Interpretations', in: Roy Ascott (ed.), *Engineering Nature: Art & Consciousness in the Post-Biological Era* (Bristol: Intellect Books, 2006), 47-52

Christoph Danelzik-Brüggemann, Hans-Dieter Huber et al. (eds.), *Kritische Berichte: Zeitschrift für Kunst und Kulturwissenschaften*, vol. 26 (1998) no. 1, 'Netzkunst'

Dieter Daniels and Gunther Reisinger (eds.), *Netpioneers 1.0: Contextualising Early Net Based Art* (Berlin: Sternberg Press, 2010)

Arthur Danto, *Beyond the Brillo Box: The Visual Arts in Post-Historical Perspective* (Berkeley and Los Angeles, CA: University of California Press, 1992)

Catherine David, 'Introduction', in: Paul Sztulman, *Documenta X: The Short Guide* (Ostfildern: Hantje Cantz Verlag, 1997), 9

Erik Davies, *Techgnosis: Myth, Magic, and Mysticism in the Age of Information* (New York, NY: Three Rivers Press/Random House, 1999)

Régine Debatty, 'Interview with Marisa Olson', *We Make Money Not Art* (2008), Web: http://we-make-money-not-art.com/archives/2008/03/how-does-one-become-marisa.php (accessed November 2010)

Annet Dekker (ed.), *Archive 2020: Sustainable Archiving of Born-Digital Cultural Content* (Amsterdam: Virtueel Platform, 2010)

Annet Dekker, 'In Search of the Unexpected: Martine Neddam in conversation with Annet Dekker', in: Cathy Brickwood and Annet Dekker (eds.), *Navigating E-Culture*, (Amsterdam: Virtueel Platform, 2009), 65-73

Gilles Deleuze and Felix Guattari, *A Thousand Plateaus* (London: Athlone, 1988)

Alain Depocas, Jon Ippolito and Caitlin Jones (eds.), *Permanence Through Change, The Variable Media Approach* (New York, NY: Solomon R. Guggenheim Foundation and Montreal: Daniel Langlois Foundation, 2003)

Steve Dietz, 'Public_Sphere_s', in: Rudolf Frieling and Dieter Daniels (eds.), *Media Art Net 2* (Vienna/New York, NY: Springer, 2005), 260-263

Brendan Dougherty, 'Kim Cascone: One Man Orchestra', *pulse berlin* (2007) no. 2, Web: http://www.pulse-berlin.com/index.php?id=118 (accessed November 2010)

Umberto Eco, *Interpretation and Overinterpretation* (Cambridge: Cambridge University Press, 1992)

Brian Eno, 'The Big Here and Now', lecture at *Doors of Perception* (Amsterdam, 2000) no. 6, 'Lightness', Web: http://museum.doorsofperception.com/doors6/doors6index.html (accessed December 2010)

Wolfgang Ernst, 'Archival Phantasms', *Nettime* (2000), December, Web: http://amsterdam.nettime.org/Lists-Archives/nettime-l-0012/msg00115.html (accessed September 2009)

Kodwo Eshun, *More Brilliant Than the Sun: Adventures in Sonic Fiction* (London: Quartet Books Limited, 1998)

Donna Ferrato and Marco Meier (eds.), *Du* (2000) no. 11, 'net.art, Rebellen im Internet'

Tom Finkelpearl, *Dialogues in Public Art* (Cambridge, MA: MIT Press, 2001)

Tobias Fischer, 'Jacob Kirkegaard: Labyrinthitis Makes you Hear your Ear', *Tokafi music blog* (2008), Web: http://www.tokafi.com/news/jacob-kirkegaard-labyrinthitis-makes-you-hear-your-ear/ (accessed December 2010)

Rasmus Fleischer, 'Navigating through the Crisis of Copyright: Lecture at Wizards of OS Berlin', *Nettime* (2006), Web: http://www.nettime.org/Lists-Archives/nettime-l-0612/msg00035.html (accessed November 2010)

E.M. Forster, 'The Machine Stops', in: Neil Spiller (ed.), *Cyber_Reader* (London: Phaidon Press, 2002), 30-33

Hal Foster, *Return of the Real* (Cambridge, MA: MIT Press, 2001)

Ken Friedman, 'The Wealth and Poverty of Networks', in: Annmarie Chandler and Norie Neumark (eds.), *At a Distance: Precursors to Art and Activism on the Internet* (Cambridge, MA: MIT Press, 2005), 409-422

Rudolf Frieling and Dieter Daniels (eds.), *Media Art Net 2* (Vienna and New York: Springer, 2005)

Charlotte Frost, 'Internet Art History 2.0', in: Chris Bailey (ed.), *Revisualizing Visual Culture* (Leeds: Leeds Metropolitan University and London: King's College University of London, 2009), 125-138

Matthew Fuller, 'Pits to Bits: interview with Graham Harwood', *Nettime* (2010), Web: http://www.mail-archive.com/nettime-l@kein.org/msg02426.html (accessed November 2010)

Matthew Fuller (ed.), *Software Studies: A Lexicon* (Cambridge, MA: MIT Press, 2008)

Matthew Fuller, *Media Ecologies: Materialist Energies in Art and Technoculture* (Cambridge, MA: MIT Press, 2005)

Matthew Fuller, 'People Would Go Crazy: Introduction to Word Bombs conference "techno"-panel', in: Vuk Cosic and Heath Bunting, (eds.), *ZKP321* (Ljudmila: prexeroxed at KGB∗ZOD, 1996), 30-31

Alexander Galloway, *Gaming: Essays on Algorithmic Culture* (Minneapolis: University of Minnesota Press, 2006)

Alexander Galloway, *Protocol: How Control Exists after Decentralization* (Cambridge, MA: MIT Press, 2004)

Alexander Galloway, 'net.art Year in Review: State of net.art 99', *Switch* (1999), Web: http://switch.sjsu.edu/web/v5n3/D-1.html (accessed December 2010)

David Garcia, 'Art on Net', *Nettime* (1997), Web: http://www.nettime.org/Lists-Archives/nettime-l-9703/msg00060.html (accessed November 2009)

Charlie Gere, *Art, Time and Technology* (Oxford: Berg Publishers, 2006)

Ken Goldberg (ed.), *The Robot in the Garden* (Cambridge, MA: MIT Press, 2000)

Beryl Graham and Sarah Cook, *Rethinking Curating* (Cambridge, MA: MIT Press, 2010)

Oliver Grau (ed.), *MediaArtHistories* (Cambridge, MA: MIT Press, 2007)

Oliver Grau, *Virtual Art from Illusion to Immersion* (Cambridge, MA: MIT Press, 2003)

Rachel Greene, *Internet Art* (London: Thames and Hudson, 2004)

Reinhold Grether, 'How the Etoy Campaign was Won', *Telepolis* (2000), Web: http://www.heise.de/tp/r4/artikel/5/5843/1.html (accessed December 2010)

Boris Groys, *Logik der Sammlung* (Munich and Vienna: Carl Hanser Verlag, 1997)

Heidi Grundmann (ed.). *Art+Telecommunication* (Vienna: Vertrieb für Europa, 1984)

Heidi Grundmann and Nicola Mayr (eds.) *On the Air - Kunst im Öffentlichen Datenraum* (Innsbruck: Transit, 1993)

Heidi Grundmann, Elisabeth Zimmermann et al. (eds.), *Re-Inventing Radio: Aspects of Radio Art* (Frankfurt/ Main: Revolver Books, 2008)

Katharina Gsöllpointner, and Ursula Hentschläger, *Paramour: Kunst im Kontext Neuer Technologien* (Vienna: Triton, 1999)

Donna Haraway, *Simians, Cyborgs and Women: The Reinvention of Nature* (London: Free Association Books, 1991)

Martin Heidegger, *The Question Concerning Technology, and Other Essays* (New York, NY: HarperCollins Publishers, 1982)

Danny Hill, 'The Milennium Clock', *Wired* (1995), Web: http://www.wired.com/wired/scenarios/clock. html (accessed December 2009)

Sabine Hochrieser, Michael Kargl and Franz Thalmair (eds), *Curating Media/Net/Art, circulating contexts* (Norderstedt: Books on Demand, 2010)

Brian Holmes, *The Potential Personality*, Web: http://brianholmes.wordpress.com/2007/04/08/the-potential-personality/ (accessed December 2010)

Hans Dieter Huber, 'Über das Beschreiben, Interpretieren, und Verstehen von Internetbasierten Werken', *Netzkunst - online und im Museum* (Basel: Hochschule für Gestaltung und Kunst and Bern: Hochschule für Gestaltung, Kunst und Konservierung, 2003), Web: http://www.xcult.ch/texte/hdhuber/huber.html (accessed November 2010)

Erkii Huhtamo, 'Twin-Touch-Redux: Media Archeological Approach to Art, Interactivity and Tactility', in: Oliver Grau (ed.), *Media Art Histories* (Cambridge, MA: MIT Press, 2006), 71-101

Anthony Iles and Mattin (eds.), *Noise & Capitalism*, (San Sebastián: Arteleku 2009), Web: http://www.arteleku.net/audiolab/noise_capitalism.pdf (accessed November 2010)

Jon Ippolito, 'Learning from Mario, How to Crowdsource Preservation', lecture at *DOCAM 2010* (Montréal, 2010), Web: http://three.org/ippolito/writing/learning_from_mario/ (accessed December 2010)

Jon Ippolito, 'Ten Myths about Internet Art', *Leonardo Magazine* (2002) no. 35, Web: http://www.three.org/ippolito/writing/ten_myths_of_internet_art/ (accessed October 2010)

Jon Ippolito, 'Edge Conditions, or Building a Better Cookie Cutter', lecture at the *Digital Object* conference (New York: American Museum of the Moving Image, 2000)

Jodi, '*yeeha!', *Nettime* (July 1996), Web: http://www.Nettime.org/Lists-Archives/Nettime-l-9607/msg00061.html (accessed November 2009)

Zita Joyce, Phonic Interview with r a d i o q u a l i a, *Log Illustrated* (2002), issue 15: 'The X Issue', Web: http://www.physicsroom.org.nz/log/archive/15/pHonic/ (accessed December 2010)

G.X. Jupitter-Larsen, 'Noise and the Noiscian', lecture at *Recycling the Future – ORF Kunstradio Conference*, unpublished manuscript (Vienna, 1997)

Douglas Kahn, 'Active Hearing: Jacob Kirkegaard's Labyrinthitis', *Limited edition CD Labyrinthitis*, CD sleeve (*Touch # Tone* 35, 2008)

Douglas Kahn, *Noise Water Meat: A History of Sound in the Arts* (Cambridge, MA: MIT Press, 1999)

Andrew Keen, *The Cult of the Amateur: How Today's Internet is Killing Our Culture* (New York, NY: Doubleday/Currency, 2007)

Derrick de Kerckhove, *The Skin of Culture: Investigating the New Electronic Reality* (Toronto: Somerville House Publishing, 1995)

Seth Kim-Cohen, *In the Blink of an Ear: Toward a Non-Cochlear Sonic Art* (London: Continuum, 2009)

Tetsuo Kogawa, 'Free Radio in Japan: The Mini-FM Boom', in: Neil Strauss and Dave Mandl (eds.), *Radiotext(e)* (Brooklyn: Semiotext(e), 1993), 90-96

Rob van Kranenburg, *The Internet of Things: A Critique of Ambient Technology and the All-Seeing Network of RFID* (Amsterdam: Institute of Network Cultures, 2008), Web: http://www.networkcultures.org/_uploads/notebook2_theinternetofthings.pdf (accessed December 2010)

Rosalind Krauss, *A Voyage on the North Sea: Art in the Age of the Post-Medium Condition* (London: Thames and Hudson, 1999)

Rosalind Krauss, *Perpetual Inventory* (Cambridge, MA: MIT Press, 2010)

Günther Kress, *Literacy in the New Media Age* (New York, NY: Routledge, 2003)

Verena Kuni (ed.), *netz.kunst* (Nürnberg: Institut für moderne Kunst Nürnberg, 1998)

Terry Kuny, 'A Digital Dark Ages: Challenges in the Preservation of Electronic Information', Lecture at the *63rd Annual IFLA General Conference* (Copenhagen, 1997), Web: http://archive.ifla.org/IV/ifla63/63kuny1.pdf (accessed December 2010)

Anne Laforet, 'Preservation of Net Art in Museums', in: Anna Bentkowska-Kafel, Trish Cashen and Hazel Gardiner (eds.), *Digital Visual Culture: Theory and Practice* (Bristol: Intellect Books, 2009), 109-113

Olia Lialina, 'Re: Re: net art history', *Nettime* (2001), Web: http://www.Nettime.org/Lists-Archives/nettime-l-0102/msg00200.html (accessed February 2009)

Lawrence Liang, *Guide to Open Content Licenses* (Rotterdam: Piet Zwart Institute, 2004)

Lucy Lippard, *Six Years: the Dematerialization of the Art Object from 1966 to 1972* (Berkeley and Los Angeles, CA: University of California Press, 1973)

Geert Lovink, *Dynamics of Critical Internet Culture (1994-2001)* (Amsterdam: Institute of Network Cultures, 2009), Web: http://networkcultures.org/_uploads/tod/TOD1_dynamicsofcriticalinternetculture.pdf (accessed November 2009)

Geert Lovink, *Dark Fiber* (Cambridge, MA: MIT Press, 2003)

Geert Lovink, 'Archive Rumblings: Interview with Wolfgang Ernst', *Laudanum.net* (2003), Web: http://laudanum.net/geert/files/1060043851/ (accessed December 2010)

Geert Lovink, *Uncanny Networks* (Cambridge, MA: MIT Press, 2002)

Geert Lovink, 'Franz Feigl is dead', *Nettime* (2001), Web: http://www.nettime.org/Lists-Archives/nettime-l-0109/msg00291.html (accessed November 2009)

Geert Lovink, 'New Media and the Art of Debating, Second Thoughts on the Organization of Conferences', *Nettime* (1996), Web: http://www.thing.desk.nl/bilwet/TXT/conf.txt (accessed November 2009)

Regina Lynn, 'Virtual Rape Is Traumatic, but Is It a Crime?', *Wired* (2007), 5 April, Web: http://www.wired.com/culture/lifestyle/commentary/sexdrive/2007/05/sexdrive_0504 (accessed November 2010)

Adrian MacKenzie, *Transductions: Bodies and Machines at Speed* (London: Continuum, 2002)

Adrian Mackenzie, *Wirelessness: Radical Empiricism in Network Cultures* (Cambridge, MA: MIT Press, 2010)

Brian Mackern (ed.), *netart_latino database* (Badajoz: Museo Extremeno e Iberoamericano de Arte Contemporaneo [MEIAC], 2010)

Jeff Malpas, *Acting at a Distance and Knowing from Afar: The Robot in the Garden* (Cambridge, MA: MIT Press, 2000)

Lev Manovich, *The Language of New Media* (Cambridge, MA: MIT Press, 2000)

Aymeric Mansoux and Marloes de Valk (eds.), *Floss + Art* (Poitiers: GOTO10/OpenMute, 2008)

Igor Markovic (ed.), *Cyberfeminizam [ver 1.0]* (Zagreb: Centar za Zenske, 1999)

Marcin Marocki, *Surfing Clubs* (2008), Web: http://ramocki.net/surfing-clubs.pdf (accessed November 2009)

Brian Massumi, *Parables for the Virtual: Movement, Affect, Sensation* (Durham, NC: Duke University Press, 2002)

Brian Massumi, 'The Evolutionary Alchemy of Reason', lecture at *5cyberconf*, 1996, Web: http://www.fundacion.telefonica.com/at/emassumi.html (accessed November 2010)

Marshall McLuhan, *Understanding Media: the Extensions of Man* (London: Sphere, 1967)

Medien.KUNSTLABOR, 'The Myth of Bolshevik: In Memory of Franz Feigl', *Turbulence* (2005), Web: http://turbulence.org/networked_music_review/2005/08/09/in-memory-of-franz-feigl/?author=4 (accessed November 2009)

Armin Medosch, *Technological Determinism in Media Art* (MA Thesis, Sussex University, 2005), Web: http://www.thenextlayer.org/system/files/TechnoDeterminismAM.pdf (accessed December 2009)

Armin Medosch, 'Adieu Netzkunst', *Telepolis* (1999), Web: http://tuija.net/netart/telepolis/adieu.htm (accessed December 2009)

Armin Medosch, 'Interview with Alexei Shulgin', *Telepolis* (1997), Web: http://www.heise.de/tp/r4/artikel/6/6173/1.html (accessed November 2009)

Joe Milutis, *Ether: The Nothing That Connects Everything* (Minneapolis, MN: University of Minnesota Press, 2006)

Matthew Mirapaul, 'Internet Art Survives, But the Boom is Over', *New York Times* (2004), Web: http://www.nytimes.com/2004/03/31/arts/digital-internet-art-survives-but-the-boom-is-over.html?sec=&spon=&pagewanted=1 (accessed December 2009)

Anthony Moore, *Limited edition CD Labyrinthitis*, CD sleeve liner notes (*Touch # Tone* 35, 2008)

Arjen Mulder, 'Interview with Humberto Maturana', in: Joke Brouwer and Arjen Mulder (eds.), *The Art of the Accident* (Rotterdam: NAi/V2 publishers, 1998)

Raymond Murray Schafer, *The Soundscape: Our Sonic Environment and the Tuning of the World* (New York, NY: Random House, 1977)

Muserna, 'Code Warriors, HTML-wrestling on the Wild Wild Web', *petiteMort.org* (2005), Web: http://www.petitemort.org/issue03/24_code-warriors/index.shtml (accessed December 2010)

Michael Nyman, *Experimental Music: Cage and Beyond* (Cambridge: Cambridge University Press, 1999)

Marisa Olson, *Lost Not Found* (2008). No longer available online. An excerpt is available in the Networked_Performance archive, Web: http://turbulence.org/blog/2008/09/24/lost-not-found-the-circulation-of-images-in-digital-visual-culture/ (accessed December 2009)

Christiane Paul, *The Myth of Immateriality: Presenting and Preserving New Media*, in: Oliver Grau (ed.), *Media Art Histories* (Cambridge, MA: MIT Press, 2006), 251-274

Christiane Paul, *Digital Art* (London: Thames and Hudson, 2003)

Simon Penny, 'Systems Aesthetics and Cyborg Art: The Legacy of Jack Burnham', *Sculpture Magazine* (1999), vol. 18, Web: http://ace.uci.edu/penny/texts/systemaesthetics.html (accessed November 2010)

Damián Peralta Mariñelarena, 'Net Art Is Not Dead: Interview with Olia Lialina', *Damianperalta.net* (2009), Web: http://www.damianperalta.net/es/teoria/38-entrevistas/52-interview-with-olia-lialina (accessed November 2010)

Jacques Perron, 'Radioqualia: Radio Astronomy', *Langlois Foundation website* (2003), Web: https://www.fondation-langlois.org/html/e/page.php?NumPage=383 (accessed September 2009)

Sadie Plant, *The Most Radical Gesture: The Situationist International in a Postmodern Age* (New York: Routledge, 1992)

Per Platou (ed.), *Skrevet I stein. En net.art arkeologi* (Oslo: Museum for Contemporary Art, 2003)

Frank Popper, *From Technological to Virtual Art* (Cambridge, MA: MIT Press, 2007)

Edwin Prévost, 'Free Improvisation in Music and Capitalism: Resisting Authority and the Cults of Scientism and Celebrity', in: Anthony Iles and Mattin Iles (eds.), *Noise & Capitalism*, (San Sebastián: Arteleku 2009), Web: http://www.arteleku.net/audiolab/noise_capitalism.pdf (accessed November 2010), 38-59

Domenico Quaranta, 'Lost in Translation. Or, bringing Net Art to another Place? Pardon, Context.' *Vague Terrain* (2008), 11. Web: http://vagueterrain.net/journal11/domenico-quaranta/01 (accessed November 2010)

Jacques Rancière, *The Future of the Image* (Brooklyn, NY: Verso, 2007)

Jacques Ranciere, *The Politics of Aesthetics* (London: Continuum, 2004)

Claudia Reiche and Verena Kuni (eds.), *Cyberfeminism: Next Protocols* (Brooklyn, NY: Autonomedia, 2004)

Richard Rinehart and Jon Ippolito, *New Media and Social Memory* (Cambridge, MA: MIT Press, forthcoming 2011)

Richard Rinehart, 'The Media Art Notation System: Documenting and Preserving Digital/Media Art', *Leonardo*, vol. 40 (2007) no. 2

Martin S. Robinette and Theodore Glattke (eds.), *Otoacoustic Emissions: Clinical Applications* (New York, NY: Thieme Medical Publishers, 2007)

Juan Roederer, *The Physics and Psychophysics of Music: An Introduction* (Vienna and New York, NY: Springer, 1973)

Gustavo Romano (ed.), *Net Art o.1 Desmontajes* (Badajoz: Museo Extremeno e Iberoamericano de Arte Contemporaneo [MEIAC], 2009)

Alexander Rose, 'Lightness in the long Term, the Clock and the Rosetta Disc', Lecture at *Doors of Perception* (Amsterdam, 2000) no. 6, 'Lightness', Web: http://museum.doorsofperception.com/doors6/doors6index.html (accessed December 2010)

Vivian van Saaze, 'Doing Artworks: An ethnogrtaphic account of the acquisition and conservation of *No Ghost Just a Shell*, *Krisis – journal for contemporary philosophy* (2009), I, 20-33, Web: http://www.krisis.eu/content/2009-1/2009-1-03-saaze.pdf (accessed December 2010)

Craig J. Saper, *Networked Art* (Minneapolis, MN: University of Minnesota Press, 2001)

Margriet Schavemaker and Jennifer Allen (eds.), *Right About Now: Art & Theory since the 1990s* (Amsterdam: Valiz, 2007)

Amy Scholder and Jordan Crandall (eds.), *Interaction: Artistic Practice in the Network* (New York, NY: Distributed Art Publishers, 2001)

Arthur Schopenhauer, *Parerga and Paralipomena: Short Philosophical Essays* (Oxford: Oxford University Press, 2001)

Jorinde Seijdel, 'Wild Images: The Rise of Amateur Images in the Public Domain', *Open* (2010), 8, 62-64

Michel Serres, *The Parasite* (Baltimore, MD: The Johns Hopkins University Press, 1982)

Edward Shanken, 'Reprogramming Systems Aesthetics: A Strategic Historiography', *Proceedings of the Digital Arts and Culture Conference* (University of California Irvine, 2009), Web: http://escholarship.org/uc/item/6bv363d4 (accessed January 2010)

Alexei Shulgin, 'Art Power and Communication', *Nettime* (1996), Web: http://www.nettime.org/Lists-Archives/nettime-l-9610/msg00036.html (accessed September 2009)

Alexei Shulgin and Natalie Bookchin, 'Introduction to Net.art', *Nettime* (1997), Web: http://www.nettime.org/Lists-Archives/nettime-l-0003/msg00007.html (accessed September 2009)

Bernhard Siegert, 'Escalation of a Medium: The Emergence of Broadcast Radio during the High Frequency War', in: Heidi Grundmann (ed.), *On the Air: Kunst im öffentlichen Datenraum* (Innsbruck: Transit, 1993)

Gilbert Simondon, *Du Mode d'Existence des Objets Techniques* (Paris: Aubier, 2001)

Luke Skrebowski, 'All Systems Go: Recovering Jack Burnham's "Systems Aesthetics"', *Tate Online Research Journal* (2006), Web: http://www.tate.org.uk/research/tateresearch/tatepapers/06spring/skrebowski.htm (accessed December 2009)

Peter Sloterdijk, *Sphären* (Berlin: Suhrkamp Verlag, 2004).

Cornelia Sollfrank, *Expanded Original* (Oldenburg: Edith Russ Haus and Ostfildern: Hantje Cantz Verlag, 2009)

Cornelia Sollfrank, *net.art generator* (Nürnberg: Verlag für moderne Kunst Nürnberg, 2004)

Neil Spiller (ed.), *Cyber_Reader* (London: Phaidon Press, 2002)

Julian Stallabrass, *Internet Art: The Online Clash of Culture and Commerce* (London: Tate Gallery Publishing, 2003)

Josephine Starrs, 'Re: net art history', *Nettime* (2001), Web: http://www.nettime.org/Lists-Archives/nettime-l-0102/msg00158.html (accessed November 2009)

Station Rose, *Private://Public: Conversations in Cyberspace*, Edition Selene (Vienna: Taschenbuch, 2000)

Isabelle Stengers, 'Diderot's Egg: Divorcing materialism from eliminativism', *Radical Philosophy magazine*, (2007) July/August, 7-15

Bruce Sterling, 'Digital Decay', in: Alain Depocas, Jon Ippolito and Caitlin Jones (eds.), *Permanence Through Change, The Variable Media Approach* (New York, NY: Solomon R. Guggenheim Foundation and Montreal: Daniel Langlois Foundation, 2003), 11-22

Marleen Stikker, 'Interview with Catherine David', *Nettime* (1997), Web: http://www.nettime.org/Lists-Archives/nettime-l-9707/msg00095.html (accessed November 2009)

Neil Strauss and Dave Mandl (eds.), *Radiotext(e)* (New York, NY: Semiotext(e), 1993)

Carol Stringari, 'Beyond 'conservative': The conservator's role in variable media preservation', in: Alain Depocas, Jon Ippolito and Caitlin Jones (eds.), *Permanence Through Change, The Variable Media Approach* (New York, NY: Solomon R. Guggenheim Foundation and Montreal: Daniel Langlois Foundation, 2003), 55-59

Paul Sztulman, *Documenta X: The Short Guide* (Ostfildern: Hantje Cantz Verlag, 1997).

Tilla Telemann, '"Hacker sind Künstler – und manche Künstler sind Hacker", Gespräch mit Cornelia Sollfrank', *netz.kunst Jahrbuch 98* (Nürnberg: Verlag für moderne Kunst Nürnberg, 1998), 82-86

Tiziana Terranova, *Network Culture – Politics for the Information Age* (London: Pluto Press, 2004)

Emily Thompson, *The Soundscape of Modernity: Architectural Acoustics and the Culture of Listening in America, 1900-1933* (Cambridge, MA: MIT Press, 2002)

James Tobias, *Sync: Stylistics of Hieroglyphic Time* (Philadelphia, PA: Temple University Press, 2010)

David Toop, *Ocean of Sound: Aether Talk, Ambient Sound and Imaginary Worlds* (London: Serpent's Tail, 1995)

Mark Tribe and Reena Jana, *New Media Art* (New York, NY/Cologne: Taschen, 2006)

Barry Truax, *Acoustic Communication* (New York, NY: Albex Publishing Corporation, 1984)

Prodomos Tsiavos, 'Common(s) Issues for Digital Art Libraries: From Open Licensing to Open Collaboration', in: Aymeric Mansoux and Marloes de Valk (eds.), *Floss + Art* (Poitiers: GOTO10/OpenMute, 2008), 154-169

Sherry Turkle, *Life on the Screen: Identity in the Age of the Internet* (New York, NY: Simon & Schuster, 1995)

Jeremy Turner, 'The microsound scene - an interview with Kim Cascone', *CTheory* (2001), Web: http://www.ctheory.net/articles.aspx?id=322 (accessed November 2010)

Lieteke van Vlucht (ed.), *Preserving the Digital Heritage* (The Hague: Netherlands National Commission for UNESCO and Amsterdam: European Commission on Preservation and Access KNAW ECPA, 2007), Web: http://www.knaw.nl/ecpa/publ/pdf/2735.pdf (accessed December 2010)

Paolo Virno, *A Grammar of the Multitude* (New York, NY: Semiotext(e), 2004)

Akke Wagenaar, *SCUM!!! Manifesto: humans‹›machines, ZKP321* (Ljubljana: Ljudmila, 1996)

Jesse Walker, *Rebels on the Air: An Alternative History of Radio in America* (New York, NY: NYU Press, 2004)

McKenzie Wark, 'Information wants to be free (but is everywhere in chains)', *Cultural Studies*, vol. 20 (2006) nos. 2 and 3, March, 165-183

McKenzie Wark, 'Post-Human? All Too Human', *NeMe* (2005), 20 December, Web: http://www.neme.org/main/290/post-human (accessed November 2010)

Matthias Weiß, *Netzkunst, ihre Systematisierung und Auslegung anhand von Einzelbeispielen* (Weimar: Verlag und Datenbank für Geisteswissenschaften, 2009)

Matthias Weiß, *Nodes: An Experimental Exhibition with Seven Artists at Seven Venues in NRW* (Gütersloh: Kultursecretariat NRW, 2007)

Mitchel Whitelaw, '1968/1998: Rethinking a Systems Aesthetic', *ANAT News* (1998), Web: http://creative.canberra.edu.au/mitchell/pubs.php (accessed November 2010)

Stephen Wilson, *Information Arts: Intersections of Art, Science, and Technology* (Cambridge, MA: MIT Press, 2002)

The Yes Men, *The Yes Men: The True Story of the End of the World Trade Organization* (New York, NY: The Disinformation Company, 2004)

The Yes Men, *Update from the Field* (2004), Web: http://www.landmarktheatres.com/mn/yesmen.html (accessed November 2010)

Carey Young, 'Net Art is Not Art?', *Nettime* (1997), Web: http://www.nettime.org/Lists-Archives/nettime-l-9703/msg00063.html (accessed November 2009)

Simon Yuill, 'All Problems of Notation will be solved by the Masses', *Mute* (2008), Web: http://www.meta-mute.org/en/All-Problems-of-Notation-Will-be-Solved-by-the-Masses (accessed December 2010)

Slavoj Žižek, 'The Matrix, or Two Sides of Perversion', *Philosophy Today, Celina* (1999), 43, Web: http://www.egs.edu/faculty/slavoj-zizek/articles/the-matrix-or-two-sides-of-perversion/ (accessed November 2010)

Also available in this series:

Ned Rossiter
Organized Networks
Media Theory, Creative Labour, New Institutions

 The celebration of network cultures as open, decentralized, and horizontal all too easily forgets the political dimensions of labour and life in informational times. *Organized Networks* sets out to destroy these myths by tracking the antagonisms that lurk within Internet governance debates, the exploitation of labour in the creative industries, and the aesthetics of global finance capital. Cutting across the fields of media theory, political philosophy, and cultural critique, Ned Rossiter diagnoses some of the key problematics facing network cultures today. Why have radical social-technical networks so often collapsed after the party? What are the key resources common to critical network cultures? And how might these create conditions for the invention of new platforms of organization and sustainability? These questions are central to the survival of networks in a post-dotcom era. Derived from research and experiences participating in network cultures, Rossiter unleashes a range of strategic concepts in order to explain and facilitate the current transformation of networks into autonomous political and cultural 'networks of networks'.
Australian media theorist Ned Rossiter works as a Senior Lecturer in Media Studies (Digital Media), Centre for Media Research, University of Ulster, Northern Ireland and an Adjunct Research Fellow, Centre for Cultural Research, University of Western Sydney, Australia.
ISBN 978-90-5662-526-9
252 pages

Eric Kluitenberg
Delusive Spaces
Essays on Culture, Media and Technology

 The once open terrain of new media is closing fast. Market concentration, legal consolidation and tightening governmental control have effectively ended the myth of the free and open networks. In *Delusive Spaces*, Eric Kluitenberg takes a critical position that retains a utopian potential for emerging media cultures. The book investigates the archaeology of media and machine, mapping the different methods and metaphors used to speak about technology. Returning to the present, Kluitenberg discusses the cultural use of new media in an age of post-governmental politics. *Delusive Spaces* concludes with the impossibility of representation. Going beyond the obvious delusions of the 'new' and the 'free', Kluitenberg theorizes artistic practices and European cultural policies, demonstrating a provocative engagement with the utopian dimension of technology.
Eric Kluitenberg is a Dutch media theorist, writer and organizer. Since the late 1980s, he has been involved in numerous international projects in the fields of electronic art, media culture and information politics. Kluitenberg heads the media programme of De Balie, Centre for Culture and Politics in Amsterdam. He is the editor of the *Book of Imaginary Media* (NAi Publishers, 2006) and the theme issue 'Hybrid Space' of *OPEN*, journal on art and the public domain (2007).
ISBN 978-90-5662-617-5
392 pages

Matteo Pasquinelli
Animal Spirits
A Bestiary of the Commons

After a decade of digital fetishism, the spectres of the financial and energy crisis have also affected new media culture and brought into question the autonomy of networks. Yet activism and the art world still celebrate Creative Commons and the 'creative cities' as the new ideals for the Internet generation. Unmasking the animal spirits of the commons, Matteo Pasquinelli identifies the key social conflicts and business models at work behind the rhetoric of Free Culture. The corporate parasite infiltrating file-sharing networks, the hydra of gentrification in 'creative cities' such as Berlin and the bicephalous nature of the Internet with its pornographic underworld are three untold dimensions of contemporary 'politics of the common'. Against the latent puritanism of authors like Baudrillard and Žižek, constantly quoted by both artists and activists, *Animal Spirits* draws aa conceptual 'book of beasts'. In a world system shaped by a turbulent stock market, Pasquinelli unleashes a politically incorrect grammar for the coming generation of the new commons.

Matteo Pasquinelli is an Amsterdam-based writer and researcher at the Queen Mary University of London and has an activist background in Italy. He edited the collection *Media Activism: Strategies and Practices of Independent Communication* (2002) and co-edited *C'Lick Me: A Netporn Studies Reader* (2007). Since 2000, he has been editor of the mailing list Rekombinant (*www.rekombinant.org*).

ISBN 978-90-5662-663-1

240 pages

Vito Campenelli
Web Aesthetics
How Digital Media Affect Culture and Society

Web Aesthetics explores contemporary cultural expressions and social experiences from an aesthetic perspective. Inspired by the observation of a diverse range of digital phenomena and practices such as social networks, website interfaces, online video and the advent of remix culture, Italian media theorist Vito Campanelli investigates how digital media permeate society and culture in extensive ways.

Explorations of the aesthetic implications of new media have largely neglected aesthetic philosophy. Taking this theoretical terrain as its basis, Vito Campanelli offers a rich and important intervention into developing an organic theory of digital media aesthetics. Drawing from aesthetic philosophy, new media and art theory, *Web Aesthetics* opens the field of new media studies to consider the profound cultural and social impact of the global diffusion of Web-related forms. As Campanelli argues, when the Web is located inside sociocultural practices, processes and expressions, it becomes a powerful agent in the aestheticization of life on a global scale

Vito Campanelli is a new media theorist and lectures on the theory and technology of mass communication at the University of Naples – L'Orientale. His essays on media art are regularly published in international periodicals such as *Neural*. He is a freelance curator of events in the domain of digital culture. He was also co-founder of the Napels non-profit organization MAO – Media & Arts Office.

ISBN 978-90-5662-770-6

276 pages